UNREAL IS

I was in Wood Green when I decided to
get out of the rain and grab a bite
to eat. The greasy spoon café
was empty apart from a group
of young men contemplating
a menu.
"What's today's special?"
asked one of the men.
"Nothing is special," replied
the elderly Greek waitress
in broken English.

Editor
David Kerekes

Layout
Walt Meaties &
David Kerekes

Design Assistant
Sun Paige

Cover Art
Dan Duce

Photography
Marie-Luce Giordani

Writers & Artists
Darren Arnold
Thomas Ballhausen
Anton Black
Ben Blackshaw
Tom Brinkmann
Mikita Brottman
Eugene Carfax
Michael Carlson
Martha Colburn
Simon Collins
Andy Darlington
Progeas Didier
Dogger
Marie-Luce Giordani
John Harrison
Adrian Horrocks
Martin Jones
Brian Krueger
James Marriott
Sun Paige
Anthony Petkovich
Rik Rawling
Stephen Sennitt
Marie Shrewsbury
John Spzunar
Johnny Strike
Verian Thomas
Will Youds
Joe Scott Wilson

EDITORIAL

Maybe we should have called this edition of HEADPRESS 'Urban Philosophy Issue'. I felt moved to doing so when I heard that old Greek lady tell a customer "Nothing is special" (see previous page). She wasn't being arrogant either, or trying to be clever. It was as succinct a reply as she could muster. So where draw the line between philosopher and waitress? Is one qualified to utter and recognise profundities only after years of scholarship? Maybe her statement carried a greater weight because it was an environment far removed from academe, and came completely unexpected. Then again the statement had the cold harsh resonance of years of truth and toil behind it. This was, after all, Wood Green in the rain, where breakfasts are served all day. Or perhaps she *was* a scholar; a mature student? What do I know?

David Kerekes

Headpress 21
"Unreal is Real"
Published: January 2001
by Headpress

Headpress
40 Rossall Avenue
Radliffe
Manchester
M26 1JD
Great Britain
email: david.headpress @ zen.co.uk
website: www.headpress.com/

World Rights Reserved

British Library Cataloguing in Publication Data
A catalogue record for this book is available
from the British Library

ISSN: 1353-9760
ISBN: 1900486113

CONTENTS

"I think there is a God. I do think he's got a beard and I do think he's got a throne. I don't think there's any women involved. He sits there and he's fuckin' great."

—Jerry Sadowitz,
favouring the concept of
God over the language of science

"I relish the idea that in the night all around me in my sleep sorcery is burrowing its invisible tunnels in every direction. From thousands of senders to thousands of unsuspecting recipients. Spells are being cast, poison is running its course. Souls are being dispossessed of parasitic pseudoconsciousness' that lurk in the unguarded recesses of the mind." —Paul Bowles

The ghost of
BRIAN JONES
speaks to the
VILLA DELIRIUM

by Johnny Strike

ABDUL, THE MANAGER, SHOWED ME around The Hotel El Muneria. Rooms were now ten dollars per night. I saw an open door. It was number 9, Burroughs' old room. Abdul invited me in. It was his room now. At the window he showed me where there was previously a view but now only a wall. I mentioned that the place would probably be a museum someday. Abdul agreed. Burroughs' furniture had been stored in the basement. Leaving the hotel, I felt different, as though I had soaked up some psychic residue.

At an outside café I decided to have a snack. The waiter pointed to a small table under an awning.

"Brian Jones used to sit there," he said, giving me pause.

He encouraged me to take that seat. I was handed a *Sebsi* (kif pipe) and a box of wooden matches. While smoking the pipe, I watched the passers-by: modern Moroccans mixed with those wearing djellabas… some women still shrouded and veiled. Suddenly I was jolted. A man passing by looked directly at me — he was the spitting image of Brian Jones! I stared in disbelief. He just as quickly vanished. I rushed out to the street, but the man seemed to have melted into the air. I questioned my own sanity for a moment. Was it his doppelgänger? Was it the twin of Jones? An elaborate prank that the waiter was in on? Or was it the kif, combined with my overactive imagination? The waiter seemed oblivious as he delivered my *harira* soup, crusty bread, and small plate of sardines and olives.

"Tangier is the prognostic pulse of the world, like a dream extending from the past to the future, a frontier between dream and reality…"
—William S Burroughs

In the liner notes for the Master Musicians Of Jajouka's CD, *Apocalypse Across The Sky*, Burroughs had placed Jones in Morocco a year after his death. I will recommend here the 1983 documentary made by Michael Mendizza, *The Master Musicians of Jahjouka*, although it is difficult to locate. At the café I had another pipe and a glass of mint tea. A blind old midget in a suit and tie came into the café and approached everyone for a donation. One attractive lady moved away in horror as the midget fumbled with her bare knees. A man wearing a djellaba, fez, and pointed slippers stood in the entranceway talking on a cell phone. Another man who bore a passing resemblance to Omar Sharif approached. He wore Western clothes and smelled of perfume. He asked if he could join me, and I motioned to the empty seat. He ordered a *café au lait* and lit a Moroccan cigarette. In the street an angry, bare-chested Moroccan man was waving an evil-looking scimitar and screaming in Arabic at someone in another shop. Everyone watched him until he wandered off. I was definitely in Interzone. By and by Omar got around to his spiel. He knew of a house for rent. Was I interested? He was busy speaking French to some exhausted-looking backpackers when I left.

Is Morocco still a land of adventure, romanticism, mysticism, or simply a cliché? A number of summers ago I spent two months in the sleepy fishing village of Puerto Angel, on the coast of Oaxaca, Mexico. I met a number of other travellers during my stay, and in particular had some interesting talks with a smart young couple from London. They worked for a promotion company that handled rock tours. The last tour they'd done was for the Rolling Stones. This opened the way to a favourite subject: Brian Jones and Morocco. I said that I wanted to visit Morocco and asked if they had been there.

"No," the girl said, "it's too much of a cliché."

A country inhabited as early as 800,000 BC, a cliché? Later I thought more about it, and Morocco, perhaps to the English, is a lot like Mexico to Californians. But Morocco is a place that has always captured my imagination. Even as a child there were all the romantic themes I was more than eager to latch onto. After seeing *Beau Geste*, I pictured myself riding camels, a deserter from the Foreign Legion, travelling through desert landscapes, Casbahs of splendour and high adventure. As a young man I began to read the literature of Morocco; the expats: writer/composer Paul Bowles, Burroughs, and painter/writer Brion Gysin. I also read the Moroccan writers Bowles had translated: Choukri, Mrabet, Layachi, and others. I listened to the recordings of Jajouka. The espionage and smuggling history enticed me even more.

On June 3, 1998, I checked into the Hotel Continental, known for its crumbling grandeur, its view of the port as well as the rooftops of the Casbah. The hotel was used in *The Sheltering Sky*, a film flawed by miscasting. I would rather recommend Frieder Schlaich's and Irene Alberti's (1995) *Half Moon*, based on three of Bowles' stories. From a loudspeaker atop a mosque the prayer call of the Muezzin echoed through the Casbah.

The next couple of weeks were spent roaming

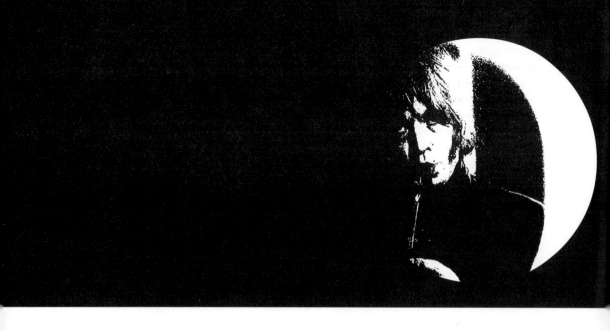

the city. I saw the beggars and Berbers, and began in the Medina, working my way through to the Casbah. Kahlid took me to lunch in the Casbah. The place had no name, just a blue building with the door open. They served tasty Moroccan dishes to the native clientele at a very low price. But to get there on my own, I had to write precise directions in my notebook and follow them carefully. I found my way through a twisting maze of alleyways that sometimes came to dead ends, or led through arched entranceways, and entirely new vistas. I once found an enchanted garden and fountain I was never able to locate again, although I would later find an identical one in Fez. Roaming the Casbah and Medina is what I immediately loved about Tangier. Starting in the Grand Socco and getting lost became a favourite pastime.

At lunch time, though, I usually wanted to find that particular restaurant that had no name. I followed my notes.

'Left at studded door. Right at elaborate door. Right at silk merchants. Right at 38. Quick left at candy stand. Keep straight…'

At a shop with old American movie star photos I'd stop and locate the blue restaurant. One time I got hopelessly lost. Later I figured out that the candy stand was not there everyday. One wrong turn and you are lost.

In the Medina, boys fell in beside me with the endless offers of watches, hashish, boys, girls,

Caves of Hercules (which I did eventually visit and enjoy), Sultans Palace, and trips to the Berber market. "Only today! Special market!" they shouted. I shooed them away with *"Emchee halik,"* which basically means, "Leave me alone, please!" I heard one boy say to another, "He lives in Casbah. He knows Kahlid." Eventually very few of these boys bothered with me. But one about five-years-old sometimes would fall in beside me so I'd give him a few Dirham.

This walled-in Casbah is the one briefly used in the film Casablanca. There have been many films made in and about Morocco, the most famous and boring being *Casablanca*. Another mediocrity, though more fun, is Gerry O'Hara's (1967) *Maroc 7*, starring Gene Barry. Among the film's strengths are its swinging sixties fashion models, and shots around Fez. Recently I watched *Casablanca* again to see if it was truly as dull as I remember. Strange, all those good actors wasted. The film is okay at best, highly over-rated. As I watched the film, I started to re-shoot it in my mind, imagining it made in the sixties, with a director like Anthony Balch or Peter Watkins at the helm, and starring the Rolling Stones. Bogie's part is played by Brian Jones, Ingrid Bergman's by Anita, Marianne, or Jean Shrimpton — take your pick. Bill Wyman in Sydney Greenstreet's role (wearing a fez of course), Keith in Peter Lorre's. Ian Stewart as the Prefect of Police, Charley as the bartender or dealer, Mick as Sam

the piano player (perhaps in black face, like he was on Have You Seen Your Mother, Baby, Standing In The Shadows?). The theme song would be As Tears go By rather than As Time Goes By.

(How odd to find out later that the Stone's song was originally titled As Time Goes By, and was changed because of the *Casablanca* tune.)

Brion Gysin as the Resistance hero, Burroughs as the Nazi, drunkenly waltzing around Rick's Bar singing *"Ich Bin von Koph bis Fuss auf Liebe Eingestelt"* (Falling In Love Again). Paul and Jane Bowles in a cameo as one of the couples. Complete this ensemble with a soundtrack of all types of Moroccan music. That dreadful dialogue would be rewritten by Burroughs and Terry Southern.

Eventually I found my way to the Ville Nouvelle, more or less a 'normal' neighbourhood, except when one veered off the French-influenced Boulevard Pasteur with its endless cafés, and Moroccan men sipping coffee, tea, and smoking. Young Moroccan boys flitted about shining shoes and selling single Marlboro cigarettes. The street names in the Ville Nouvelle have been changed so many times (French, Spanish, Arabic) that it can be as confusing in its own way as the Casbah.

I was smoking kif and hashish one night at Café Hafa (also known as the hippie café) which is perched on a hill overlooking the Strait of Gibraltar. I was hanging out with a couple of Moroccan lads (not *guides*, mind you; no one here is *actually* a guide). One boy turned on his tape player and I thought, what interesting music, and asked who it was. "Rolling Stones," he said in disbelief. And then I recognised it. The later part of the 7:58mins Sing This Song Altogether (See What Happens) from *Their Satanic Majesty's Request*. Café Hafa was a legendary hangout for Bowles and company, and later the Beats and even later the Stones and the hippies.

Paul Bowles was the man to meet but I had received disappointing reports: "He's not seeing people any more… He's too sick…" At the Tanja Flandria Art Gallery — part of the new expat contingent of eccentric English — was John 'Blunt' Lawrence, and his advice was congruent with my own philosophy: "Stay persistent."

Mohamed Choukri and Mohammed Mrabet are two writers who have been translated by Bowles. I decided to try and meet at least one of the 'Mohammeds,' which might very well lead me to Bowles.

Choukri had two books in the window of the Librairie Des Colonnes on Boulevard Pasteur — *Le fou des roses* and *Paul Bowles, Le Reclus De Tanger*. There were also a half dozen French titles by Bowles, and a beat up English copy of Mrabet's *The Lemon*. Choukri was now sixty-eight, living and working in Tangier. His reputation preceded him as a heavy drinker. Alcohol is forbidden by Islam, and the Moroccans I spoke with told me, "He drinks too much. Too much." I tracked him through the bars in the Ville Nouvelle. Gone were the days of hanging out at the Socco Chico, the square within the Medina. A few of the bartenders were talkative. At Negresco, the barkeep made a call. A meeting was arranged for the following

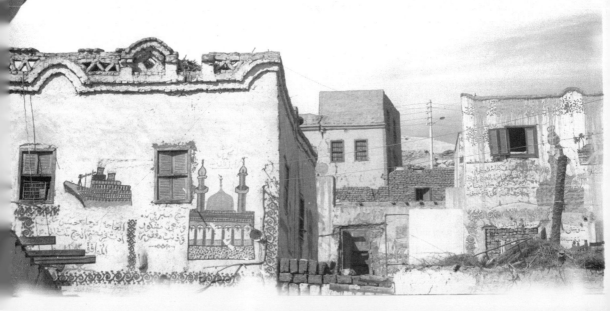

morning at the Roxie Café.

Choukri looked spry and lean with bushy hair, complete with moustache and beard, both being two differing shades of grey. He wore a grey shirt and jacket. I also was wearing a grey shirt. *Grey area.* Mohamed didn't care for the bars anymore. Now at the end of the day he bought his bottle and went home. Today he ordered a Pimms and directed me upstairs.

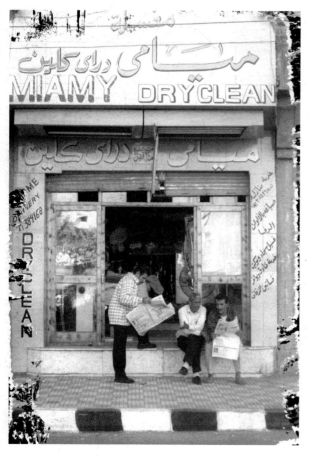

"I WAS BORN NEAR MELILLA, MARCH 25, 1935," Choukri said. "You know Melilla? I'm Berber from the Rif. My first language is Berber, and I learned Arabic later. My family came to Tangier in '42; I was seven-years-old. We came to Tangier because people said at this time it was a paradise. But in reality it was not a paradise for my family. My father was also a deserter from the Spanish army and, as a result, he served three years in prison. It was necessary for my mother to sell goods in the market. And I would eat anything. They were difficult years for my family, the forties. When my father was released from prison we went to Tetouan. I left my home when I was ten- or eleven-years-old. It was a difficult for me. My father was very cruel. Have you read my book *For Bread Alone*?"

Yes, I enjoyed it.

"My story with my father is there. A very difficult man, not only for me, but for all my brothers and sisters. I studied the alphabet when I was twenty-years-old, in Larache. But in 1956 we had the Independence. I stayed in Tangier and did business with the tourists and the marines."

*So, **For Bread Alone** was a true story, and eventually you worked some jobs?*

"I worked in the bars and the restaurants, and sold things in the streets. I didn't have an education to take a job, but each day I worked before I went to study."

How old were you when you started to write?

"In the sixties I tried to write — for about six years. I tried to write poetry, sometimes prose, but the first short story I wrote in 1966 at the age of thirty-one. I published my first short story, but the Arabic publishers, magazines, and newspapers would not publish my stories. They considered my work pornographic. [*We both laugh.*]

"Well you know the mentality of the Arab world… it's very conservative. It was very difficult for me to publish my short stories. Between '66 and '73 I wrote several books, but none were accepted for publication in Arabic. Just Paul Bowles… he translated, in '72, *For Bread Alone*. Peter Owen published it but without success. And also Peter Owen is a… rubbish man, garbage man. He gave me one hundred pounds, no more. And he sold it in Canada, the United States, City Lights… he's a bad publisher. I don't know why Paul Bowles continued to publish books with Peter Owen. When I asked him he said, 'Well I'm in Morocco. I cannot choose another.' His response was not clear to me. Maybe he has a pact with Peter Owen. And Mrabet said he saw some copies of cheques at Paul's. [*With a look of exasperation Choukri rants*] They stole my children, and they steal also now… And I don't pardon

that. It's very bad. It's not easy. It's not just the money it's the dignity."

When did you meet Bowles?

"1970. I knew him through a friend, Edouard Roditi who died some years ago. He was an American Jew and a very good man. Edouard took me to Paul. He told Paul to look at some short stories of mine because he liked them. Then Paul began to translate some of my stories into Spanish. Paul Bowles knows very much, he understands good Spanish, French, and English. He is very intelligent, a genius, but I don't like some of his criticisms."

Was Jane Bowles still alive at that time?

"She was in the hospital. I wrote a book about that, *Le Reclus De Tanger*.* I wrote this book as an analysis of Jane and Paul."

And you knew Burroughs, as well?

"Yes, I met him. Well, I saw him several times with Paul Bowles. I saw many of the writers in the Socco Chico, at restaurants and bars but I didn't have a relationship with them. I wasn't in that literary circle. But then in 1970 I met Paul Bowles, and through him I met William Burroughs, Genet, and Tennessee Williams." [*One of Choukri's friends shows up and he claps hands to notify up the waiter.*]

This may be a boring question, but do you have any kind of writing schedule?

"No, I write it in my head before I write it down. No discipline or schedule. I stopped once for a year and once again for two more years. To write a book, I must first write it in my head."

Are you working on something now?

"Yes, a new book of fiction."

Most of your books are autobiographical.

"I wrote two, *For Bread Alone* and *Streetwise*. Both were published in England."

*I just finished Bowles' **Let It Come Down**.*

"Yes, it's one of his best books. He presents in his fiction what it was like in Tangier at that time. What I don't like in his books and stories is that he is a nihilist; more than a pessimist. Nelson Dyar kills his friend in *Let It Come Down*. In another a woman dreams of a scorpion. [*Choukri grabs his throat.*] Another, a teacher of English, they cut his tongue out. Another his sex is removed. They're so dark."

I found it amusing in your Genet book, when you

asked him if he had ever read Tennessee Williams. His response was, "No, and I don't want to read anything, either. Everything I've read about his works leads me to think it wouldn't interest me."

"I met Genet for the first time in 1968. He came here from Chicago. He was with Burroughs among others. I knew him in the Socco Chico and we became friends."

Were any of these men influential for you?

"No influence. I forget the influence and I keep only the admiration."

Photos: Marie-Luce Giordani

*A controversial book in Bowles' circles, translated from Arabic to Spanish and French.

MOHAMED CHOUKRI APOLOGISED FOR HIS English, and said he wished the interview had been in Spanish or French. "Or better yet, Berber," I joked. I asked about Mohammed Mrabet and he said, "Yes, you should meet him. He is a very nice man." This was not exactly his reputation, but yes I liked Mrabet's books, and wouldn't mind meeting him. Choukri said that Mrabet and Paul

were now on the outs. He suddenly stood up, saying that he was late for another appointment.

Everybody had a different opinion about Mrabet — that is, whether he was living or dead. People were adamant in either instance: the people at the bookstore were certain he was dead, and a waiter at one of the cafés agreed; but a boy at the souk swore he knew Mrabet, and could take me to him. And according to Choukri he was alive. I eventually found out from a reliable source (his agent) that he was indeed alive but had been very ill, and had recovered from a

Photo: Marie-Luce Giordani

number of difficult operations. His most recently published book was *Chocolate Cream & Dollars*.

How does one go about meeting Paul Bowles?

"He lives near the old American Consulate," Choukri told me. "Get in any cab and tell them *Itesa*. They will know it. Go between four and five."

In my room I read an article about Aisha Kandisha entitled 'A Tempting Spook'. This sensuous ghost materialised before men. She is believed to be a descendant of Astarte, for

whom sexual orgies were performed. One of her haunts was the main entrance gate to the Casbah, near where I was staying. Many believe her to have once been a promiscuous woman, but now in limbo. She appears to lustful men who are thinking of visiting a House of Pleasure.

> *"As each sharp outline melts and weaves and undulates in time with the compulsive rhythmic insistence of each pounding musical line, the scornful dancing lady dressed in black at last reveals she really isn't there at all. She simply isn't real. So thank you for being there my love. At least I know that you're real."*
> — Brian Jones

A MUCH ABRIDGED AND HIGHLY TYPO'D VERSION of the Paul Bowles segment that follows recently appeared in the New York art magazine *Cover*. Not only did they cut everything that was even remotely controversial, but the copy editor did such a lousy job that he had things which Bowles said, coming out of my mouth, and vice versa. He incorrectly transcribed one line to read, *"I spoke to the Villa Delirium."* Was the editor suffering from delirium? The Villa Delirium was the name given to The Hotel El Muneria, a favourite of the Beats in Tangier, and famous for being the place a first draft of *Naked Lunch* was written.

Around 3:30 PM I flagged a Petite cab and said, "Itesa." The puzzled driver shook his head. Neither did the next cabby have any idea of what I was talking about. To the third one I practically yelled, "Near the old American Consulate, Paul Bowles... *Itesa.*" He too shook his head, but gestured me into the cab. He knew where the old American Consulate was. On the way, he picked up another Moroccan who spoke some English and knew of Bowles, but he too was mystified by the name *Itesa*. Staring at my scribbled note I pronounced it different ways with no success. We got to the general neighbourhood and asked a few people but nobody could help. After paying the

driver, I continued to ask around. Finally an old man with a dead eye, wearing a striped djellaba with the hood up, motioned for me to approach.

"Paul Bowles is at *Itesa*," he said through broken teeth. He pointed to a dull-looking apartment building beyond a scrubby lot.

In front, by the first floor grocery store I found a gang of young boys sitting on some crates, half bored, half curious. "Paul Bowles," I said and one smiled and stepped out directing me around the side of the building. We went in a side entrance and entered a small elevator in the dark. I knocked on Bowles' door No answer. I waited, knocked again, harder this time. Silence. The boy pantomimed a person sleeping. I motioned that I would wait by pointing to the stairs leading to the next floor. The boy left. As I waited I reread the intro to *Let It Come Down*. When I looked up, the boy was back and offering me a cup of freshly squeezed orange juice. I tried giving him a few Dirham, but he declined and instead stared greedily at the two pens in my breast pocket. He desired one of my pens. How apropos. I gave him his choice and he went away happy.

A little while later I heard some voices and looked down to see a man putting a key into Bowles' door. "Hello," I said as I descended the stairs. Nearby, a hippie woman looked away as the man considered me with some suspicion. Perhaps he considered me a stalker of sorts.

"Yes," he said, "what do you want?"

"To see Paul Bowles."

"Well... he doesn't see people at this hour. She has some business with him," he said nodding towards the hippie woman who continued to stare at the floor.

"Mohamed Choukri said to come between four and five," I added.

"That drunken idiot! He's no friend of Paul's. He wrote a horrible book about him. Didn't you read it?!"

"Uh, no! It hasn't been translated into English."

"Yes that's true. Hopefully it won't be."

I mentioned that I had interviewed Burroughs and he seemed to brighten a little.

"Well, *that's* interesting! Come back at five thirty. His attendant will be here then."

At the front of the building I returned the cup

to the boy. I wandered around the neighbourhood and finally into a hotel. In the back I sat by an abandoned pool where leaves covered the surface. I sipped from my *Sidi Harazem* water bottle and smoked Moroccan cigarettes that tasted like dead leaves. I thought back to a question I had posed to Burroughs in 1983. Actually it was an inquiry into what Brion Gysin had been up to. Burroughs replied that Gysin was writing for some art and photography magazines, and had published something on Brian Jones and Jajouka.

Once back at Bowles' place I looked forward to meeting the legend. He was a forerunner to the Beats, like Brion Gysin, a bridge perhaps from the Surrealists. Like Graham Greene, he was among the greatest of the exotic locale fiction writers. In the overly quoted line of Nor-

man Mailer's, "Paul Bowles opened the world of Hip. He let in the murder, the drugs, the incest, the death of the Square... the call of the orgy, the end of civilisation." In a catty mood the eccentric, paranoid, writer, Alfred Chester called Bowles, "The Mickey Spillane of North Africa." During one of Chester's freakouts, he was convinced that Bowles had arranged a contract to have him killed.

I knocked on Bowles' door. A middle-aged Moroccan man opened it and let me in.

"You may see him," he whispered, "but only for a short time." He gestured past the famous stack of luggage to another dim room. There I found Bowles in bed looking the same as his pictures only much older. He was eighty-seven. White hair. Blue eyes. He was sitting up in bed with a breakfast tray across his lap which held various medicines and liquids in glasses with straws. The hippie woman was there, off to the side sitting and writing in a notebook. I asked if I was interrupting anything. She gave me a darting look and said, "No." I introduced myself to Bowles, we shook hands, and I took a stool by his bedside. He warned me that his hearing wasn't so good, so I drew myself closer.

IT'S NICE OF YOU TO SEE ME, I SAID. I read an article once where you said, "Tangier is still a fascinating place. Do come, just don't come see me."

"Did I say that?" Bowles replied with a laugh.

I was in Sri Lanka a few years ago and met Arthur C Clarke. I told him I planned on coming here next and would try to see you. He sends his regards.

"Thank you. I understand he's a very busy man. He's very interesting."

Sri Lanka is interesting as well.

"I loved it."*

Burroughs said somewhere that he

Photo: Marie-Luce Giordani

*Bowles had owned the island of Taprobane near Weligama and had finished his novel, *The Spider's House*, there. Brian Jones also had visited Clarke in, as it was called then, Ceylon. And there was Brian's famous teardrop guitar. Sri Lanka was known as the teardrop island.

never doubted the possibility of an afterlife.

"How peculiar."

Well, he was always interested in the mystical.

"Yes, I suppose. Yes, but that is carrying it rather far."

I take it you don't agree with that idea.

"No, I don't. I would never, how could I? First I would have to believe in a supreme being, be religious and all that, which I was never taught to do as a child. My parents didn't believe, my grandparents didn't, so I was saved from religious training as a child. I wouldn't want to have had it."

What do you think of this 'millennium' business? Some people think that since we're going into a new century that maybe it's the end of the world. Even some Moroccans I've talked with feel this might be the case.

"Why? I don't understand because after all it's purely arbitrary counting. Well, its supposed to be 2,000 years after the birth of Jesus Christ, is that it?"

Right, something like that. [2,000 light years from home?]

"Well, that's fine, but what do they [Moroccans] have to do with that?"

I don't know. 'Millennium mania?' In your novel **Let It Come Down**, *Nelson Dyar struggles with this idea of being truly alive, and of living in the moment. Is that a desirable thing in the long term or is it even possible?*

"Living for the moment, in the moment?"

Well, and knowing or being aware that you're really alive.

"Well, it keeps one's feet on the ground. I think it's all right. And you have to because it doesn't come automatically. It probably comes automatically to animals. Or other mammals. But I'm afraid it doesn't come automatically to human beings because they have a brain and they're able to remember. They like to think they can foresee the future. And that does away with the possibility of being always aware of what's going on at the moment and/or of taking part in existential life."

Have you done any more writing that is similar to your book of journals, **Days**?

"No, I did it especially for Dan Halpern, my editor at Ecco Press. He wrote me once and asked,

'Have you ever kept a diary?' I laughed to myself and thought, 'No I never had.' Dan responded with, 'Too bad. Why don't you start one now?' I wrote that it was rather late to keep a diary at the age of… I forgot how old I was, in my late seventies. And he said, 'No, no, no, I would like to have you do it, and I'll publish it.' I took his offer seriously and started a diary, which went on for two years. It was published in England, first as *Two Years Beside The Strait*."

I wasn't aware of that title.

"Well, that's its original title and *Days*, is simply a… Dan didn't like the original title because he felt that no one in the States would understand it. Americans are not good at geography. They don't know what strait is here. So I had to go with a title that had more or less to do with time than place. It's true, Americans don't seem to know anything about where things are. I don't know why? I don't understand it because I certainly as a child lived with an atlas. A big one I spread it out on the floor and got down and lived with it."

Many Americans think the United States is the centre of the universe.

"I think they probably do, yes I'm sure that they do. They call it 'God's country'. That's pretty silly."

I've been trying to find trance music in Tangier and it seems impossible… the trance drumming that you've talked about.

"Oh well, those things are not appreciated by the Moroccans at all. On the contrary, they're connected with religion. They're not hallowed by traditional observance. I mean, if you go into anything to do with Islamic religion, you have to do it properly, because Morocco's not an Arab country, it's an African country. It's an Arab colony. The Arabs came here and did their best to colonise it, and they got along better than the Romans did. But they were more consistent and I guess they had something to offer that the people here could absorb… that is, the Moslem religion. They managed to cover the population completely with it. They succeeded in their Islamization but they have not yet succeeded in the Arabization. They contrived to make it an Arab country for a long time. It isn't yet. It's got a long way to go, too. It's not an Arab country, it's

a Berber country — different languages, different everything. The Berbers have accepted Islam but they don't observe it in a completely approved fashion. The people who really speak Arabic are far and few between. It's rather like I suppose in the Middle Ages, the people who really knew Latin were far and few between, who could read and write it properly. It's more or less analogous with the situation."

I'm off to Fez next. [Bowles smiles at the mention of the medieval city.] Do you think I'll find that music there?

"How do you want it? You want to find it in what sense?" [*He taps on his tray with his forefingers; perhaps tapping out his own personal Jajouka.*]

I want to hear it live.

"Ah, that's hard. It exists but it's hidden, particularly from foreigners. When I had a Rockefeller grant to record Moroccan music for the Library of Congress, I did but I left out all what you call trance music, because I knew I'd have much trouble to get it by. In fact, I did include music of the Sephardic Jews with a little trepidation. But it went through alright because the State department agreed to send it by diplomatic pouch which meant they couldn't get at it… "

AT THIS POINT THE ATTENDANT CAME BACK announcing that the "Yarmolinskys" had arrived. He asked me to wrap up the interview so I handed Bowles my copy of *Let It Come Down*. While writing an inscription he explained that he had glaucoma and couldn't see what he was writing too well. I told him about the boy with the orange juice and he wondered aloud which boy it may have been. The attendant who was lurking nearby said it must have been Abdeslam or Ahmed.

During my wanderings I came across Gysin's old club, Thousand and One Nights, now a tourist joint called Café Detroit. I visited the fishing village of Asilah. Walking through the winding Medina with my friend Kahlid, he suddenly stopped. "There, see that blue house?" I nodded. "Brian Jones used to stay there. He would play music all night." More Brian Jones synchronicity. I hadn't mentioned anything to Kahlid about him.

"What about the other Rolling Stones?"

"Oh, yes, them too," he said, "But Brian Jones especially."

Leaning against a wall, an old man in a faded djellaba began playing a haunting tune on his *nira* (flute). I drifted off while listening to him, standing in some shade. When he finished, I dropped a few Dirham in his hand. On the beach we took a table under bamboo awnings and indulged in a feast of fresh fish. The waiter brought out a variety of fish, each prepared in a different manner. Kahlid had done all the ordering. Skinny cats meowed from somewhere and were soon slinking around for scraps.

After a five-hour train ride, I arrived in Fez. Now famished, I headed for the nearest café and ordered a cheeseburger. I had seen the cook make one for a Moroccan lady. I explained I didn't want all the suspicious-looking condiments he had put on hers. I preferred only mustard. And what the hell, the inevitable egg that they felt belonged on top. I gobbled it down with the french fries. In Tangier when one orders a sandwich, the fries come stuffed inside with the meat.

It was as hot in Fez as an Indian sweat lodge, and I was thankful for the hotel's air conditioning. The pool looked inviting. Brian Jones was drowned in his own pool by a jealous thug-workman referred by the Rolling Stones organisation.

"He does not yet know he is dead. But he does know his hair is getting wet and he hates it. It reminds him of the time he almost drowned in a rockpool on the Straits of Gibraltar, just outside Tangier. He is only barely aware of the earth shaking under him. It is exactly 23 minutes past five in the afternoon, Pacific Summer Time…"
—Brion Gysin

THE ABOVE QUOTE WAS WRITTEN ABOUT IAN Sommerville, but somehow seems relevant here. Sommerville also died young, in a car crash. Gysin and Jones were friends, as well. When Jones had visited Ceylon he had spoken with an astrologer who had supposedly worked with Hit-

ler. Picture Jones wearing his Nazi uniform. The astrologer had told him, *"Be careful swimming in the next year. Don't go into the water without a friend."* In her autobiography, Marianne Faithfull tells the story of the time she threw the I Ching for Brian with Mick observing. Both times the reading was death by water.

I took a look around Fez. The Medina was impressive, as well as the King's palace where a guard with a rifle chased me off. I contacted Kahlid's brother (who I was to deliver some documents to) and the following evening I was the guest of honour at a dinner held at his house in the country. The presentation of the meal was as extravagant as anything I had ever read about. It seemed fit for a desert chieftain. After too many courses to count, a baby lamb couscous was served. After only a couple of weeks in Morocco I had ceased to be a vegetarian. In addition, I had picked up smoking again, which was difficult to avoid since the Moroccans mostly insisted that kif and hashish be smoked with tobacco.

The following week I took a bus to Chaouen, in the Rif mountains. During the trip I contracted a cold, presumably from the extreme hot and cold I had been experiencing in Fez. Chaouen appeared suddenly, looking beautiful. The bus stopped for a few minutes while a donkey finished up his back massage on the road. When we arrived I was feeling down-right lousy. I checked into a hotel that turned out to be lousy as well. I had a poor meal at one of the restaurants. Back in my room, I found myself with a case of diarrhoea. After a crummy night in the lumpy bed, I woke up with a nosebleed. I had had a feverish dream. It concerned Bou Jeloud, Pan, the goat god of Panic, and Brian Jones dressed in the outfit Mick Jagger wore on the cover of *Their Satanic Majesty's Request*. Men with goats heads leapt about. Flames spewed forth from potholes. One year Brian had been invited to be Bou Jeloud in Jajouka's Dionysian festival, but he had not been able to make it. I thought about the oft told story of Brian seeing the slaughter of a goat and his premonition of death

Back at the Hotel Continental in Tangier I was treated for my cold by Mohammed, a waiter I had befriended. He insisted that I drink freshly squeezed lemon juice and honey served hot, four

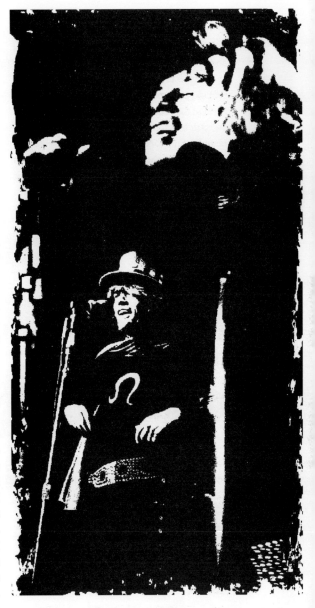

times a day. By the second day I was better and had stopped puckering my lips. I became friendly with Yuki, a Japanese man I found on the terrace one morning keyboarding into a laptop. He was working on an article about Moroccan pop music for the Japanese *Esquire*. Yuki was knowledgeable about all Moroccan music. He said that he had met Bowles on a trip the previous year and had asked him what he was going to do next. Bowles had answered, "Nothing. I'm just await-

ing my death."

We went off together to the cassette stands in the Medina. A group of blacks wearing caftans and turbans passed by playing their drums.

"Tourist G'naoua," Yuki stated. "No heart."

Yuki imitated a trance dancer to the amusement of the cassette salesmen. He helped me put together an excellent collection. A few days later he invited me to hear some live Andalusian music at a private party in the Casbah. A year later I would see an outstanding performance by The Master Musicians of Jajouka in San Francisco.

Mid-set Bachir Attar spoke about Brian Jones. As the crowd cheered, they launched into Brahim Jones, the song done in tribute to him. There's also the intriguing song Godstar, and its various mixes about Jones, by Genesis P-Orridge and Psychic TV on their 1986 Allegory & Self. Supposedly track 23 was left open for Brian and a sound was

picked up on it. (The release was followed by a sticker campaign that proclaimed 'Brian Jones died for your sins'.)

Some days were spent transcribing my interview tapes at the Dawliz Café, enjoying mint teas and gazing out at the sweeping views of the city and the sea. At one point I looked up and it occurred to me that I was alive in the moment like Bowles had talked about. Everything seemed to stir with life. I felt both in the moment and as though I'd stepped into some timeless spot, with a distinct North African tempo. The night sky and sea were various shades of blue and the subdued whitewash of the buildings made me feel I had stepped into a film. I was now known by different people around the city. I even began referring to others as "My friend." I would occasionally hear my name called out. Sometimes it was a paraplegic midget painter in a wheelchair I had spoken with, or somebody like Azzi, the hash salesman. The staff at the hotel were even beginning to send new arrivals to me in order to orient them.

The seaside in Tangier is not much to mention. The water is polluted and chilly, the beach is windy and mostly used for boys playing football (Americans, read: soccer). A disgruntled camel standing there in the morning summed up the mood of the Tangier beach scene. Most people went by bus or car to Cape Malabata, Cape Spartel, or Robinsons. Being somewhat lazy, I opted to crash the pool at the elaborate Hotel Minzah, where everyone from Brian Jones to Jean-Claude van Damme had stayed. The pool is in a garden of Allah setting and no one ever bothered me, even though I didn't have the right colour towel. I also used the Minzah when I got tired of the Flag Speciale beer.

Tangier today is a bit of a slum, something akin to Miami Beach in its down period. But once one learns their way around, there is still plenty of exoticism to discover. Despite its reputation I didn't feel the city was threatening or dangerous. It was amusing to see the tourist groups carefully minded by guides. I wandered around at all hours. I never had any trouble. One night in a back alley in the Medina, a drunken

Moroccan man looked at me and uttered, "Fuck America!" then stumbled along on his way. I shared his sentiment.

On the terrace of the Hotel Continental I struck up a conversation with an English couple approaching middle-age. They had just come from St Andrews English church and cemetery. While there the couple had visited the graves of social lion and second son of the Earl of Pembroke, David Herbert, the gangster Paul Lund, Dean of Dean's Bar and others. After exhausting the history of Tangier, its eccentric expats, and a discussion on most of the relevant books, I asked with my tongue halfway in my cheek, "So what's new with the Spice Girls?" The man guffawed and the lady squealed. I kept a straight face. "Well I like them," I said. It was true. What red-blooded male didn't? The man was reserved and he kept silent. The lady however confessed that she, too, "secretly" liked some of their songs. The man poured more wine all around. As the night drew on I talked about Aisha Kandisha, Kahlid's UFO sightings, and his theory that Brian Jones, being an infidel, could not be a saint but was instead a *djinn*. He was now one of the "hidden men". I noticed some significant looks and body signals between them. To veer from the esoteric, the man stated that Americans were referred to as "chewing gum" by the Moroccans. I parried that Moroccans referred to the English as "fish bones".

On an early tour of America, Brian Jones had used the word "esoteric" in an interview. Later at the show, kids showed up with signs that read, 'Brian you're so esoteric.'

In a review of my journal I see notes on so many other things: The fresh apricot jam spread on warm oven bread for breakfast... The olives and goat cheese sandwiches on the beach... The pharmacies that can still provide *anything* one desires... The spinning weavers with hand operated looms... The wild wind of Northern Morocco — "the *sharqi*" as it's called — and when it would whip up, Kahlid said it confused his mind; when it was severe you'd see casualties wearing eye patches, from flying sand or stones... The guide in his fez and djellaba who played Satie on the hotel's old grand piano...

The discussions with Abdullah in his narrow,

three-story, carpet shop in the Casbah: He pontificated on *Ramadan*, sorcery, *baraka*, proper toilet hygiene, and man's inherent right to own slaves. Kahlid, who considered Abdullah a teacher, nodded appreciatively and rolled hashish bombers... Later, that evening we surveyed the stars on the roof using binoculars...

Watching the World Cup with some overexcited pro-Brazil Moroccans... The TV shots of a petulant then forlorn Mick Jagger before leaving the stadium... The hippies with their henna tats leaving for their camel treks in the South... The police coming in the middle of the night to take away a fugitive drug smuggler... The spices of Cinnamon, Cumin, Sesame and Harissa... A piece of a tune from Philip Thornton, a whiff of Barbara Hutton...

After a final evening spent smoking with friends at Café Hafa we ended up back on the terrace at the hotel. We nibbled on freshly made nougat candy, bought in a tiny kiosk in the Petite Socco. We sipped heady mint tea brewed by Mohammed. I shared my Dunhills, and we sat there under a crescent moon, looking out over the ships anchored in the port. My mind drifted to a vision of Brian Jones playing his recorder.

"Brian was the most psychic of the Stones. He saw the spirit world; for the others it was just the climate of the times. One gets the impression he just dissolved into it." — Kenneth Anger

BRIAN JONES BELIEVED IN AN AFTERLIFE AND would tell his last girlfriend stories about ghosts of the dead that roamed the Earth. "*Ba'saha* (As you wish)," one of my new friends said, as though he had read my thoughts.

Michelle Green's excellent book on Paul Bowles and the Tangier literary renegades is aptly titled, *The Dream At The End Of The World*. Morocco is a country seeped in magic; one of the qualities that draws people there. If there are cities that are transient points for ghosts and the fantastic, then Tangier is one of them.

"*Incha'Allah.*" 📖

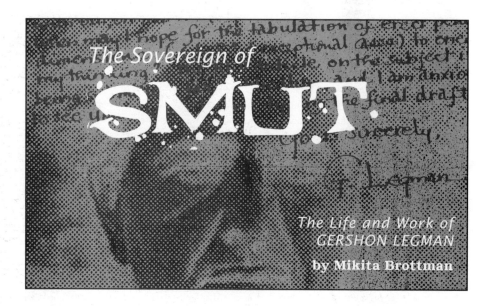

The Sovereign of SMUT

The Life and Work of GERSHON LEGMAN

by Mikita Brottman

IN FEBRUARY 1999, a fat, white-haired old man lay dying in an ancient semi-dilapidated ruin just outside Antibes, in the South of France. He had lived in this crumbling Knights Templar ruin since 1953, when he bought the property from an inheritance he received from a horse-trading Hungarian uncle, who made a fortune during a glue shortage in the Second World War. Over the last fifty years, the ruin had been used as both a home and a library for its owner's enormous collection of arcane erotica, from rare Oriental prints and Tijuana Bibles to hundreds of filthy limericks jotted down on index cards in a beautiful inky scrawl. This fat old man was Gershon Legman, the world's greatest scholar of the dirty joke.

Legman's death last year attracted little attention beyond a brief obituary in the *New York Times*. His books never became especially popular, and his writing was rarely taken seriously by academic folklorists, mainly because he attacked scholarship with skill, wit and a perverse glee. Academics, for their own part, were scornful of Legman's tendency to lapse into perverse asides, his virulent homophobia, his constant groundless swipes against anyone or anything he happened to dislike. He had very few real friends and numerous enemies, and died, just as he lived, on the poverty line. But for those, like me, who found themselves fascinated and compelled by his unorthodox ideas and violent polemic, Gershon Legman will remain the Sovereign of Smut.

I first came across Legman's work in the summer of 1995 in a second-hand bookstore in Madison, Wisconsin, where I stumbled upon a huge book bound in a dark brown cover with the intriguing title *No Laughing Matter*. This book, I soon discovered, was a mammoth collection of outrageously filthy and obscene jokes, divided into various categories including 'URINATING ON OTHERS', 'BEND OVER', 'SELF CASTRATION' and 'FECAL MEALS'. In fact, even Legman himself admits in the introduction — and not without a touch of pride — that "this book is full of mate-

rial so disgusting that it will make any decent, clean, healthy person want to throw up".

It was also the most unfunny book of jokes I'd encountered since reading Freud's *Jokes and their Relation to the Unconscious*, which Legman claims to be his primary model. Only, Legman takes Freud's already depressing hypothesis even further, suggesting that the tendency to tell jokes is not only a manifestation of sexual neurosis, but actually a symptom of psychopathology. In Legman's book, each joke, or each category of jokes, is followed by a brief expository analysis which more often than not takes the form of a rash, funny, blistering Jeremiad against everyone and everything that happened to get on the author's nerves — from zip codes and digit dialling to DH Lawrence, science fiction, and women who smoke, swear or shave their armpits. It was the best ten dollars I'd ever spent.

Born in Scranton, Pennsylvania to a working-class Jewish family in 1917, Legman first worked as a breaker-boy in the mine collieries, then moved to New York and was employed as a medical researcher for the Planned Parenthood Program. Around 1942 he started to work as book-buyer and bibliographer for Alfred Kinsey, tracking down arcane and obscure items in dusty collections of specialist erotica. However, the two men quickly fell out when Kinsey — with some good evidence — began to suspect Legman of ripping him off. The two men continued to correspond for a number of years, but their relationship remained less than cordial. For the next ten years, Legman worked as one of the editors of *Neurotica* — a daring little lay Freudian quarterly of the late forties — and was closely involved with *Maladicta*, a journal devoted to the study of swearing, dirty words and verbal aggression. He also published regular articles in *Playboy*; in fact, despite Legman's frequent grumbles about having to "eat crow", he was supported consistently by Hefner for a number of years.

In 1949, at the age of thirty-two, Legman published what has probably become his best-known work, *Love and Death: A Study in Censorship*. In this fuming rant, Legman argues that the increasing sadism and violence of American culture is the result of society's relentless suppression of sex, claiming that not sex but violence — including

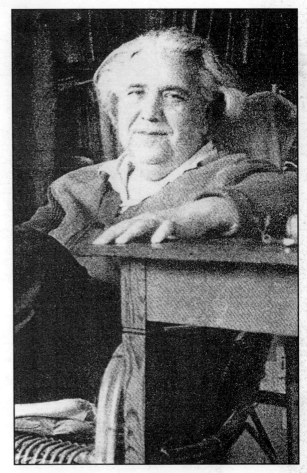

Gershon Legman in France, 1980s.

patriarchy's cruelty to women — is the *real* pornography. Unable to find a reliable distributor for his work, Legman started selling *Love and Death* from his house in the Bronx, a three-room cottage formerly owned by Charles Fort. It was, he claims, his subsequent harassment by the US Postal Service that led him to buy his place in the South of France, where he and his first wife took care of an olive farm and seventeen cats.

1968 saw the publication of the first series of Legman's *magnum opus, The Rationale of the Dirty Joke*. In this 811-page collection of over two thousand jokes, the author sets out his controversial premise that dirty jokes spring from unconscious fears and rages, and are usually directed by males

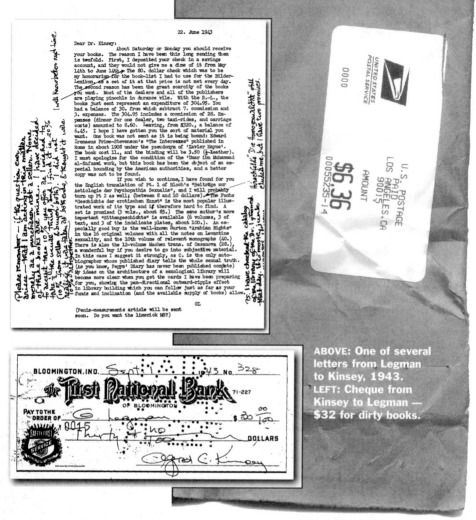

ABOVE: **One of several letters from Legman to Kinsey, 1943.** LEFT: **Cheque from Kinsey to Legman — $32 for dirty books.**

against females. He expounds the theory, following Freud, that dirty jokes are attempts to express or allay people's fears about sex, and to project these anxieties and fears on to others. He claims in this book that "a person's joke is a key to that person's character... In other words, the only joke you know how to tell is *you*". His theory — continued into the second volume; published in 1975 — basically argues that dirty jokes create an arsenal of weapons against neurosis, a defence to ward off anxieties about sex, and that "under the mask of humour, all men are enemies".

These two mastodons of lay psychoanalysis are really, I think, Legman's masterpiece, but they represent only a small part of his lifetime's work. He also wrote a book on oragenital techniques; collected, analysed and published 1700 examples of limericks; introduced the Japanese art of ori-

gami to the west, wrote a study of the Knights Templars, edited and translated Alfred Jarry's *Ubi Roi* cycle, and was the originator — or so he claimed — of the phrase "make love not war" (despite a lifelong hatred of hippies).

Legman once claimed that his fascination with the dirty joke came about partly as a result of his name — itself a dirty joke, he said, because it belied his preferred part of the female anatomy ("there are 'tit-men' and there are 'leg-men,'" he wrote, "which just goes to show you, because I happen to be a 'tit-man'"). Most ironic of all, perhaps, was the fact that Legman was a moody, testy, aggressive man who was never known to tell a single joke. In fact, he once confessed, he didn't like jokes at all, and admitted to finding them "depressing". "I'm a poor raconteur," he claimed, "and I never laugh".

CHOPPER SQUAD!

ALTHOUGH BRITISH DAYTIME TV appears to be densely packed with American melodramas, worryingly interchangeable chat shows, dodgy repeats and Antipodean soaps, there is a genre that occasionally manages to shoehorn its way into the crammed schedule: the Australian detective show.

Most UK viewers associate Australian television with soap operas. Hardly surprising, really, given that the past fifteen years or so have seen a steady diet of NEIGHBOURS, HOME AND AWAY, BREAKERS, and similar fare enter millions of homes across the country. However, a few Australian detective shows have popped up on British shores, although those that do tend to be rather inconspicuous amidst a sea of QUINCY and IRONSIDE re-runs...

On the case with Australian TV Detective Shows

by Darren Arnold

Unlike

a series such as *Neighbours*, however, these detective shows will have been made for prime-time evening viewing in Australia, which makes their UK profile — little more than daytime filler — seem just a touch surprising. Still, a good cop/detective show has usually always been a ratings winner in Oz, so it's not too surprising that these programmes have been hammered out for many years.

Going back a few decades, *Matlock Police* was a show that acted very much as a blueprint for the type of material that would be produced in ensuing decades. The workmanlike title accurately summed up what this series was about: the activities of the police in the small Victorian bush town of Matlock. The idea may have been unspectacular, but it was a solid enough programme that proved that this sort of thing carried broad appeal; after its initial appearance (in 1971) *Matlock Police* went on to run for a grand total of 220 episodes. The show was also notable for being a product of the mind of Colin Eggleston, who went on to direct a number of feature films, including *Innocent Prey* and, more crucially, the Aussie classic *Long Weekend*.

A show that didn't last anywhere near as long as *Matlock Police* was 1975's *Chopper Squad*. Oddly, however, *Chopper Squad* is probably more widely remembered (catchy title, maybe?), and one of its stars — Jeanie Drynan — went on to feature in successful Australian movies such as *Don's Party* and *Muriel's Wedding*.

If the 1970s was the decade in which the Aussie detective drama was established, then this genre had to take a back seat in the 1980s as Australian TV became soap central. The decision to produce the Australian soaps of the eighties was influenced not just by the domestic market, but also by how marketable these programmes would be to an overseas audience. The major overseas market for such shows was always the UK, although interest has flagged a little of late with the poor reception afforded to 1998's *Breakers*, and the unwillingness of ITV to fork out for more episodes of *Home and Away* (although this is scheduled to appear at some point in the future on the low-profile Channel 5). Nonetheless, the proliferation of soaps contributed to detective shows receiving a much smaller slice of the domestic market. It would take until the breathing space of the 1990s for cop and detective programmes to really re-emerge on Australian screens, and it appears that once they made one of these shows they couldn't apply the brakes: numerous like-minded shows appeared throughout the decade, sausage factory-style, and the quality proved to be somewhat variable.

Perhaps the most successful show of this kind is *Blue Heelers*, a fairly generic offering from Hal McElroy, a producer who, with his brother Jim, brought us Peter Weir's early films.[1] Kicking off in 1994, *Blue Heelers* has long been one of the biggest programmes on Australian TV, and indeed can still be found milling around in an afternoon slot on ITV. Set and filmed in Victoria, *Blue Heelers'* central figure is Sgt Tom Croyden (John Wood), a traditionalist who looks after his bush town and is wary of those from that perennially troublesome place, the city.[2] Despite Sgt Croyden being the main character, there can be little doubt that most viewers found Constable Maggie Doyle (Lisa McCune) a much better reason to tune in, and McCune was duly elevated to being virtually the most famous actress on Australian television.

For many years it's been a criticism of Australian programmes — well OK, mainly soaps — that the same actors seem to pop up in different series'. This isn't just a quirk that's limited to soaps, however, and the same situation applies to Aussie detective shows. Names such as Peter Phelps, Gary Day, Tony Martin, Alex Dimitriades, Aaron

Pederson, and Chris Haywood have all featured on more than one cop show, and certain producers (such as Hal McElroy) and directors (David Caesar, Peter Andrikidis) have become synonymous with the genre.

Of course, such things don't really matter — especially when something as impressive as *Blue Murder* pops up. Based on true events, this 1995 mini-series has gone down as one of the finest pieces in Australian television history, mainly due to the outstanding acting. Richard Roxburgh (from *M:I–2*) gives a creepy, uncanny performance as Det Sgt Roger 'The Dodger' Rogerson, a corrupt detective whose case caused shockwaves throughout Australia; Peter Phelps also excels as 'Abo' Henry. No doubt part of the highly charged atmosphere is generated by the story being based on factual events, but this doesn't detract from an edgy, murky and compelling piece of television. *Blue Murder* is without doubt the most important detective programme ever to be screened in Australia, and it stirred up a great deal of controversy — not just for the content, but because of problems with the real-life court case around which it was based.[3]

After the heights of *Blue Murder*, what was to follow was always going to look pretty dumb, so it's perhaps just as well that the programme itself *was* pretty dumb: *Water Rats* was an expensive Hal McElroy series that focused on the water police around Sydney Harbour, and it was all just a bit too flashy and pointless. Despite some fairly well-known actors (Colin Friels, Steve Bisley), the show constantly slipped up on a gigantic banana skin of clichés — although this didn't prevent it from being sold to many nations across the globe... come to think of it, it probably helped.

Far better things came in the shape of McElroy's 1997 *Murder Call*, which, although formulaic, established a degree of care and invention not present in *Water Rats*. It also felt fairly refreshing due to the relative lack of familiar faces (barring *Blue Murder*'s Gary Day). Around the same time *Wildside* also aired, and this Tony Martin/Alex Dimitriades-starrer went on to gain plaudits that stopped just short of those awarded to *Blue Murder*. Like many of the best detective shows, *Wildside* was dark, gritty, downbeat and claustrophobic. Poor overseas sales led to its can-

Art: Martha Colburn

cellation after a mere two series.

As mentioned earlier, the 1990s saw a glut of detective shows in Australia, and even the axing of a fine programme like *Wildside* didn't stop Channel Nine from putting out the enthusiastic *Stingers*, a Melbourne-based series where undercover agents set up criminals for the final 'sting'. *Stingers* is perhaps of a little more interest than most generic detective shows, for the reason that it is based on the career of Guy Wilding, a twenty-year veteran of the Queensland Criminal Justice Commission (among other bodies), and therefore a bit more of a dynamic is added to what is, to all intents and purposes, a very routine televisual experience.

Anyway, it seems appropriate that the last show we'll examine here should be the most bizarre: *Good Guys Bad Guys* appeared not too far ahead of *Stingers*, and proved to be a fairly perplexing affair. The series, which starred Bruce Venables, Nadine Garner and Sophie Lee, concentrated on reluctant investigator Elvis MacGinnis. Elvis spent most of his time following up grisly slayings and other such atrocities, and fending off the unsettling attentions of his mum. Phil Motherwell featured as 'The Exterminator'. There was an episode entitled *A Bilby in Rat's Clothing*. All said, it wasn't exactly *Matlock Police*.

Although the show never pretended to be a mainstream cop show, there can be little doubt that a few viewers would have been left very confused by Elvis' adventures. Worth celebrating then, as an interesting experiment with the detective show format, and a suitably strange title to cap a look at what has been one of Australian television's most popular genres in recent times. 🖳

Thanks to Dave Huxley for suggesting this article.

NOTES

1 The McElroy brothers produced *The Cars That Ate Paris*, *Picnic At Hanging Rock* and *The Last Wave* for Peter Weir. They also re-teamed with the director in the early 1980s for *The Year of Living Dangerously*.

2 Characters in many Australian shows — such as *Neighbours* and *Home and Away* — always speak of "the city", and never use the actual names of the real cities (in these examples, Melbourne and Sydney respectively).

3 There was a ban on *Blue Murder* being screened in the state of New South Wales; this was a product of the complex legal affairs surrounding the case. *Blue Murder* alluded to Rogerson's involvement in the murder of prostitute Sally Huckstep, a notion which could have opened up a whole new can of worms in the real-life court case.

Art: Rik Rawling

A Trip of a Different Kind

by Verian Thomas

AVEBURY. THE SITE OF THE LARGEST stone circle in the world is about 100 yards away, obscured by a section of the seventeen-foot chalk bank that surrounds it. I read somewhere that it was chalk, it's impossible to tell now as it's covered in grass which is being devoured greedily by a flock of sheep. The car's parked and I'm walking along a path by the side of a junior school. As I get nearer I can feel something — nothing mystic, no reverberations, just an *it's-around-the-next-corner* feeling; an awareness of its presence despite the fact I have never been here before.

I'm holding my camera and tripod and nothing else; they are all I've brought with me. As I walk on, the chalk bank gradually subsides and the stones are revealed to me. I'm disappointed. Not in the site but in myself. How this place must have inspired awe in people 5000 years ago. All the stones in place. The deep chalk ditch, the bank glowing white. It must have been a spine tingling, jaw-droppingly wonderful sight to behold. For me it

is different. I've seen the Grand Canyon, man walking on the moon and countless other things that only serve to dilute my sense of wonder. I feel lessened because of it. I'm standing looking out over a wonder of the world and longing to be a child again, when everything was new and exiting. I want to involuntarily say "Wow!" But I don't. I can't.

I stop and take a picture, looking vaguely professional with my camera on my tripod but also feeling a little foolish. With a click I have a *permanent record of my first ever sighting of Avebury.*

A car passes to my left and follows the road right through the village at the centre of the circle. Perhaps this is one of the things that diminishes the power of this place. The road, the cars, the houses, the evidence that modern civilisation and all its trappings have set themselves down here. I knew before I came that some of the houses even used the stones in their construction, just tore them down and smashed them up.

TOP: My god it's huge... The view as I contemplated what the original purpose of this place in Avebury might have been. In front of me: a huge piece of stone that would be difficult enough to move two yards let alone a couple of miles; in the background, the village that sits in the centre of the stone circle. It's a pretty enough village but I'd rather it wasn't there.

I wander amongst the stones, which are so much more accessible than those at Stonehenge. Here I wander where I please, touching stones, leaning against them. There is nobody much around and I have the place to myself. For a moment I feel that it is mine, that it was built for me. I tell myself that a cold day in December is a good day to come here. To my personal stone circle.

I come across a stone that has an *interesting pattern* upon it, looking as though it was carved initially then worn over for centuries by water. I run my fingers along it, feeling the texture of the stone and — feeling something else. There's a connection of some description; my hand is where countless others have been throughout history. From the original creators of this place to me, right now. I will be leaving some small part of me behind in the stone, just as they did. I set up the camera and take a picture. Before I know it a whole roll of film is used up and I start a second one. The more pictures I take the more people won't come here: they'll have already seen it. I'm feeling selfish and protective. Perhaps it's because I am on my own and am unusually introverted? Whatever the reason, I feel this place has been damaged enough. I want to call the Police, get them to form a cordon around the perimeter and have a detective wave people away,

saying "Move along, nothing to see here", whilst I sit peacefully in the centre knowing that I won't be disturbed.

As I walk, strange thoughts run around my head, snippets of songs and poetry; words repeating over and over until they are meaningless. I invent gadgets that are time consuming rather than time saving. This is usual, normal. All is well. I suspect that I'm probably enjoying myself.

There's a tall male stone ahead. The short squat stones have been classed as female and the tall ones as male. Phallus and vulva. I can't resist the urge to **_hug the stone_**. To put my arms as far around it as I am able and press my face to the rock. I close my eyes and just stand there — hugging what I understand to be a giant representation of a penis. Perhaps I should let go now. I find that for a fleeting moment I don't want to. I want to melt into the stone and become one with it, to see the world pass by for the next 5000 years and step out into whatever is left by then.

I let go.

I come to two large stones that are directly in line with the avenue that leads — after a mile-and-a-half — to The Sanctuary on Overton Hill, and I feel a small tingling, a tiny sensation, a whispered "Wow". Sitting down on the grass I think about the dedication it must have taken to move these stone beasts here. I try and contem-

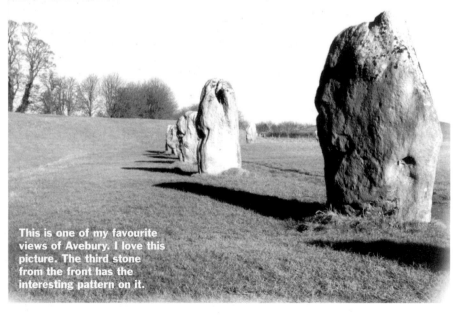

This is one of my favourite views of Avebury. I love this picture. The third stone from the front has the interesting pattern on it.

plate what this place was originally designed for, as nobody else has been able to tell me. I can't look it up in a book and get a definitive answer because nobody really knows for sure. I formulate my own theory — one that pleases me and is not clouded by facts. I pay taxes, am governed by people I didn't elect, I conform to rules I don't agree with but I think what I like, it is one of the only freedoms I have.

I think for a while…

This place was a seat of power. Tribes gathered here to mark out boundaries, trade goods, to meet and make friends, to find partners and marry them, to bury their dead and to celebrate their passing. It was a market, a government and a church. Contrary to popular belief it is extremely unlikely that the people of these times where barbarians. They had to live together and co-operate. How could barbarians get their act together for long enough to erect something as large and complex as Avebury or Stonehenge? It was a complex and advanced civilisation, I decide.

The pub is open, so I go in for a drink. A couple of pints later and I am ready for a bit of exploration in the ditch that surrounds the stones. I almost slide down to the bottom because it's damn steep, but I make it OK. Looking up, my first thought is about how it was when it was built, seven-foot deeper than it is now. My second thought is about how I'm going to get back up again. *Oh Bugger!* I'm not going to panic, I'm going to think this out logically and come up with a solution. I'm sure my brain works better when saturated in nicotine so I roll a cigarette, sit on the muddy grass — an act I regret immediately as I feel the moisture seep through my trousers. I see something off to my left that will stay with me for a very long time: a McDonald's paper cup. Here, miles from the nearest McDonald's, is a McDonald's cup. It even has a picture on it of a little man putting it into a bin. I consider going to Callanish, which is miles from anything, just to see if I find one there. People care less and less about their environment — not necessarily *the*

environment, but *their* environment. I recall walking once with somebody I knew who was extolling the virtues of some foreign country, and how clean the streets where. As we walked he finished his cigarette and threw it on the floor. I questioned him about it, and he said that one cigarette stub wasn't going to make any difference. I expect soon I'll have to climb over a rubbish dump when I leave my house, and wade through trash to get to work. I pick up the cup and put it in the side compartment of my camera bag.

Pacing up and down, smoking, I formulate a plan on how to escape the ditch. There is a piece of tree growing out of the bank about three-quarters of the way up and I'm going to make a run for it. I back up against the opposite bank, make sure my camera bag is securely attached to my

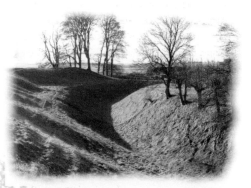

The ditch. It's much steeper and higher when standing at the bottom looking up. There on the right is the little bit of tree that I clung onto before completing my ascent. If I'd carried on walking around toward the camera I would have found a much easier way out.

back and begin my run. I'm moving up now towards the tree, scrabbling, slipping and... *bloody hell, I make it!* I sit on the tree a while and then clamber up the last part of the bank to freedom.

Like Rocky at the top of the steps where they would eventually build his statue, I raise my arms in the air and bounce from foot to foot in triumph. The *Rocky* theme music pops into my head.

"Hello there." I turn and an old couple have appeared from behind one of the stones and are strolling by. I do one of those slow wind-downs that try to make out that I was doing nothing strange. "Hi," I reply with a smile. They are nonplussed; they must be locals who see this sort of thing every day.

After one quick last look around I feel it is time to go.

I am leaving this place with a feeling different to the one I had when I arrived. It has grown on me during the hours I have spent exploring. Realisations grow slowly, I suppose, and as I go I say to myself "Wow".

There's a theory that the one-and-a-half-mile avenue is a celebration, a marking out of the first steps on the trip to Stonehenge. This may be true, but I think it's the other way around. It marks that the traveller is about to arrive having left the formality of Stonehenge for the freedom of Avebury.

Though it pains me to do so, I say to you, go and visit Avebury. Experience it for yourself but leave no sign that you where there. ☻

PS. I put the cigarette stub in the McDonald's cup!

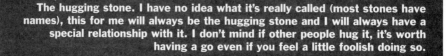

The hugging stone. I have no idea what it's really called (most stones have names), this for me will always be the hugging stone and I will always have a special relationship with it. I don't mind if other people hug it, it's worth having a go even if you feel a little foolish doing so.

Andy Darlington

The Night They Murdered Love

Charles Manson &
The Family Franchise

A Feast of Evil

Headpress

586 03717 9

Including contributions from Mikita Brottman, Simon Collins, David Kerekes & Sun Paige

Beautiful freaks. The price of admission — Your mind...!

Cease to exist, just come and say you love me
Give up your world, come on and you can be me,
I'm your kind, I'm your kind and I can see...

—'Cease To Exist', Charles Manson

CHARLES MANSON CASTS A LONG SHADOW. He's one of the flashpoint beacons of reference for the lives of his generation. Now there's Marilyn Manson. Shirley Manson. Or just plain Mansun. But there's only ever one *CHARLIE* Manson.

Ed Sanders wrote a book about Manson. Sanders is the one-time Fug, the shock-rock Beatster responsible for a mimeo poetry rag called *Fuck You*, and for provocatively spontaneous rock-theatric happenings such as the ritualistic 'Exorcising The Evil Spirits From The Pentagon', and the satiric anti-military 'Kill For Peace'. As such, he'd already flirted artistically with the Hippie Dark Side, the same zone that Manson took Helter Skeltering into mass-murder. And it was teasing out these moral connections that led Sanders to write *The Family*, still the most rigorously detailed insider account of Manson's career. But much material is necessarily omitted. This book — he subsequently admits — uses 100th of his total research, or "as much as could be safely told... I could have written a ten-volume day-to-day narration of events". For example, Sanders asserts that one phase of his data-collating involves under-covering as a porn-dealer for investigative research purposes, in which guise he's offered hours of erotic movie-footage featuring the miscreant Manson Family. Asking price-tag *then* is $250,000 for pre-video-age film-cans containing explicit group-gobbling orgy se-quences depicting the disembowelling of dogs, cats and pigs — then pouring freshly spurting blood over copulating couples. Rituals climaxing with a human sex-magick sacrifice. And all using Manson's notorious derelict Spahn Movie Ranch in the Santa Susana Mountains, as location. Sanders then begins sourcing-in on rumours of further snuff movie material reputedly held by a friend of Manson-victim Gary Hinman, soon after which he's also anonymously contacted by a *third* witness claiming to have hung out on the skewed acid casualty fringes of the Family who can hence divulge lurid details of yet more macabre filmed freakiness, in which bizarro hooded weirdoes enact full sex rituals on secluded private beaches north of Malibu, culminating in the bloody beheading of a young girl.

Perhaps even Manson's most celebrated victims weren't entirely untouched by the occult either. Of course, art, movies and life don't *necessarily* interact. And it's wrong to infer that Roman Polanski's movie *Rosemary's Baby*, in which twenty-six-year-old Sharon Tate gets impregnated by the Devil, is anything other than a shockingly effective horror movie. But, like Sanders says,

"there was a lot of information, particularly related to the occult, concerning the private lives of various murder victims" that deference to the dead must leave unsaid. And soon, the implications of sex-death cults still flourishing in LA freaks Sanders to the extent that he deliberately closes off further enquiries, fearing for his life: "I can't get any facts because everybody is paranoid and there are all kinds of death threats... all kinds of weirdness and bribes and freakiness and nothing makes sense..." (IT No 127, April 6, 1972).

Such fears seem hardly unfounded. After all, fabled hippie cult murderer and would-be songsmith Charlie Manson was the man who put

Frykowski, Steven Parent... and something like thirty-four lesser mortals too. He's still serving time, a blotted ideologue with inch-long fingernails who signs his name with a swastika. Still there... saved from Old Sparky's lethal kiss — or at least from San Quentin's green-painted steel cyanide-gas chamber — only through the unwitting intervention of renowned Pinko Liberal Pussy and future-President Governor Ronald Ray-Gun's timely moratorium on the Death Penalty...

In autumn 1999, Dr Robert Beattie, Lecturer-Attorney at the Newman University at Wichita, Kansas, enacts a mock trial of what he calls "the most notorious prisoner on the planet". His CV

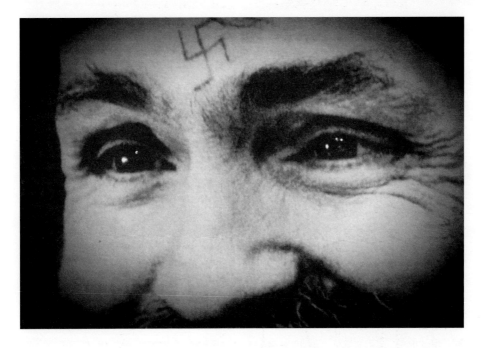

the mental into transcendental, wasn't he? On October 20, 1969 — over three decades ago now — Charlie and his accomplices were the subject of a high-profile media-bust for the slaughter of beautiful golden-haired eight-months pregnant Sharon Tate (Polanski's wife), and four others. He was found guilty and locked up for First Degree murder, even though the jury agreed that Manson was *not* a direct participant in the killings. Instead he was convicted of *ordering* his 'Family' to do it... and to do it not only to Tate, but to Leno and Rosemary LaBianca, Abigail Folger and her lover Jay Sebring, Voyteck

bulging with four hours of new 'phone interviews' with Manson, conducted to assemble his 'evidence'. And, as Beattie confirms, Manson persists "that he never killed anyone or ordered anyone to kill anyone, and that he never had a fair trial because the judge would not let him defend himself..." Directly accusing Mr and Mrs Amerika, Manson finger-points: "I am what *you* have made of me, and the Mad-Dog-Devil-Killer-Fiend-Leper is a reflection of *your* society. Whatever the outcome of this madness you can know this: in my mind's eye, my thoughts light fires in *your* cities..."

Perhaps the story ain't over, till it's over?

My Life with the Love-Thrill Cult...

When I stand on the mountain and say do it, it gets done...

—Cartoon Charlie Manson guesting in the 'Merry Xmas Charlie Manson!' episode of South Park

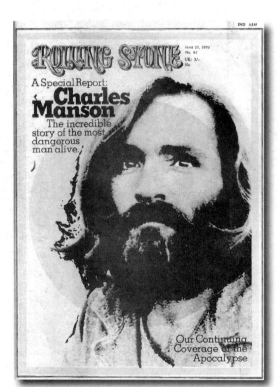

stages of gradual personality-implosion which disintegrates inexorably through earlier smaller offences — theft, arson, delinquency and social withdrawal — towards the Black Hole event horizon of mutilation-a-go-go. Similarly, you don't get to *become* a murderer simply because someone *tells* you to become one, but because — in some circumstantial way — your own aggressive propensities are now no longer impeded by inhibition. With Manson's Family, all these elements are present and (in)correct. Check the media's long three-decade drool: here, Manson (that is Manson = *son* of *man*) is the macabre führer of a Family of Satan's Slaves with 'restructured minds', he exercises total control over his zombie groupies through systematic mental derangement. "He had them gobbling dogs, just every form of hideous kind of submission," reports Sanders.

Yet Manson's life and crimes begin with the spooky slaymeister heading West dreaming of being a Beatle — or at least a Monkee — not a rock-apocalyptic crazed psycho-mass killer. But talent? Star potential? Listen to his records. No. It's not there.

He was born (November 12, 1934) as 'No-Name Maddox', then Charles Miles Manson, to a feckless single-parent, sixteen-year-old mother Kathleen Maddox, who sacrificed him to the hellish mercies of various juvenile care institutions. Raised in Cincinnati, Ohio, showing early evi-

A KILLER'S LACK of emotional understanding or empathic responses, their necrophiliac tastes, habits and secret personality/ies can seldom — if ever — be matters of fact. Only interpretation. Inference. Conjecture by comparison. But it's clear that murderers *don't* invent themselves. Their murderous death-games don't suddenly erupt up out of a void. Rather, they're the final

dence of a messy delinquent temperament, young Manson soon becomes a con man cheque-forger petty-crook and criminalised loner, in and out of reformatories from childhood, deserted by a wife and child while stuck in jail, where he continues his sex life in the only way possible — "by hand, by mouth and by buttock". By age thirty-four he's already endured seventeen years in some form of incarceration. "I was a half-assed nothing who hardly knew how to read or write, never read a book all the way through in my life, didn't know anything except jails, couldn't hold onto my wives, was a lousy pimp, got caught every time I stole, wasn't a good enough musician to hit the market, didn't know what to do with money even if I had it and resented every side of family atmosphere," he confessed to an interviewer.

But let's get this straight from the off. The six-rounding himself with fellow fugitives from unhappy homes, mostly young nubiles like sexy-ghoul Susan Denise Atkins — Family-name: Sadie Mae Glutz — a topless dancer and sometime-prostitute with Botticelli psycho-cherub eyes. Then there's red-haired nineteen-year-old Lynette 'Squeaky' Fromme and middle-class drop-out Sandra Good who, years later, will still be moving from LA to Sacramento to stay close to the imprisoned Manson, and who still — allegedly — carries out his instructions. There's Patricia Krenwinkel, a twenty-one-year-old ex-choirgirl and once-aspirant Nun, Leslie 'Lulu' Van Houten, twenty-year-old former school prefect. And fickle squealer Linda Kasabian, a New Hampshire-born mystic-wanderer and single parent, a non-partici-pant in the murders, who will later 'snitch' on Manson in virgin-white blouse, to reduce her sen-

ties does strange things to people. Agreed? Manson is a human trashcan, an inadequate, a fucked-up dud. He's a loser, Baby. Yet he becomes Pop Culture's first Celebrity Psychopath. And the American Dream seldom comes more fractured than Charlie's.

It's 1967. Scott McKenzie's 'gentle people' telepath the signal around the world that, hey — there's a "new generation with a new explanation". "Hep? — er, that's hip, they changed it," gags Monkee Mike Nesmith. And on his release from yet another prison spell (March 21, from Terminal Island) Chuckie Manson lucks into California's Summer Of Love. He's hungry, several levels down from even a Clark Kent. Takes a bite of mind-altering lysergic acid. Gets totally gooked, and suddenly gets super-real powers. The full Zero-to-Hero deal. Now he's suddenly sur-

The Four Horsemen of the Apocalypse

tence. Originally there are others too: fourteen-year-old floweroid Diane 'Snake' Lake who earns her aka by sensuously 'wiggling' during sex, and Didi (daughter of Angela *Murder She Wrote*) Lansbury — even younger (thirteen?). Yet for now at least, they are 'family'. Big time. Separate bodies. Single soul. "Loyalty to our kind." When Family member Bobby Beausoleil (hippie musician of the Magick Powerhouse Of Oz, and bit-player for occult-movie-maker Kenneth Anger's *Lucifer Rising*) gets jailed, initially for driving without a licence, the girls — Leslie, Sadie, Katie and Kasabian — are happy to dress kinky and become hookers, happy to suck dick for stop-over Piggie Businessmen in Motels and parked-cars for as long as it takes to raise legal fees. They are Family, opting for wolf-pack rather than rat-race, spending two scrambled-(egg)-brain kaleidoscopic years of peripatetic peace, love and mind-bending drugs. Manson's natural biorhythms are sexually hyperactive. Now he's slurp-slurping and group-groping it all the way. Supposedly, according to legend, fucking seven times a day.

But Manson's weirdized Family don't thrive in isolation. They happen within the context of other similarly spaced hippie collectives all over California... and beyond. There are Wacky Charismatic Knaves, Psychedelic Confidence Tricksters, and Delusional Pschopathetic Charlatans of a more sinister stripe aplenty — all busy filling gullible Love-Seekers dumbo cravings for enslaving certainties. Think Ken Kesey's Merry Pranksters. They have the same nubiles-on-tap with equally kooky aka's — Stark Naked, Mountain Girl and Anonymous X. Same Dominant-Male Guru-Philosopher Shaman-figure identically intent on going *further*! Same levels of LSD-dosage... for Acid is the sacrament shared by them all. Appropriately parallel Lit-texts would have to include the Martian Messiahs sharing rituals in Robert Heinlein's cult novel *Stranger in a Strange Land*. While in Brian Aldiss' novel *Bare-*

MANSON MUSIC

THE MANSON FAMILY SINGS
The Songs of
Charles Manson
 12" LP / white vinyl
 publisher unknown

There is tantalisingly little information given on the sleeve and labels of this weird little collectors' item, which I picked up from my local bootleg dealer for a tenner. The sleeve carries no catalogue number, record company name or track listings. Scratched into the vinyl around the run-off groove are the following inscriptions:

Side A: ORLAKE YGGDRASSIL FOR NINE DAYS [*or 'PAYS'?*] CMLP + 1 + A
Side B: ORLAKE SCORPIAN [*sic*] BACKWARDS CMLP + 1 + B

[*Ed: 'CMLP' would appear to be a reference for Grey Matter, who also released the album* **Charles Manson and the Family**... *but don't quote me on that.*]
Apart from this, the label on side B carries a quotation from *Thus Spake Zarathustra*, whilst the sleeve is tastefully adorned on the front with a circular design of ravening wolves leaping out of blossoms, and gun-toting arms forming a swastika surrounding a scorpion within a pyramid. The rear of the sleeve carries a short text:

The materials contained herein are not presented to provide you with cheap vicarious thrills [*yeah, right, it's just for bona fide researchers like me!*]. Beyond MANSON — the media circus, the creepy-crawly mega-monster — there remains the man and his family. For these end times they have a message, be it good or evil (...or, perhaps beyond this) — WHO REALLY IS IN PRISON, AND WHO IS FREE?

Well, shucks, I'l have to think about that one for a while. However, since acquiring this record, I have finally become Internet-literate, and one of the most interesting sites I've visited so far is the *Access Manson* website at http://www.atwa.com. Established and maintained by George Stimson, Lynette 'Squeaky' Fromme and Sandra Good (or 'Red' and 'Blue' as they style themselves nowadays), this is a mine of information on Charles Manson, the Family and the murder trials, as well as on ATWA (Air Tree Water Animals), the extreme environmental group run by Manson from prison. Amongst the many useful features of *Access Manson* is an annotated discography of Manson's recorded works and the multifarious editions they have been issued in, as well as an exhaustive bibliography of Manson-related publications. From this I was able to glean a few more facts on *The Manson Family Sings*.
The Net in general is stuffed with Manson sites, but *Access Manson* is the motherlode. However, the site effectively functions as the official Net mouthpiece of Charles Manson. Its operators are Manson's most devoted followers. Squeaky Fromme, indeed, is still in prison, following her abortive attempt to assassinate President Ford. So don't expect objectivity

foot In The Head, future Acid-Wars use psychoactive weapons which leave nomadic tribes roaming the ruins of a hallucinogenically transfigured Europe of shifting landscapes on the permanent brink of hyper-reality. Elsewhere, in Mick Farren's *The Texts of Festival*, post-apocalypse gypsies consult sacred rock'n'roll lyrics for the deep spiritual guidance they provide. But in his head, Manson *already* lives these worlds. Manson's Family have already gone through several neural armageddons, and come out the other side, transformed and biomorphed into strange new lifeforms. They are the original Chemical Brothers — and sisters. So ask, why *did* Manson's trip turn so emphatically to the Dark Side while Kesey's didn't? Bad karma is why, man.

Manson is alive NOW — as you read these words. He's sat in a cell. He's pacing up and down. He's squatting on the crapper — now, at this instant of breathing. What's he thinking? What are his thoughts after all this time? He's an institu-

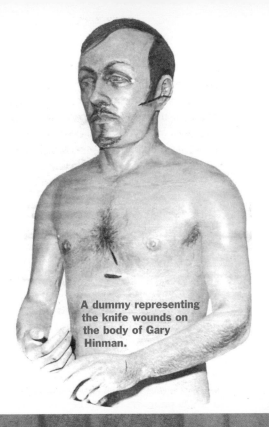

A dummy representing the knife wounds on the body of Gary Hinman.

here, don't believe everything you read (in particular about the various Family prosecutions), perhaps think twice about leaving your email address and think more than twice before joining ATWA — its supposed "environmentalism" is a façade for hardcore death-worshipping fascism.

Anyway, to get back to the ostensible subject of this review, what is contained within these rare grooves? The voice of Charlie himself certainly isn't — as the cover admits, this is 'previously unreleased stereo material recorded in 1970', when Manson was safely incarcerated. So what we have here is the rump of the Family, left at liberty under the caretaker leadership of Sandy and Squeaky during the Tate/LaBianca/Hinman murder trials, getting together to sing Manson's songs in the manner of a revival camp meeting. The sound quality isn't bad, but I guess these are mostly live, rather than studio, recordings, although there are some echo effects that may have been added during production. *Access Manson* informs us that most of the male lead vocals were performed by Steve Grogan, backed by 'Gypsy, Capistrano, Brenda, Ouisch, and even Red and Blue'. There are twelve tracks altogether, with only one ('I'll Never Say Never To Always' — the title of the next Bond film?) duplicated from the earlier, and better-known *Lie* album (and even then I think this is a different version). The music and arrangements are mostly in the Woody Guthrie/Bob Dylan/Donovan Leitch acoustic folk tradition, with elements taken from blues, gospel and Negro spirituals. The overall mood of the music is one of solidarity in the face of oppression — fairly or not, the Family certainly considered themselves unjustly persecuted. Occasionally the mask slips and Manson's psychopathy shines through:

When you see the children, Xes on their heads / If you dare look at them, soon you will be dead...

I'm scratching peace symbols in your tombstone / Scratching peace symbols in your mind.

Spooky stuff! Perhaps even creepier (or more "oo-ee-oo-y", as Ed Sanders would put it), is the evidence on this record of the group mind-thing the Family had going — the whispered asides, the waves of eerie giggling, the massed screams, the in-jokes being swapped back and forth.

Excerpts from this record were used in a Radio One documentary broadcast in 1994 to mark the twenty-fifth anniversary of the Manson murders, which detailed Manson's involvement with, and murky legacy within, the music business. *The Manson Family Sings* offers a powerful taste of the mindset that resulted in the perennially fascinating series of cult crimes now known as Helter Skelter, crimes which brought Manson the fame he failed to find as a musician.

Simon Collins

tionalised human. In some ways, he always was. The Family was a brief window he probably always knew was operating on a diminishing timefuse. Perhaps he's thinking of that? When blissed-out nude Hippie-chicklets were eager for his favours and blow-jobs came on a whim. So why did he lose it? Perhaps be didn't. He'd studied Pimp technique in jail, how they psycho-control and discipline 'bitches' through a combination of narco and sexo-emotional cerebral strategies. So he controlled his Family sexually, and pharmaceutically. But control needs momentum. It needs to keep raising the stakes. So Kesey gets a psychedelic bus. And Manson goes 'discorporating Pigs' in Helter-Skelter. Today 'Pigs' is an underclass name specific to Cops. But back then it was also generic to the conspicuous-consumption celebrity fat-cats, Movie Tsars, Rockristocracy, all of The Golden Ones Charlie's tried — and failed — to join. His 'Family' are Junkyard Dogs scavenging and dealing dope and sex on the periphery of a world he can never join. He feels revulsion. And exclusion. He feels jealousy. And disgust. The same things he hears on the Beatles 'White Album' when Hari Georgeson whines **"you can see them out to dinner / with their Piggie wives, / using forks and knives / to eat their bacon..."**

Significantly — or perhaps ironically — Manson first draws press-mention through London's Mod glossy *Rave*, tucked inconspicuously into a Beach Boy's interview. Dennis Wilson says, "I have a friend, Charles Manson, who says he is god and the devil, and he likes to be called 'The Wizard'. The Wizard frightens me. Fear is nothing but awareness. It all comes from within. The Wizard sings, plays guitar, writes poetry and may be another artist on Brother Records". It seems Manson's charm can take strangely bisexual forms, flitting from wistful little-boy-lost to hirsute virility at the drop of a tab. While he's equally adept at dispensing mystical Mansonian jargon patched together from gonkoid Scientology, grokked Robert Heinlein, and misunderstood Tim Leary's acid commercials. "He's pretty glib," admits Sanders, "and he's very elegant in his phrases in a paranoid, schizophrenic way..." Now, with hindsight, it's scary hearing the harmless loopiness of any inoffensive hippie "sparechaynge" panhandler on the street talk of ego-suppression and attaining selflessness, from a creepozoid like Manson. But such is the psycho-spiel Manson uses when his musical ambitions first drive him to seek out industry contacts, including Byrds producer Terry Melcher (a former occupant of Tate's mansion — where Manson initially visits him) and John Phillips of the Mamas and Papas. He approaches Zappa. No reaction. Parties with Mama Cass Elliott. Once. Experiences the Grateful Dead. From the audience. Impresses a young Neil Young. And then… the Beach Boys' drummer finally succumbs — seduced as much by the 'Wizard' as by his free drugs…. and nude chicklets. Seduced, at least until he discovers he's picked up a bad dose of genital clap from the Family, and that they've ransacked and looted his house. He takes the excuse of a long Beach Boys tour to escape the Wizard's further attentions.

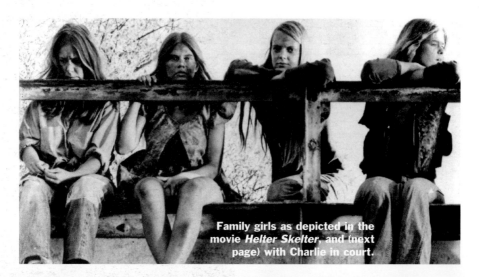

Family girls as depicted in the movie *Helter Skelter*, and (next page) with Charlie in court.

Dear IT,
Can you tell me if it's possible for me to get from you a poster of Charlie Manson? I am a loyal fan of his and collect all I can about him and his Family! So could you please send me a reply? I've sent a SAE for your reply.
Thank you, peace, yours
R Johnson

—Letter to IT No 103, May 18, 1972

IN THE *TWINKLING OF AN EYE*, to Aldiss "a Jekyll/Hyde tragedy is to be acted out… and under the Love-Ins of the Flower-People, the trashcans of Haight Ashbury begin to fill with dead foetuses". So now it's the Big '69, Neil Armstrong gallumphing around in a haze of low-grey moondust, Hendrix seemingly higher still at Woodstock, Vietnam already Napalm ciuster-bombed halfway back to the Stone-Age, while the psychedelic dungeons and neon headshops of Haight Ashbury — nexus of hippie culture — are swamped by dealers and weekend hippie chick runaways looking for glimpses of instant Zen. From counter-culture to crazy-culture. To Hunter S Thompson "it was like (tectonic) plates shift-ing. It was clear that the game had changed." And *"Look Out!* Helter Skelter! / Helter Skelter! / *Helter Skelter!"* goes into interstellar overdrive. Accord-ing to prosecutor Vincent Bugliosi's startlingly transfixing account, Manson is suddenly levitat-ing his claim to Messiah status by nailing racist apocalyptic doctrines divined from the Bible's

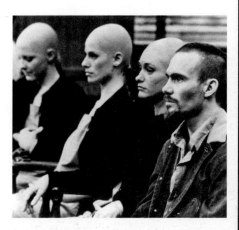

THE FAMILY JAMS
Double CD, £18.00, AOROA
Available from: AK Distribution, PO Box 12766, Edinburgh, EH8 9YE

The first disc of this deluxe double-CD package is a simple duplication of *The Manson Family Sings* album (see page 34) — the *Access Manson* website discography states that the tracks have been remastered, but if so, it's lost on me; the sound quality is still not great. Disc two contains sixteen tracks, a mixture of new material (five tracks in all, including the very Woody Guthrie-esque 'The Young Will Overcome') and alternate takes (some radically different) of songs from the earlier re-lease. Some songs are featured three times over the two discs — 'Give Your Love To Be Free', 'The Fires Are Burning' and 'Die To Be One'. The total running time of the two discs is around ninety-five minutes.

The Family Jams is the closest thing yet to an 'offi-cial', 'authorised' Manson release — the twenty page booklet directs interested parties to the ATWA website, and also contains 'extremely focused' (ac-cording to the AK catalogue) sleeve notes from Sandra Good, Lynette Fromme and the Man him-self. Good offers the following testimonial to Man-son's vocal powers:

He has a rich, fine voice. I thought of the image of liquid golden sunshine, like the deep gold brown of his eyes. And it's so full of feeling.

Perhaps I should point out once again that these discs don't contain any of Charlie's own singing, the recordings having been made after his incar-ceration. The booklet also contains many rare pho-tos of the Family, and the front and back covers feature beautiful and evocative photos of Manson's magical waistcoat, a fetishistic garment embroi-dered over a period of years by the women of the Family, containing their secret history and mythol-ogy, like a modern Bayeux tapestry. Squeaky Fromme makes this poignant comment on the waistcoat:

The vest is like wearing your mind and soul on the outside. He gave us the gift of getting us to do what we were capable of doing, then wore what we wrought, both the wonderful and the awful.

At eighteen quid, *The Family Jams* is not cheap, but it's a lot easier to find than *The Manson Family Sings*. And if, like me, you just can't get enough information about the terrible deeds committed by the followers of Charles Manson — over thirty years after the fact — then you already know that you'll be digging deep into your pocket for this well-crafted artefact.

Simon Collins

MANSON MUSIC

The image droned on and on with his insane message of mayhem and murderous carnage...

And when it finally finished, Lürkraszia was left a crazed hypnotised zombie killer!

Seizing up a dagger, she walked on down the chocolate mine, to where her father lay...

Revelation 9 ("... *neither repented they of their murders, nor of their sorceries, nor of their fornications, nor of their thefts...*") onto spurious analyses of Beatles lyrics which turn the 'White Album' into a necrophiliac's instruction manual. Defence even propose calling Lennon (one of rock's 'Four Horsemen Of The Apocalypse') to testify — to *really* explain songs such as 'Piggies' and 'Helter Skelter', which provide an Armageddon Strategist's Mad Dream, to be provoked into fulfilment by sensational shock-horror murders and laying the blame on the black community, thereby initiating a meltdown race war. The trigger-event is variously identified as Family hothead Charles 'Tex' Watson botching a drug burn, so initiating the (il)logical consequences of acid-

fried group paranoia, leading into a slasher-fest of comic-strip violence enacted like spiralling gore-splatters exploding up out of Robert Crumb art-frames.

Manson's squad creep into Benedict Canyon to the Tate mansion, this black reality-suspending midnight of August 9. Susan Atkins, Patricia Krenwinkel, twenty-three-year-old Tex Watson — who first amputates the phone-lines — and driver/look-out Linda Kasabian. The first to die is eighteen-year-old accidentally on-site delivery-boy Steven Earl Parent, shot to death with a nine-inch Buntline revolver in his car in the Polanski's drive at 24:20. Voyteck Frykowski — survivor of Poland's Hitler Nazi atrocities — fights back, escapes, is pursued across the lawn, only to be knife-

blitzed by Watson. There are fifteen defensive wounds to his left lower arm, and fifty-one to spleen, abdomen, lung, chest and neck. Then Hollywood celebrity-Hairdresser Jay Sebring (Sharon Tate's former boyfriend) is shot to death. And twenty-five-year-old coffee heiress, Abigail Folger. Sharon Tate, pleading for the life of her unborn child, is killed last — as Manson's Helter-Skelter blueprint specifies — so she can watch the full slaughter of her guests first. Watson holds her down. Court evidence quotes 'Sadie Glutz' as saying, "I just kept stabbing into Tate until she stopped screaming… it's a form of sexual release…" Tate's blood (type OM, records Sanders meticulously) is now used to graffiti the living room walls, Sadie smearing **PIG** on the front door.

One-hundred-and-two stab wounds are inflicted in thirty minutes. A stab every twenty seconds. But death is messy and often confused. Versions of events conflict. And there's still details unexplained. Corpses are re-arranged, even within accepted memory-variables. Perhaps — between the acid-assassins leaving Bel Air's 10050 Cielo Drive, and the maid's discovery the new morning — person or persons unknown have been creep-crawling within? Some say Manson himself? But now it's already the next night — August 10 — and in ripples of Manson-pleasing media-fear, Van Houten, Watson and Krenwinkel hit 3301 Waverly Drive, Silverlake, just ten miles away. Here, they kill forty-seven-year-old Beverly Hills Supermart boss Leno and Rosemary LaBianca, while Manson and driver Kasabian kill time by going for milkshakes down the road — sucking up the last froth of bubbles even as

The comix underground interprets the Manson phenomenon and fallout… Panels from (previous page) Mike Matthew's *The Curse of Manson's Chocolate Mine!*; (above) R. Crumb's *I Remember The Sixties*; and (below) Veitch, Irons & Sheridan's *The Legion of Charlies*.

Krenwinkel is carving **WAR** on Leno's stomach with a fork, then daubing **RISE**, **DEATH TO PIGS** and **HEALTER** [sic] **SKELTER** in his blood around the walls and ice-box.

"These children come at you with knives," gushes Manson, "they are *your* children. *You* taught them. *I* didn't. I just tried to help them stand up…"

Later, Family-members creep-crawl MOR crooner Jack Jones' house. Fortunately, he's out. But Family-girl Sandy Good claims up to forty more Charlie-inspired murders happen around

this same time-frame… including Gary Hinman, Shorty Shea who gets group-tortured and dismembered, and further bodies, leaving severed limbs and vertebrae yet to be excavated from the most inaccessible areas of inhospitable Death Valley. Not so, says Charlie. Niet. Nada. With all the charisma of a frazzled wino interminably running off at the mouth about nothing, Hippiedom's biggest bogeyman *bête noire* now sits on California's Corcoran State Maximum Security Prison's Death Row with no illusions of ever being released. But he continues to deny culpability. Not to researcher Nuel Emmons, not to Nikolas Schreck, and not to Beattie. He *did* tell Yippie-leader Jerry Rubin — during a pre-trial cell-visit — that "as far as any connection with the Tate murders and myself, and the Family that I live with, I'll say this, I am connected with killing the Indians, and I'm connected with killing the Mayans, the Incas. I'm connected with everything that's been done in the name of Christ in nineteen-hundred-and-seventeen years… I'm responsible for everything man is doing to this earth, its sky and its waters, and its animals, all of it…" But more specifically, no — he insists to them all that he was *not* responsible for the actions of others,

SACRILEGE
p/dir: Michel J Rogers
with: Jane Tsentas, Gerard Broulard, Ruthan Lott, Charles Smith
SEXUAL AWARENESS
dir: Lotto
with: Jonol [*no other players credited*]

These two early seventies' sex films comprise a 'Frank Henenlotter's Sexy Shocker' double-bill from Something Weird Video. The Manson connection may be subtle (or tenuous, depending on how you choose to look at it), but unquestionably there is a creepy-crawl influence hanging the sex scenes of both artefacts together.

Sacrilege is the first and most inventive of the films, opening with a young man called Jay reading a book beneath a tree on an isolated hillside. From afar he spies a mysterious dark-haired woman who holds outstretched the cape she is wearing. Jay does a double-take, but the semi-naked woman is still there. She walks slowly closer, before her appearance switches to that of a plain-looking, bespectacled girl who introduces herself as Cassandra. The two strike up a conversation on witchcraft, in keeping with the nature of the book Jay has been reading. Cassandra is very knowledgeable on the subject and states, "It used to be a… hobby of mine."

With the offer of some tea made from fresh jasmine leaves, Jay follows Cassandra to her isolated hillside home. Cassandra lives alone except for her cat called Lucifer. But Jay begins to envision Lucifer as a bedraggled bearded hippie wearing a big cheesy grin. "Cass, I must be going insane," he cries as the visions become more intense — not only does he keep seeing the strange-looking man popping up, but Cassandra becomes the caped, dark-haired woman from earlier, and the tea before him begins to froth and bubble.

At the insistence of her thrusting hips, Jay starts to perform cunnilingus on the strange woman — "a witch" he calls her — entering a lengthy sex scene which culminates in the woman standing over her now-somnambulistic partner and laughing maniacally. That night Jay calls his girlfriend Maria and requests that she comes to pick him up. Maria is annoyed at this, having been masturbating in the bath (a terribly framed sequence of shots where the focus is primarily the soap suds). Following Jay's directions, Maria arrives at the house only to find her boyfriend behaving as though in a trance. Cassandra makes Maria a cup of jasmine tea, and the girl complains of feeling drowsy, as if "falling into a dream".

When Maria comes round she is naked, tied to a table, and being fucked by Lucifer (in his human form). Jay and the witch stare wildly into the camera, licking their lips. During a brief hiatus in the lovemaking, Maria queries, "What's happening? Has everyone gone mad?" before Lucifer flogs her momentarily with a handful of straw. The witch laughs again and announces, "My sacrilege is complete!"

Sacrilege is b&w ('pretty rare for a hardcore feature', states the box blurb), with occasionally interesting acoustic music that also alternates between electronic beeps and a pilfered orchestral score. Naturally the film concentrates on the sex act, which is shot with an air of spectacular disinterest. The exposition in-between is brief but suggests that director Michel J Rogers' heart may not have been in making a hardcore feature. For instance, the appearance of the caped witch on the hillside is spooky and surreal, evoking the work of Jean Rollin (whose *The Nude Vampire* was made in 1969, undoubtedly before *Sacrilege*). The only time we get to see Lucifer's face is in the trippy sequence when Jay first arrives at the house — after that we never get a clear

shot of him and, frankly, it could be anybody in his place in the fuck scenes. His (genuine) shit-eating grin and psychotic glint probably led somebody down the line to believe it would be a bad idea to tie girls up in his presence. *Sacrilege* ends with a nicely composed shot of Jay and Maria awakening alone in the house at sunrise.

The next feature, *Sexual Awareness* (*Sexual Satanic Awareness* according to the videobox), is an 'Ocult Films' [*sic*] presentation. It's in colour and contains more dialogue than *Sacrilege*, but sorely lacks the previous film's oddball edge. It concerns a guru figure called Aaron and the successful indoctrination of several hippie chicks into his cult. The film opens with a woman lying on his altar. "You cannot be serious," she says in a completely bored manner as Aaron informs her she is about to become a dedicated follower. Aaron's "worthy assistant" Jerome takes over as the master retreats to a balcony to watch over the proceedings. Jerome begins to play with the girl's genitalia. "No... no... this can't be happening," she responds. The soundtrack plays lite-rock as the sex starts. After he has come, Jerome determines cluelessly that the girl is "now united with our occult". We cut to see Aaron embracing the curiously made-up Dorothy, another would-be disciple. "Obey... obey," he tells her, lifting his tunic to reveal his erect member. "Oh great almighty cock of the universe," says Dorothy, slurping and sucking, "I'm yours."

Aaron and Jerome hand out calling cards to passers-by. One recipient is intrigued by the idea of 'sexual awareness' — the wording on the card — and convinces Diane, a girlfriend, to investigate. At cult headquarters Aaron explains to Diane some of the philosophy of his cult. "Become one of us," he says, and they have sex. It is during the preamble to yet another sexual indoctrination that a scrawny Hispanic hippie gent with a bad command of English calls. He flashes a badge and introduces himself as a detective in search of a missing person. Why — the girl on the altar fits the description of the girl he is looking for! The unlikely detective begins to direct questions at the girl, but the only reply he gets from her comes at Aaron's prompt. To prevent the detective from reporting the incident Aaron brainwashes him and ensures that he is serviced by the girl. "Obey... obey," he commands.

The film concludes with Aaron overlooking the scene and lifting up his tunic. "Come all my dear ones," he announces with his hands raised triumphantly. His cock jerks and squirts its seed.

Sexual Awareness is extremely low-budget, a factor that is made all the more evident by the constant references to all the other members of the cult — who we don't get to see — and the tacky satanic paraphernalia and sets: Aaron uses a (ridiculously large) wooden stick for his walks around the grounds, the implication evidently being that a gnarly walking stick somehow makes a man wise; the grounds themselves are actually set within the overgrown reaches of a public park (children can be clearly heard playing); while the altar itself is a kitchen table furnished with nothing more ornate than several mismatched candles. Aaron's prophetic dialogue is recited verbatim from a book (interesting how *Sacrilege* also uses a book to implicate satanic congress), and takes a fantastic turn for the worse during the sex scenes when Aaron puts the book down and struggles valiantly for something profound of his own to say. "Suck the almighty tip... You're becoming one of us now," he'll repeat as some wench tickles his testicles. "Obey... obey."

David Kerekes

they just did what they had to do. He ascribes the mythic origins of his status to 'Sadie' Atkins, whose monitored prison-cell conversations with other inmates at the Sybil Brand Institute for Women (on November 18, 1969), were vital in nailing Manson, even though she later retracted — making her 'confessions' non-admissible as evidence. Manson garbling (to Nuel Emmons) that "a week after Sadie's story, I was a charismatic cult leader with a family, a genius who could program people into doing whatever I asked of them..."

Yet the trial — opening on October 3, 1969 — is pure Situationist Circus. A Black Happening. Manson is forcibly removed from court for insistently singing 'That Old Black Magic' at the Judge. Manson and Atkins are charged separately for the July 27, 1969, torture and murder of musician Gary Hinman (a drug-deal killing that Beausoleil is already sentenced to die for). Both defiantly turn their backs on the court and refuse to plead. While angelically-miniskirted beatifically-smiling co-defendants Atkins, Krenwinkel and Van Houten sing Charlie-songs in three-part harmony and chant "Hail Caesar" as the Judge walks in. Then Manson himself leaps headfirst over his attorney's ta-

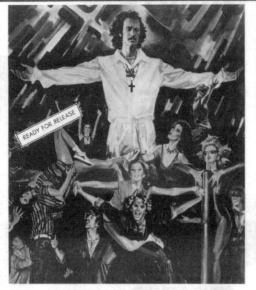

WHITE "POP" JESUS

READY FOR RELEASE

starring AWANA-GANA, STELLA CARNACINA, GISELLA HAHN, TONY SCHNEIDER

choreography by DON LURIO music by BIXIO Jr. and VINCE TEMPERA

released by EMI
Records-Italy EMI

directed by LUIGI PETRINI produced by SIRUS INT'L FILMS

MONO AND STEREO SOUND TRACKS

WORLD SALES DOBERMANN INT'L Via Pietro Ottoboni 12, Rome - Phone: 434268
Cable: LUCEYCINE 00159 - Telex: 680294 Att. DOBERMANN
AT CANNES: L. DI-CARLO, M.A. KROWITZ - 13 Rue Latour Maubourg
(Corner Martinez) 2nd Floor, Suite 25 - Phone: 9915'1

SCREENING
AMBASSADE 2
May 19-9:30 A.M.

SCREENINGS AVAILABLE IN 35mm and VIDEO

DOBERMANN
Film Distribution

ble brandishing a sharpened pencil, while yelling verbal obscenity at Judge Charles Older. Even President 'Tricky Dickie' Nixon gets some soundbites in pre-verdict: 'MANSON GUILTY NIXON DECLARES' according to the *Los Angeles Times*, much to the chagrin of the legal process. Until, by 'JUDGEMENT DAY' (January 25, 1970), with the guilty verdict finally delivered after a week's deliberation in jury room 314J, all four defendants simultaneously appear with shaven heads — as if telepathically connected despite their separate detention cells. Then Manson carves an **X** into his forehead, and the chanting Family-Girls outside — orchestrated by Squeaky (who is unconvicted of any Family-related killing) — also go bald overnight, bare scalps turning red in the scorching sun as they duplicate-scar themselves. But it's not until April 21 that the jury finally delivers death penalty verdicts on all four, plus Tex Watson. None of which have been carried out.

It might not even have much to do with Manson, but who's ever heard of — let alone seen — Luigi Petrini's *White "Pop" Jesus* starring Awana-Gana?

SATAN'S SLAVES
by Richard Allen (aka James Taylor aka James Moffatt)
£6.95 / 132pp / Codex 1998
(originally published by NEL 1970)

This was one of a slew of instant books on Charles Manson and the Family written and published to slake the appetites of a prurient thrill-hungry public before the Tate-LaBianca trials had even started, and it is thus liberally seasoned with "allegedly". What has prompted the reprinting of this book some thirty years later is that its author is James Moffatt, one of the most prolific producers of pulp fiction for New English Library in the sixties and seventies. Moffatt, the very archetype of the whisky-soaked hack (an in-spiration to us all!), wrote so many books under so many pseudonyms that no-one is quite sure of his total oeuvre, but he is best remembered now as 'Richard Allen', the creator of Jim Hawkins, the hero of some eighteen 'Skinhead' novels. I was aggravated to learn from this introduction that original copies of *Satan's Slaves* are now prized collector's items — I used to have one that I picked up at a rummage sale for 20p, but I lent it to someone and never saw it again. However, with this reprinting from Codex, everyone can once again benefit from Moffatt's valuable insights into the Manson case...

So what does *Satan's Slaves* have to add to the bloody smorgasbord of Manson literature?

Well, lurid hilarious garbage, really. Moffatt's qualification for writing the book appears to have been that he spent some time in California in the mid-sixties, but he evidently didn't enjoy it very much. Writing from Britain and short on verifiable facts, he churned out a 125-page tabloid-style editorial rant against the permissive society, interspersed with titillating fantasies of perverted, Satanic sex-and-drug orgies. All of this is dished up in an authorial style which contrives to be simultaneously torrid and sanctimonious, and which reads like a camp Russ Meyer voiceover:

'Brides' of Chucky — the real story, the full horror

in their eyes there's
something lacking /
what they need's a
damn good whacking...

—'Piggies', George Harrison/Beatles

MANSON CASTS A LONG SHADOW. One of the flashpoint references in the lives of his generation. After Manson there's cult-leader Jim Jones, whose followers mass-suicide in Jonestown, Guyana in 1978. Marshall Applewhite founds the Heavens Gate cult in 1975, leading to another mass 'voluntary discorporation' — twenty-one women and eighteen men (including the brother of *Star Trek*'s Uhuru!), who believe that dying with their Nikes on checks them into an armageddon-dodging UFO hidden in the Hale-Bopp comet-tail. Next, ex-Rock guitarist David Koresh founds the Branch Davidians, leading to a fifty-one-day siege ending on April 19, 1993, with more than eighty dead. Then there's fifty-three members of the Ordre Du Temple Solaire who ritually die in linked Swiss and Canadian centres in October 1994. March 20, 1995, sees Shoko Asahara's Aum Shinrikyo doomsday cult launching a Sarin nerve-gas attack in a Tokyo tube

From its inception (and who can say that the Devil didn't impregnate this saucer-shaped bowl of celluloid iniquity?) Los Angeles has been a haven for the unstable... However, while it is true to indict regions with a tar-brush, it is, strictly speaking, very true to say that Los Angeles alone shares the responsibility for attracting the type of individual that is now giving the Golden State its bad name.

Hippieism has tried, without much success, to judge from The Family, to lift old-fashioned love from its magical moonlight into a scrub-infested desert commune and replace the intimacy of two people "very much in love" with the orgiastic gutter-ravings of mass-inflamed lust.

It is even recorded that maiden school-teachers flock to Hawaii where the men are virile and brash and every bed has its frustration-eliminator hiding underneath the mattress.

I could go on, but quoting every laughable bit of nonsense in *Satan's Slaves* would involve reproducing the entire text. About a third of the way through, Moffatt realises that he has exhausted his meagre store of knowledge about Manson, and even his considerably larger store of wildly bigoted opinions, and he embarks on a desultory history of religious cults in California, taking in Aimee Semple McPherson, Krishna Venta etc, before running out of steam on the cult thing altogether

and launching into a street-crazy monologue on Hot Rods, Fatty Arbuckle, tight sweaters, the "Spankies" (i.e. SM enthusiasts), autograph collecting and whatever other random associations his melting synapses throw out. The end result is almost hallucinatory, and deserves to be revered as a camp classic. *Satan's Slaves* is the literary equivalent of *Plan 9 From Outer Space* — you will learn next to nothing about the Manson case from it, but far more than you really wanted to know about the late James Moffatt's personal hang-ups and obsessions. This book is stupid, fatuous junk... and therefore highly recommended!
Simon Collins

FOLLOW THE LEADER
by Linda DuBreuil
269pp / Belmont Tower, 1979

This novel, with its cover that emulates Bugliosi's book *Helter Skelter*, clearly exhibits a Manson-story influence, despite it having been published ten years after the infamous murders. The tale concerns a cult run by Prophet Walters, who imprison and execute hotel guests. Like Manson's Family, Walters' cult has no qualms about killing as a prime means of getting their point across — an attitude said to be borne of their "great respect for life" and the need for God's Army to sacrifice a few for the good of all. People only sit up and take notice when idle threats are disbanded in favour of violence used "in peace and in trust", we are informed, where the disobedient are destroyed.

Similarities go deeper. Both leaders have a Messiah complex — Walters tells a guest to "Go and sin no more" and talks constantly of Judgement Day with the assumption that he is one of the saved. Believing himself to be a martyr for "all that's good and right", Walters in fact turns out to be a convicted violent criminal. The inherent instabilities in both leaders are obvious, and both choose followers from amongst the weak and insecure, who are then filled with hopes of everlasting life, or the threat of fire and brimstone. And though his followers seem sweet and loving, they are nonetheless armed and dangerous, perceived as lunatics following after a leader who is not mad, but bad. Walters, like Manson, is a persuasive man who could make certain people "...believe black is white and white is black".

Obviously, the character of Prophet Walters is not intended to be a direct copy of Manson. But it gets pretty close. The major deviation comes with the impression that should Walters be gunned down, another leader would rise in his place. The same could not be said of Manson.

Sun Paige

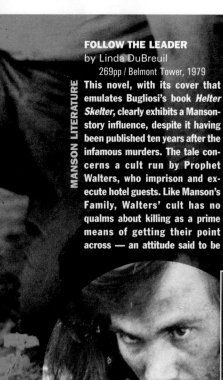

VACATIONERS IN A RESORT HOTEL ARE HELD PRISONER BY THE LEADER OF A CULT OF DEATH!

Follow The Leader

Linda DuBreuil

BACKGROUND IMAGE
Steve Railsback as Manson, in *Helter Skelter*.

station, killing twelve and injuring 5,500 people. Each 'He-Who-Must-Be-Obeyed' lethal Messiah re-using elements of Mansonesque quasi-DNA, while playing Mansonian mind-manipulation head-games. Some of Applewhite's followers undergo voluntary castration. Asahara's disciples drink his blood and his dirty bath water. Koresh has multiple sex with 'spiritual wives' while other cult-members endure enforced celibacy... and then Eric Harris and Dylan Klebold randomly slaughter twelve fellow students and a teacher before turning their artillery on themselves in the Littleton classroom massacre in Colorado. "From Jesse James to Charles Manson, the media since their inception have turned criminals into folk heroes," argues pop pussycat Marilyn Manson, lambasting 'dipshits' Klebold and Harris. "Times have *not* become more violent. They have just become more televised." Discuss.

But there is no Punk Manson. And there's been no Acid-House Manson. So let's get this straight from the off, there's only ever been one CHARLIE Manson. Pop Culture's first and nastiest Celebrity Psychopath and perverse cult icon; The Great Beast 666, the Anti-Christ New Messiah of the Chemical Generation. The Man Who Murdered Love. A man who's shit-eating stare melts the chrome off passing cars. With fucked-up darkness seeping out his very skin, Manson's story is "not so much a who-done-it, as a *why-done-it*" according to trial Public Defender Paul Fitzgerald. So OK, *why*? "Continued use of LSD was a significant factor in the crimes," opines Dr Joel Fort, pioneer psychedelic researcher and author of *Pleasure Seekers*. Well yes, but perhaps it's more because Charlie's unique slant on charismatic

psycho-guru is peculiar to the naïveté of the sixties? He happened, after all, inside a perfect pill-freedomed pre-HIV'd casual-sex window, ideal for the infliction of sicko mind-games. Here in the sudden 'we-didn't-ask-to-be-born' existential moral vacuum of the 'do-your-own-thing' Cold War hedonism, media-commentator Marshall McLuhan suggests with impeccable radical chic credibility that "The criminal, like the artist, is a social explorer". While Woody Allen — in *Manhattan Murder Mystery* — can dismiss the entire ethical equation of a criminal sub-culture with a "Hey, it's an alternative life-style". But death, like

newspaper column inches, is also susceptible to editorial spin. And the global counter culture's Thinking Head — its print network linking San Francisco's *Rolling Stone* and *Berkeley Barb*, through New York's *Village Voice* to London's *OZ* and *IT* (*International Times*), could never quite work out how to deal with a reptile like Charlie. He is evidently 'one of us', a product of the instant-gratification Alternative Society, it's just that he's taken its philosophy full tilt to hell. Ken Kesey talks of taking it *further!* Charlie takes it clear off the map. And sure, the underground press like to jibe playfully about 'revolution for the hell of it'

The Night They Murdered Love

while the vinyl soundtrack of choice is the Stones' 'Street Fighting Man' or 'Sympathy For The Devil'. And sure, Hippie kitsch digs the freaked-out Warhol-style Mao and Che Guevara posters on the squat-wall, while posing as Cerebral Terrorists of the Kounter-Kulture — but then, how do you relate that to the bloody intestinal gore of *really* 'offing pigs'? Turned-On Tuned-In Dropped-Out journalists have the same ethical dilemma with Ireland. Hey, the IRA are Freedom Fighters kicking the aged ass of a corrupt Imperialism. But at the same time *they kill people*! Situationist Stunts and Agit-Prop Antics are one thing, but the stench of carved-up corpses ain't quite so groovy. *Rolling Stone* simply cover-blurbs it the shock-horror 'incredible story of the most dangerous man alive'. While only journalist Susan Griffin is smart enough to recognise Manson's systematic 'desoulment' of women — observing, with pre-feminist perception, that "the attraction of the male in our culture to violence and death is a tradition Manson and his admirers are carrying out with tireless avidity" ('The Politics of Rape' in *OZ* No 41). Old games. New guises. Old skin.

New Ceremonies.

Ed Sanders starts out by attempting to untangle such conundrums through a series of articles for the *Los Angeles Free Press* — 'First Interview With Charles Manson In Jail' — while elsewhere they either rip off his research, report without moral judgement on stuff like Manson's impassioned "You've ordered me to stop living. You won't let me make noise. You've deprived me of the right to counsel, you won't let me receive mail, and you limit my visits to five minutes" or headline his complaint that 'THEY WON'T EVEN LET ME MASTURBATE IN JAIL', while simultaneously leaching Manson's perverse celebrity value by tying it in with bleached-out Rock-Star style artwork, highlighting Manson's supposedly manic crazier-than-Jim-Morrison supernatural stare. Journalist Paul Krassner, intrigued by Sanders' hints of MORE, takes up the research where he's left off, reaching a variety of conclusions — including the 'real villainy' of Tex Watson, who first tells Sharon Tate "I'm the Devil. I'm here to do the Devil's business", and who then pleads "not guilty by reason of insanity" (his psychiatric report now

THE CULT OF KILLERS
Donald MacIvers
198pp / Leisure Books 1976

This is a little misleading. We have a book with a picture of Manson on the cover (overseeing the flogging of a white-robed brunette by a hippie), and in Donald MacIvers, an author who proposes that the Manson-fuelled hippie-cult story which follows is autobiographical. These are 'the horrifying revelations of a fiendish, sadistic murderer' states the brazen cover blurb.

Hippie MacIvers claims to have first encountered the Cult of Killers when rolled by a couple of their members one night. Instead of killing him, however, they discover his bank account is rich with a recent inheritance, and so sap all his money while he falls in with the outlaws. Before he knows it he is robbing and killing for the 'cause'. This particular era of MacIvers' life is referred to in hindsight and remains ambigu-

ous. Cut to the present when he decides he's had enough and makes a break for it, literally running out on the gang whilst in the middle of a shoplifting caper. MacIvers immediately becomes a hunted man, with the deadly cult dogging him throughout the story, never far behind as he turns tricks in Times Square and takes one bum job behind a bar after another to earn a crust.

We learn that with Charles Manson incarcerated, some of his female followers have formed a 'splinter' group. 'They still loved and respected Charlie,' MacIvers writes, 'but it was inevitable that the work should be carried on by women'. (A reference to Squeaky Fromme's attempted assassination of President Ford helps corroborate this point.)

The Cult of Killers is primarily an adventure yarn with heaps of kinky sex and brutal violence. The Manson angle serves to lend a cutting, contemporary edge to the

(mid-seventies) proceedings, and just so we don't forget where we are, Manson's name crops up every couple of dozen pages or so. 'I ain't shitting you,' MacIvers tells an old bartender friend on page 118. 'I got mixed up with a whole bunch of spaced out murderers in the East Village. They kill people just for fun or because they think they get messages from Charles Manson.'

This is a tenet hammered out in the opening pages, where we are informed that 'All enemies of Charles Manson must die' and that from his maximum security cell, Manson is still able to deliver orders to his followers, probably telepathically. "His soul — and his psychotic ideas — go marching on."

On route to a somewhat self-effacing finale — in which he simply resigns himself to a cruel and ugly death — MacIvers frantically dodges the savage disciples Crazy Mary and Big Esmerelda, who

says he's "a vegetable and rapidly reverting to a foetal state"). He's found guilty anyway, but escapes the Manson demonology. While Krassner goes on to suggest CIA intervention in setting up the Manson 'stooge' as agent provocateur to divide and destroy the un-American Hippie conspiracy. Vincent Bugliosi is just as certain that Lynette 'Squeaky' Fromme is culpable. After all, she's not only left in charge of the Family by Manson after his arrest, and organises the weird band of shaven-haired girls chanting outside the LA courthouse where the trial happens, but she even goes on to launch an attempted presidential assassination a few years later, grabbed by secret service agents in Sacramento as she yanks the trigger of a .45 exactly two feet away from Gerald Ford. 'DID MANSON ORDER FORD KILLING?' demanded a September 7, 1975, news story. So did he? Squeaky said, "When you see a bad spot in an apple, you cut it out." Meanwhile Susan 'Sadie' Atkins is variously reported as rebranding her spiritual addic-

tion by becoming a Born Again Christian, and Dennis Wilson — the only Beach Boy who could actually surf — drowns to death while breathing ocean in December 1983.

Me? I remember the shock-print news-bursts too. Pretty much the same ones that were attracting Ed Sanders' attention on October 20, 1969. Black & white — all news was monochrome then. The "last survivors of a band of nude and long-haired hippies" arrested in a Death Valley commune, punched out by the 'glaze-eyed' half-tones of Manson — 'Hippie Satanist/Car-Thief/Cult-Leader/Sex-Maniac/Bastard-Butcher'. And my disbelief. *NO!!!* Hippies don't *do* weirdosity like that! Hippies are peace and flowers, man. In my own defence, I was just a kid at the time. But hang this on for size: Manson was the dark mirror, re-

have the uncanny knack of being able to sniff him out no matter where he ends up. To supplement these scraps and scrapes, MacIvers gives blowjobs to wealthy executives, earns $250 when he is called to remove a coke bottle lodged in a Congressman's ass, meets high class call-girls and ropy street-walkers, and has plenty of sex. The tale is surprisingly well-written given that it probably took some hack a weekend to knock out. There's also a savvy in the way in which MacIvers talks about his subject matter: the drug use, for instance, and — perhaps more importantly — the environment in which the cult thrives. MacIvers calls this the 'anti-summer of love'.

However, the blurb on the back jacket appears not to have been written by anyone familiar with the story being told, and concentrates instead on the rumour of snuff films that hung over the Manson case. **David Kerekes**

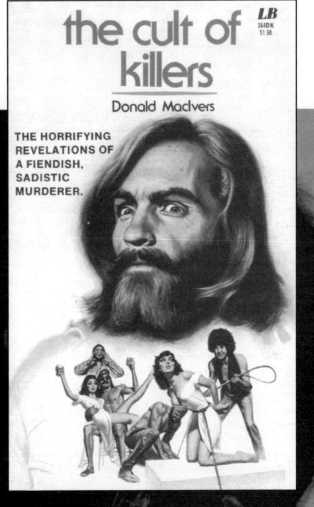

flecting hippies' absurd pretensions back at them. A burning effigy of everything they used to be. Perhaps the psychedelic maggots were always there, squirming beneath the Day-Glo Love and Beauty? Absolute freedom also implies absolute evil. And if it wasn't Manson it would have been some other lowlife charlatan. He was the necessary pratfall, the luckless stooge who just happened to have the weight of all those warped dreams dumped on him. The sacrifice essential to pay the price for a global generational delusion. The sick culmination of the hideous undertow of nightly televised Vietnam atrocity. The murky subcurrents of Hollywood's butt-sucking Babylon. The collective vomitback of diseased gunfixated TV-evangelised shiny consumer-hypocrisy fear-and-loathing American Psycho. For crazed individuals exude in the naked extreme the silent screaming poison at its centre. Don't they?... Hey — Squeaky, Sadie, Linda — you're

They ask him "What do you say to people who say Charles Manson is a psychopath?" He grins that bland shit-eating smile and says "So? There's a lot of us nowadays."

Now pretty-boy Evan Dando claims a Manson fixation. Guns'n'Roses cover a Manson song (saving face by then donating royalties to Manson murderee Frykowski's son Barry). While the mansion in the Bel Air suburb where Tate and friends were slaughtered remains unoccupied, three decades and a comprehensive redevelopment later, its asking price down-sliding from $12M to $8M (although Trent Reznor, Nine Inch Nails vocalist, claimed stewardship for long enough to record 1994's techno-industrial-satanic-goth album *The Downward Spiral* on-site — an album of thudding electronic rhythms, nihilistically raw howled vocals, and Manson slanted titles like 'March Of The Pigs').

Manson sits on Death Row. "They'll never let

Sleeves for a couple of Manson LPs, both containing improvised material recorded in Vacaville: *The Son of Man* and *Live at San Quentin* (on which Manson sings about a radio and from whom he acquired it, amongst other subjects).

out there too, NOW. If you ever get to read this — have I got it half-right? Have I?!? Have I?!?!?!... Or is to go this way just a crock of over-analytical psychobabbling shit? After all — Black is Black. It says so on the rock'n'roll radio. Anyway — by the end of 1969, the Love-Decade's final issue of *Life* magazine is fronted by Manson's stare and his 'The Love And Terror Cult' story. So he finally cracks fame big time.

him out," opines Ed Sanders — without regret. "I have corresponded with Manson, but he's not that friendly to me." Instead, he raves on to anyone else who'll listen, about his environmental concerns, his ATWA (Air Trees Water Air) freedom fighting group, the fact that he never had a fair trial in the first place anyway, and that you can't tell people who don't want to kill, that they should kill... 📖

Charles Manson
- A Consumer's Guide
to the Merchandising

This in no way is intended as a definitive list, more a primer.

BOOKS

THE GARBAGE PEOPLE
The Trip To Helter Skelter & Beyond With Charlie Manson & The Family
By John Gilmore & Ron Kenner

(Omega Press / Amok Books) Spectral, long out-of-print exploitation-style 'True Crime Collectible' volume now reissued (most recently under the title *Manson: The Unholy Trial of Charlie and the Family*) with thirty additional pages of previously unpublished photos, added text and post-mortem documentation.

THE FAMILY
The Story Of Charles Manson's Dune Buggy Attack Battalion
By Ed Sanders

(Panther 1972) First, and still the definitive guide.

WITHOUT CONSCIENCE
By Charles Manson

(Grafton 1987) Not quite what it seems. Rambled conversations with a jailed Manson, transcribed by journalist Nuel Emmons, which nevertheless "explains his psychological background and the train of events more plausibly than the rock-apocalyptic conspiracy theories" (Mat Snow in *Q* July 1987).

HELTER SKELTER
The Manson Murders
By Vincent Bugliosi with Curt Gentry

(Bodley Head 1975/Penguin 1977) Deputy District Attorney for LA, and prosecutor at the Manson trial, recounts the story on the basis of official police investigations and court-room proceedings.

THE MANSON FILE
Edited by Nikolas Schreck

(Amok Press 1988) Features Manson's own drawings, poems and druggy sex-charged stories.

RECORDS

CHARLES MANSON LIVE AT SAN QUENTIN
(Grey Matter CM2) "An hour of songs and improvisation recorded in his jail cell in 1983" says the sleeve. Contrary to the title, this was apparently recorded at the California Medical Facility in Vacaville. Poor sound quality and "hideously unlistenable" according to Tim Hibbert (*Night & Day*, Feb 20, 1994).

LIE
The Love and Terror Cult
(ESP 2003) Initially Phil Kaufman engineered this as Manson's pre-'Helter Skelter' demo tape at the Van Nuys studio on August 9, 1968. Kaufman then financed and issued it as an album after the 1970 trial (he coincidentally went on to steal Gram Parsons' body for ritual desert-cremation six years later). With a long and varied re-issue history — including an incarnation for the Awareness label — it features thirteen tracks, with 'Look At Your Game, Girl' later covered by Guns n'Roses on *The Spaghetti Incident* (guitarist Slash claims "a certain dark humour in Manson singing these love-song lyrics", while Axl Rose murmurs "thanks Chas" into the fade). Other tracks include 'Don't Do Anything Illegal', 'People Say I'm No Good', 'Home Is Where You're Happy' (covered by the Lemonheads on *Creator*), 'Garbage Dump' and 'I'll Always Say "No" To Always'.

UNPLUGGED 9.11.67 VOL 1
(Zylo Records) Original out-of-tune acoustic-strum versions of *Lie* tracks without Kaufman's later instrumental overdubs and girlie 'Family'-added harmonies. $2 from each sale go to charity.

CHARLES MANSON AND THE FAMILY
(Grey Matter CM1) Fourteen demos and twelve Manson songs sung by the Manson Family, including 'I'm Scratching Peace Symbols On Your Tombstone', and 'Cease To Exist' later recorded by Red Kross, and which the Beach-Boys covered (and credited to Dennis Wilson) as 'Never Learn Not To Love'. At one point issued in a spoof 'White Album' sleeve.

THE SON OF MAN
(No details) A one-sided album of improvised material, from the same source as *Live at San Quentin*. Limited to 500 copies.

VIDEOS

HELTER SKELTER
Made-for-TV movie directed by Tom Gries, starring Steve Railsback (as Manson), Marilyn Burns (ex-*Texas Chainsaw Massacre* as Linda Kasabian) and Nancy Wolfe (as Susan Atkins). "Gries uses the camera like a stun gun, with no mercy or sharp edges, lingering with loving detail on the corpses to the accompaniment of the Beatles screaming 'Helter Skelter'" (Julie Burchill, *NME*, March 5, 1977). [*Ed: Whatever happened to this movie? It was only once screened on British television back in the seventies. If memory serves me right, it used original Beatles songs on the soundtrack — a fact which may have upset Apple?*]

CHARLES MANSON: SUPERSTAR
(Video Werewolf) Docu-style TV-primer version of Nikolas Schreck's book *The Manson File*, with interview footage of our incarcerated hero himself "exploding with caged animal wrath at his keepers in front of your eyes" (*NME*, July 18, 1992).

MURDERERS, MOBSTERS & MADMEN VOL 1: *Charles Manson*
(1977) Part of a six-video set of "hitherto unseen footage and interviews of the vilest murders ever to take place this century".

So Far Underground You get the Bends

An interview with
MARY WORONOV

by Jack Sargeant

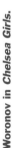
Woronov in *Chelsea Girls*.

MARY WORONOV BECAME INVOLVED WITH THE WARHOL FACTORY whilst still a teenager. With Gerard Malanga she was one of the Velvet Underground's dancers, performing faux-S&M and mock drug taking (using a gigantic fake syringe) to the Velvet's songs. She also appeared in the film *Kiss The Boot* (1966) that was projected behind the band as part of the Exploding Plastic Inevitable. Woronov was 'filmed' by Warhol for one of his three-minute *Screen Tests* (1964–66), as well as for *Shower* (1966) and *Milk* (1966).

She also appeared in Warhol's narrative movies.* Her most famous acting role from this period is probably *Chelsea Girls* (1966), in which she was cast largely because of her potentially aggressive nature. As Woronov has subsequently commented: "It was the people at the Factory who coaxed the unwanted stray out of my shadow and encouraged her to play in movie after movie."

Woronov also became involved in the Glitter Theatre, appearing in the plays of Ronald Tavel, such as *Vinyl* (1967) and *Arenas of Lutetia* (1968), as well as Charles Ludlum's *Conquest of the Universe* (1967). She performed as part of John Vaccaro's Playhouse Of The Ridiculous, alongside Factory regular Ondine and Penny Arcade. Woronov also appeared in the New York Theatre Ensemble production of *Women Behind Bars* (1974).

Leaving New York for Los Angeles in the early seventies to pursue a career in acting, Woronov turned up in numerous movies. These included *Silent Night, Bloody Night* (Theodore Gershunny, 1973), *Death Race 2000* (Paul Bartel, 1975), *Hollywood Boulevard* (Allan Arkush, 1976), *Rock'n'Roll High School* (Allan Arkush, 1979), *Eating Raoul* (Paul Bartel, 1982), *Black Widow* (Bob Rafelson, 1986), *Scenes From The Class Struggle In Beverly Hills* (Paul Bartel, 1989), and *The Living End* (Gregg Araki, 1992), amongst many others.

She has also appeared in numerous TV programs, including *Logan's Run* (1977) and *Buck Rogers in the 25th Century* (1979), but is perhaps best known for her appearance in the (1976) *Charlie's Angels* episode 'Angels In Chains'. ("I play this matron who gives them a hose down," says Woronov. "I swear to God, people love it.")

Whilst living in Los Angeles Woronov also began to paint and, later, write, completing her autobiographical account of her years spent with Warhol, *Swimming Underground*. She has also written the novel *Snake*, a book inspired in part by the outsider personalities who gravitate to Los Angeles, and the Viet vets and survivalists who live in the rural West. (Both books have recently been published by Serpent's Tail.)

*Written by Ronald Tavel, these included: HEDY (1966), SUPERBOY (1966), and **** (aka FOUR STARS, 1966–67).

Mary Woronov was interviewed in a 'quiet' space at the Lux, London. Unfortunately this quiet space turned out to be next to some major construction work, and the conversation was punctuated with the scream of drills and relentless thump of hammers.

HEADPRESS Lets start with the Warhol years. You talk in SWIMMING UNDERGROUND about other women trying to get on the stage whilst you danced with Malanga, and how you didn't like them, and how there was conflict between yourself and the other women on the set of CHELSEA GIRLS; and also about the woman Vera Cruz who you didn't like, and how she gets in really close with Andy Warhol. And I was wondering, all this conflict appears to be engineered by these gay guys who are vicariously living on these confrontations between women. What is your take on that?

MARY WORONOV The Factory was like a court — the old court of King Louis or something like that — and people were always fawning after [Warhol's] favour, and at times he did toy with them. And one of the many ways that he'd toy with them is these girls would fight over whether they were going to be in a movie, or not in a movie, and whether they were a superstar or not, and whether they were sitting next to him or not. And the queens who also were there, would thrive on a bit of fighting amongst the girls. They liked it very much.

I, on the other hand, would never succumb to fighting about whether I was going to be in a movie or not. I was quite butch and if I did fight I'd punch somebody and hurt them. I was very scary, and I liked it, and it kept that kind of fighting away from me, so I didn't become a show for everybody else. I was extremely conscious of it. The other girls, I don't think they were conscious of it.

You read the other biographies, and they tend to talk about being Warhol's favourite or whatever, and you avoid all of that. Well, I wasn't [his favourite; *laughs*]. I don't believe they were his favourite — I believe they wanted to be his favourite. If he did have a favourite it was the first girl he had up there, which was Edie Sedgwick. And he liked her because she almost looked like him, and it was <u>him</u> as a <u>girl</u>, and, of course, he was interested in that. But was he interested in Edie herself? No, I don't think so. I don't think he was interested in anybody. He was too busy thinking about things to be interested in people.

But what about the idea he exploited the girls in the films? I would hesitate to call it exploitation, because the women exploited themselves. It wasn't so much that he desired that or wanted that, he would open the film, not say anything, be this vacuum of a director and they would do it to themselves. They would completely exploit themselves.

But what about the case of the woman in your book who overdoses when you are hanging with all the hardcore speed freaks, and everybody's like "Who cares?"... It was more than "Who cares?", it was like "Let's mail her down the mail chute". It was a complete denial of death. And a complete... "Not only do I deny it, I'll wear it as a necklace." They were completely insane, they were really, really insane. They were great. Most people would go "Oh my god, how is she?" and there they are, not only not caring, but putting stamps on her forehead: "Oh we have to get rid of the body, let's put a stamp on her forehead and see if the postman will take her." I mean they were in another world. They knew every minute that they were in another world. They just didn't care.

You were eighteen. It must have been an education to be in that scene. I was amazed. I was absolutely floored. I couldn't get enough of them. I would go into situations that were almost periless because they were so insane. First of all the way they dressed: they'd walk

into a room, rip a curtain off, wrap it around themselves, make a toga of it, and walk around like that for the rest of the night... I mean, my mother didn't do that. My mother was in a girdle and nylons. It was really different [*laughs*]. And then they'd walk around in a dress made out of curtains and they'd be a man.

Those people all tie into that speed scene and the scene around [filmmaker, actor and artist] Jack Smith. Exactly. You know about that scene you know what this is like. I mean the arranging of the absolute jewels of the cobra; spending five days just to arrange it. What insanity. What intense... obsessive... focusing on a detail that does not matter. But then you think "Ah!...what does matter?"

But that's a form of speed thinking, you just focus on obsessive minutiae. Yeah. And finally you dissolve into nothingness.

You were saying in the book about working with Ondine on a Jack Smith film — do you know which one it was? I don't know, I really don't know. There were people who seemed to be there [on the 'set'] for a week. He was known for taking hours and hours and hours to do something; taking days to do the smallest thing. People would come and go. What can I say, the only film of his I ever saw was the one of the doll on the Roman steps*, where he just keeps on moving it around — and FLAMING CREATURES. And when I saw FLAMING CREATURES my jaw fell to the floor... I thought he was brilliant.

[*drills begin*] **I was interested in the whole theatre thing. How did you get involved with that?** I did [the film HEDY about] Hedy Lamarr... and the person who wrote that script was Ronny Tavel. He saw me and said "I have other plays for you". Then I did VINYL with Gerard, then Ronny wrote a play for me, ARENAS OF LUTETIA, which was a giant flop I guess you'd say, it was just an insane play. Then he did an-

*Jack Smith created various performances, slide, and film shows throughout his career, and I've been unable to find out exactly what this film is.

other play for me called KITCHENETTE (1971). Actually it was a play for Edie, but I did KITCHENETTE and that's what made me famous on the stage. After that I did queen theatre all the time. I did NIGHT CLUB (1970)... I did Vaccaro's plays.

These were all Theatre Of The Ridiculous plays? It wasn't Ludulm's Theatre Of The Ridiculous; it was Vaccaro's Theatre Of The Ridiculous. Entirely different. Totally different. One was a happy family, the other was a sadistic neurotic man.

Which was which? Vaccaro was insane. I saw him trying to kill someone behind the curtain. I mean, he was just nuts, then he'd laugh. I mean sometimes people wouldn't show up — we'd think, "Oh my god! He's gotten rid of them" — but so what? [*loud drill noises*]. He would say [while directing] "You're the conqueror of the universe, you can do whatever you like, you want to torture them? Kill them? Fine. Fine. All of that is fine". And, what he really meant was that I could improvise, I didn't have to follow my lines, I could talk to the audience if I wanted to. So this is already a weird use of staging. The other thing he was very, very fond of... there was always a pail of something around which was shit — shit eating — he always had that in his plays. You know those Greek things with large penises that they walk around in? He always had a chorus line with those on.

Right, with glitter all over them. Right, just insane, stupid stuff. He had a chorus line that he was screaming at and badgering and things like that. With me he was always very, very polite and very nice, he never screamed at me. He was very smart in a way. I remember one play, he didn't know whether to use me or Ondine as the night-club owner, and he said "I can't decide, so you'll both play it". And it was amazing. They were certainly the most amazing plays that I had ever done, and they broke a lot of rules about what you could do sexually and on stage.

All of this time, whilst you're doing all these plays, you were a total speed freak? Yeah. I didn't really do much without speed. By the time I got to Lincoln Centre [in 1973, with IN THE BOOM BOOM ROOM!] I wasn't taking anything, I was totally straight — when I knew I was going to be an actress. Before I really didn't, I thought I was an artist, I thought all of these were happenings. I certainly never trained as an actress. I thought, "I am a work of art myself, I'm just this thing that they used and I alter it according to what they need." And it was all a very artistic approach, but, when I hit Lincoln Centre... I just pretended I went to school...

What made you move to California? To be in movies with Roger Corman. I went to do a movie with some guy, who I ended up marrying, and then he had to go cut the movie in LA. I lived in LA and suddenly I liked it. Then I came back, and Paul [Bartel] said, "If you live in LA you can do movies." And once I was working in Los Angeles, it was much better. There was tremendous independence.

When you were in LA you started doing Corman films. Starting doing Corman films, and then I knew that was my living — and I tried, I really tried to break into Hollywood, but I never became the Hollywood kid. I always ended up doing these new filmmakers; filmmakers who were just starting out who knew about my cult status or something. Then I realised, those were the films I like. I'm not a power person, the films I've done for Hollywood [are ruled by the powerful], there's nothing you can do. But those other films, where the kids are just starting, you can pretty much do what you want. And I like that, it's more fun.

What films are you happiest with out of the Hollywood films? EATING RAOUL? It's the best because it took twenty-six days over a year to shoot it. [Paul Bartel] used to call us up at weekends and say, "Oh I want to shoot again." And because they really didn't know what they were doing and they didn't have any time to do anything, I got to improvise a lot. I got to do what I wanted to do. All the stuffed animals were my idea. They ran around finding me stuffed animals. Just sweet things like that happened on that film, it was really great. ⏻

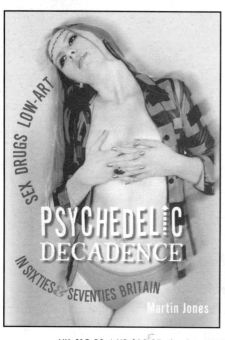

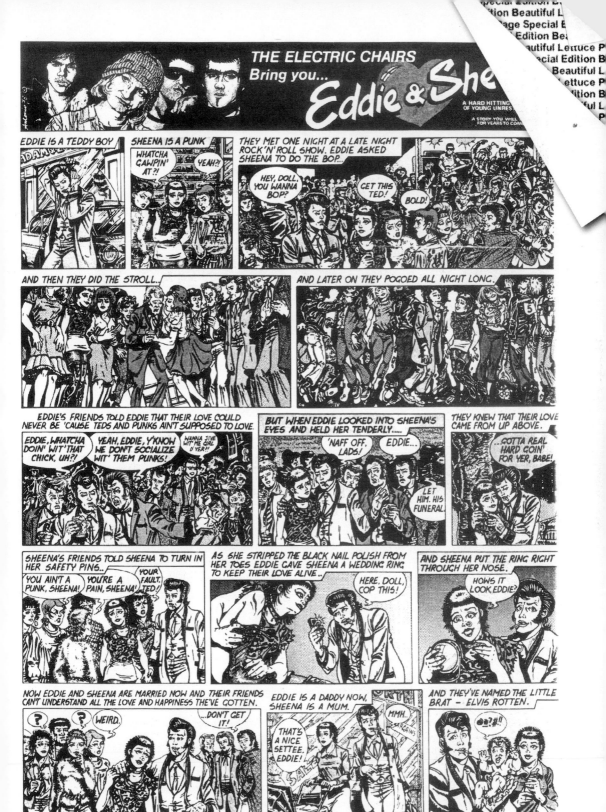

The Headpress Lettuce Pages have recently contained correspondence on Wayne County of punk band The Electric Chairs. BRIAN YOUNG of Belfast, N. Ireland, kindly sent in this Antonio Ghura promotional comic strip which came with the Electric Chairs' original 'Eddie And Sheena' 45. Normal Beautiful Lettuce Page service will be resumed next time. Write: Headpress, 40 Rossall Avenue, Radcliffe, Manchester, M26 1JD, Great Britain.

OBITUGOREY

*Farewell to a
Frankenstein person*

by Martin Jones

*"Sometimes I'm aiming to make
everyone a trifle uneasy. Life is rather uneasy
making, so art should be too. In a way."* [1]

The artist, writer, set designer and dramatist
Edward Gorey died of an apparent heart attack
on April 15, 2000. He was seventy-five.

Author of over a hundred books (and illustrator-for-hire for some eighty others), Gorey lurked in the darkness between Aubrey Beardsley and Charles Addams, a self-contained creation clothed in a huge fur coat and tennis shoes. His sparse, pitch-black tales are mostly set in worlds of Victorian and Edwardian exaggeration (**"I tend to think life is pastiche. I'm not sure what it's a pastiche of — we haven't found out what yet"**[2]), where boredom and unaccountable dread — the waste products of civilised society — invade the lives of sinful men, mute women and whey-faced children. Death or madness is the only escape from this very English callousness. Fittingly, the Reuters report of Gorey's demise concludes with a line that could have come from any one of his books: 'It was not clear if there were any survivors.'

Born in Chicago in February 1925 (some-

where between the 15th and 25th, depending on which source you care to believe), Edward St John Gorey was drafted at the age of eighteen, and, after sitting out the Second World War as a clerk, went on to Harvard, subsequently becoming entangled in the imaginative life that would make his name. His first published work, *The Unstrung Harp; or, Mr Earbrass Writes a Novel* (1953) is a glorious debunking of the solitary terrors faced by the Great Novelist, the writer who would rather do anything except write. Here, even insomnia provides poetic taunts:

In the blue horror of dawn the vines in the carpet appear likely to begin twining up his ankles.

Although a dedicated Anglophile (especially

where the works of Evelyn Waugh, Ivy Compton-Burnett and Agatha Christie were concerned), Gorey soaked up influences and interests from a diverse array of cultures: Japanese art, the philosophies of Surrealism and Dadaism, silent cinema (Murnau's *Nosferatu* and Dreyer's *Vampyr* were particular favourites), television soap operas and unremarkable horror films such as *Friday the 13th* and *Spawn* (**"Why was I stupid enough to see it?"** he asked one interviewer. **"It was all in the trailer."**[3]). Some influences emerge barely-hidden in his work — Compton-Burnett's fissured families in *The Doubtful Guest* (1957), for instance — but, in the finality of the printed page, Gorey's world is entirely his own. Not nearly enough is seen, and the most horrific events happen beyond the frame of his drawings, never to be explained:

At sunset they entered a tunnel in the Iron Hills and did not come out the other end.

▲ *The Willowdale Handcar*, 1962

Homicidal alphabets feature largely in Gorey's work: twenty-six chances to maul an innocent — or not-so innocent — person. The most well-known of these is probably *The Gashlycrumb Tinies* (1963), which offers an imaginative variety of gruesome child deaths, another Gorey theme. But not all of his inhabitants are so unworldly, and many books provide a balance of the hunted and the hunter:

The Proctor *buys a pupil ices,*
And hopes the boy will not resist
When he attempts to practise vices
Few people even know exist.

▲ *The Fatal Lozenge*, 1960

Such a macabre outlook was infused in Gorey through a childhood spent devouring Stoker, Shelly and Hugo. In 1978, when his set and costume designs for a Broadway production of *Dracula* earned him a Tony Award, a concurring interview offered a glimpse of his own philosophy:

"I'm really much more of a Frankenstein person myself," he says, agreeing that all of humanity can be divided into two classes, the Dracula people and the Frankenstein people. **"I was quite precocious as a child and read a lot. I read *Dracula* when I was 5, and *Frankenstein* at 7. It scared the bejesus out of me. Of course, I was bored by a lot of the book. At that age, it hadn't ever occurred to me you could skip anything."**[4]

Appropriately, missing details are key in his work. The poised surrealism of *The West Wing* (1963) offers sets from an unmade silent movie. In them are discarded shoes, open doors, chairlegs, static figures in various states of dress and distress, and other things more spectral.

THE INSECT GOD

Illustrations used in this article are © the estate of Edward Gorey and respective publishers.

1 Paula Span, 'Uncategorizably Edward Gorey; The Artist's Weird Whimsy Takes Wing With A Ballet At The Kennedy Centre', *Washington Post*, October 8, 1991.

2 Interview with Ed Pinsent, *Speak*, Fall 1997.

3 David Streitfeld, 'The Gorey Details', *Washington Post*, September 14, 1997.

4 Alan M Kriegsman, 'The Glory of Being Gorey', *Washington Post*, June 11, 1978.

▼ Opening lines to The Gashlycrumb Tinies, 1963

In the never-quite explicit *The Curious Sofa* (1961; written under one of many anagrammatic pseudonyms, Ogdred Weary), the at-first virginal Alice progresses from one sexual partner to another, until events begin to go horribly out of control: **'Still later Gerald did a terrible thing to Elsie with a saucepan.'** Whilst in Gorey's one truly depressing book, *The Loathsome Couple* (1977; based freely on the Moors Murderers case), a man and a woman set about planning the deaths of a number of children. Halfway through the story, an illustration shows nothing more than an open doorway, a chair within, and the chilling caption: **'They spent the better part of the night murdering the child in various ways.'**

In his latter years, Gorey lived in dilapidated seclusion in a perhaps-haunted farmhouse on Cape Cod, Massachusetts. Never quite the eccentric recluse the media portrayed him as, he spent his time at the local coffee shop or visiting relatives, or at home writing, drawing or making stuffed creatures, CNN on the television, surrounded by free-roaming cats and ever-growing piles of books, CDs and videos. He travelled abroad only once in his life, on a cruise to the Scottish Hebrides. Perhaps it was unnecessary to leave the dark, unnatural shores he had created, a place mapped out perfectly in *The Listing Attic* (1954), a Gorey Bible of vile verse, depicting paranoia, deformity, perversion, murder and ennui:

A is for AMY who fell down the stairs
B is for BASIL assaulted by bears

There was a young curate whose brain
Was deranged from the use of cocaine;
He lured a small child
To a copse dark and wild,
Where he beat it to death with his cane.

An incautious young woman named Venn
Was seen with the wrong sort of men;
She vanished one day,
But the following May
Her legs were retrieved from a fen.

In being so prolific, Edward Gorey has left a taste of the treasure hunt to his legacy. Many of his books are collected in the popular anthologies *Amphigorey* (1972), *Amphigorey Too* (1974) and *Amphigorey Also* (1983); and, in Britain, Bloomsbury have made a decent beginning of repackaging selected titles. But these are just the tip, and the path leads back nearly fifty years, through a bewildering array of publishers, pseudonyms and rarities. A caption on a Gorey T-shirt says it all, really: **'So many books, so little time.'** ⌨

Thanks to Carrie Donovan for her assistance with this article.

In a Lonely Place

An interview with a BBFC Examiner

by Adrian Horrocks

This interview was conducted with BBFC (British Board of Film Classification) Examiner GIANNI ZAMO in 1996, when the media were once again frothing at the bit over sex and violence in films. David Alton MP had instigated a change in the law concerning video several months earlier, with amendments within the Criminal Justice and Public Order Act 1994. Since this interview, JAMES FERMAN has been replaced by ROBIN DUVAL as director of the Board. Recently the Board announced that it was to be more relaxed with regard to material classified 18 for adults, a decision reflective of public attitude and made following 'an extensive consultation and research exercise'. This isn't to say that all films submitted to the Board will now escape intact, rather horror and action films at 18 are unlikely to see cuts of two or three seconds anymore, and sex films rated R18 will show a little more sex. Nevertheless the interview is a rare insight to the classification and censorial process as it stood for too many years. — *The Editor*

"SHE'S A GIRL AND A HALF!" Gianni Zamo chuckles as he watches an uncut video of *Terminator 2*. On the screen, Sarah Connor frenziedly beats a guard with a broom handle, continuing to hit him even after he is prone on the corridor floor. "Quite juicy in its real format, to say the least," the likeable and enthusiastic Zamo says, grinning broadly. Next to his chair, he has a small stack of other videos he wants me to see. Amongst them, uncut versions of *Cliffhanger*, *Lethal Weapon 2* and a Pamela Anderson porn tape. But Gianni Zamo is no dodgy tape collector — he's an Examiner for the British Board of Film Classification, and here the both of us are, sitting in a small, glass-walled cubicle in the Board's Soho Square offices.

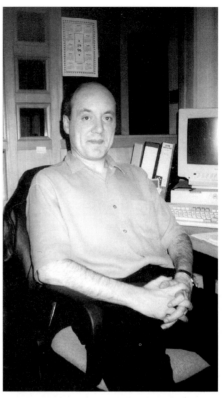

Gianni Zamo

THE *T2* SCENE ENDS AND ZAMO GIVES his opinion. "It's just really when she bashes his head against the floor," he says. "He was already down. I wouldn't have a problem with this at adult level, but for a 15, I was uncomfortable. It dwelt on the process of the violence a little to much for my taste. But you can't know how every individual human being is going to react to a particular sequence. And that's the difficulty with this job. You're working to a best guess, really."

We watch the other tapes. For each, Zamo shows the BBFC cut version first and, while watching, encourages me to agree that the censored version is quite explicit enough. The uncut versions follow, and suddenly they do look pretty gratuitous. Nevertheless, I argue against the cuts, and Zamo's constant smile begins to look a little glazed. A little later we visit a tiny room, dominated by a giant-sized TV set (which is switched off), with a VCR beneath. A young man sits behind a desk, holding a clipboard. "What are you watching today?" Zamo asks. The man flicks the remote and the screen suddenly fills with hardcore gay porn. It's a jolting sight, coming without warning and out of context; I'm startled, and obviously I show it. Zamo and the man both laugh at my reaction. "We have to watch a lot of this," says the young man wearily. "We're gonna cut all of this scene," he then adds.

Back in the main office, with cups of tea and chocolate chip cookies, I ask Zamo about his background. Before joining the Board, he spent five years working for the Cambridgeshire policing service, involved with an intensive probation day centre. "I took on groups of offenders, and put them through a forty-day programme, which attempted to address their behaviour. In the course of that work, much of what I did at a therapeutic level was using video cameras with the offenders, to make short films, some of which they drafted themselves, and which were generally centred on the kind of issues they were facing every day. Things like drug abuse, crime generally, that sort of thing. And on the basis of that, I applied for the vacancy here, which I saw advertised in the paper. And the rest, as they say, is history."

And what of the other Examiners? Where do they come from? "They're drawn from various professions. We have people who are child psychologists. We have an array of teachers and educationalists. We have a couple of ex-journalists. People who have worked in media-related studies; lecturers, that sort of thing. So it's a fairly broad-based, but professional background for most of them."

The examiners work five-hour viewing days, three-and-a-half days a week, mixing film and video. They're given a viewing programme by "a lady who sits in Programming". Over one week how much does Zamo watch? "Let's think... My God, probably two or three feature films a week, and probably fifty or sixty videos. And there's not just the mainstream Hollywood features, there's the European films, Asian films. Video wise, it's a fairly hectic old week's work. And a good eighty-five to ninety per cent of what we view is fairly routine and ordinary. Some to the point of mind-numbing dullness, it has to be said! People tend to think, 'Wow! That's great! Sitting there watching films all day!' But that's not the truth. It's like being let loose in a chocolate factory — after the first two or three days, you sort of overdose on it almost. But fortunately, there's enough good stuff to keep the juices going, as it were."

I ask Zamo if it's a problem keeping his critical facilities on an even level. "It's hard. There's no doubt about it; it is difficult. But I suppose what we do have here is a process of being able to talk things through with other colleagues. And where perhaps you get a particularly difficult film, what would normally happen is that *all* the Examining team would view it, probably the man-agement as well. And then we would try and thrash out the various issues that arise from that film. Which all sort of helps to keep one on one's mettle. Some of the arguments that occur over certain features can be quite dynamic at times, as people take different positions and put different readings onto each film. That actually keeps the faculties fairly sharp."

But what makes the Examiner's views more valid than anybody else's? Zamo smiles broadly and says, "Because I'm right, that's what it is! I am right! Everybody else is wrong!" He laughs loudly, before stating, on a more serious note, that: "All you can do is, hopefully out of that de-bate, arrive at a conclusion which is reasonable not only to the audience that is going to go and see that film, but also to the film itself. And I think that often the point that we don't make clear enough, when we're doing interviews like this, is that without exception, all the Examiners have a very deep seated interest in films. There's no doubt about that. You cannot do this job if you don't like them. It sounds slightly perverse, you know, we're sitting here saying we love films, and yet here we go with our scissors, and start snip-ping here, there and everywhere. But if we didn't, we couldn't do this. And I think that goes a long

way to be being able to stand back and just occasionally say, hang on, let's not carried away, let's not get carried away about this film. It's actually okay. It's a well-made film, there's no need to start inflicting drastic action upon it at all."

Just what is the BBFC concerned about? Do they really think that people are going to go berserk if they see certain films? "I think the Board's changed so much, that in this day and age, it's fair to say our main concerns are with child protection really. Some years ago, the home secretary drew up an amendment to the Video Recordings Act, which was part of the Criminal Justice Act, where we had to apply a particular test, not only of suitability for viewing in the home (so far as video is concerned), but also the potential viewer. And by that, they were taking into account the fact that certainly some adult films of certain genres, of certain styles, were likely to attract the attention of quite junior viewers, who perhaps were not developed enough, not mature enough to see the context within which those films sit.

3 Soho Square, home of the BBFC.

So the concern there really was about taking into account what the potential was for very young viewers seeing inappropriate films and videos. But that's specifically video, rather than film, because the cinema has a much more powerful gatekeeping facility than home video, obviously."

In that case, why not pass all 18-rated films *without cuts* at the cinema? Zamo's answer reveals that the Board's concern isn't just for children after all. "In this age, quite rightly, we say that adults should be free to choose what they wish to see. But it's a peculiar national characteristic of this country. I think there's still quite a powerful puritan element within British society, which feels that not all adults are developed enough to understand, or experienced enough to come to terms with some of the visual imagery that's presented in some of the more adult orientated features. And I think the concern there is not one particular film. I don't actually believe that any one particular film is going to bring about the downfall of society in Britain, and we're all going to turn to a life of crime immediately. But the concern is that in time, a constant feeding of that sort of material, to a particular, and very small section of the audience — who might get quite hyped on that imagery — just coarsens attitudes, and people are no longer shocked by the sight of someone being shot in the head at close range, repeatedly, complete with blood spurts. That is the concern, more than anything else: that it actually coarsens attitudes, and that people become perhaps less outraged than they should be. And in those instances, yes, we do cut adult films."

Is there a particular type of audience, or genre of film, that particularly worries the censor? "I suppose an *action* film. Where — not in all cases, but in some at least — the tendency is to offer a fairly limited level of narrative. The characters seem almost two dimensional in many respects, and the overriding emphasis of the film throughout is not just the action, but where for example, the film tends to dwell on the somewhat sadistic infliction of pain and injury on people. Whether they be good guys, bad guys or whatever. It's the kind of film that almost presents the process of destruction as quite glamorous, as quite sexy, as quite appealing. And that *type* of film tends to be made with an eighteen to twenty-three-year-old

audience in mind. Again, I would emphasise that the vast majority of that audience would see it as a bit of exciting hokum, which would send them out singing and dancing. But we do get concerned, I would certainly get concerned about a film which did nothing but present that sort of process as something to be enjoyed."

In the early eighties there was no video censorship at all in England. Did anything happen as a result of that? Was there an increase in violent crimes? "Well, not that I recall, no. We had all this business about 'video nasties', didn't we? A fairly well-orchestrated campaign. And as a result of that, Parliament voted the Video Recordings Act in, which effectively brought videos into line. But as far as I can recall, no, I don't remember mass murderers running around and doing things as a result of what was available. But it was a new technology, much as film was in the late nineteenth, and early part of this century. And perhaps it's a measure of a certain *nervousness* on the part of Governments through the ages, really. Whenever anything new comes out, and seems to be uncontrollable, and beyond their ken, there seems to be this urge to bring it under some sort of control."

One of the most annoying things about film censorship is the arbitrariness of it. Some extremely violent films are passed uncut (*Braindead*, for example), while others (*The Evil Dead*) get heavy cuts. Why is that? "Each film is taken on its own particular merits. You see, we don't work with set rules here, with the exception of one thing, and that's language. That's the single biggest issue people get worked up about. That's the only thing where we say, right, at this point either it goes up [a category], or it remains in this particular category. As far as everything else is concerned, the overriding principle is really context; what that film is trying to get over, and *how* it gets it over. You can't say every violent film that shows, say, somebody having their head hacked off *must* be cut, or *must* be 18. There may be a context in which that action is justified. And you hope that most people will see it. The vast majority of reasonably minded people will see that.

"Maybe we would say, given the context of a film like *Schindler's List*, it is perhaps going to appeal to quite a thoughtful, considered, or con- siderate audience, that is actually going to sit down and read it for what it is. Rather than try and put what we call an *aberrant viewing* on it, and get carried away, and think that the Ralph Fiennes character is some sort of real cool macho guy that they want to copy. You know, 'I want to go around and blast people with a hunting rifle from my balcony.'"

But isn't it true that if the tabloid press gets worked up about a film, it gets cut, and if they ignore it, it doesn't? Zamo sighs. "Ah, the dear old tabloid press." Does the BBFC take notice of them? "Let me get this right," Zamo says, starting his sentence several times over, stopping mid-flow, before finally settling on the following: "We *do* listen to what people say; we do listen to people's concerns. We read the papers, we watch TV, we listen to the politicians, the cineastes, all those interested parties." He gesticulates wildly, determined to convince. "But we cannot, we *cannot* allow the interests of those individual groups, really to impact greatly on overall decisions. We're put in the position… we're the people that say, OK, we're gonna go and do this job, we have to do it. We can't start suddenly jumping out the boat, as it were, and saying, 'Oh, it's not our problem, let's go and ask this group over there, or this group over here, what they think about this film.' Because we would never end up with a satisfactory solution. Everybody brings their own particular agenda, be it the moralists on the extreme right, or the libertarians on the other end of the scale. Somewhere we have to make a decision, and we have to make that within the Board."

A lot of now acknowledged classics have been banned and cut, haven't they? "Yes, yes they have," he admits.

We finish our tea, and descend to ground level in a tiny lift. Standing outside the offices, we have a smoke, and watch as a postman hauls a seemingly endless number of boxes from his van, and stacks them up in the BBFC lobby.

I ask Zamo a final question. What does he think about David Alton's campaign against *Natural Born Killers*? Zamo thinks a moment. "You know, you don't realise what power some of these groups really have." He stamps out his cigarette and waves to me as he makes his way inside the building, stepping around the boxes. ▧

Hey! LET'S WATCH JADE MARCELLA TAKE A PISS.

Or better still, let's watch the twenty-year-old, olive-skinned nymph bend over, bare-assed, and fart a spit bubble out of her Indonesian poop pit. Then there's *always* a white trash whore — like hot-titted, hoagie-humpin' Teri Starr — ready to get sloppily gangbanged and, thus, uphold the supremacy of the "master race" when it comes to *their* sluts being the BIGGEST tramps in town — next to innah-city, chocolate bunny ho's, that is. What's that? You want some bukkake? You got it. Get into Nadia and a truckload of street slobs spraying spew onto her tight-jawed puss until eye shadow and mascara mix with still-steaming sperm to streak like wet charcoal down the cunt's cheeks, making it appear as if her kisser were melting before our very eyes. Face rape? Sure, sure, sure. We got that stuff, too. Open-

BELOW: Powers at the California Broiler in Chatsworth, CA (Note: That's porn stud Devlin Weed's big, black head growing out of Powers' shoulder).

NEXT PAGE: Julianna Sterling in *Naughty Little Nymphos 4*.

Lord Jim

Photo: Anthony Petkovich

mouthed bitches getting violently, *mercilessly* deep throated, one after the other, to the point of rolfing up bile'n'tofu. Amputee love is on the bill, as well: like stud JJ Michaels fucking the armless/legless torso of European tramp Zarina, then carrying stumpie under his arm and droppin' her off at the bus stop. After all, human fire hydrants gotta work, too.

Such is the perfectly filthed-out, no-bullshit, twisted world of director Jim Powers. In order of mention, Powers is the sick fuck behind such XXX series as *Liquid Gold* (*No 2*), *White Trash Whore* (*No 19*), *Bootylicious*, *American Bukkake* (*No 9*), and *Perverted Stories* (*No 25*). He's also the pornographer responsible for such super smut lines as *Gutter Mouths*, *The Violation Of...*, *Naughty Little Nymphos*, *My Black Ass*, *My Ass*, and *YA* (short for *Young and Anal*).

But who *is* Jim Powers?

and his
Abusive Powers

by Anthony Petkovich

T HE PROLIFIC, UNDERRATED PORNOGRAPHER was born thirty-seven years ago in Stanford, California. "Classic scenario," says Powers, "parents met in college, mom got knocked up, they had to drop out of school." Due to the transitory work of Jim's architect father, the Powers family frequently moved around the country, eventually settling down in Albuquerque, New Mexico, with young Jim spending his summers in California. "But I left home when I was like in 11th grade... came out to California to be in a punk band and skateboard. One of my bands was Killroy and the Hellcats."

Porn was also high on his list of interests.

"Loved watching the stuff. As I grew up, my favourite director was Greg Dark, and my favour-ite porn stars were Traci Lords, Gail Force*, Ginger Lynn, Amber Lynn... those were my girls."

Powers did eventually finish high school, soon thereafter enrolling in Cal State Northridge as an art major. In his sophomore year he switched his major to business while also deciding to tackle the "professional student" program.

"I went to college for *six* years!" he laughs. "My dad gave me a house in Encino to get *out* of his house. But I really didn't want to leave college because I didn't want a career. I mean, as soon as I left college, I knew I'd be on my own... that my dad wouldn't pay my bills any longer."

After graduating from Cal State Northridge, Powers worked as a stockbroker — but, as time wore on, he succumbed to the ever-present porn

*Whom Powers married in 1992.

bug: He began distributing adult videos in Florida in 1990 and, in turn, worked part-time as a porn producer. His first feature — *Speed Trap* (VCA Pictures), directed by porn stud Buck Adams — came out in January 1991. "So I started bouncing back and forth between different stockbroker jobs and shooting porn on the weekends… and I eventually got *fired* from a few companies when they found out I was shooting porno."

In the mid-nineties, Powers threw in the stockbroking towel altogether to team up with JM Productions as a full-time filth director. And the rest? Well, it's heinous-anus history. Feel free to check out Powers' wealth of vile vids at **www.jerkoffzone.com** and/or **www.legenddirect.com**.

I recently interviewed 'Lord Jim' at a sports bar called The California Broiler in Chatsworth, California (of the Van Nuys/ Canoga Park porn tri-cities). The 'bar' was jam-packed with screaming, fist-thumping, vein-in-the-neck-popping, baseball-cap-donning jocks, their bloodshot eyes glued to various televisions around the place all blasting some football game. Out on the patio, Powers was thoroughly enjoying himself as he held cooze court with his porn-star buddies **Mark Cummings**, **Devlin Weed**, **Tony Eveready**, **Cuba** and (the ubiquitous) **Dave Hardman**. All have starred in Powers' fucklines. And, as it turned out, all were pretty cool. Especially while shit-faced on mugs of *cerveza* and, consequently, giving me the inside scoop on the porno industry at large. My major focus, however, was on bungle-in-the-jungle Jim.

Ultimately, Powers is the Eric von Stroheim of porn. Nope — there are no ankle-high leather boots, riding crops, or megaphones here. But, like the megalomaniacal Stroheim, Powers is a no-nonsense director: Either he gets what he wants, or the cunts are out on the street. One could, nonetheless, see Powers as a deep humanitarian. Indeed, who *else* would hire bald, fat, old, and ugly women for fuck movies? Truly, Powers is the equal opportunity terror of porn.

THIS PAGE: JJ Michaels (right) and friend in *Perverted Stories 21*.

NEXT PAGE: Jade Marcella's foul-talking cake hole requires a good plugging in *Gutter Mouths 12*.

So how did you get interested in smut as a youngster?

Powers: Well, when I was a teenager, I never had girlfriends, so I used to sit around jacking off to porno mags. I wasn't a nerd… I was basically a stoner-punk rocker and all I did was skateboard and listen to punk music. In the 7th grade I even used to draw my own porno comics. I have a sister who used to get penetration magazines — in fact, they were the *only* penetration magazines I ever saw growing up. My sister would buy 'em… from *somewhere* (*laughs*)… and sometimes we'd even sit around and watch hardcore videos together. She just loved the stuff. Now and then me and my friends used to sneak upstairs and watch her bone her boyfriend. (*laughs*)

Who's the weirdest person you've ever worked with?

Dave [Hardman]! Definitely Dave. (*laughs*) You know, when I met Dave seven years ago, he thought the world was going to end in the year 2000, and he told me on New Year's Eve that he was going to take every conceivable drug because he figured the planet was doomed. And way back in 1995 Dave started stockpiling arms and ammunition and food.

Hardman: I sold it all off —

Powers: — because the world *didn't* end. But he was stockpiling all this crud. He even bought an RV and all sorts of furniture from garage sales because the spores in outer space were going to hit the Earth. See, Dave believed that when this particular comet came by the Earth, deadly spores were going to come off it and rapidly spread to all the major population centres on our planet because they'd be attracted to the heat. As a result, they'd attach themselves to human bodies, killing every single person, so that all you'd have left were mutants and people living in the high desert areas. Dave was cutting holes in his house so that he could run from room to room when the spores came to get him. The entire inside of his house, of course, was covered with black plas-

tic to shield the sunlight because of these spores, that way when the aliens started to attack our planet, Dave could quickly jump into his RV and make it to the high desert. All true.

Yeah, I'll take your word for it.

Hardman: When the cops raided my house one time, they asked me what all the holes were for.

Sounds like an updated Roger Corman sci-fi script — *Panic In The Year 00*. Maybe Spike Lee could shoot it as a follow-up to *Tales From The Hood*. So, Jim, tell us… what type of girls you like working with?

Powers: Oh, that's easy: Good-looking girls, with good attitudes, who guys like jerking-off to. I also like shooting people to whom porn is kind of new. But anybody who is a Vivid girl can go to hell. They're boring on the set. They want to give the minimum for the maximum dollar and wind up giving you bland, jaded sex. Hey, I don't care what I say about these people because it's not going to affect me getting any work. For the most

Photos this and previous page: courtesy JM Productions/Legend Video

part I get hired to abuse people. That's my job. Like Brooke Ashley? Most of the times I shot Brooke I hated her guts. (*laughs*) Yeah, I loved torturing her. She was bitching the whole time during that milk scene in *Perverted Stories 9*. She was cold, shivering, complaining, shouting "Fuck you!" at me… and that's how I like 'em. Besides, when they start complaining during anal sex, it

TOP-LEFT: Powers loved torturing Korean-born Brooke Ashley (aka Fantasia) during the 'milk' scene in *Perverted Stories 9*.

BELOW: Linda Blair, eat your heart out! Mila as possessed-whore in the 'Exorcist' vignette from *PS22*.

lasts longer. I especially liked it, though, when Brooke got more and more mad, and slapped me. I'd just tell her (*with mock sweetness*) "Honey, I'm only doing it for *yooo-oou.*" (*laughs*)

Any other Brooke stories?

Well, *Return of the Meatman* was great, too. Brooke was crying because she didn't like the blood, guts, and the smell of the raw meat we had on the set. See, even though we had a meat

freezer on the set, the freezer didn't really work. All Hollywood. (*laughs*) It *looked* cold because I changed the filter on the camera to a daylight setting when I was in tungsten and we pumped in smoke; so, again, it *looked* really cold. It was actually hot and sweaty in there. And this meat, the smell... I mean, I really *love* doing scenes where the conditions are miserable because they're more fun to shoot. There's more of a survival thing going on. The girls are ready to puke, you're fucking 'em in the ass, the shit starts to come out, they're about ready to cry... and in *Return of the Meatman* we ripped open the liver and blood was pouring all over Brooke. And when she was getting ready to puke, that's when it started getting really fun. Especially when she couldn't take it anymore. I used to love shooting Marilyn Starr, biggest cunt in the world. Hated her. I love it when they get to the point where they're ready to walk off the set, threatening to sue me. Like on *The Violation of Marilyn Starr* — Marilyn said, "Fuck you, Jim! I hate you!" and marched off the set. That's how it ended and we left it in there. We kept pouring beans on her and humiliating her because she's such a fucking bitch. The best thing is when these prima donna cunts like Dean Lauren are in a situation when they're not in control — and that's when you fuck 'em up.

It takes a real man to admit that he actually rented *Fatter, Balder, Uglier.*

(*Laughs*) Did you like it? I think the new one is much better. In this one I got a fatter fat girl, a cuter bald girl, and an uglier ugly girl. But, see (*smiles, points to Dave Hardman*) Dave over there actually *likes* fuckin' ugly women.

Hardman: The thing about fuckin' an ugly girl is that you can do a lot of things to them which you can't do to a pretty girl.

Powers: And they *appreciate* it, right Dave? See, when I was a teenager, the gorgeous girls for the most part were lame. But the pseudo ugly ones, those were the ones who would *fuck*. They wouldn't just lay there.

Hardman: I once fucked a liver in *Meat Man* while a girl was masturbating in front of me. Hell, I've even fucked a sixty-year-old woman.

Powers: You fucked a seventy-two-year-old woman, Dave!

Hardman: I tried to fuck her pussy but it was closed shut because she was so old.

Devlin Weed: Like a mummy!

(*laughs*)

Hardman: (*looking hurt*) So... I *had* to fuck her in the ass.

What are some things you hate about porn?

Powers: I hate management agencies. I mean, let's say a girl is going to get $800 total for a scene... well, the agency wants $300 of it, so the girl's only pocketing $500 — and she's a dead-ass fuck! Meanwhile, if I shoot a girl who's working with me *directly*, she's making $600. So not only is she making more money, but I usually get a better sex scene out of her, too.

Any other items on your 'things-I-hate-about-porn' list?

Any girl who says to me, "How much footage do you need?"... I hate you. The people who say, "Are we going to do softcore now?"... I hate you. I also hate the people who are weaned on 'fea-

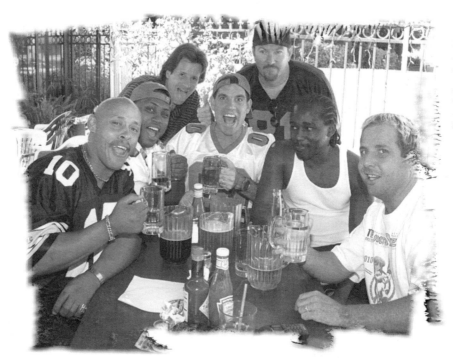

tures' because these are not porno people, these are people who are no different than IBM or McDonald's workers. "Let's make our five-scene, bland-sex porno video with four boy-girl scenes, one girl-girl scene, one of those scenes will be anal, all positions will consist of: starting with cunnilingus, blowjob, missionary, doggie, then pop"... I *hate* those people. They simply make paint-by-numbers movies.

What's one of the most disgusting scenes you've ever shot?

We did a bean scene one time with Brooke Ashley and on that one Dave did one of the most *disgusting* things I've ever seen: He opened his penis and shoved a bean down his spout.

Hardman: I wasn't even sure it was gonna come out. But Jack Hammer wanted to top that, so, while we were all fuckin' in the big mud pit full of beans, he grabbed a handful of the beans and ate 'em.

Powers: But that's *nothing* like shoving a bean up your penis, Dave.

Hardman: He ingested it, though.

Powers: Dave, they're *made* to be eaten. Nowhere on the can does it say, 'Stick in your penis.'

Hardman: But he was eating them after everything else was in there.

Powers: Well... he was hungry. (*laughs*)

Let's talk bukkake. American girls do 'em for the money and seem to enjoy the whole experience. That's great in a sense, but it also defeats the whole purpose behind bukkakes, which is total humiliation of the women involved.

Powers: You're right — in Japan it's more of a humiliation thing. In the old days, when they'd bukkake a woman for cheating on her husband, she'd usually commit hari kari afterwards. Nowadays, I do try to book the girls who really *want* the cum on them. Although, I admit, the best bukkakes are with girls who are shivering and don't like the cum. (*smirks*) Those are the fun ones. When they're up there on the stage and you tell 'em (*shouts*) "Shut up! *Shut* up and keep your mouth open!"... those are fun moments. (*laughs*)

Any bukkake girls who stand out in your memory?

Nadia Childs... there's a stuck-up little bitch. I think Nadia Childs is totally cute, absolutely gorgeous. I like her. But I like nothing more than watching her get fucked up the ass and crying... she deserves it. Nadia... she's a bitch. I owed her money for another shoot, but I wouldn't pay her until she got bukkakeed. (*laughs*) Nadia, like a lot of girls I've worked with, would book for a bukkake then try to back out of it. But when you

think about it, that type of movie is really the easiest thing these women can do.

Generally speaking, would you consider your videos dark, comical, what?

My stuff is not dark; it's really happy. You need to have a little happiness, no matter how bad things are.

Any favourite video lines?

It depends on what mood you're in. I love bukkakes. We do 'em three Wednesdays in a row, once every three months. We always shoot on the night that guys get off work 'cause I advertise to the people. We used to stick up fliers in Laundromats in East LA and things… put out ads in the local beat-off magazines…

Ads such as…?

"Men needed to work with female porn stars — $50." Right now everybody is copying *American Bukkake* — Metro, Video Team… I stole it from Japan, but we were the first ones to shoot it here. It'll be *passé* next year, anyway, and we'll be shooting something else.

What do you watch and/or read for inspiration?

Cartoons. I also buy lots of porno comic books, like *The Young Witches*, because you can do stuff in the comics which you can't really do in the movies: raping 'em, killing 'em, dismembering 'em.

Did the erstwhile law prohibiting pornographers from portraying women as underage girls cause you many problems?

Yeah, a little. Like when we shot the *Young and*

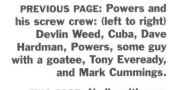

PREVIOUS PAGE: Powers and his screw crew: (left to right) Devlin Weed, Cuba, Dave Hardman, Powers, some guy with a goatee, Tony Eveready, and Mark Cummings.

THIS PAGE: Nadia with cum bong in *American Bukkake 9*.

Lord Jim and his Abusive Powers 71

**Teri Starr is a 10
...a White Trash
Whore 10, that is.**



Photo courtesy JM Productions/Legend Video

Anal series, it came out as *Assy* for a while, and that was because of the court ruling. What happened is the mainstream got upset because they felt the law defeated the whole purpose of acting. What becomes of movies like *Pretty Baby*, for instance? Are filmmakers going to be arrested for what Brooke Shields did in that film? I mean, she was actually underage while filming all the sex in that movie — which was *implied*, of course. So, for a while, we had to stop doing the pigtails, I wasn't allowed to do the stepdaddy and stepmommy stuff, or the rape videos. But when the law was overturned, we went right back into it full steam. Now JM Productions is having me do these *Gag Factor* lines; they're basically face rape, where we make the girls puke and everything. But porno is like that. I mean, when you see a traffic accident, you're going to slow down and look at it. And my entire history of creating porn is basically creating traffic accidents, anything to draw attention. *Fat, Bald, and Ugly* is obviously novelty porno. *American Bukkake* is nothing but excess. Stuff like all those 'record-breaking' gangbang movies, though... they're just a total fucking joke.

Who's one of the biggest pig-sluts you've ever shot?

Sonia Red was definitely one of the biggest

pigs. In one scene she shot green shit all over the place. Some of these girls get upset and are apologetic when they do stuff like that. What did Sonia do? — she tells Dave, 'That's your colour. You look good in green." We held her eyes open like they did to Alex in *A Clockwork Orange* and had the actors pop off into 'em. That was great. Lot's of fun. Jade Marcella, Mila, Candy Apples... all classic sluts. Briana Banks, too. And I love girls like Cat Langer who wanna do something different, like a triple penetration. I don't like the girls who say, "Oh no, an extra guy in this scene? I want more money." I *hate* those girls. Cat Langer is the type of girl who'd come on down here and just have fun fucking everybody. I mean, to keep it all from getting boring, there's gotta be some sort of spontaneity to it, some sort of chaos involved. I just don't like the safe material that a lot Cable stations push. The chaos just happens, it's never planned; it's a kind of magic.

Weed: Hey, man, lemme tell you somethin', if it wasn't for Jim, I'd probably be out robbing houses — *right now!*

Hardman: Porno keeps us off the streets and out of trouble. I would be dead or in rehab if it wasn't for Jim. (*laughs*)

Cuba: I'd be in the military, stationed abroad somewhere.

Powers: Just call me the Pied Piper of porn! (*laughs*)

Any projects which you're anxious to shoot?

Powers: I wrote this one movie called *Flesh Fest* — it's going to be the ultimate exploitation/horror/sex movie. Remember back in the sixties when they used to make movies with rape and killing yet still had hardcore sex? Then, of course, *Deep Throat* came out and really separated porn from art and you really couldn't mix the two. Anyhow, *Flesh Fest* will be the ultimate females-in-prison/cannibal/serial-killer movie. Gonna have all the hardcore sex and murder in it, and I'm gonna do different versions of it, too. (*Pulls out wallet, looks inside it, frowns*) Man, I came here with almost 300 bucks and I'm down to less than 100. But, you know, I really wish we had girls with no arms and no legs for these movies. We could steal 'em from hospitals, roll 'em into the studio, and toss 'em around in a gangbang like a hot potato or something. ∎

Art: Dogger

AN INTERVIEW
WITH
JERRY
SADOWITZ

by Will Youds

**Additional text by
David Kerekes**

Total Abuse!

Jerry Sadowitz is probably best known for his confrontational comedy and for the recent
Channel 5 TV talk show, *The People vs Jerry Sadowitz*. For the latter, members of the
audience tried to interest and entertain the host with a pet topic, wary that Sadowitz
didn't suffer fools — or boring topics, or funny-looking people — lightly. A bell would curtail any
'unworthy' subject, while a 'guest bouncer' — Mark E Smith, Judge Pickles, and celebrity gangster
Dave Courtney, amongst them — were on hand to assist dogged guests back to their seat.
A new Channel 5 series, *The Jerry Atrick Show*, has given Sadowitz a broader platform on which to
perform, with risqué comedy sketches, stand-up, and card tricks. The first series concluded with
an unusually humble host meeting one of his card magician heroes, an elderly Alex Elmsley, and
watching him perform one of his tricks.
In the eighties, Sadowitz wrote several books on card magic. Having opted for a life on the road as
a comic, magician and busker, he landed a two-year headlining stint at London's Comedy Store. In

ARE YOU A TRADITIONAL MAGICIAN?

Sadowitz

IN SOME WAYS EXTREMELY TRADITIONAL AND IN MANY WAYS EXTREMELY NOT. Some of the tricks are traditional, but some are hyper modern — tricks I have made up myself. In my act it's a sixty to forty ratio. Sixty per cent being classic tricks, which are very contemporary classic tricks; the old classic ones are still very contemporary. I think the ones that are best are the ones I worked out for myself. When you do a show like this you get all the magicians telling you that you should never do just card tricks because they are really boring and you are not gonna fool anyone. That is fucking absolute rubbish. It's like saying never go and see a pianist because they are boring, they have no violin solo. It's rubbish! I don't like elaborate magic, I hate that shit; it's the fault of elaborate magicians that magic is not as popular — in fact I fucking hate that kind of magic! I don't feel proud to be related to an art that has that side.

What do you think of the 'outrageous' magicians like Penn & Teller?
Penn & Teller I can't really say because I haven't seen enough. I know a problem why they don't appeal to me, however: it's because they are not quite comedians and not quite magicians. They are somewhere in the middle. They are not just magicians; they do some outrageous kind of tricks. They are not quiet comedians, although they are sort of funny, they just seem in the middle and I never feel the urge to want to watch them. I know they are very popular.

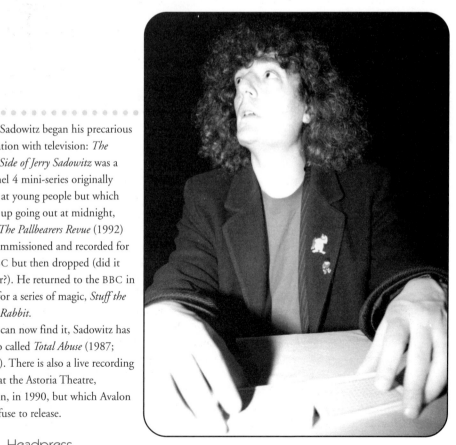

Photo: Marie-Luce Giordani

1987, Sadowitz began his precarious association with television: *The Other Side of Jerry Sadowitz* was a Channel 4 mini-series originally aimed at young people but which ended up going out at midnight, while *The Pallbearers Revue* (1992) was commissioned and recorded for the BBC but then dropped (did it ever air?). He returned to the BBC in 1997 for a series of magic, *Stuff the White Rabbit.*
If you can now find it, Sadowitz has a video called *Total Abuse* (1987; Virgin). There is also a live recording made at the Astoria Theatre, London, in 1990, but which Avalon still refuse to release.

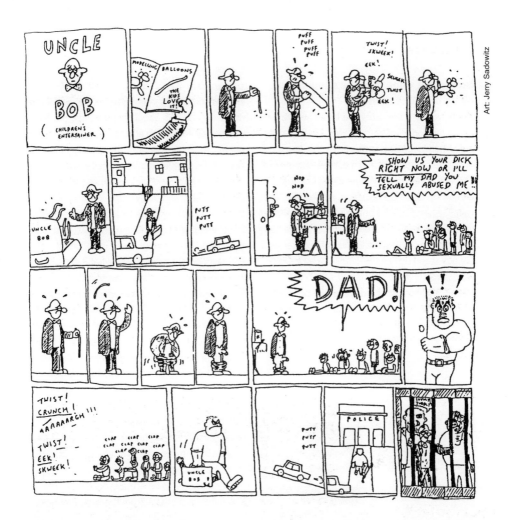

Have you ever met them?

I did once, when I was working in a magic shop a couple of years ago. One day in came Penn & Teller looking for a location for filming and asked could they do the shoot in the shop. So I asked the manager and he said yeah, all right. So I hung about whilst they filmed. I stood in the background trying to sneak into the frame.

What do you think of these magicians who reveal the secrets of the trade?

Let's begin at the beginning. All magicians are crap. They are probably the worst people in the fucking world, but they are also the most harmless people. They are not crap like politicians are crap or paedophiles are crap, in fact they are very harmless and are just fucking crap. Nobody is interested in them. They have nothing

to show. So the next thing you know they're thinking they should expose the tricks, maybe then it would be of interest to the public. What they don't do is get their act together. There are plenty of close-up magicians. It baffles me.

People have walked out of your shows due to the nature of the comedy. I believe you made one comment: "What is the best and worst thing about fucking a seven-year-old girl? Best: pretending she is three. Worst: Burying the body afterwards." Why do you think comedy upsets people so much?

I think that people like to be seen walking out. Like walking to the toilet in the middle of a show. But the thing is with people who walk out is they also come back. Why make such a show? I

really don't want anyone coming to see me who doesn't like it.

Do you not think they are genuinely being offended then?

I don't know really. I think a lot of people pick up on my anger more than what I'm really saying. When I was playing Montreal, this guy come on the stage and punched me, knocking me out. The line on that one was he didn't like my joke and so he came up on stage and hit me. Just calmly walked up and punched me. He seemed to just pick up on the anger volume. It also happened when I played the Edinburgh festival. This big guy stood up like this [*makes angry face*]. I was all ready for it this time. I said "What is it, mate?" But he just stood there like he wanted to punch my face in. Then his mates, one on each side, got hold of him and walked him out.

You can be quite scary yourself.

I can be quite scary in a small venue. I will have to start a cult thing or something. I really don't want these kinds of people there.

Did you have full creative freedom on
THE PEOPLE VS JERRY SADOWITZ?

I did have full freedom, but the production com-

pany didn't do their job. I had this idea of fifteen topics — I could remember them off the top of my head if you want; fifteen topics of conversation that I found interesting. The television company's job was to get the people to come on and talk about those things. So, they went away and put an advert in THE STAGE newspaper. The outcome was that ninety-nine per cent of the people who responded were speciality acts, freaks and various types. They were not 'ordinary', and began turning up in sitcoms. It just was not what the fucking show is about. In the end I was telling jokes because this fucking thing was not working. I was introducing comedy stuff, but it really was not what it was about. To be honest, I am really disappointed with the whole thing. The original idea was to be a roadshow, visiting different cities. The people would have certain categories of conversation to talk about. It was not a discussion or interview; the people were there solely to make a point. The topics I asked them to comment on were: What is your favourite book? Favourite music? Favourite film? Is there a God? If not why not? What is your philosophy on life? Any advice about relationships or sex problems? Any idea on how to improve anything, from buses to trams? I wanted everything that was to be said by these people to be actually dead interesting. If you only went away from the programme liking or learning just one thing, then you actually got something from TV bubblegum. I am now thirty-seven, and have finally managed a solid way of meeting women. It's no joke; it's not funny. Why didn't someone tell me fucking years ago? I know you're laughing, but I am deadly serious. Now if someone had come on the show and said, "Look, I worked out how to get a girl-friend," that would be important and what a fucking great programme it would have been. For Channel 5, it would have been the cheapest show in the world. Just get a group of people and a desk and a bell. The bouncer was there if you gave me hassle. I got all kinds of weirdoes. Remember the three guys who were monster hunters? Give them a big round of fucking applause. I'm not interested in that.

Did you know about the subjects your

guests were going to talk about before you met them?

No. I don't want to know anything. All I want to know is what they are saying to me is good, because it gets boring otherwise. It's no good just one person saying something interesting, I want everyone to. As long as they are interesting, that's all.

Would you like to do the show again?

Yeah, I would. But make it more like the original idea. I get a bit cross because I think that Channel 4 would be fairly suitable to what I have to offer, but they have this fucking policy against me. I wouldn't mind but I have never even met anyone from Channel 4. It's all very strange.

Do you find you have to tone down you act for television?

A live show and a television show are two different entities, and one has a certain greater influence than the other one. I think they are both very different mediums, but there are things you can do on the telly that you can't do live, like sketches. There are also things you can't do on camera because it's a different audience. I think that I combined both a live and TV show for the idea of THE PEOPLE VS... I thought that was the right idea for that medium. People got it. I wasn't thinking about anything but me particularly. I found myself going off my head at people because that wasn't the show, it wasn't the idea. I have learnt that if there are things you want to say, then say it on any media you can.

What are your views on drugs and alcohol?

I think that everybody by law should be made to write an essay on what they have learned from life. This information should then be passed on to everybody else. If you imagine that at a good age in life you are given this book to read, and in it is everything you need to know — all the good things and all the things you need to watch out for; all the things about puberty and stuff, important things you need up until you're twenty-one. Like that alcohol is a cunt, you make that mistake and no fucker tells you. Pensioners should be made useful and pass on information about life.

Do you have a good relationship with your audiences?

[*Sarcastically*] Yeah. I mean they are here today gone tomorrow. I don't trust them; they are all fucking fickle. Fickle fuckers!

You produce your own magazine, THE CRIMP. What's that about?

It's A4 size. All of it hand-written and illustrated by myself with some contributions. Full of card tricks and comic strips. I'll send you a copy to have a look at.

Do you read comics?

No, I only read pornography.

Thank you, Jerry Sadowitz. ▣

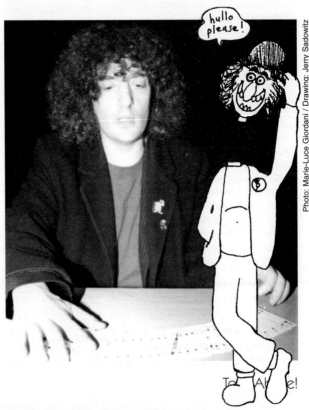

web.fun

by Verian Thomas

LET'S TALK ABOUT PORNOGRAPHY on the net for a moment.

Now I'm not the preaching sort — as far as I'm concerned people can do whatever they want so long as it doesn't impact on me. The thing is, every now and then things crop up that worry me and something needs to be said. What am I going on about? Well, the amount of hardcore pornography on the net doesn't bother me, it doesn't interest me particularly either, but what does concern me is the claim made by the people who run these sites that they are conscientious and only allowing access to people with passwords. This is all well and good and I would applaud it if it wasn't for the fact that you don't actually *need* a password to see their pictures. Almost every site includes a little taster on an introduction page. I did a little test: In Altavista (www.altavista.com) I entered a search for 'Free Sex', and clicked on the first link that came up (which happened to be http://www.sexmania2000.com/). Without any password or disclaimer, without any warning, I was immediately confronted by a picture of a woman giving a blowjob while being anally penetrated. Some might say 'Lucky you' — but what if it wasn't me, what if it was, say, an eight-year-old kid...!

Okay, now that's out of the way, let's have a look at what else is going on...

Are you the Anti-Christ? Now you can find out by visiting THE ANTICHRIST DETECTOR. The site has been designed in reaction to a theory that if you take the name Bill Gates and calculate the value of the letters using ASCII the numbers add up to 666. Sounds a bit techy but it isn't, the site allows you to enter your own (or somebody else's) name and quickly tells you whether you are 'The Beast' or not.

On the other side of the coin we have THE SECOND COMING PROJECT which is attempting to clone Jesus Christ in time for his predicted Second Coming using the same techniques that were used in Scotland to clone a sheep. Apparently they need a fertilized Jesus zygote no later than April of 2001 if Baby Jesus is to come to term on the predicted date. Here is their explanation of how they plan to do it: (A) Modern cloning technology enables us to clone any large mammal — including humans — using just a sin-

gle cell from an adult specimen. (B) Throughout the Christian world are churches that contain Holy Relics of Jesus' body: his blood, his hair, his foreskin. Unless every single one of these relics is a fake, this means that cells from Jesus' body still survive to this day. (C) We are already making preparations to obtain a portion of one of these relics, extract the DNA from one of its cells, and use it to clone Jesus.

Er, good luck.

Ever wondered what people think of your looks? In everyday life, to keep asking people 'Am I attractive?' is a sure way to lose friends and get yourself branded as a bit of a nutter. If you really want to know, however, AM I HOT OR NOT? may be the answer to all your problems. Post a picture of yourself here and thousands of people will vote on how attractive you are out of a scale of one to ten. It's incredibly addictive stuff, I just kept on rating and rating. Probably one of the best features of this site is that after you have voted you get to see the overall rating and the number of people who voted on a particular picture. I know it's shallow and beauty is only skin deep and all that but it's bloody good fun.

I sometimes find that I ask myself stupid questions. Occasionally I ask them of other people and receive one of those looks, you know the one, where you get looked at with a tilted head and a slightly worried expression. To avoid this I now use THE STRAIGHT DOPE who positively love being asked stupid questions. Here are a few from the current crop: What is the sound of one hand clapping? How many calories are in the average male ejaculation? If all one billion Chinese jumped at once, would the world be thrown out of its orbit?

The answers are surprisingly full and could even be right. There's also a searchable archive.

Finally we come to ON TAP, containing the quite brilliant 'Stinky Meat', which is what happened when a guy took three kinds of meat and left them in his unwitting neighbour's yard for nineteen days. He took photographs of the meat as it decomposed, and the story makes for a hilarious read. Of course, the neighbour eventually found the meat in his yard, but to not notice it for nineteen days!? The site also includes the first instalment of 'Stinky Feet' which deals with the life-shattering illness of athlete's foot and, coming soon, 'How to beat little kids at anything'.

Verian Thomas can be contacted at: downandout@hotmail.com

Ed: The WWW is a mutating glob and sites that are here today may be gone tomorrow. The ON TAP link mentioned above now directs you instead to something called THE SPARK, which contains a Jesus Cam and personality tests.

AM I HOT OR NOT? http://www.amihotornot.com/
THE ANTICHRIST DETECTOR http://www.sporkspace.org/antichrist/
ON TAP http://www.ontap.com/
THE SECOND COMING PROJECT http://www.clonejesus.com/
THE SPARK http://www.thespark.com/
THE STRAIGHT DOPE http://www.straightdope.com

the TEFLON JESUS syndrome

Contemporary Revivalism & the Story of a Campaign

by Marie Shrewsbury

Those who have read my previous article 'Evangelical Mind Control and the Abuse of Altered States' [*Headpress 19*] will already be acquainted with the methods of mass manipulation used by cult-like religious groups. For the benefit of those who have not, a brief introduction follows.

Trance has characteristically been used by many religions in different guises throughout history. For the remit of this article we are looking specifically at its use by fundamentalist Christian groups. Many of these — dubbed 'charismatic' or 'new age' — are engaged in using trance as a catchment and control tool and have no qualms about employing it in a dangerously manipulative fashion, frequently on vulnerable young people. Those thus ensnared are told that it is the power of the holy spirit, and through this and other well-established means of ameliorating critical thought can quickly lose touch with reality. Finding them-selves in the charismatic fantasy world, they believe forces of light and darkness are at work all around them.

This article documents my campaign to have the North Leeds Vineyard removed from local authority premises, primarily on the grounds of their use of precisely such methods of manipulation and indoctrination. They are a subsidiary of the US based multinational Association of Vineyard Churches (AVC), founded in 1984 by John Wimber and based upon his 'signs and wonders' ministry. This organisation grew rapidly: church planting in the UK began in 1987 with the St

Albans Vineyard, and many more have since been established. They currently have a strong presence in India and former Eastern Europe, where extremes of poverty, unemployment and human despair make for easy pickings.

Charismatic churches have many links with the orthodox Christian community via the network of 'Alpha' churches, which are of a charismatic persuasion irrespective of denomination. These support and finance the Alpha course, a dissemination tool for contemporary revivalism and its associated theology. Such links are often used where deniable conference bookings are required, or when venues are needed for the latest series of revival meetings.

To the uninitiated, it might be assumed that a religious group engaged in such practices and endorsing sexist and homophobic fundamentalist beliefs would not be allowed to meet on local authority premises, or would be swiftly removed as soon as their activities came to light. To understand why this is not the case, we must first look at the wider influence that the Judeo-Christian tradition has had upon our culture.

THE CHRISTIAN CONDITIONED CONSCIOUSNESS

FROM AN EARLY AGE, WE ARE BROUGHT UP TO EQUATE JESUS WITH GOODNESS, AND THAT being a Christian equates with being a good person. This message is hammered into us repeatedly by many sources, especially during our education. There is even a law stating that there should be one religious event every day at school. Children are taught about the Judeo-Christian God, Jesus and miracles, and obliged to sing joyous songs about His supposed achievements. Conversely, anyone who is seen to oppose this is quickly branded as wicked or blasphemous. In this way a framework of belief is established in our minds prior to the formation of our ability to think critically and to vet the credibility of the information we are given.

Additionally, this process of education is done in such a way that we will later come to associate it with many fond memories of our childhood. This has the effect of creating a general reluctance to accept that something that claims to be 'Christian' may not necessarily be good. If the Unification Church or Hare Krishna were engaged in strange practices at a local school they would no doubt quickly be removed. There is the innate assumption that because something claims to be Christian it cannot possibly be harmful, whereas in truth it is equally as dangerous as the comparable activities of any other religion. Thus we are working against a high level of resistance before we even come into contact with the manipulative methods of a specific group.

There is the further problem in that many of the established denominations originated from 'revivals' similar to that which the charismatic movement is presently experiencing, particularly the Pentecostals, Baptists and Methodists. This gives rise to a liberal attitude towards these methods of manipulation, even among those who do not practice them themselves, as they are unprepared to address the unpleasant reality of their own church history.

As a result of this widespread indoctrination, the charismatics themselves are only part of the present problem. The other component is the nominally Christian and the agnostic who will protect them with their ambivalent liberalism.

THE LOCAL AUTHORITY SAGA

THE CAMPAIGN BEGAN WITH MY MAKING A WRITTEN COMPLAINT TO THE HEADMASTER of Beckett Park Primary school in November 1997. This did not receive a reply.

I then rang the switchboard of Leeds City Council and was connected to the Advisory and Inspection Services, who upon having the situation explained to them, requested that I make my complaint to them in writing. I did so, providing some documentation about Vineyard and the Toronto Experience, and informing them that my letter to the headmaster had been ignored. They promptly wrote back to inform me that lettings were not the responsibility of Advisory and Inspection, and that 'In the first instance, it might be helpful for you to discuss your concerns with the Headteacher'.

After speaking to this office again, I was told to direct my complaint to the school's board of governors. This was done on January 16, 1998, and Mrs Jean Horsman, chair of this board, wrote telling me that the Local Education Authority had already made them aware of my complaint. Mrs Horsman informed me that the governors were launching an investigation, and that she had already spoken to the group's pastor who had invited them to observe a service. She said that she would contact me as soon as the investigation was complete. She didn't.

On June 7, I wrote to query their progress and was sent a copy of the board's report, which claimed to have witnessed nothing out of the ordinary, and that the governors were generally quite impressed. Mrs Horsman's accompanying letter, dated June 17, told a rather different story, expressing that while she and several others 'had individual reservations, some of them serious', there was insufficient evidence to discontinue the letting. She offered to meet with me to discuss my concerns about this group.

My acceptance of her offer by return of post was ignored. When I wrote again about a month later, enclosing some more information about Vineyard, her reply claimed that she had stood down as chair and that I should direct all further correspondence to Mr Clarke, the vice-chair, who would be acting as chair in her absence. When I wrote to him on July 29, expressing my concerns about the overall handling of this matter, his reply read:

'There is no evidence that the extremities of behaviour you have alluded to as occurring elsewhere in Vineyard groups have occurred at Beckett Park, and no complaint as such has been received from other persons. In the absence of such evidence the Governors remain satisfied that this group be allowed to continue their tenancy of the school premises, and regard the matter as now closed.'

There are perhaps a number of points here worthy of consideration. Had the governors carried out their observation anonymously then they would almost certainly have witnessed numerous 'revival phenomena', as these were a standard part of the charismatic service. Having being invited, Vineyard were arguably in a position to limit the scope of the observation. Further to this,

the report indicated that while two governors had gone to observe (David Clarke and Ms S Whitrod), one had left immediately after the initial 'worship' and the other had shadowed the playgroup. There was no-one observing the main group during the sermon, later worship or ministry period. This may have been by prior agreement or simply a contrivance in the reporting, either way it allowed the governors to report upon their investigation without having to 'lie' directly. The initial chorus singing would still have seen many people acting strangely, speaking in tongues or shaking uncontrollably. Perhaps this is what Mrs Horsman's serious concerns refer to.

My own enquiries revealed that David Clarke's local church is South Parade Baptist, who are a keen supporter of the Alpha course.

After this I tried referring the matter back to the Advisory and Inspection Services, only to be told that they could not act as the letting was outside of school hours, and that the Governing Body are not answerable to any authority. A Governors Unit exists within the council whose job it is to ensure that the body act lawfully. I spoke to an officer of this unit, who expressed that there was nothing that they could do.

A complaint was also made to the council's Equal Opportunities Unit about the pastor's homophobic attitudes. They informed me verbally that they could do nothing as it is not unlawful to discriminate on the grounds of sexual orientation.

Up to this point my 'evidence' about Vineyard consisted of a couple of chapters taken from textbooks describing the events taking place at the Toronto Airport Vineyard, where this current wave of 'revival phenomena' had begun. This allowed for considerable denial, such as claims that this had been written by opponents of the charismatic movement, or that it was an isolated case. John Wimber's earlier expulsion of Toronto Airport from the AVC was presumably for this motive. Communication with INFORM (Information Network Focus on Religious Movements) and the Cult Information Centre provided much more information, including some especially good articles documenting the occurrence of the Toronto experience in this country. One was Vineyard's board report, which laid down guidelines for the

administration of this procedure. The other was an account from *Renewal* magazine, in which a prominent figure in Vineyard spoke about the current 'revival'. She related how the 'holy spirit' had fell upon a number of five-year-old children during a talk she had done at a primary school in Croyden. This was the evidence that I needed, as it allowed absolutely no room for denial.

Copies of this were sent to Mr Clarke. He did not reply.

My next step was to write to Tom Murray, the Chair of the Education Committee for Leeds, detailing my complaint both about Vineyard and the governing body, and providing copies of the now conclusive evidence. His reply was rather bizarre, and read:

'The North Leeds Vineyard have had a letting at the school since 1997. An application has been received on a yearly basis by the Lettings Unit and approved by the school. The school have agreed a charge with the group for use of the premises and valid hire agreements have been issued by the Lettings Unit. The Lettings Unit would have no reason to cancel the agreement unless instructed by the school to do so.'

There was no mention whatsoever to any of the points that I had raised, neither did it acknowledge the documents that I had shown him.

Further to this, I wrote to the MP for Leeds North West, which covers the Beckett Park area, on January 18, 1999, sending him this evidence and copies of my correspondence file. He immediately passed this on to my MP, John Battle. Mr Battle's response was to write to the school governors with my complaint, even though he was well aware that they were part of the problem. Not surprisingly they wrote back to tell him that everything was in order. In his reply to me, he expressed that:

'The Governing body of Beckett Park Primary School have advised me that they feel they have taken adequate steps to ensure that the letting of the school to the North Leeds Vineyard is in order and do not intend to cancel the letting. I am at a loss therefore to see what else can be done.'

This in itself is odd, as the usual procedure is to copy the other party's reply, attach a brief note of their own and return this to the complainant. The fact that he had not done this suggested that the content of Mr Clarke's letter may be of a de-

famatory nature, perhaps branding me a crank. When I wrote requesting a copy of the governor's letter to him for reference purposes, he refused to release it on the grounds that 'it was individual correspondence and not from an organisation'.

Having been informed that Mr Battle is a practising Catholic, and might be mistakenly defending Vineyard on the basis of his Christian beliefs, I forwarded to him a document produced by the Christian Order concerning Catholic opposition to the Toronto experience and the Alpha course. I also further requested a copy of Mr Clarke's letter, enquiring as to why the letter of complaint that I had made as a private individual could be referred to Mr Clarke, but not vice versa. Mr Battle refused this in his letter of April 25, 1999, claiming that Mr Clarke had stood down as head of the governing body, and that he believed the letting to be a private matter between the governors and Vineyard. He also stressed that neither Beckett Park School or Vineyard were in fact in his constituency.

Some time later (on the advice of a work colleague who is a school governor), I wrote to Mr Battle and asked him to refer this matter to the Secretary of State in his capacity as head of the Department of Education and Employment. The Department's rather noncommittal reply stated that

'The Secretary of State is not at liberty to substitute his judgement for that of the Governing Body, even if a different decision would have been reached in the circumstances.'

I had presented the same material to the Lettings Unit on January 29. They similarly would not comment on any of it, and backed up Tom Murray in stating plainly that the letting would continue until such time as the governing body decided otherwise. I went to their office and discussed this with a member of the Lettings Unit, who said that they could only act precisely as directed by the governors, irrespective of whatever Vineyard did or whatever evidence I could present to them. When I gave her an extreme hypothetical example, I was told that even if a group were sacrificing children in the main hall (outside of school hours, naturally) they could not terminate the letting. I did however discover that the letting was due to expire on August 31, 1999, and

that the Lettings Unit cannot be forced to renew if they choose not to do so.

There was a major misjudgement that I had made here, in assuming that the Governing body would not tolerate Vineyard's conduct. I knew that they had had some difficulty in finding a venue that would be let to them, so it is probable that they had informed the Govenors about their practices prior to the letting commencing. From the content of Mrs Horsman's letters, it is evident that there is a significant Christian representation within the governing body. It is probable that only such a group would knowingly allow Vineyard to let in the first place.

Another landmark development was the obtaining of testimony from an expert witness to confirm that the Toronto experience could indeed be harmful. I had been writing to a number of contacts in the medical profession for some time, often being referred through several people before a particular lead went cold. The progress here was by chance, after a woman — who had had similar experiences to myself with Solihull Christian Fellowship — contacted me via the Christian Order. She had made contact with a member of CASH (Campaign Against Stage Hypnosis), who provided me with an excellent statement confirming that

'… so far as my own investigations are concerned, this bizarre form of the Christian ethos is dangerous, misleading and calculated to deceive the gullible'.

On the June 31, 1999, I presented the Lettings Unit with my case for their not renewing Vineyard's letting, including the evidence, expert testimony and a number of press cuttings indicating that the Toronto blessing could be harmful. Their reply of the June 22 read:

'Unfortunately, I must correct the information to which you refer regarding the decision not to renew a letting being entirely the decision of the lettings unit, I refer to Councillor T Murray's letter of 4 January 1999 and my colleague's letter of 29 January 1999, the lettings unit do not have the authority to not renew an agreement unless this unit is instructed by the school to do so.'

It is this sort of conduct that I find extremely frustrating, I had not only wasted my time preparing documents for perusal, but had released some new evidence — in this case the expert witness testimony, that I did not want Vineyard to be aware I possessed.

In utter frustration, on Friday, July 2, I went to Beckett Park Primary School to confront the Headmaster in person with the incriminating documents that I had. She did not invite me in, and spoke to me in the doorway while a male member of staff observed from a few feet behind. I identified myself and the issue, and asked her to take a look at my evidence. She did not directly refuse, but said that it was a matter for the school governors. Did she then have no say in what happened at her school? I asked. She told me that it was a joint matter, which had to be agreed upon between her and the governors. She flip-flopped between these two points several times; every time I tried to show her something she claimed it was the governors affair, and every time I insinuated that she was not in control, she claimed it was a joint matter. I must admit to never having seen a human being in such fear of a piece of paper!

When I did manage to show her the *Daily Express* article on the events at Toronto Airport Vineyard, complete with colour picture of dozens 'slain in the spirit', she just stood there and let me speak, making no effort to look at it or argue with me. After I had put it away, she said 'It's just some picture in some paper, they print all sorts of things'. I offered to hang around and show some of this material to the parents. Annoyingly, she pointed out that it was an 'inset day' and there were no children on the premises. I asked her if she would like me to come back when there were children there? She laughed and said that I could do that if I wanted.

She offered to discuss my visit with the school governors. I asked if she was going to do this anyway, and she said 'Yes, I will have to now'. Her offer then was clearly rhetorical. Eventually I announced that I had had enough of this farce, and left.

Shortly after this I visited the North Leeds Vineyard during their Sunday morning service. My plan was to arrive just in time for the ministry period and photograph their charismatic shenanigans. I arrived too early, and upon entering was challenged by a member of the group who insinuated that I had come because I needed Je-

sus. She also attempted to cause mental cruelty by gibbering at me 'in tongues'. I wandered around the hall and took a number of photographs. The service continued around me, and the guest speaker — who was unknown to me — continued to lecture. His anecdote concerned a man who prayed for God to get him out of a difficult business meeting, who arrived at work on Monday morning to find a note on his desk saying 'You're Fired'. The audience of about thirty adults pretended to ignore me whilst casting suspicious glances. Their pastor was sufficiently keen not to be caught on film that he ran from the hall with his hands over his face. I left after it became evident that there was no chance of my further achieving anything useful. One member threatened me, saying, 'I can't let you leave with that film'. I suggested that he try and stop me, before having to sprint across the school playground with five evangelists close behind.

While this visit did not achieve its intended goal, I found it personally empowering to stand up to the people who had previously tried to manipulate and abuse me.

The following Wednesday evening I received a visit from a police officer who informed me that a complaint had been made, though I had not actually broken the law. I asked to make a counter complaint about the threat. However he dismissed this as making the matter too complicated.

Four weeks later there was a letter from Craig & Co solicitors (reproduced below), making a variety of claims that I had behaved obnoxiously at the North Leeds Vineyard service. They repeatedly insinuated that I had behaved in a threatening manner — the threat of violence being one of the few grounds upon which a court will grant an injunction. On the advice of a friend with some lay knowledge of the libel laws, I issued a succinct reply denying that I had in any way broken the law, or that I had intended to do so. It took several weeks before I was able to get expert advice, which I obtained variously from Catalyst,

CRAIG & CO.
Solicitors

6 - 8 THE HEADROW
LEEDS LS1 6PT

Telephone: Leeds (0113) 244 4081

Fax No. (0113) 244 5850
DX 12053 Leeds

Our Ref. SC/LJH/Restrick

Your Ref.

Date 13 August 1999

Ms Marie Shrewsbury

Dear Madam

Our Client: Rev. Stephen Restrick and the Trustees of the North Leeds Vinyard

We have been instructed by our clients Stephen Restrick and the Trustees of the North Leeds Vinyard with a view to commencing legal proceedings against you.

On 11 July 1999 you unlawfully gave entry to Beckett Park Primary School, premises lawfully occupied by our clients, where you caused a disturbance and refused to leave when repeatedly requested to do so by the Trustees. Your behaviour caused alarm and consternation to the members of the Church and their children who were gathered in the premises for a worship service. You were abusive to Stephen Restrick and other members of the Church and you acted in a threatening manner towards some of them when refused entry back in to the main hall.

You have repeatedly made false defamatory allegations against Stephen Restrick and the members of the Church and the Trustees both in writing and verbally.

Your behaviour on 11 July 1999 was an unlawful trespass and harassment. If there is any further trespass on our clients premises or on premises used by them or any further harassment our clients will apply to the Court, without further notice, for an injunction restraining you from further trespass. They will apply to the Court for you to be ordered to pay the costs of such legal action and these are likely to be considerable. Any subsequent breach of the injunction would be a contempt of Court punishable by a fine or imprisonment or both.

Similarly if you persist in liabling and/or slandering our clients we are instructed to commence legal proceedings against you.

If such proceedings prove necessary a copy of this letter will be

Alan Craig, LL.B.* Melanie Craig, M.A. (Cantab.)* Patricia Gore, B.A.* Keith Lomax, B.Sc., Ph.D.* Philip Booth, B.A.*
Fatima Bhula, LL.B.

This firm is regulated by The Law Society in the conduct of investment business. * Denotes Partner

produced to the Court as evidence of your wilful refusal to desist from unlawful behaviour.

Yours faithfully

CRAIG & CO

Marie Shrewsbury

Craig & Co
6-8 The Headrow
Leeds
LS1 6PT

13 September 1999

Dear Sir/Madam

Your Client: Stephen Restrick and the Trustees of the North Leeds Vineyard

With reference to your letter of 13 August 1999, I have now assessed the situation more fully and am prepared to clarify the following points.

I do not believe that my behaviour on 11 July 1999 was in any way threatening or aggressive. I was subjected to unlawful restraint by several members of the North Leeds Vineyard and was also threatened with unlawful imprisonment by one member, a tall man equipped with a wooden stick, to quote 'I can't let you leave with that film'. This was duly reported to the police.

Upon entering the hall I was confronted by Pauline Wild who behaved in a bizarre and unusual manner. I have previously been threatened by Mrs Wild in front of witnesses at the Iceland Frozen Foods store on Kirkstall Road.

Further, approximately twelve weeks ago I was approached in the 'Bar Phono' night-club by a member of the NLV, Chris (married to Monika) who behaved aggressively towards me. I have since then been approached closely by members of the NLV in this location in a manner that I believe was intended to intimidate. This clearly constitutes harassment, and I would thus request that all members of the NLV refrain from approaching me in any way. If there is a repeat of the incident in which I was unlawfully restrained then I will inform the police immediately and bring charges of assault.

I have not made any claims about your clients that I know to be false. It would certainly be illuminating to know what I have claimed that has so offended your clients, and how it can be demonstrated to have injured them.

A libel action would invariably bring to public attention not only an accurate and truthful account of my experiences with the NLV, but also a substantial body of information that will cause extreme embarrassment to both your clients and a number of respected figures in the local authority

Producing a copy of your letter of 17 August 1999 in court could very interesting, as it contains demonstrably false testimony. I refer specifically to the claim that my behaviour caused 'alarm and consternation to members of the church and their children'. I have photographic evidence to show that there were no minors in the hall at the time that I was present, or indeed in the immediate vicinity. This claim is pernicious and I believe intended to illicit a knee jerk reaction in anyone reading the letter by suggesting that I had caused distress to children. I am sure that the court could draw its own conclusions what this says about Mr Restricks character, methods and motivations.

Yours sincerely

M. Shrewsbury

Marie Shrewsbury

who have considerable experience of case law regarding cults and religious groups, and from a civil liberties organisation. Both agreed on two things. One, that it was 99.99 per cent probable that the threat of libel was a bluff. The other was that a stronger denial needed to be made. (A copy of my letter to Craig & Co is also reproduced.) I specifically requested clarification as to what Mr Restrick considered to be libellous, as this would allow me to see if he actually had a case against me, or was simply making hollow threats. (A prerequisite of libel is that the plaintiff must be able to establish that an injury has taken place, hence my making clear in my wording that I was aware of that fact.)

After four weeks there was still no reply. I chased up the matter with Craig & Co, with a further request for clarification. The text of my final piece of official correspondence read:

'With reference to my letter of 13 September 1999, in which I requested clarification of what I am alleged to have claimed that your client considers to be defamatory, I have as yet received no reply as such and am thus renewing this request.

'I would be pleased if you could verify whether you are still acting on behalf of your client. In the absence of a reply within the next 14 days I shall presume that this matter is now closed and that the earlier threats of libel/slander action were of a purely rhetorical nature.'

Predictably enough, no reply was forthcoming.

It was shortly after this that I decided to conclude the campaign at the end of 1999, almost two years to the day from its inception. I felt that there was little more that could legitimately be done, and was concerned that this was taking up time that could be more rewardingly channelled into other areas of my life. As a final gesture, I gathered together the most incriminating documents that I had about Vineyard, the Alpha course and the Toronto experience, scaled them down to a smaller format and linked them together in a twelve-page booklet. On November 27, 1999, copies of the booklet were disseminated to houses in the locality of Beckett Park Primary School.

As the locals are now in full possession of the facts, they can make an informed choice for themselves as to whether or not they want Vineyard meeting at their school. One would expect that this information would cause the school governors extreme embarrassment.

THE ONLY AREA IN WHICH I ACHIEVED AN UNEQUIVOCAL SUCCESS WAS IN RETRIEVING a sum of money from the North Leeds Vineyard which I had foolishly 'tithed' during my involvement with them. A demand was sent to Pastor Stephen Restrick on November 18, 1997, which was ignored, as was the reminder of December 3, 1997. There was then a delay of twelve months, during which I was gathering sufficient evidence should Mr Restrick attempt to defend his case in court. My final demand of December 1, 1998, was again ignored.

On December 16, 1998, a summons was served on Mr Restrick by Leeds County Court. The cheque came by return of post, the accompanying letter, dated 17 December, read:

'We the trustees of The North Leeds Vineyard Church are in agreement to return the free will offerings donated to the church as detailed in your letter 1ˢᵗ December 1998.

'We do so on the basis of goodwill and on the understanding and statement that we the trustees of The North Leeds Vineyard do nor admit or agree to any of your claim in full or part.'

I responded to this with a brief acknowledgement, informing Mr Restrick that his claim that this was on the basis of goodwill might be more convincing had it not taken three letters and a summons to extract.

SOCIAL SERVICES

IT WAS NOT ONLY WITHIN THE EDUCATION AUTHORITY THAT SUCH RESISTANCE WAS MET. A complaint was made to Social Services area office at Buckingham House, Leeds, on April 8, 1998, expressing concerns about the dependants of those involved. This is not as unlikely an avenue as it might at first seem: members of the Icthus fellowship (aka Word of Life) have had

adoptions discontinued for engaging in this kind of indoctrination, though natural offspring have never been removed.

Like much of my other correspondence, this letter got no reply. A second letter was sent to Social Services on May 15. Again there was no reply. Some time after this I rang the office and spoke to the duty officer of that occasion, explaining to her at length the situation with Vineyard, including their use of mass manipulation, and mentioning my earlier letters to them. She went to discuss the matter with her colleagues, and returned to inform me that, 'They can practice whatever religion they like.' When I told her that that was not the point, she then said, 'Well, what is the point?' Cue explanation again. She also said that there was no record of my original letter being received.

I duly sent Social Services a copy of the original letter, along with some information, and did receive an acknowledgement with the assurance that they would make 'discrete enquiries'. Further information was sent to them as I had it, though this continued to go unacknowledged.

INTERCOURSE WITH THE MEDIA

A NUMBER OF ATTEMPTS WERE MADE TO EXPOSE THIS GROUP VIA THE MEDIA. INITIALLY I tried making anonymous tip-offs to the *Yorkshire Evening Post*, which I can only presume were not followed-up.

Next stop was *The Big Issue*, who are usually good for covering controversial social issues. I wrote to them to see if they would be interested in an article documenting my experiences with Vineyard. The reply from their features editor claimed that she just happened to be researching the subject of cults and would like to speak to me. We had a bit of a chat. I described what had happened to me, and she expressed an interest in some of the information and book references that I had. I sent a number of photocopies through to her. Upon ringing to discuss them, I was repeatedly told that she was busy, and finally that 'She will ring you when she wants to speak to you'. She never did.

A particularly lucky break came by chance. After reading an article in the *Independent on Sunday* — 'Meet Tracey, the first nightclub chaplain in Britain' — I wrote to the newspaper and had a letter printed with regard to the dangers of nightclub recruitment. This led to my receiving a letter from a reporter at *Company* magazine, who was enthusiastic about doing a story. She agreed that we could use it to expose Vineyard, and I gave a lengthy interview which provided the basis for her article. At the last minute however, she was warned by *Company*'s solicitors not to name them due to fear of litigation. The article did run, but Vineyard got to remain anonymous. This was still something of a triumph, as we got to warn young people nationally about the dangers of charismatic Christianity, the Toronto experience and night-club recruitment.

I had several offers of radio interviews as a result of the article in *Company*, with Radio Leeds and Radio Wales. The latter was the most in-depth and allowed me to name Vineyard. The most striking thing to come out of this high profile awareness-raising was the frequent disclaimer that such activities were not practised by 'mainstream charismatic churches' and were simply the domain of cult-like fringe groups.

When I rang our local free paper, the *Leeds Weekly News*, they expressed an interest and so I sent them some information. On ringing back I was told that they had received my papers but that the person I wanted to speak to was on holiday. I spoke to her upon her return two weeks later, only to be told that my letter to them had not been received. When I pointed out to her that her colleague had already confirmed receipt of these documents, she said that I must have spoken to 'someone who works here sometimes who just said that because he couldn't be bothered looking'. She was referring to the person who had answered the phone on every occasion.

Contact with the University run Leeds Student newspaper looked optimistic for a while. After sending some information through to them, I received a call from an enthusiastic young reporter who wanted to run the story that week. We arranged to meet the next day, by which time his interest seemed to have waned somewhat. I told him about my experiences with the group,

but he was concerned about possible litigation and wanted to speak to others who had had similar experiences. I do know of about a half dozen people who have left Vineyard — two are silent from utter embarrassment and the other two married couples are still practising a form of charismatic Christianity, so there was no chance of them speaking to him. He kept saying that he didn't understand why none of them would be prepared to talk to him. I did suggest that he went along to one of their services and take a look for himself to verify my claims. If he did, nothing ever came of it.

Finally, I rang the *Yorkshire Evening Post* and spoke to a reporter. He similarly expressed some interest and said that he would contact me again the following week. In the meantime, I sent some of my evidence to him.

When I called he claimed to have rang 'all of the council departments' and they had told him that there was 'no evidence of [Vineyard's] cult status'. I referred to the documents that I had sent to him. 'Yes,' he said, 'but from my/the *Yorkshire Evening Post*'s/the council's point of view…', and proceeded through a variety of perspectives, none of which actually involved looking at the evidence. This conversation was perhaps the most farcical and frustrating example of denial yet, with my continually pointing out that he had the required evidence in front of him, and he digressing with ever more creative 'Yes, buts'. Finally he could sustain the argument no longer, and stated that 'I'm not going to argue with you, at the end of the day we are not running this story.'

Taking his opening statement at face value, it is perhaps perverse that the same council offices that have refused to comment on the information sent to them, and deny responsibility, are now prepared to testify that there is 'no evidence of cult status'.

CONCLUSION

ANY FORM OF CAMPAIGN WORK IS BY DEFINITION ARDUOUS AND PROTRACTED. THE progress of this one in particular stands as a disturbing indictment of unmandated power — an example of how a minority with arguably bizarre beliefs in supernatural entities and special powers can establish themselves in positions of authority, and from there can influence those offices involved in the running of a city.

Most of my complaints were reported back to the school governors and thus, in all probability, also to Vineyard. I have little doubt that each rejection was masticated upon as a victory for Christ. This kind of resistance is relatively easy to maintain, given that the governors appear to be accountable to no-one.

To those who might like to believe that this resistance is the result of God-Power, I offer the following proposal: If it is your God-Power that persuades those in positions of responsibility to behave ignorantly, to apparently lie and break their promises, and which silences the media with the fear of financial might, precisely what manner of entity do you presume to have sworn allegiance to?

Whilst failing in its primary objective, this campaign resulted in some effective awareness-raising both in the locality of this particular cell and nationally. Ultimately, this article is a depressing testimony documenting those who would appear to abuse their power, their collaborators and the unwittingly compliant. ▣

the smell of MAGGOTS

Every curve of her body was a come-on.
But the big problem I had
to face was simply
whether she could
be trusted!

in the
ALLEY

HORROR SEX TALES
vol 1 no 1
1972 / 66 pages
Gallery Press
5583 W. Pico Blvd.
Los Angeles
CA 90019, USA

by TOM BRINKMANN

A s you open this magazine... you are entering a world of horror! The editors suggest that you keep the bright lights on as you begin to turn the pages. As you read the text... you will almost be sure that you hear the chilling screams... the creaking doors... the wailing wind... and the other horrible sounds conjured up by the story and your imagination. You will read wild and sensuous tales of lust and perversion... of horror and the occult. Madness or realism... believe it or not... you will find this publication unlike any other you have seen or read. Turn the pages carefully... for you know not what lies ahead on the next page... for you are now entering the world of Horror Sex Tales... BEWARE!!!

O NLY CRISWELL could put a voice to this intro on the inside front cover of *Horror Sex Tales* — a bizarre magazine, quite unlike any other.

Most of those familiar with the legacy of Ed Wood Jr are, more often than not, acquainted with his directorial and acting efforts. But when not directing, acting, hustling for money to film in Hollywood's shadow or heavily drinking (or maybe while drinking), he also wrote many adult paperbacks and short stories for adult magazines. These are all long out of print (several paperbacks have recently been reprinted by AK Press and Four Walls Eight Windows)

gore, twisted sex, the occult and horror — subjects that he fancied himself knowledgeable in. The illustrations alone are worth the price of admission, being pen-and-ink drawings, paintings, photo collages and plain, posed shots of naked women with hastily pencilled-in panties and sometimes blood. In other words, *Horror Sex Tales* has all the earmarks of adult and crime periodicals of the time.

SLOWLY TURNING the pages we come to the first tale, **GORE IN THE ALLEY**. This opens with a pencil drawing of an alley, accompanied by a photo of a near-naked woman in panties only. She lies in an almost foetal position, with bruises painted on, next to a garbage can. A pull quote next to the picture reads:

She was bruised, cut, and her box felt as if a steamroller had entered it and left it flat and raw.

and expensive, hard to find items. I found one such item, however — *Horror Sex Tales* Vol 1 No 1, published in 1972 by Gallery Press. It was one of four "Sex Tales" titles Gallery released — the others being *Legendary Sex Tales*, *Monster Sex Tales* and *Weird Sex Tales*, some of which contain other Ed Wood contributions (Ed also penned stories for Pendulum and Calga Publications). Gallery Press generally produced mail order/adult shop girlie mags, which incorporated photo layouts and a couple of stories in each. *Horror Sex Tales* is an amazing example of the peripheral publishing of the time, and actually slightly ahead of it's time with regard to its dark sexual content (which only really seems to have become popular in the past decade or so). Ed wrote at least seven out of the ten articles/stories in this magazine. It was his gig, a special blend of

This is a little tale of a street-walking prostitute (wearing a pink angora sweater), the alleys she haunts and the revenge she metes on one of the shadow-crawlers she encounters. She remembers a time when she had been attacked and raped in an alley, after having been dumped half-naked there by another trick. Now she has taken to wearing a blade on her inside thigh, which comes in handy during an attack by a penis-wielding "maggot" who comes away from the ordeal holding his severed worm in his hand and his throat cut from ear-to-ear. Alleys play an important part in Wood-literature.

Next up is **SCREAM YOUR BLOODY HEAD OFF**, a tale illustrated by the strangest assortment of images in the magazine. Starting with a pen-and-ink drawing that covers the first two pages of the story, the text goes on to describe how

She had flown across the kitchen floor at him screaming her bloody head off... screaming like a wounded eagle. She was screaming as if all the devils of hell... the creatures from the grave had entered her very being. It was not even her own voice.

Continuing with:

...that gleaming butcher knife, raised so high above her head and it was coming in his direction... the high-pitched scream... the gaping mouth... the saliva dripping tongue and lips... bloodshot red eyes which suddenly seemed to have no eyelids... never blinking... and that black negligee trailing out behind her like sheer bat wings on a heavy breeze.

It seems Johnnie, Stella's husband, is a stud to all the neighbourhood women, including the next door neighbour, Barbara. Stella herself happens to be Barbara's lover, and having seen Johnnie enter Barbara's house only to emerge hours later, she is beside herself with rage and hate. That's when she starts sharpening the butcher knife. She would send him to hell — but without the organ between his legs! Johnnie turns the tide on her, however, gathering all his animal strength, grabbing her wrist, and plunging the blade through her left breast and into her heart. After contemplating the corpse on the floor, he plans to dump the body — suddenly remembering that it's winter, with a blizzard raging outside, and that the lake and ground will be frozen. Oh, what to do? He opts for the electric saw in the garage and proceeds to cut Stella's body into pieces "three or four inches in depth and width," pushing the pieces down the garbage disposal unit in the kitchen. However, going down the steps into the garage to clean things up, the scalp that he had inadvertently dropped while lugging Stella's pieces to the kitchen proves to be his downfall — literally. He slips, tumbles down the stairs and bashes his head on the concrete floor. His body is later found with his wife's bloody scalp stuck to his foot!

In **BUMS RUSH TERROR**, by Ann Gora, we have a hate-filled homeless wino who preys on other bums for loose change and vino, but who then rapes and murders a pretty social worker. After his first kill he reads about an "old hag" who is discovered dead in a flop house with $100,000 cash pinned to her longjohns! This sets the rusty wheels of his mind turning, and he comes to the conclusion that there may be other bums walking around with money hidden on their person. The murder of "street bums" increases as he chases the elusive bum with a cash stash. Finally while lurking in an alley for his next victim, he sees a figure approaching, dragging a deformed foot and carrying a half gallon wine jug. Bingo! He figures he can suck on this jug for the rest of the day. Wrong! Mid-swing, about to clout the bum in the head, he gets a clear view of the face —

The homicidal bum drops dead from shock before landing a single blow, and as the rotting figure moves slowly past, a fifty dollar bill drifts down from his trouser leg and lands nearby.

The next Ed Wood piece in *Horror Sex Tales* is **HELLFIRE**, with a great two-page illustration of the Devil's face with flames rising in the background, while in the foreground is a young woman lying prone, dressed in a plain white diaphanous gown. The Devil's head is hand-rendered while the woman is once again a photo; both are printed in red and black ink. The pull quote reads:

But there was little which you could call a face. The disease, if it was a disease, had torn most of it down to the bone, and the puss and sores which hung there were being eaten by the flies. The scabs oozed, the white flow mixed with the continued flow of rotten blood.

WHO KNOWS WHAT EVIL LURKS
UPON THE DARKENED STREETS?
ONLY THE DEVIL KNOWS . . . AND INTO
EACH SOUL HE BREATHES.

Who knows what evil lurks upon the darkened streets? Only the Devil knows...

HELLFIRE is not so much a story as a series of vignettes, with the Devil seducing and having sex with a string of human slaves. In this case he calls himself Lived (the story ends on the revelation that "Lived" is "Devil" spelt backwards!). Lived, who smells like maggots and the grave, finds hookers in alleys wearing angora sweaters. His last encounter is with a male hustler, who he brings into an alley only to then be surrounded by a gang of the hustler's friends swinging chains and such. You don't mess with the Devil even if his name is Lived, and they all end up in Hell in "the blink of an eye."

Dick Trent makes his debut in this magazine with a tale called **THE WITCHES OF AMAU RA**. Karen is a witch and belongs to a "conclave" of the Prince of Darkness. She's not happy with her lowly status, and aspires to be the "witch princess". The up-coming black mass on October 31 would seem her best opportunity to

gain this exalted status, a position which would place her next to the all high Amau Ra. Karen sets out to seduce Toni, the woman who is currently on the list for Amau Ra's "favours." We read:

> ### Karen's hand already drifted to that region and probed and petted and slipped across *the little man in the boat*...

(Ed's emphasis.) Right at the moment of Toni's climax, Karen shoves her tongue down Toni's throat and puts an airtight lip-lock on her, while simultaneously pinching her nostrils together and cutting off her air supply! Toni expires after five minutes of this. The High Priests of Amau Ra enter to find the dead girl. Karen's explanation is that she just died while talking to her! The priests note that Amau Ra will be dis-

Karen suffocates
Toni in THE WITCHES
OF AMAU RA. Plus,
the impressive
double-page spread
of HELLFIRE.

pleased without Toni and might take out his frustration on the rest of the conclave — until that is, Karen chimes in with "Would I not do? Am I not more beautiful?" Karen explains how well schooled she is in the bed chamber, and how willing she is to please Amau Ra. The priests duly note her eagerness and grant her wish, but not before deciding that "Fellatio is the first step in taking the venom". Karen obliges them orally.

This task complete, Karen is taken to the cave of Amau Ra, a dark, dank cavern, with none of the finery of a throne room. A hissing sound draws her to the huge boa constrictor nestled in the wet straw and mildewed rocks. She caresses its head lovingly, then lays back and spreads her legs wide to accept the length of Amau Ra. His forked tongue flicks at her clitoris. But ecstasy

victim is left with a broom handle in her vagina, as in the Boston Strangler case). But Ed is in way too deep here: Poe's original is such a masterpiece it only makes this goresexploitation version look dire and ridiculous in comparison. The comedic use of photos doesn't help — somebody dressed in a gorilla costume, with two women wearing only the ubiquitous painted-on panties.

Reading the short stories in *Horror Sex Tales*, I noticed recurring themes and a repeated use of certain words throughout. Ed seems to be fascinated by alleys in warehouse districts on the edge of town, and what he imagines goes on there after dark, i.e. rape, murder and sex for sale (courtesy of hookers in angora, naturally). The "smell of maggots" figures in many of the stories. From GORE IN THE ALLEY, for instance —

She didn't pass out from the violence... but the maggot smelling breath brought on the delights of unconsciousness from which she didn't recover until the first signs of dawn crept over the eastern end of the alley.
...the hot breath grew nearer.... and there was the smell of cheap wine as all the others had produced. All the others who lurked in alleyways and in those dark corners of the warehouse districts. Maggots... always maggots.

In SCREAM YOUR BLOODY HEAD OFF we have, suddenly,

the smell of maggots... of the grave and of cemeteries and of ancient mausoleums.

HELLFIRE:

Nor did she mind the dank smell of earth, and the nostril-filled stench of maggots and other grave creatures... she had laid with men of many smells...

turns to pain as the snake's head penetrates Karen — and continuous to do so, coiling up inside her womb until she dies. Amau Ra's hunger is satiated.

The second Dick Trent offering is THE RUE MORGUE REVISITED — a retelling of the Poe classic with the Ed Wood sexual spin, and detailed descriptions of the mutilations of two women by a razor-wielding orang-utan (one

All in all, *Horror Sex Tales* is a fascinating insight into the mind of ellipsis happy Ed Wood, Jr, as it is the publishing efforts of a small girlie mag house in the early seventies. This debut issue, I'm sure, turned out to be the only issue, although the promise of a second *Horror Sex Tales* is offered on the back cover (dripping with blood).

See you next time! ▤

an interview
all shook up
with
greil marcus

by Michael Carlson

g REIL MARCUS' **MYSTERY TRAIN**
IS A LANDMARK OF ROCK CRITICISM —
a look at American myth seen through the magic lens of rock and roll, from Robert Johnson through Elvis to The Band. Its publication turned Marcus, at age thirty, into an instant *éminence grise* to an entire generation. There had been writers, like Ralph J Gleason, who had discussed rock music in terms of the wider world, but no one had attempted so wide a sweep, nor accomplished it so gracefully. With one book, Marcus changed rock writing forever, becoming, in effect, the music's creative conscience.

Behind Bertold Brecht spectacles, Marcus resembles a cultural commissar. He's never considered himself a rock critic. "I ignore the industry, don't go to the parties," he says. His essays now appear in such rocking outlets as ARTFORUM, SUDDEUTSCHE ZEITUNG and SALON. But you can still see the excitement behind his eyes each time an idea clicks into place. A sense of risk-taking danger gives MYSTERY TRAIN its edge. It's criticism as creative art.

Marcus was in London to promote the twenty-fifth anniversary edition of the book ("presented finally the way I always envisioned it") alongside simultaneous publication of DOUBLE TROUBLE, a collection of essays dealing with a very different American myth.

DOUBLE TROUBLE is subtitled "Bill Clinton and Elvis Presley in a Land of No Alternatives". When we meet at his London hotel, Marcus is worried about the alternatives to Bill Clinton. He's living temporarily in New York while he teaches at Princeton University, and although he's registered to vote there, his wife isn't.

"We registered on the subway. New York sends people to wander the cars, signing up voters; they pay them a commission," he says. "But only my registration went through. So if an absentee ballot hasn't arrived by the time we get back, Jenny's going to fly home to San Francisco, just to vote."

Marcus was born in Palo Alto, outside San Francisco, and educated at Berkeley. His lifelong addiction to rock began with a different sort of poll.

"I was eleven-years-old, my favourite song was All Shook Up. Chuck Berry's School Days was everyone else's favourite, and threatening to knock All Shook Up out of number one in the local charts. So I went and bought the record, in an unsuccessful attempt to keep Chuck Berry from number one."

He became a "self-conscious" fan in the sum-

mer of '64.

"I was interning in Washington, and I'd brought the Beatles' album with Money on it with me. One of my flatmates said 'what's the big deal?' and I said, 'just listen to the instrumental break, the way you hear the whole machinery of industrial society grinding the man down, and he refuses to go under.' A light bulb went 'click' in my head. I knew it was all bullshit, but I also believed it."

When ROLLING STONE magazine appeared,

might work if I could combine the instinctive reaction of a fan with the bigger ideas that attracted me. I felt that the whole of America was somehow captured in songs like Mystery Train, Robert Johnson's Stones In My Passway, The Band's Cripple Creek, Sly Stone's Thank You For Talkin To Me Africa, Randy Newman's Sail Away. If you're presuming that, the theoretical ideas wouldn't work without the visceral reaction.

"But that book was really motivated by Watergate, by the idea that the country was up

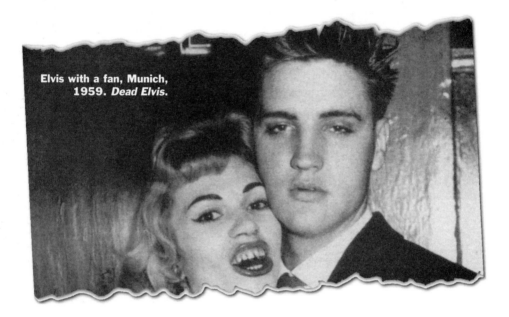

Elvis with a fan, Munich, 1959. *Dead Elvis*.

Marcus submitted a review to editor Jann Wenner, a college buddy. "A week or so later it was printed and I got a cheque for $12. That was it. I'd spent all my time studying at Berkeley, undergrad and grad school, and my professors seemed to have stopped trying to inspire students, and instead were training them for jobs. It was time to leave."

Marcus eventually became ROLLING STONE's book critic, and in MYSTERY TRAIN he brought the devices of literary criticism to bear on rock music. The particular influence of Leslie Fiedler, author of LOVE AND DEATH IN THE AMERICAN NOVEL, is obvious in the way Marcus uses his personal sensibility to interpret wider issues of myth.

"That sums it up pretty well. I thought a book

for grabs, being fought over daily. It was tremendously thrilling, but also scary, the sense of a battle taken away before it was finished."

MYSTERY TRAIN was published in 1975, by which time many of the artists profiled had already slipped from the creative peaks Marcus chronicled. Soon Bob Dylan would retreat into Born Again Christianity, Sly Stone would begin his odyssey through jail and rehab, Elvis would be beyond comebacks. Almost immediately after MYSTERY TRAIN appeared, The Band would play their Last Waltz.

Coincidentally, on this trip to London, Marcus read an article in MOJO chronicling the bitterness among the Band's surviving members over song-writing credits. In INVISIBLE EMPIRE, his

study of The Band and Dylan's 'Basement Tapes', Marcus wrote that he still found himself framing questions for Richard Manuel, who hanged himself in 1986, knowing Manuel could not answer them.

Marcus won't go into some of the aspects of the MOJO article, but remembers when Manuel once told him he hadn't been able to finish a song in two years. "Why not?" asked Marcus. "I haven't been able to finish a song in two years," said Manuel.

"I was most interesting in seeing Rick [Danko] say he got a $200,000 cheque for his share of Wheels On Fire. This was twenty-five years ago. There are various stories out there about what went on with song writing credits. For example, there's one that Garth wrote the early version of Daniel And The Sacred Harp, but I won't say any more about that."

As America turned to mellow rock and disco in the late-seventies, Marcus embraced punk, which led to LIPSTICK TRACES, a study of punk and dada which attempts to deconstruct the entire twentieth-century. The book left many Marcus fans cold, perhaps because it was more intellectual?

"It didn't feel different to me, but it is more intellectual in the sense that I started with a question I wanted to answer, 'Why is Anarchy In The UK so powerful?' which is a different approach than MYSTERY TRAIN, where I started with an instinctive understanding. But I found the lack of understanding no less thrilling. LIPSTICK TRACES was very much a Reagan book; in the same sense MYSTERY TRAIN sprang from Watergate. It was written at a time when I literally couldn't bear to think about America. So intellectually, I left for Europe.

"It was a burning desire to get to the heart of something I knew I wasn't going to get to the heart of. I do think I got close to figuring out what made dada a thorn in the side of the twentieth-century. After I'd finished my research and before I wrote the book, I actually wrote a play combining all its characters in a night-club. I spent a month writing footnotes to the play, but it never got into the book itself.

"Recently a theatre company in Austin, Texas, adapted LIPSTICK TRACES as a play. My only in-volvement was to see the finished product, which they did as a comedy. I said, 'you've staged the book I *wanted* to write!'"

A quarter of a century after MYSTERY TRAIN, Marcus says America is once again up for grabs. Again, he's following instinct, because the parallels between Bill Clinton and Elvis go further than their white-trash upbringings in the hinterlands of Memphis. Clinton auditioned for his job by playing America's First Elvis on the Arsenio Hall show, donning shades and blowing the sax.

Dummy cover for *Elvis: Undercover*, a proposed comic book from Mad Dog Graphics. According to a press release, it was abandoned after the publisher was visited by the disgruntled ghost of the King. Taken from Marcus' book *Dead Elvis*.

When President Bubba's activities below the waist began exciting America's right-wing would-be moralists, he literally forced Elvis off the front pages of the scandal sheets. What was Kenneth Starr, after all, but another Ed Sullivan telling Clinton to keep his hips out of camera shot? In DOUBLE TROUBLE, Marcus quotes Jonathan Alter saying '[Clinton] may be a hound dog, but he's *our* hound dog'.

"From the moment Clinton was elected, the right has tried to deprive him of his legitimacy," he explains. "His temerity was believing in himself, just like Elvis. Elvis could've been accepted, if he'd dropped his Memphis buddies, took the right drugs, slept with the right celebrities. Instead he stayed in Memphis, where local society treated him with contempt. Clinton went to Washington and met similar contempt from a similar high society. He didn't do what Reagan did, invite them all to the White House, where'd they'd say, 'what class!'. Clinton didn't schmooze them. He and Elvis are fundamentally *outsiders*, hicks who see no reason to become sophisticated.

"And if he had invited them, they'd feel this deep sexual terror, a nightmare of waking up in the White House hungover with Clinton snoring next to them. Elvis communicated a sense that life is *easier* than you've been told it is. The people who hated him, who hate Clinton, are the ones telling you it's not."

During the London Film Festival I watched ELVIS: THAT'S THE WAY IT IS, Rick Schmidlin's magnificent re-edit of Denis Sanders' 1970 Las Vegas documentary. The new film captures Elvis' ability to draw something from an audience. It struck me I hadn't seen a performance like that since Bill Clinton's speech at the Democratic Convention in August.

"Exactly," Marcus smiles. His eyes light up again and I feel like a student being given an 'A'. "Think about it, from the time Elvis was nineteen or twenty, he was a citizen of a nation divided. Half the country wanted to *be* him, and the other half wanted him removed! Clinton divided the country in the same sort of way. People thought: 'If they can do that to the President, what can they do to me if I step out line?

And they keep redrawing the line!' They look at Clinton and they'd simply like to feel as good as he does in his element."

We also agree on the film's defining moment, when Elvis flirts (during Suspicious Minds) with one of his backup singers. "Yes, here's the woman who is black, she could feel 'oh, he's stolen our music', but then he spins around to her and turns it on, and she's jelly."

He misses that sense of joy in music today. Does he believe, as he writes in DOUBLE TROUBLE, that rock music 'no longer seems to speak in unknown tongues'?

"Well, so much is subject to commodification. John Langford, of the Mekons, plays in the Waco Brothers, and he began one show I saw by saying 'we do not play no alt country'.

"Someone wrote that Britney Spears is eighteen, and she looks like a thirty-five-year-old 1950s housewife at the same time she's an ingenue. Like she's used up her capacity to have new experience."

In an essay 'The Summer of Love Generation Reaches the White House, and So Do Their Kids', Marcus quoted Margaret Drabble's 1977 observation that people are 'more ironic, more cynical, more amused by more things, and less touched by anything'.

"It's more true than ever now," he says. "But people are still moved by what they hear. Polly Harvey and Corin Tucker of Sleater Kinney are infinitely more alive — it isn't age — they will be touchstones in the next twenty years. They're younger than other people and of course now they're younger than I am.

"The last music to come out of nowhere and change my expectations was the last three Dylan albums, the two acoustic and TIME OUT OF MIND. They tell a single story, it's a great detective story, as good as THE BIG SLEEP.

"Most music today is a different story, but it's a continuing one. The groups I revile, like Rage Against the Machine, Limp Biskit, Christina Aguilera, well they were created so I wouldn't like them. Dock Boggs, the banjo-playing white bluesman said it best when he was older, 'I don't really like rock and roll, but then, I'm not supposed to like it.'" 🔖

the ANATOMY of OBSESSION

the dark films of MARK HEJNAR

by Mikita Brottman

Bible of Skin

Chicago-based underground filmmaker MARK HEJNAR is perhaps best-known for his 1996 production AFFLICTION, a forty-five-minute documentary chronicling the life and work of several performance artists and underground film and music makers through short interviews and edits of their creations.

This graphic testament to fringe culture is probably most renowned for its showcasing of scatological punk rock performance geek GG Allin, before he died of asphyxiation from a cocaine/heroin overdose. The movie is something of a legend in the world of underground film, and was unanimously voted "Best Documentary" at the 1996 Chicago Underground Film Festival.

Apart from *Affliction*, however, Hejnar has produced a number of lesser-known short films that are less overtly sensational, more subtle in their themes, and yet, if anything, even more disturbing than his best known work. Since the early eighties, he has been making soundtracks to his short films and videos with his band Pile of Cows, whose music offers a raucous accompaniment to Hejnar's curious and disturbing montage sequences.

In its heyday, Pile of Cows had anywhere from two to fifteen members, and was banned from virtually every club they ever performed at. Live shows often featured the use of film, video, power tools, scrap metal, tape loops, fifty-gallon drums, glass, a large collection of homemade instruments and whatever mood modifiers they could acquire. Some of their most infamous shows were at a housewrecking, a Jaycee's Haunted House, a Hell's Angels Picnic and the Elgin State Mental Hospital, where the patients ballroom-danced to their noisy clamour and the band was paid in cupcakes and coffee. Hejnar's film *Herd Mentality* captures some of these live events as well as presenting other films and videos his band have made soundtracks for.

Hejnar's short films, like *Bible of Skin*, *Christian Hole* and *Dreams of Amputation*, fuse sexual obsessions with mondo-style fixations, distorting and retouching old home movie loops and concentration camp footage until they take on the patina of a cultural, familial or psychic trauma, to be endlessly repeated but never overcome.

Hejnar's latest piece, a six-minute short entitled *Slow Death of a Large Animal*, is a haunting, elegaic montage of found footage put to an apocalyptic soundtrack by orchestral noise band Larval. And this is "found" footage in the most literal sense: every single image is from someone's discarded waste; all the film stock used was found in a trash can, abandoned warehouse or burned-out store front in Detroit. Black-and-white images from a small-town carnival dance beside gaunt visions of holocaust victims; semi-disintegrated film stock weaves abstract shadows on the screen; strange, sad-eyed clowns and tight-rope walkers go through their lonely routines, somehow rendered frightening and pitiful by the bleakness of the print. In the film's last sequence, Edison's famous elephant suffers the pangs of execution, and falls heavily to its terrible, heartbreaking death. Two figures are shot out of a circus cannon; a horse stands eating grass in a post-apocalyptic setting with the film stock decaying all around it, then the screen suddenly fades to a decayed and dirty black.

Final Blindness is a video made by Hejnar for a best-selling track by industrial disco dance squad 'My Life with the Thrill Kill Kult'. A dance video seemingly shot in hell, *Final Blindness* was the number one club video for several months in the summer of 1993. The fact it was released as a club video in heavy rotation (rather than an MTV music video) meant that the film was not subject to the rigorous censorship of the regular media, and thus could contain images of full-frontal nudity, homosexuality, and so on. *Final Blindness* is a hypnotic inferno of flashing lights,

bright colors (mainly ambers and yellows) and images from the depths of some demonic kaleidoscope. A bare-breasted women dances seductively; an odd man sits at the wheel of a stationary car, set on cruise-control to oblivion. The whole film has the tone and feel of a witches Sabbath filmed for MTV — part grotesque cartoon, part *Scorpio Rising*.

For a real creepy treat, however, check out *Jeff*, Hejnar's four-minute take on the Jeffrey Dahmer case. *Jeff* is a spooky hybrid of documentary and experimental film, shot mainly during Dahmer's trial in Milwaukee. This short film juxtaposes elements from a variety of sources: trial footage, re-enacted crime scenes, manipulated images and television material re-filmed from monitors. The resulting composition is a haunting testament to the nature of obsession — both Dahmer's obsession with his victims' bodies, and Hejnar's own obsession with the Dahmer case. This disturbing parade of images is backed up — again, using audio footage taken directly from the trial — by several voiceovers that are mixed, worked and woven together on top of one another to reiterate details of Dahmer's crimes in a repetition compulsion of deadpan monotones, until what seems truly frightening are not the crimes themselves, but the way they are so readily "assimilated" by the court system and "neutralized" by the mainstream, A&E-style "true crime" documentary.

Mark Hejnar seems to know the words to some occult spell that unleashes the true power in the image, some secret key that unlocks the doors of what Luc Santé calls "the house of spooks that is photography". Hejnar's work is a rare glimpse into the forbidden and taboo, an unholy prayer to the demons of voyeurism and fixation.

Mark Hejnar can be contacted at:
mhejnar@hotmail.com
Mark Hejnar, PO Box 578503
Chicago, IL 60657-8503, USA

FANFARE for the COMMON MAN

An interview with
FREDERICK WISEMAN

by Michael Carlson

THIRTY-THREE YEARS AGO, WHEN FREDERICK WISEMAN started making the documentary films which shaped our understanding of *cinéma-vérité*, no one imagined we'd be living in world where fly-on-the-wall filming would engulf us from any and every screen we chose.

Reality television — everything from police car chases to the pseudo-reality of BIG BROTHER — captivates viewers on both sides of the Atlantic. Does Wiseman see these programmes as his legacy?

"Actually, I've never seen them at all," he says. "I guess that's a comment right there. I'm too busy working. But I would hope that I'm in no way responsible. I think these programmes arise simply from the advances in lightweight equipment. The new technology demands to be used for new purposes."

I spoke with Wiseman twice. First from Paris, where he was directing a play at the Comédie-Française, and then at the Sheffield Documentary Film Festival, where he presented a masterclass being interviewed by the GUARDIAN's Derek Malcolm. This was followed by a retrospective of his films at London's National Film Theatre. Such a show was long overdue, because for more than thirty years no one has shone as consistently sharp a light on American institutions as Wiseman. After thirty-one films, he has become something of an American institution himself.

His first film, TITICUT FOLLIES (1967), set at Bridgewater State Prison for the Criminally Insane, was banned for twenty-four years in Wiseman's home state of Massachusetts. "Actually, it put me in a good position," he says, "because lots of people had heard good things about the film, but for a long time no one had actually seen it!"

Educated at Williams College and Yale Law School, Wiseman says his legal background is a "bit of a gloss. I never went to class, I read novels for three years. I'd been a clerk/typist in the Judge Advocates office when I was in the service."

He was teaching a course in legal medicine at Boston University Law School, and began taking his students on field trips, out of which grew the notion to film at Bridgewater.

TITICUT FOLLIES, so-called for the variety show in which inmates perform for the staff, and with which Wiseman bookends the film, breaks down our definitions of sane and insane. The prison doctor, who chain-smokes throughout, asks patients, in an almost-comic accent, about their sexual preferences. You check to see what he's doing with his hands. When an inmate complains about the doctor to the board, they decide the inmate is "falling apart".

"The film was originally banned because an inmate was shown naked," Wiseman explains, "and then because they claimed I'd given the superintendent and the attorney general control of the film. I never had, but they claimed it was an oral contract. Eventually the State Supreme Court stopped them from destroying the film, but until 1991, when another court overturned the decision, it could only be shown to scholarly film groups.

"The banning, of course, was for political reasons. It embarrassed them, because they got the point I was making."

PREVIOUS PAGE: Vice squad cop strangles a hooker in *Law and Order*.

LEFT: Killing time... *Juvenile Court*.

Today Wiseman is backed by America's Public Broadcasting System, which allows him to deliver films for network broadcast at whatever length he chooses. Yet in Paris he directed a theatrical monologue based on a chapter of a Russian novel, LIFE AND FATE, by Vasili Grossman. It takes the form of a Russian woman doctor who is Jewish, and about to be executed by the Germans, writing a letter to her son.

"I made a film about the Comédie-Française, which they liked, so they invited me to direct a play," Wiseman says. "I'd done that play once before, at the American Rep Theatre, because the subject fascinated me. I learned a lot from my mistakes and thought I could do it better this time."

It reflects his attitude towards his films, which often seem to veer back towards the same subjects. "All my work is about learning something," he says. "The subjects interest me, but I don't know much before I start, and I try to approach

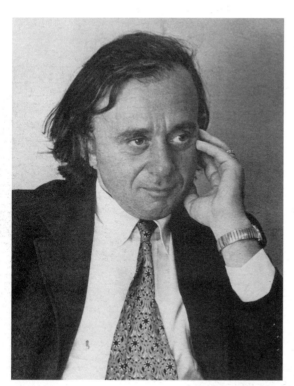

Frederick Wiseman, circa mid-seventies.

them without preconceptions." Directing a monologue also seems appropriate, because the essence of his documentary technique has been letting people talk. For LA COMÉDIE-FRANÇAISE OU L'AMOUR JOUÉ, Wiseman shot 126 hours of footage, and spent a year editing it down to a three-hour-forty-minute film. Like all his films, it had no narration, captions, or music. One American reviewer complained that viewers "had to do way too much of the work".

"Well, that's show-biz," Wiseman says. "I try to provide the audience with information obliquely, through the structure, so they can draw their own conclusions. You can fall into the Hollywood trap, dilute your material to reach the lowest common denominator, but I'd rather not reach an audience at all than reach them by treating them like morons."

In his 1991 film ASPEN, for example, Wiseman lingers on scenic views of the Colorado resort town, letting the viewer grow familiar with its natural beauty. As scenes build up, you sense the dichotomy between those who live and work in Aspen and those who come there to play. The editing makes these points subtly, but relentlessly, and you feel a sympathy building for the natives. The rich are simply set against them, not with animosity, but with an eye toward spotting the differences. The key to it all is Wiseman's own sensibility, showing great compassion, but intensely aware of pretence and hypocrisy. It's very much a 'New Deal' liberalism, tempered with American idealism. Many audiences might disagree with the points he tries to make — far more seem, in the same way as the subjects he films, to miss the point entirely.

"I try not to approach with ideological blinders," he says. "When I made COPS, right after the 1968 Chicago riots, the cliché was all cops were pigs. After twenty seconds in a cruiser, I realised piggery wasn't restricted to the police. So we show what people do to each other, why they need the police. Which isn't to say the police never acted like pigs."

Wiseman's camera becomes amazingly unobtrusive; people forget its presence and behave naturally. "I work with a cameraman, and do sound myself. If I have a question, I won't ask it," he says. "I look for other situations that

will answer it for me. Sometimes people do play to the camera, but if I think they are, I won't include that.

"The gym scene in TITICUT FOLLIES, which many people find disturbing, actually happened three times, and I'm filmed it the third time," he says. "The first two times I was filming other stuff, and the worst thing you can do is stop and start within a sequence. In thirty-four years, I've only exercised self-censorship once. In HOSPI-TAL, I cut out footage of a guy who'd touched a third rail — but from the point of view of the film I now regret it.

"I'm not suggesting it's a style everyone has to work in," he says. I ask if a film like Erroll Morris' MR DEATH, which uses many feature film techniques, gets the same result.

"Yes, he let Fred Leuchter talk and lots of audiences just didn't get it," he says. I mention that Morris remarked that MR DEATH "would be the first film about The Holocaust not to win an Oscar" and Wiseman laughs. "The changes in

LEFT:
Hospital
BELOW:
Submersed inmate in *Titicut Follies*

the process of choosing documentary Oscars were long overdue," he explains. "They've opened the doors to a wider range of films, but I have very little experience with the situation, because my own films can't seem to get qualified for consideration."

It's hard to believe the regularity with which Wiseman's subjects hoist themselves on their own petards. "Never underestimate the power of vanity," he laughs, "and I don't mean that cruelly. All of us like what we're doing, and we'd like to share our experiences. People running institutions are usually trying to do the best job they can.

"The awareness of the camera lasts about five seconds," he says. "Very rarely do people act for the camera, and very rarely do they object to being shot."

The rush to share experience defines the avalanche of so-called 'reality television'. Programmes like BIG BROTHER purport to show ordinary people, but cast all young and attractive exhibitionists, camera-wise as they play-act game-show challenges and soap-opera scenes. Wiseman's camera shows something far more sympathetic; it's the difference between watching rats being trained in a maze and watching lions in their own environment. And society's

ABOVE: *Primate*
BELOW: *Welfare*

institutions, the environment in which people live, has always been his theme.

During the Wiseman masterclass, a clip was shown from WELFARE (1975), in which a pair of ne'er-do-wells attempt to wheedle money and accommodation for which they likely don't qualify from the department. "I wanted to show the complexities," says Wiseman. "The lies, the class closeness between the workers and the clients, the lack of intelligence which permeates the system, the places where ethics and tactics coincide, or don't.

"Ordinary life is my subject," he says. "I start

with the assumption that people's daily life provides as much tragedy and comedy as great drama. I think of my films as dramatic movies, not archival material."

There is a pattern in Wiseman's return to subjects. HIGH SCHOOL (1967), my favourite of his films, deals movingly with the social conditioning that kids received in the days of the Vietnam war. The school's microcosm of the adult world outside is seen in the preparation of young people for war, jobs, obedience. The moments when ideals of free speech or human rights pop up are shattered quickly. It catches the mood of disillusionment with the American Dream as well as any film I've seen, in large part because it shows the willingness, indeed, the eagerness of the young to accept that dream as reality. 1994's HIGH SCHOOL II showed an educational pendulum swung 180 degrees. In it is a world far more sensitive to social diversity, to individual freedom, but at the same time there appears to be less knowledge being passed on.

Wiseman made PRIMATE (1974) about researches into primate behaviour, and ZOO (1993) where the 'inmates' are contrasted with the visitors. LA COMÉDIE-FRANÇAISE OU L'AMOUR JOUÉ could be seen as another view of BALLET (1995), which was about the American Ballet Theatre. "It's not intentional, but it's a reasonable retroactive comment," Wiseman says. "For HIGH SCHOOL II, for example, I just was interested in seeing what another kind of high school would be like, a quarter of century later."

His latest film, BELFAST, MAINE, is a study of a small working town, which encompasses many of the institutions that have engaged Wiseman over the years. Did he see Belfast as somehow old-fashioned, off the mainstream of America? "No, not at all," he says. "I know the area well because I summer near there; it's where I retreat to do my editing. There are lots of blue-collar workers, a good deal of rural poverty, it's the essence of America.

"It's about the nature of daily life and work," he says, "and the work is defined by one sequence in a fish cannery, where we took four hours of rushes and edited it into one nine-minute sequences. It's got 270 cuts, which might be a record for a documentary."

Despite the dramatic nature of the cutting, the rhythm of work on a production line soon takes hold of the viewer, and the feeling of monotony and boredom soon follows. "I feel an obligation to present what went on," Wiseman says. "Not just cut to the most profound, most humorous, or even most obtuse sound bite.

"My original view was that films could change things," he recollects. "That seems naïve and pretentious now. It's rare for any document to be that powerful."

How about UNCLE TOM'S CABIN, I suggest? "The exception that proves the rule."

In the end, the essence of Wiseman's America is defined the same way his films are defined, by the sensibility which knits so many ordinary scenes together. This is a virtue, and it can be a liability, especially for those to whom such a sensibility is alien, in the sense of what makes us human, not what makes us nationals. The French, who despite inventing chauvinism, appreciate such things; they would call it a concern for the human condition. For Wiseman, it is American life. There is no difference. ◪

FREDERICK WISEMAN FILMOGRAPHY

Titicut Follies (1967)
High School (1968)
Law and Order (1969)
Hospital (1970)
Basic Training (1971)
Essene (1972)
Juvenile Court (1973)
Primate (1974)
Welfare (1975)
Meat (1976)
Canal Zone (1977)
Sinai Field Mission (1978)
Manoeuvre (1979)
Seraphita's Diary (1980)
Model (1980)
The Store (1983)
Racetrack (1985)
Multi-Handicapped (1986)
Deaf (1986)
Blind (1986)
Adjustment and Work (1986)
Missile (1987)
Near Death (1989)
Central Park (1989)
Aspen (1991)
Zoo (1993)
High School II (1994)
Ballet (1995)
La Comédie-Française ou
L'amour joué (1996)
Public Housing (1997)
Belfast, Maine (1999)

Psychedelic Nazi Fräuleins

...and an interview with
ROSA SCHLÜPFER

by David Kerekes

Rosa Schlüpfer is the editor of a series of fanzines on NAZISM and SADOMASOCHISM, and was brought to my attention through John Harrison (see 'The Horwitz WWII Roughies' on page 113). She lives in a quiet suburb of Brisbane in a home she affectionately refers to as "My Bunker". By way of an introduction, she has this to say:

I'm afraid the offerings for women these days isn't very desirable. I'm a woman who enjoys her lingerie and I have some rather nice early 1960's style lacy panties and brassieres which I wear daily. Unfortunately, I don't get much opportunity to wear my black leather and fur coats, what with the Brisbane weather. And, of course, my Nazi uniforms are even more restricted.

What kind of distribution do your publications have?

They have only appeared in a Melbourne shop and a few copies of *Nazi Fräuleins* were sold at Brisbane's Trash Video. My own peccadilloes prevent me from indulging any more time than necessary to hustling magazines on street corners…

Any idea what kind of people buy your zines?

My contacts inform me they are mostly young people attracted by the bizarre and forbidden. Possibly a few closet perverts and quasi-fascists. People almost, but not quite, as twisted as myself!

What kind of reaction do your zines elicit?

The Melbourne distributor has sold out of my zines a few times and I'm about to send him another batch. A year ago an Australian ABC-TV show were doing a profile of zines and publications this Melbourne outlet carried, and two of my zines were held up to be filmed. They stopped the camera and informed the proprietor it was not the sort of material they wished to promote.

I suspect that neither the political left nor political right would be amused by this material — given that the Third Reich is depicted in farcical situations as much as they are powerful ones. Have you encountered much hostility?

I am more concerned with art and ontology than narrow political constraints. Perhaps 'Nazi Anarchist' would be an appropriate designation of mind, but it is inherently impractical and contradictory. I have been attacked for my so-called controversial views by the trendy 'politically correct'. They believe they are rebellious, but they cling to the same old hackneyed dogma.

One of Rosa's fanzines, containing a collage of Nazi imagery from the movies.

You have a title called SM: THE LAST TABOO. However, I think your 'Nazi kitsch' is probably more taboo than SM. Why do you regard SM as a 'last taboo'?

The full title is *Bizarre — S&M, The Last Taboo*, and it's a tribute to the writer, artist, photogra-

pher and publisher John 'Willie' Coutts, who produced — under difficult circumstances — the magazine *Bizarre* between 1946–56. The subtitle is taken from a very informative book by Gerald and Caroline Green. I agree with you, 'Nazi Kitsch' is a more taboo area than S&M. Some people lack a sense of humour.

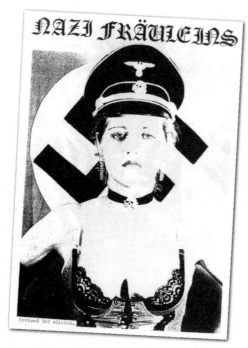

What drew your interest to the subject of Nazi iconography?

Fundamentally, the inherent sadism drew me to Nazi iconography. I remember seeing a book when I was young called *The History of the Gestapo* by Jacques Delarue, containing photos of the Secret State Police posing for the camera, along with SD men conducting a raid against dissenters. The images are still clear in my mind even now. About the same time I saw pictures in a magazine of Nazi men and women on trial. I now know it was the Belsen Trial, wherein the infamous Irma Grese played centre stage. Since sadism was in my personality from a very young age, the underlying ambience of Nazi sadism drew me like a magnet — rather than repelling me, as it would most. The Nazi uniforms are the most elegant ever designed. I identified with the concentration camp guards, although it was the power of arbitrary shootings and whippings that thrilled me, rather than the Holocaust *per se*.

What can you tell me about your newest title, PSYCHEDELIC NAZIS? What connections do John Lennon and Jimi Hendrix have with Nazism — given that they both feature in it?

Psychedelic Nazis was born when I accidentally came upon a bespectacled John Lennon photo in my archives and the shadow on Lennon's face gave an uncanny resemblance to the myopic Himmler. The misanthrope in me decided to combine the dichotomy. I'm still working on this zine which, when finished, will be full-colour throughout. I have Leni Riefenstahl meeting Andy Warhol, Dalí's infatuation with Hitler, the avant-garde artist-fascist mystic and SS translator Julius Evola, Hippies adopting Der Führer's VW car and more. I liked Hendrix in his military Hussar tunic (not quite Nazi, but at least military) and added a Nazi/cosmic swastika — "'scuse me while I kiss the sky". He is juxtaposed with Mick Farren from the rock band The Deviants in Nazi uniform, Frank Zappa in a dress and Germaine Greer flashing her pudendum.

Do you have a steadfast criteria for each publication you do? What inspires you?

I suppose my format is pretty similar with an emphasis on visuals. Sometimes I want to move towards a more Dada or surrealist format, but the Nazi in me keeps being drawn to an ordered page layout. I've branched into coloured covers for some of my zines, which is more satisfying as I enjoy colour and wish I could afford to produce every zine completely in colour. I'm inspired by different aspects of Nazi iconography. In my younger days it was more the frontline fighting and soldiers' uniforms, whereas over time, I've become interested in the homefront, along with some of the oddities and inconsistencies of the Third Reich. For example, Nazi art… Artist A Paul Weber's art could certainly not be regarded as fitting Hitler's criteria for classical art. However, many of his illustrations appeared in various magazines and books during the Third Reich; one book was even prefaced by Himmler. Even stranger is the use of Van Gogh's painting, *The*

Bridge, in an edition of *Signal* magazine. (*Signal* was a popular publication produced during WWII for both home consumption and in translation for the Occupied Territories.) Van Gogh, of course, made the Nazi 'degenerate' artist list. I'm also fascinated by original colour cine of the Reich and there is an outstanding example of colour footage shot on 16mm Kodachrome film with a Bolex camera by Hans Feierabend of the 1939 opening for the House of German Art in Munich — it is breathtaking to see the SS formations and other paramilitary phalanx assembled in their smart and colourfully detailed uniforms. The classic Nordic beauty Frau Ley makes a cameo appearance adorned in a pink dress and stylish hat, and attempts a Hitler salute with her left arm. The public television-telephone service which opened in March, 1936, between Berlin and Leipzig is an inspiring tit-bit, as it prefigured Kubrick's 1968 film *2001* by a number of years.

PREVIOUS PAGE: Cover for *Nazi Fräuleins*.
BELOW: Working design for the cover art of *Psychedelic Nazis*.

Francoise Suzanne Marie Dior features in a number of your publications, most notably GODDESS OSTARA. How much of an influence has she played on your life?

Francoise Dior is only one of many Nazi/fascist women to whom I'm drawn. I feature nine of them in my zine *Hitler's Panties*. However, I do think Dior was on the right track regarding her philosophy of gynosupremacy.

Dior considered herself a Nazi and yet her private life could be regarded as subversive and perverse (from a Nazi ideological point of view). Why do you think this contention exists, in Dior's life as well as many of the other principle 'movers and shakers' of Nazi history?

I believe most societies are hierarchical, whether acknowledged or not, and those in the upper echelons — in this case the Nazi movers and shakers — have the appropriate personalities for the positions they gravitate towards. These outsiders do indeed march to a different drummer and while they can muster empathy for the masses, there is forever a gulf in their inner beings between leaders and the masses. The

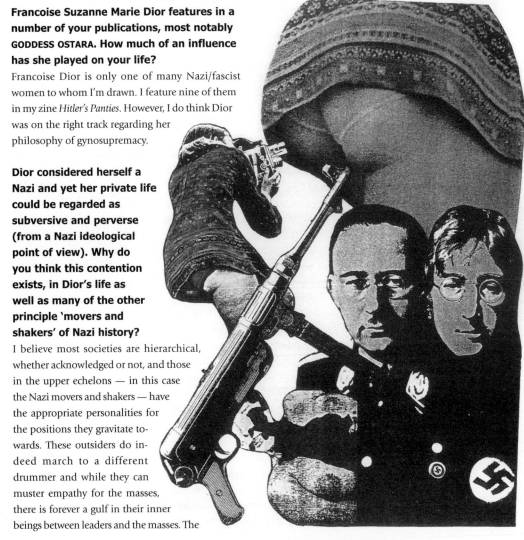

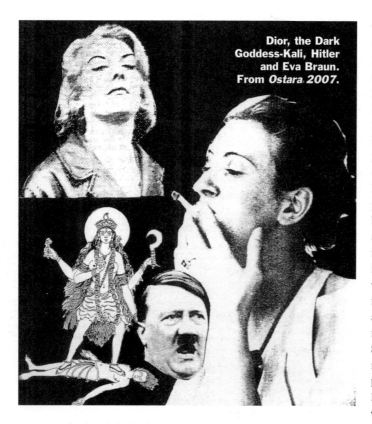

Dior, the Dark Goddess-Kali, Hitler and Eva Braun. From *Ostara 2007*.

Third Reich leadership corps and the mental processes of post-war neo-Nazis were/are those of a more highly strung, overly sensitive, artistic and reflective personality type. For those of this temperament it is easy for extremes and contradictions to form and blissfully co-exist. Dior believed fanatically in the Nazi ideology, while at the same time having a black leather fetish, a propensity for younger men and a very strong 'dominatrix' personality. Hermann Göring was an effeminate transvestite with painted nails, dresses and pink boots. Half-Jewish American neo-Nazi Frank Collins (Cohen) is a convicted child molester. British fascist/Nazi Della (Derek) Aleksander is a transsexual who was a post-war bodyguard to Oswald Mosley. British Nazi Vic Norris was a Satanist and convicted paedophile. Ernst Röhm was a homosexual. British Nazi Terry Flynn had a black leather and jackboot fetish. American Nazi Frank Spiask is a transvestite and convicted murderer. Alessandra Mussolini, granddaughter of Benito, is a fascist and former porn star… The 'elite' preached and continue to preach a philosophy of family values for the masses, while they themselves indulge in a cocktail of deviance and perversion.

It is interesting that some far-right supporters, such as Frank Collins and Dan Burros, were Jewish or part-Jewish. How would you explain the desire to promote an almost diametrically opposed ideology?

There are all sorts of complexities regarding this… Dietrich Eckart, Hitler's early mentor, spoke of the Jew within and the Jew without. Besides the biological Jew he admitted to the mental Jew and that both could be transcended. The fascist Julius Evola had similar views, opining the Aryan can think like a Jew and vice-versa. Surprisingly, quite a few Jews have been involved with Nazism and fascism. Strictly speaking fascism need not contain a racist element and many Jews were associated with Italian fascism in its early years. Actually, Mussolini had a Jewish mistress named Margherita Sarfatti who edited his fascist magazine *Gerarchia*, as well as penning a biography on 'Il Duce' in 1925. After breaking with Mosley in 1937, William Joyce — as the infamous Lord Haw Haw — founded the extremely anti-Jewish National Socialist League with former Blackshirt John Beekett, who was half-Jewish. As I mention in *Nazi Wunderland*, the half-Jewish Frank Collins led the most successful American Nazi party of the seventies, while blonde-haired, blue-eyed, bar-mitzvahed Dan Burros was a full Jew who marched in the ranks of Rockwell's American Nazi party during the sixties. If you look at the Nuremberg Race laws (1935) regarding *Mischlinge* (Mixed Race), not only was biology a factor, but psychology and religious membership a determinant as to who was a Jew in National Socialist Germany. A *Mischlinge* second degree — those with

one Jewish grandparent — were eligible for membership in some NS organisations, as well as the Wehrmacht (Armed Forces) during the early stages of the war. It is ironic that one Werner Goldberg featured on the title page of a Nazi newspaper as the 'Perfect Aryan Soldier', whereas in reality he was a *Mischlinge* second degree. So, what constituted a Jew during the Third Reich is a little less rigid than is generally thought. If we take the position that an Aryan is diametrically opposed to the Jew and never the twain shall meet, then a Jew genuinely of this persuasion who takes up the Nazi cause must have a large masochistic aspect to his personality. The half-Jew maybe chooses to identify with his Aryan self. Of course it could be an expression of rebelliousness, or an attraction for the Nazi image in popular entertainment: jackboots, truncheons, Lugers, order, discipline, obedience, sadism, cruelty and general belligerence. Reflection or cognition of ideology may not arise — rather it is a matter of being at odds with the status quo and cloaking oneself with an exotic and erotic aura to both enhance and justify beating the shit out of people.

What are your own origins?

I'm half-Jewish and half-German and was born June 2 — same as de Sade. From this you can understand that duality is very pronounced in me, and that many of the personalities who feature in my zines have parallels to my own personality. Really, my zines are an investigation into and an artistic expression of my psyche. ▣

Rosa Schlüpher can be reached at:

PO Box 3344, Norman Park 4170
Brisbane, Queensland, Australia

Thanks to John Harrison, and also Andrew Leavold at Trash Video,
www.urbangroove.com.au/trashvideo

The Horwitz WWII Roughies

Sex, Sadism & Sleaze for 4/6 a Month by John Harrison

These days, the sydney based HORWITZ company are the well-known, respected publishers of such glossy monthlies as *Australian Women's Forum* and *Inside Sports*, as well as a string of popular childrens' books, and a series of gardening manuals put together by high profile Australian TV personality Don Burke. But no doubt many of their current readers would be a little dismayed, shocked, and even disgusted to learn that during the 1960s, Horwitz made their mark by grinding out a seemingly endless stream of lurid war paperbacks, most of which proudly wallowed in the sadistic treatments which the Japanese and German powers meted out on their enemies during the Second World War. What makes these novels even freakier (particularly the Nazi themed ones) is the fact that Horwitz was a Jewish-owned company!

*John Slater's other war novels, published by Horwitz, include such tantalising titles as: *Death March, Horror Camp Escape, Swastika Castle, Hitler's Experiment, Gestapo Prisoner, Sin Camp, Victim of the SS, The Slash of Death, The Nazi Fiends* and *Torture Road*.

One look at the Horwitz war paperbacks, and it's easy to see the type of scummy, cheap thrills readership which they were aimed at. Lurid, colour saturated cover art firmly emphasised the sex'n'sadism angle of the novels. Of course, just like most other adult oriented paperbacks from this era, the content of the Horwitz novels could rarely match the expectations raised by the titillating covers. However, more than thirty years later, they still make for reasonably entertaining (and supremely tacky) reading, and I've found them to be an ideal way to pass the eighty-five-minute train journey from my home town of Berwick to the city of Melbourne (particularly rewarding is the puzzled and often appalled look I receive from some of my fellow passengers). Therefore, I felt it was worth taking a brief look at some of the best Horwitz titles which line my bookshelves of filth.

HITLER'S WOMAN
by Anton Gronowicz (1962)

This is actually a reprint of the 1942 title *Hitler's Wife* ('The daring best-seller about the intimate life of Adolph Hitler and Eva Braun'). In reality a fairly staid and laboured bio (Gronowicz also penned volumes on Chopin, Tchaikovsky and Rachmaninov), Horwitz brought their printing of it down to gutter level by replacing the word *Wife* in the title with *Woman* (indicating a more illicit content), and adding a cover illustration featuring Der Führer biting into the neck of some obviously naked blonde woman (who looks nothing like his one and only, Eva).

WOMEN OF AUSCHWITZ
by John Slater (1963)

With over fifty titles to his credit, the late John Slater (real name: Ray Slatery) was without doubt one of Horwitz' most prolific scribes.* Featuring what is probably my favourite piece of art to grace a Horwitz cover, *Women of Auschwitz* uses as its base the (fictional) 1960's Frankfurt trial of recently apprehended concentration camp Direktor, Felix Hauser. Through witness testimonies and flashbacks, we learn of the violent, forced love affair which Hauser embarked upon with a beautiful young Jewish prisoner named Pola

Koruac. A subplot involves the activities of an insane doctor, who uses one of the cell blocks as the base for his own sadistic experiments —

> Cell Block 10 — the infamous Auschwitz ward where only the healthy were sent never to return as normal women. It was here the Direktor threatened to send the women who would not submit...

OPERATION RABAUL
by John Slater (1964)

Slater (an Australian) delivers a strong home country flavour in this title, with Melbourne woman Susan Rennie taken captive by the Japanese after her freighter is torpedoed ("It is sensible to realise that you are woman and my crew and I are far from home. It is sensible to surrender to women's fate, to do what you are required to do whether in the galley or on a cabin bunk. Take off your remaining clothes, please"). Susan is subsequently placed in a camp commanded by the sadistic Shimisu, and forced to assist captive scientist Max Terrace in his search for a cure for jungle fever.

Amidst much debate as to whether Terrace is doing the right thing by not sabotaging his experiments, an Australian commando team led by gritty Lieutenant Harrigan hack their way through the steamy jungle in order to rescue the scientist and Rennie.

Operation Rabaul differentiates itself from the majority of Slater's war titles, in that it is centred around the Pacific rather than European conflict. At one point, an Aussie soldier says, "The English are the ones who lose all the tests." Nice to see that some things never change...

PRISONER OF DACHAU
by John Slater (1967)

Another eminently readable slice of demented cheap thrills and low-rent sleaze from Slater, this title was published by Horwitz under their SCRIPTS imprint. Once again set within the barbed wire fences of a notorious Nazi death camp, *Prisoner of Dachau* revolves around the experiments which medical officer Rascher subjects the camp's prisoners to, all for the benefit of the Luftwaffe. One particularly harrowing passage has a young

Jewish 'volunteer' facing the horrors of a pressure chamber (affectionately dubbed 'The Sky Ride Wagon' by Herr Doktor):

> I looked in the chamber again. The victim was writhing. She tore at her short-cropped hair and her mouth was opened wide as if screaming. Perhaps she was, I could hear nothing, but the chamber might have been sound-proof. Then suddenly her suffering reached a new peak. She tore at her face and threw herself about so violently that the strap around her waist snapped and she hurtled out of the chair.

JUNGLE HATRED
by Jim Kent (1967)

While not as prolific as John Slater, Jim Kent (another Australian based writer) managed to churn out a number of war titles for Horwitz, with *Jungle Hatred* standing as one of my personal favourites. Kent plays on a favourite male fantasy, by having Aussie Diggers Bill Callaghan, Rob Jackson and Jack Young escape from the horrors of the Burma-Thailand railway line to find solace in an

*Among Jim Kent's many other Horwitz titles are *Partisan Patrol*, *Torture Camp*, *Changi Terror*, *Slave Women*, *Death's Wake* and *Nazi Castle*.

isolated tribe of sexy, half-naked Thai women, whose 'men-folk' have been decimated by the Japanese.

> Their skins were dark, but not as dark as those of other natives they had seen in Asia. They glistened with oil. They were tall, and supple, with well defined features and slightly slanted eyes — betraying Oriental ancestry. There were about fifteen of them, all carrying crude bows and an assortment of arrows. They were young and they were all women.

Of course, the Aussies' idyllic paradise is ruined when the tribe's leader, Salah, is captured by the Japanese. Using a cache of stolen weapons hidden away by the girls, the gruff Harrigan (after realising he is in love with Salah) leads an all-out attack to get her back.

Lots of sex and racial slurs are peppered throughout this one, and the Japanese are portrayed as typically sadistic. But the novel is written with genuine gusto, and Kent balances out the racy material with some genuinely exciting action sequences.

VILLAGE IN CHAINS
by Jim Kent (1969)

This is one of the more brisk Jim Kent* war paperbacks that I've managed to dig up, and reads like a treatment for some scuzzy Italian sleaze-ploitation film. It's set in the small Italian village of Lucevento in 1944. After the defeated Italian army surrenders to the Allies, German troops move in to occupy the town, and proceed to extract revenge on the 'cowardly' Italians by systematically executing the entire village. As usual, the Nazi hierarchy take several of the more attractive villagers for their own carnal enjoyment, before angry partisans finally free the village from its enslavement.

> Roaring with rage, Ferretti whipped the knife from beneath his waistband and, moving with a speed and drive that could only come from a madman, attacked the nearest of the three Germans, neatly slitting his throat. Then, still shouting, he buried his knife in the second man's stomach, at the same time snatching the gun from the chair beside him. He aimed the weapon at the third man, who having been knocked

down in the melee, was now reaching for his own weapon. Ferretti almost cut him in two with a long burst of fire.

According to Lyall Moore, a friendly guy who's the current director of Horwitz, the company published a total of sixteen titles per month during the height of their popularity in the mid-1960s, with each title having a print run of 20,000 copies. Distributed mainly through news-stands across Australia, Horwitz ceased publishing their war paperbacks in the early-1970s, by which stage their popularity had severely declined.

Written under contract, Moore remembers the author's payment at around Aus $250–300 per title (not a bad wage back then, keeping in mind that most of these paperbacks clocked in at around 120 slim pages, and writers like Slater were pumping out one title per month on average). Local, mostly obscure artists such as Theo Batten and Grant Roberts provided the (uncredited) cover paintings, at around $150 a pop. Unfortunately, all original artwork was returned to the artist upon publication, and Moore presumes most of it to be lost. Towards the end of their paperback publishing era, Horwitz would often cut costs by using a cheaply staged photograph for their covers (a prime example being Jim Kent's 1969 title *Tyrant of the Alps*).

Although Moore revealed that the Horwitz archives currently houses uncirculated, pristine copies of all their paperbacks, the chances of any of these gems surfacing in the near future are almost zilch. Still, a search through any decent second hand bookstore in Australia will likely yield any number of Horwitz paperbacks, usually at a reasonable price of between $2–$4.

While Horwitz did dabble in other genres of adult fiction, with paperbacks like *The X Report*, *The Sins of Janie*, *The Sex Trap* and *The Butch Girls* to their credit, it is their WWII roughies which seem to have gained them the most favouritism amongst lovers of vintage hip pocket sleaze. ⌷

l'abécédaire chimerique
by Progeas Didier

GEOBONISTE : musicien lymphatique, virtuose des bulles de bémols sur rythme flegmatique

HALOTROPE : Fin gourmet, grand amateur d'hallucinations et de voyages immobiles

ICONOMINE : belle et raffinée, elle pose pendant des heures pour fixer son image dans le vent

to be continued...

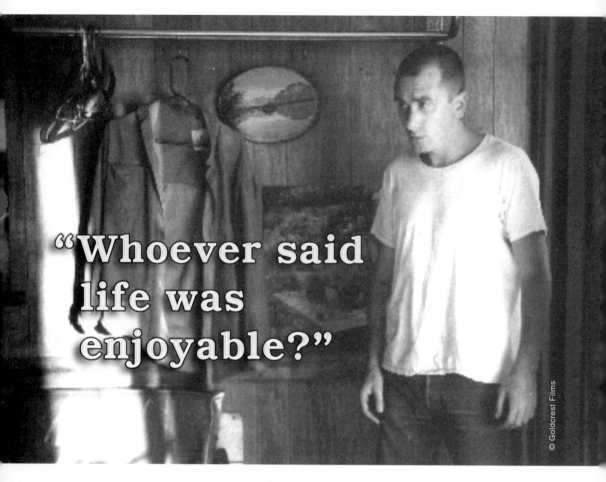

"Whoever said life was enjoyable?"

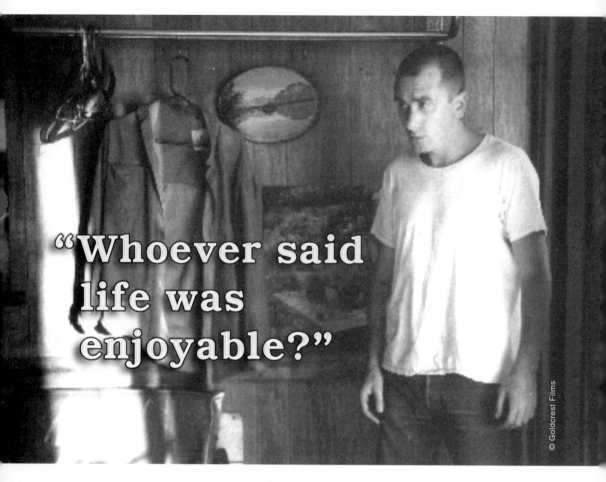

© Goldcrest Films

COMBAT-SHOCK THERAPY WITH BUDDY GIOVINAZZO

by John Szpunar

The flight to Berlin

was uneventful. Roughly eight hours
of Hell, disguised as transatlantic transportation. No smoking anyplace
in Detroit Metro Airport. Not even at the bar. "You'll have to take
yourself outside," snarled the woman as she brought me my drink, a
five dollar Heineken. "Down the stairs and through the door." I didn't
feel like being X-rayed again, so I bit the bullet and sat down.
The bar was filled with people from all over the globe. A group of
Indians sat to my left. The bartender wanted to know if they were
going to India. They shot her a look of disgust. "I know some Hindi,"
she offered. She got the hint and moved on.

I drank about half of the beer, left the bottle on the table and walked over to my gate. Boarded. And prepared myself for the worst.

It's pointless to talk about the food, the jovial captain, and the screaming children. But there was something wrong with the man who sat across from me. He seemed normal at first. Laughing with the stewardess, snapping his seat-belt together. But shortly before take off, things changed. Out from his carry-on came a King James Bible. I leaned over for a closer look. He had it opened to Ezekeil. As the plane charged down the runway, he extended his arms in prayer, whispering to himself silently. "He's scared to death of flying," a stewardess informed us. The Book of Ezekeil was his talisman. We hit the cruising altitude, choked down the food, and I closed my eyes. Next stop London, then a transfer to Berlin. With God on our side, we made it.

Berlin is a sprawling city of stone houses with gaping windows. A city of dogs, dust, and people. It's also the city that director Buddy Giovinazzo has called home for nearly a year — a bit of a change from his native streets of New York. Buddy is primarily known as the director of COMBAT SHOCK, a low budget film shot in Staten Island in 1984. A bleak tale steeped in nihilism, COMBAT SHOCK is the story of Frankie Dunlan, a down-and-out Vietnam vet who finds salvation for himself and his family with six bullets. Depressing, violent, and all too real, the film proved too rough a ride for a public that craved escapism. It also made Buddy a marked man, the man who made that movie. He didn't get another shot at a film until 1997.

NO WAY HOME was Buddy's second outing as a director. "It's basically COMBAT SHOCK with a bigger budget." And an all star cast. Tim Roth plays ex-con Joey Larabito, recently reunited with his low-life brother Tommy (James Russo) and his disillusioned wife Lorraine (Deborah Unger). Before long, the past rears its ugly head and their whole cesspool existence begins to boil before exploding with unavoidable betrayal and violence.

With two novels under his belt (LIFE IS HOT IN CRACKTOWN and POETRY AND PURGATORY), Buddy has waited patiently to direct another feature. In a small café in East Berlin, over a breakfast of coffee and eggs, Buddy talked of his past films and of his new project, EVERYBODY DIES.

Headpress

So how long have you been in Berlin?

Buddy G

Well, I've been here since April now, but last year, I was here for eight months. From May to January. So, almost a year.

You're here because you're working on a new film. Yeah. It's called EVERYBODY DIES. It's a cool thriller, a dark thriller. For me, it's more of a genre piece than my other films. I looked at them more as character studies that just happened to strike a note with a genre audience. This is really more of an intense thriller. It's going to have a completely different look than my other films. I'm shooting the entire film in Steadycam, so I'm to use moving camera throughout. A real striking visual style. I really tended to lean away from that in the past.

Who's responsible for writing this one? It's written by a guy from New York City named Todd Komarnicki. I met him through my producer. He put us together. Todd had a really cool story that took place in Europe. I've wanted to shoot a film in Berlin for about three or four years now. The stories I was coming up with just weren't right, they didn't seem to work. So this guy had a cool story.

Can you go into it at all? It's convoluted. It's kind of like an old style Alfred Hitchcock plot, where you don't really know the truth. It sets up a certain story and that story isn't right; nobody's telling the truth. It's got some twists and surprises. But it's hard to get into the details without giving shit away.

So you're starting pre-production tomorrow? Yeah. We need to cast one more actor and we need to hire a few more crew people. I have most of the crew together, but there are some key people that haven't been hired yet. Like my camera person, the script supervisor

James Russo and Tim Roth in *No Way Home*.

and the assistant director. I need to fill maybe three or four key spots and then those people have to hire their assistants. It's like a factory once it gets running.

Sounds like you've got your work cut out for you. What kind of schedule are you looking at? We're supposed to start shooting on September 23. We have about seven weeks. That's about the same schedule that I had on NO WAY HOME.

Budget wise, is this a step up? It's a step sideways. It's almost the same budget as the last one.

Could you compare the sensibilities of EVERYBODY DIES to COMBAT SHOCK? You know what? It's more fun. It's got some darkness; it's called EVERYBODY DIES...

Is this a conscious effort on your part to do film that's more digestible for the public? Yeah. Yeah. Really, it was ten or eleven years between COMBAT SHOCK and NO WAY HOME. It's not like I didn't want to make a film in that time. It's just that people were so disturbed by COMBAT SHOCK. Or else, they just thought it was just so completely bad. I ran across that for ten years, dealing with producers. They'd say, "COMBAT SHOCK was a really cool film but you might do it again." Or else they thought it was horrible — amateur and stupid. So it got really hard. And I realised that I couldn't keep making these dark character pieces that were appreciated by seven people. And also, I just wanted to do something that was just going to be a little bit lighter. At least lighter in tone.

You've also had problems with the MPAA because of the violence in your films. Well, not with the MPAA. For NO WAY HOME, we didn't have a theatrical release. So the MPAA never really came into play. Maybe there might have been a problem in the kitchen scene. But NO WAY HOME got such a fucked up release in America. The company that originally bought the film was then in turn bought by a new one. And they didn't like the film at all. They didn't want

to release it. So the MPAA never came into play. I had to deal with my producers. They had some problems with the violence. Some of the shots were out there. There's one scene at the end where James Russo gets shot in the neck. And it was like, completely on camera. I thought it was such a great effect; it really was horrifying. It was just too much. But that's violence.

The truth hurts. The violence in NO WAY HOME hurt the film with the art crowd. The festivals thought it was a good character piece until the end. And then they were like, "What happened?"

For me, there was no other resolution. How could you change the ending? That's what I said. But they thought I took a wrong turn by making it violent. Nobody came up with another way to resolve it, they just said, "This is a great character study and suddenly you horrify us with violence." I pretty much said, "It's a simmering pot, the whole story. It's just simmering along. It's got to explode." I think the problem is that the violence in my films is not funny. It's not a Tarantinoesque violence where you can step back and just say, "What a laugh riot! The guy's head got blown off!" My violence mainly tends to involve the main character and it's horrific. The way it's supposed to be, I think. But it's not commercially a good choice. People don't want to go to a film to be horrified or appalled.

Did you anticipate anything like that before NO WAY HOME came out? I thought people were going to love it. I thought it was one of Tim Roth's best performances and Deborah Unger's best, by far. I don't think Deborah has ever been as good. And I think it's some of James Russo's best work. I just thought people would love it. And I was completely shocked and depressed and fucked up for a long time over the fact that it didn't do well. Although it does well on cable, it plays all the time on cable and people seem to like it.

Did it play any festivals? It played in Hamburg, in France, one or two in Montreal. But it didn't play in the ones that I needed. I needed it

to play in Toronto, Sundance, Berlin, London... The people just didn't like it. But you know, I like it. I have no regrets.

You grew up in New York? Yeah. I grew up in the neighbourhood of COMBAT SHOCK and NO WAY HOME. I literally shot the films on the streets that I played on as a kid. And that's why I think the films have a certain ring of truth to them about neighbourhoods. Just the way a neighbourhood will deteriorate. I saw it as a kid. When I was a kid, the neighbourhoods of COMBAT SHOCK and NO WAY HOME were very lively and very exciting. Families, kids playing. And now they're completely devastated.

Did you always have it in you to direct? I never really thought about directing when I was younger. I was a musician. My father ran a music school. He was a musician. I was in a band with my brother Rick. I played drums, Rick played bass. And that was my life. I never dreamed I'd be a filmmaker. That just happened.

You started with some Super-8 shorts. How did those come about? I must have been around twenty-two or twenty-three. I was in school and I took a film course, just to fill up my schedule. And once I took that course, my teacher got me to see films in a way I'd never seen them before. I mean, I grew up with horror films, from when I was a little kid. I still remember the first time I saw MARK OF THE DEVIL. I saw it in the theatre. And the tongue getting pulled out of that woman's face still horrifies me. I remember FIEND WITHOUT A FACE. There are moments from my childhood that just relate to horror films. I just remember where I was and what happened. So, I've always loved films. It wasn't until I was in my twenties that I started looking at film as something to do.

What were your shorts like? They were pretty bizarre. They usually dealt with violence and sex and tried to be artistic at the same time. John Waters was a really big influence on me. Before I saw his films, movie making was something that was out of range for me.

Did growing up with horror films affect your subject matter at all? I guess my films attract a horror audience. Although I don't look at them as horror films. I think generally the people who respond the most positively are the horror audience. I mean, I thought NO WAY HOME would have been more accepted on a more commercial level. I thought the audience would have been broader, just because of the cast I had. But, in the end, it was just the same audience.

NO WAY HOME had a lot in common with COMBAT SHOCK. It's funny, I think NO WAY HOME is just a remake of COMBAT SHOCK in so many ways. It's almost the same film with more money. And it's done better. But some people say it's not better at all. I think visually, COMBAT SHOCK is more interesting. My brother Rick is fantastic as the main guy. The actors around him are kind of weak. But NO WAY HOME is much better in terms of the over-all acting. I learned a lot from COMBAT SHOCK. I learned that you can't just meet somebody on Tuesday and say, "Be in my movie,"

and shoot with him on Friday. That went on in COMBAT SHOCK. I couldn't pay people, so whoever was available on shooting days was in the movie. That's not a good thing to do.

What made you decide that it was time to direct a feature? I'd done a lot of short films. The last short film I'd done was a bizarre fifteen-minute surrealistic film about drugs. It was kind of like ALTERED STATES. This guy gets this really exotic drug and then has all of these crazy, religious, violent visions. And it took about a year to make. As I was making it, I realised that the only difference between this and a feature is that a feature is about five of these that connect somehow. So, I just figured it was time. You know, if I was going to spend a year of my life on a film, I wanted to do something bigger.

You were already familiar with 16mm? I did maybe four Super-8 shorts, but I shot around eight in 16mm. Music videos, short ten minute films.

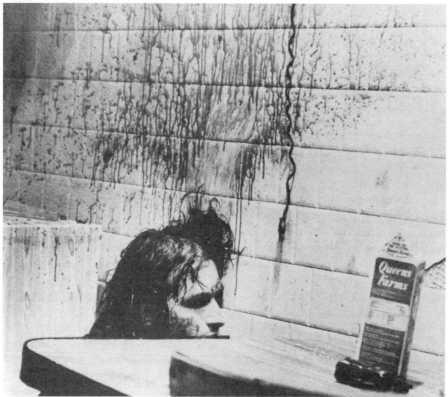

© Troma

Why make a film like COMBAT SHOCK in the first place? Well, you know, I had no money. Nobody was professional. I guess I thought I had to do something that was so completely different. I just looked at what people were making and wanted to make the opposite. And I felt really true about the story, it really touched me. This fucking guy who had nothing, and everything went wrong. I was always fascinated by the stories that I'd read in the papers about a guy who would just kill his wife, his kids, and then himself. It's one thing to kill another person. There are many reasons. There's greed, there's hatred, there's jealousy. But what drives someone to kill his own family? And then himself? There was something in that idea that really intrigued me. I just came up with this story. What if? What if this happened, and everything that could possibly go wrong — right up to drinking sour milk, the shoelace breaking, the sock with the hole in it — went fucking wrong? It's just a big pile up of depression.

How many stages did the script go through? Not enough. I should have spent much more time on it. I had a forty-page script and I was doing a ninety-minute film. I thought the brilliance of my directorial style would carry the film. It was really the wrong approach. I should have spent much more time developing the script and going over certain scenes. And, if anything, shortening the film. If I made the film today, it would be ten minutes shorter. I think it'd be much better. The middle of the film really lags. I can tell, when I screen it for people, that it's a hard section of the film to get through. Just because there's so much walking, and there's so much stuff with the baby.

How did you raise the money for the film? It was pretty much my own money. I had three jobs. I would save up my money from the jobs that I had. I had a girlfriend who worked as a nurse and we were living together. She was pretty much paying the rent. All of my money was going into the film. I'd work for a few months, save up the money and shoot for two weeks. I did that over the course of a year, it took a year to shoot doing it that way. When we

were ready to start post-production, my girlfriend and I got married. I took the money we got from our wedding and started post-production. I actually shot the ending of the film with that money. So, it took around two years. People lent me things and the lab gave me tremendous breaks. By the end of the film, I had to borrow some money from my family to do the mix and make the final answer print. I had tremendous debt by the time I was finished with COMBAT SHOCK.

ABOVE: **Buddy G directs.**

PREVIOUS PAGE: **A resonant moment in cinema: Ricky G finally bites the big one in** *Combat Shock.*

What kind of crew did you have? The entire jungle sequence had me as the cameraman. We had a crew of three people. On some of the more violent days, we had a crew of maybe ten. All of the Vietnamese people and all of the guys who are all chopped up were all friends, people from the neighbourhood. But generally, when you see scenes that are just my brother walking through the jungle, there were three people. Me, somebody else, and my brother.

How many cameras did you have? Well, on certain days I had three cameras. For the gunshot stuff. I shot most of the film with a Bolex. A wind up camera. When I did my last short film, I lost the soundtrack. So all of the dialogue was

gone. And I realised that I had to replace dialogue. So I learned how to synch up, to post-synch dialogue. For COMBAT SHOCK, I realised that I could just post-synch the film; I could worry about the imagery and not deal with the sound. So that's what I did.

How difficult was that? Tremendously difficult. It took nine months to put the sound design together. So I'm really proud of the sound in COMBAT SHOCK. I think for a low budget film, the sound design is almost as good as any film comparable.

It's really layered. I think from the first scene to the last, there's no scene that doesn't have something. And I did that for a number of reasons. One of the reasons was when I had to shoot dialogue scenes, the camera was kind of loud. I needed to mask it. I loved ERASERHEAD. ERASERHEAD was one of my favourite films. The sound for the film was so unbelievable, it was one of the best things I'd ever heard. I wanted to really layer my film like ERASERHEAD was layered. I had about eighteen tracks of sound. Which, you know, eighteen tracks is nothing at all. People have seventy tracks. But back then, in 1986...

You did the sound in '86? We finished in '86. We started in 1984, it took two years. So in '86 I was finished.

Did you record the dialogue wild? I tried to get the dialogue in synch with a CP-16 camera. But everything that's not dialogue — footsteps, clothing sounds, dogs barking, people in the background — was all post dubbed.

You've said that the Vietcong in the opening nightmare were your drum students. Yeah. One poor guy was Korean, he wasn't even Vietnamese.

So you just said, "Come on out, I'm shooting a film?" I gave him a free drum lesson [laughs]. That was the deal. I gave him one free drum lesson and he agreed to be in the film for two days.

Where did you get the weapons for the movie? The guns? There was a store in New York City called Center Firearms. It was the greatest store, you go in and it was just wall to wall guns. Every kind of gun. I just rented them. I had to get a letter from my college saying I was making this film, that I was a student. There were no problems, they were really great about it. They want to rent you their guns. They make no money when they say no. I only had two guns, the M16 and the revolver, so I didn't need much, either.

Buddy G in East Berlin, August 15, 1999.

The opening moments of COMBAT SHOCK pretty much establish that things aren't going to get any better for Frankie. Everything is structured very well. Yeah. But I think there are certain scenes that we should have shortened. It's a hard film to sit through. I screened it over here in Mannheim. I could sense that the audience was getting anxious in the middle. It wasn't a positive anxiousness; it was more like, "Get to the point."

You weren't originally going to show the baby. Is there any particular reason why? Yeah, I had no money to make it. I was going to use a doll. You were never going to see the baby, you would just hear it. I had no access to anyone who could make me anything like that. I shot all of the jungle stuff in the beginning, I had around fifteen minutes of that. I was just showing it to people; I was prepared to make it a short at any time. I wasn't sure what I was going to do. Then I met this guy, Ralph Cordero. He looked at it and I told him what I was going to do. He just said, "Let me make you a baby." He was a puppet special effects guy, a puppeteer.

Are you glad you put it in? Well, it's ridiculous.

Either the audience is going to be totally affected by it or— They laugh.

It's funny and sickening in an EC comics kind of way. Well, it makes the film a cartoon. I think most people hated the baby when the film first played because it took them out of the reality of that situation. Once they saw that kid, it was like, we're in fantasy land. And that kid was modelled after ET. Ralph was fucking around with ideas and said, "Let's just make a really sick ET."

It took me a couple of viewings to appreciate some of the black humour in the film. My girlfriend thinks it's a comedy. And I kind of think it's a comedy too, because everything goes wrong. It's just so out it's in. I think there's real black humour that people generally don't get. I remember when I first screened it to some people for the IFP market in New York. I screened it for the committee. I said, "So, didn't you think that was funny?" They looked at me and said, "You thought that was funny? How can you possibly think anything in there was funny?" I was saying things like, "He goes to drink the water at the end and there's no water. Then he pours the milk, and the water starts dripping." Just stupid shit like that. The shoelace breaking; I just think there was a lot of dark humour. Maybe it was a little too subtle. To me, it was kind of funny.

The main actress was named Veronica Stork? Yeah. I lost track of her many years ago. I heard that she moved to Los Angeles to peruse acting. She might have come back to Staten Island. I met her when she was singing and dancing in a musical variety show in Staten Island. When she was singing, she was able to really act. She not only sang the songs, she portrayed the characters of the songs. She had a real gentle likeability, which is kind of funny, because I did the opposite with her. I definitely took away any likeability. When I used to watch her in this variety show, I really liked her because she had such a softness and sensitivity. She was one of the few people who was an actor in that film. There were few people in COMBAT SHOCK who even wanted to act.

Had your brother Rick done anything prior to that? No. He didn't want to act. He just felt that the people I was auditioning were so bad. He just said, "You know, I can do better than those guys. Let me take a shot." And he wound up to be great.

He also did the music for the film. Yeah. That's what he does, he's a composer. He works out in Hollywood for some big budget films. He arranged both AUSTIN POWERS movies; he did John McNaughton's WILD THINGS.

So, COMBAT SHOCK was his first film credit. Yeah, his first movie tracks. He did a good job on it. Frankie's theme is really cool.

How did you want the audience to sympathise with Frankie? I think the people who like the film like it because they like Frankie. Even though he does those things. One of the things about my approach to violence is that I think you really have to structure your characters to be so completely real. When violent things happen to them, the audience cares. First off, who really is disturbed when the baby gets shot? It's a relief. The fact that the wife is really a shrew throughout the film — for me, the guy is so misguided. I think the audience likes him. My intention was that they always would like him. Here's a guy that wanted everything to be like it is in the movies. He figured he's going to put these people to peace. He's going to kill his wife and kid, and it's all going to be OK. So he shoots

for some of the seedier characters in COMBAT SHOCK? I don't know people like them, but I know the types. I've seen them. A good part of being a filmmaker is observing life and looking at gestures and mannerisms. Trying to read body language, so you can give the history of somebody in a glimpse. Mike the junkie was actually in my short films. We were in film school together. He just finished his first feature as a director. He just did a real low budget film in New York. I've been friends with him for a long time. He used to hang out with one of my younger brothers when they were thirteen or fourteen. So he's someone I've known for a good part of my life. He isn't anything like the junkie in the movie. And actually, if you think about it, he's too heavy to be a junkie. I don't know what

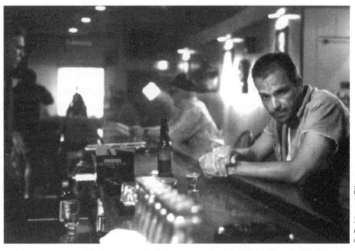

Nowhere to go. No one to trust. James Russo in *No Way Home*.

© Goldcrest Films

his wife, and it's not at all like the movies. It's bloody, it's horrifying.

She doesn't die at first. Yeah, he's looking down and he's screaming, "Die! It's not supposed to be like this." My whole approach to violence is that TV fucks it up. In TV you can kill everybody and there's no blood. It's very clean; somebody gets shot, they fall to the floor, that's it. Here's a guy who's confronted with the reality of it. His wife's puking blood. He's shooting her, there's blood everywhere, and she's still not dead. It's the opposite of what he wanted to do to her.

Did you have any real points of reference

I was thinking. But, again, it was one of those things where he was available. I'd worked with him before. I didn't have any credibility to get actors, so I got my friends.

Paco was an actor, though. That was Mitch Maglio. He was interesting because he was a guy who I hated in high school. He was Frank Sinatra. Luck be a lady tonight, he was always in GUYS AND DOLLS. He wore the hat. We were wearing T-shirts and jeans, he's coming to school in a suit. He was always in the glee club, acting — I hated him. Basically what happened was that we lost touch. I was in college and I bumped into him in a comics shop. I always knew he

was an actor and I was shooting that weekend. I said, "Hey Mitch, are you still acting?" He said, "Yeah." I said, "Do you want to be in a movie?" And that's what happened. Mitch, Veronica Stork, and Frankie's father were the only actors out of the whole cast. Mitch was really great. I really liked working with him. I met him on Tuesday and we started shooting on Saturday. It was just one of those freak things. I didn't think of him, I hadn't seen him in a couple of years.

He really brings something to it. I really liked the guy with the glasses as well. Paco's flunky. That guy was a student of mine. I was teaching film at the time. I was still a student, but they said, "If you teach, we'll pay you." I was teaching a beginning class and he was one of my students. I just liked the way he talked. He just had such an unusual accent, I'd never heard an accent like that. His name was Asaph. So I just asked him to come in and he was cool.

Did the place where Paco sold his drugs have any particular reference? That factory would be like hanging out at the main bus station or hanging out at the quarry. When I grew up, there was a big quarry, a place with big piles of rock. It was a place where you would hang out, get drunk, buy some pot. I mean, that's how I played that. It was just a place where they sold their drugs.

As far as the unemployment office scene goes, why have pictures of Ted Kennedy and a DAWN OF THE DEAD poster hanging up on the walls? Well, I'll tell you what. That room was a room in my college and there was nothing on the walls. It was just a white room with a desk. And I just grabbed every poster and picture that I could find. I just figured, the more bizarre the better. Frank Zappa's on the door, there's DAWN OF THE DEAD, Ted Kennedy, family pictures, pictures of strippers. It was just clutter. That picture of Ted Kennedy was so strange. How could I not put it in? Also, I wanted to play it up that the guy there was this liberal: "I'm sorry, my heart bleeds for you, but I can't help you." The typical left wing liberalism.

Why the line about the Veg-O-Matic? That's a good question [laughs]. I'm showing my age. When I was a kid, Veg-O-Matic was this thing that was always on Channel 9. Do you know what the Veg-O-Matic is? It slices, it dices, it cuts, it does this and that. I don't know, I just wanted to have something to break up the scene, and I wanted it to be in the film. I'm such a terrible actor that I just did a stupid thing like that. I'm also the crying bum. I'm very proud of that. At the end of the phone conversation with my brother, when he hangs up the phone, that's me crying.

You've mentioned that the guy who played the pimp was actually a Born Again Christian. Yeah. He was an actor too. He was actually really good. It was like ninety-five degrees when we did that scene. He was wearing that thick coat. When he took it off at the end of the day, he was soaking wet.

Did you have any problems using the soundtrack from MARNIE in the television scenes? Troma almost didn't want to use that, they thought we were going to get in trouble. They thought they might get sued or something. But that was so perfect. It was like her speaking. "Get away from me. I didn't want to get married. You're animals." Finally, Lloyd [Kaufman at Troma] said, "Let's leave it in. I think Buddy likes that." And Buddy did like it.

I've read that you built a bloody foetus for the end of the coat hanger in the overdose scene. Yeah. I kind of regret not filming it better. It's to Mike's left. When he throws the coat hanger away, it's black, it's all covered in blood. It's a little foetus with a tube hanging from its gut. It was made by Jeff Mathes. You can kind of see it in the film print. Maybe it's better that you can't see it a little clearer. It's there, but it doesn't read.

Was there anything written for COMBAT SHOCK that you didn't film? God, let me see. There were some really fantastic shots of my brother walking. He walked so much, I just couldn't put them in. That was part of having a

forty-page script. I was trying to stretch the length, so I had all this endless travelling from one place to the next. There were really no scenes that were shot that didn't make it in. Certain shots, of course, but no scenes.

How long did it take you to edit the film? About a year.

What was your first reaction when you sat down to watch it? The first time I screened it, I was completely upset and devastated. The guy who cut my negative did such a terrible job, he scratched up the entire thing. So, the very first time I screened it, I really freaked out. Then, my lab told me that it was OK, they could liquid gate it, print it through liquid to fill in the cracks. So, once I saw it in good shape, I was proud of it. One of the first people who screened it was Rick Sullivan from GORE GAZETTE. He used to have these screenings at New York City at The Dive. I remember, I finished the film a week or two before I met Rick. He just would screen all this stuff, so I said, "I just did this film. It's pretty bizarre, what do you think?" He said, "Sure, fuck it. I'll screen it." Just sight unseen, he didn't know me. And not only did he screen it, he brought over some distributors. It was so fantastic, I never forgot Rick for doing that. And that was the beginning of things, because Rick always wrote favourably of it, and would tell people about it.

Didn't John Waters give it some press? He gave me advice and support. I'd written John a letter or two when I was in production and I sent him some pictures. I sent him the film when it was finished. He called me back around midnight and said he really liked the film. The thing that struck me was that he thought the milk scene was the most disgusting thing he'd ever seen. He said that it was much more disgusting than the violence. And to this day, if I see him, I'll mention that. He remembers me as the guy who made that film with the milk.

I think that's the most disgusting scene as well. [Laughs] Really? It's so easy. It's just vanilla ice cream.

It goes along with the entire mindset at the end. He knows the milk is spoiled and he just sits down and drinks it. Nothing registers. You know that's it, he's gone. That's true insanity. Brad Pitt in 12 MONKEYS, that's not insane. People who behave that way are not insane. The insane guys are the people who are completely normal and then have that snap. Like the guy who takes a rifle and kills twelve people for no reason at all.

Do you consider COMBAT SHOCK exploitation? No. I didn't make it with any — I didn't dream it would be released. I thought I'd be really lucky if it would be like John Sayles' first film, SECAUCUS 7. He made that film to show to people and say, "Here, I made a feature film. Hire me to do another one." That's what I wanted to do. I wanted to do a ninety minute film just to show that I did a feature. Let's move on to the next one. I never dreamed it would be released. If I did think it would be released, I probably would have done a few things differently. I think that's the reason it's so dark and so bizarre. I had no commercial goal whatsoever. I didn't give a shit, I just wanted to make the film I wanted to make.

Did COMBAT SHOCK play any film festivals? No. It played in Munich because the woman in Munich really liked it. It played in Florence, but it was rejected by maybe seventy festivals. I tried to get it into every festival I could. I mean, I tried. I thought it was a festival film, an art film in a way. I remember I screened it once at the IFP. There were about eighty people watching. Little by little, they left the theatre. Then, with the coat hanger scene, literally thirty people got the hell out. That was it. They left. I had been at the festival for a week or so, just meeting these people. After the film was over, I said, "I've been telling you guys about my film for a week. What happened?" They just pretty much said, "The coat hanger scene is the limit. Anyone who can film that has made a film that we don't want to see." I felt two inches tall. I was really pissed off, because they're supposed to have an open mind. But they didn't.

How long did it take to generate some fan interest in the film? Three years. I really credit Steve Bissette [comic artist, SWAMP THING, TABOO, TYRANT] for that. That article he wrote for DEEP RED was probably the most comprehensive piece on the film at the time. He wrote about the sound, about specific frames and things. I think he brought the film to people's attention. Chas Balun [editor, DEEP RED] was really instrumental too. People read about it and said, "Here's this little film we should check out." Word of mouth introduced the film to a lot of people.

You were involved in shooting the MANIAC II promo reel. Yeah. The guy who did the lighting on COMBAT SHOCK was named Jim Gribb. He knew Bill Lustig and had met Joe Spinell. He called me up and said, "Joe Spinell is looking for a director for MANIAC II. He hangs out at this bar up on 82nd Street. He's there after eleven o'clock, you should call him." So I called him at the bar. I was a huge fan. Joe was like the only celebrity actor I'd ever met at the time. I talked to him and said, "I just did this film." COMBAT SHOCK wasn't even finished yet. I wasn't done with the sound design. Joe said, "Meet me now, come on out." He gave me the address of the bar and I came over at midnight. We started hanging out, and one thing led to the next. I asked him why Bill Lustig didn't want to do it. I was a big fan of MANIAC. Bill was doing another film at the time and he wanted to do his own films. VIGILANTE and HIT LIST, and whatever he was doing. So, I got teamed up with Joe. We worked together on the script and I put together pretty much the same crew that did COMBAT SHOCK. We shot it in three days.

What was Spinell like? He was fantastic. I learned so much from Joe. He was tough at first. The first night of shooting, I almost quit the film. Joe was really trying to take over, calling out camera shots. I realised later that he was testing me to see if I was really a director. Just seeing how far he could go. I finally called him on it and said, "Joe, if you want to direct the film, direct it. I'm going to be out of here in another ten minutes." He took a step back and we talked about it. From that point on, he was a dream.

I've found in every film I've done, actors want to see what type of person they're working with.

I've read about a script of yours called 123 DEPRAVITY STREET. I've been dying to make that. Roy Frumkes [STREET TRASH, DOCUMENT OF THE DEAD] might produce it. He's been doing his own projects and he never got involved in the fund raising. If I could ever pull things together, Roy would be the guy to produce it.

Is it along the same lines as COMBAT SHOCK? It's better. It's really sick. It's really sick, sexually sick. It deals with religion, sex, and violence. I'd love to make it. If I have any amount of luck in my career and I can reach some level of success, I would bring that script along and say, "Look, I can do this for under a million dollars. Just let me do it." I'd shoot it in 16mm if I had to. I've been wanting to make that film for seven or eight years.

What sort of experience was selling the screenplay for SHE'S BACK? Did you write it with the mind to direct it? Yeah. It was originally called I4NI. It was a really dark vigilante piece about this guy who takes the eyes from the victims and leaves them in jars. He's haunted by them; wherever he goes, the eyes are always looking at him. He has this dead wife that comes back and forces him to kill. She just nags and nags him. She's everywhere. I met Tim Kincaid. He was doing films for Charlie Band's company. He directed ROBOT HOLOCAUST and things like that. He was able get a deal with Vestron, they wouldn't make it with me directing. Once Vestron came along, things got more commercial. It wasn't a good experience.

Another film I wanted to ask you about is your short, SLICE OF LIFE. That was kind of a documentary with two friends of mine, Steve and Nancy. They're going through this break up in their relationship. Steve cuts himself to keep control over their relationship; he starts hurting himself and she feels terrible about it. She doesn't want to see that happen, she comes back and they work it out. But then, she reaches the point where she's not going to put up with it anymore.

There's this whole psycho-drama thing with her. She's telling him, "It's over, I can't take it anymore. You're controlling me, you own me." He starts cutting himself and she refuses to give in. But you can see it in her face that it's really destroying her to see him like that. It's incredible what the guy does. He was able to just put his mind in a certain area where he could just do that. People don't think it's real, because it's so sick.

So it's for real? Absolutely. I shot it with no cuts whatsoever, because I knew if I cut it, nobody would believe it. And people still don't believe it. It's seventeen minutes long with no cuts, it's just [mimics slashing] all the time.

Where did the idea for this come from? It just happened. It was one of those freak things. We were going to be filming something else, something entirely different. Steve was going to cut himself on camera, but his friend didn't show up for the shoot. I was there with the camera and Steve said, "Well, fuck it. Me and Nancy will just do something." They went up to the roof and it took place. I just stood there and kept my mouth shut.

What lead to your first novel, LIFE IS HOT IN CRACKTOWN? I got sick of writing scripts like DEPRAVITY STREET that could never be made. I knew that if I wrote a book, it would be finished when it was finished. CRACKTOWN is such a violent, depressing vision. I knew that I could never do it as a film. You can only do a COMBAT SHOCK once in your career, I think. So, I just wanted to write a book that would be like a kick in the balls. To say to the world, "Fuck you, this is a slice of life, too."

What about POETRY AND PURGATORY? I think that's dying to be made into a film. Well, I'd love to do that as a film as well. At one time, Eric Stoltz wanted to play Eddie. I thought that would be perfect; you don't even need make-up. But, his producer didn't like it as much as he did. We never had any official talks about it. But he was asking about it. It would be a tough film to make, just because of all the vi-sions. CRACKTOWN would be easier.

How did that book do? It didn't do as well as CRACKTOWN. Part of the reason, I think, was that it was so bizarre. I love it, that book is one of the closest things to my heart. When I was writing it, I thought I had brain cancer like Eddie. I had these headaches. But it was all in my mind. Just writing that book gave me a headache every day. It took place where I was living, in the lower east side. I would just walk the streets like Eddie. Things that I saw wound up in the book. I really didn't connect the same way with CRACKTOWN because I wasn't on crack, and I'm not a fifteen-year-old black girl who's being raped by her father. There was a certain distance in CRACKTOWN that I didn't have in POETRY.

Or in NO WAY HOME. How did that film get started? I was trying to make that film for four or five years. I couldn't raise the money. I wrote it so that it took place in a house like COMBAT SHOCK. I thought I'd raise $40,000 and shoot it with unknown actors. I couldn't raise the money. It's much easier to raise five million dollars, believe it or not. For some reason, nobody will give you a small amount of money because they think you just can't do it. They feel much more comfortable giving you a lot of money because then they know you can make a real movie. Nobody wants to take a chance on making another COMBAT SHOCK, I guess. Finally, Tim Roth got the script through an actor friend and loved it. He was the reason the film got made. Without Tim, I could never have raised the money. He was great, he said, "Use my name, tell people that I'm in your film." So, that's what I did. And once you have Tim Roth in your movie, everything falls into place. Deborah Unger wanted to be in it, James Russo came on board. It was a dream. Hard work, though. When you work with people like that, they keep you on your toes. They're at the top of their game and you don't get away with anything. You have to have some valid reasons for what you're doing.

What's it like to make a film with no money and then move on to a film with a budget, not to mention Tim Roth? You know some-

LIFE IS HOT IN CRACKTOWN

BUDDY GIOVINAZZO

aren't around. I didn't have any interference. When the film was finished, things were different. They came in for post-production because it's just me and the cutter. Every situation is different. My producers would have preferred that I didn't do the sex and violence intercut at the bar. The company was very upset with that. They said it looked like a porno film. I said, "Yeah, but that's exactly what was in the script." They'd go back and check the script. They'd argue that it was one thing to read it, but another thing to see how I'd filmed it. They felt that way about the kitchen scene as well. All that was in the script, but they didn't know I was going to let the blood sit on the floor like that, to have them fight and roll around in the blood. But, producers don't want to take over your film, because it's not good for their reputation. They try and convince you, they try and bring you over. What I ultimately had to do was compromise, because in this case, they had final cut. They could say, "We need to change this scene," which was a scene I really liked. They'd say, "Give us a little here and you can keep a little there." But, to be fair to the producers, they really didn't want to take over. They were actually kind of cool about it. Nobody wants that reputation, because I have

thing? Honestly, it wasn't that different. We shot the prison sequence on my first day of shooting. I was really shocked at how much it was the same. There wasn't that much pressure at all. As a matter of fact, if anything, there was more pressure on COMBAT SHOCK. We had nothing on that one, it was a challenge just to make it into a film. With NO WAY HOME, I had people to do the jobs — I didn't have to sweep the set. I had a crew of fifty people. I thought I would have to be so locked into my shooting script and schedule, I thought I'd have to have things so prepared. I realised on set that first day that I could just say, "Fuck this. We're doing this instead." I'd change shots and I just made things up. If something occurred to me, I went with it. That's when I realised that filmmaking's always the same. But then, it really wasn't a big enough budget film where I had pressure.

What kind of budget did you have? About three million. The company wanted quality, so I didn't have to shoot quickly.

Did you have any hassles from your producers? When you work with stars, the producers don't lean on you at all. The stars don't want the producers around, so the producers

POETRY AND PURGATORY

BUDDY GIOVINAZZO

to do the festival route and interviews; they want everyone to support the film.

What do you have planned for the future? Well, I'm talking to some of the people behind EVERYBODY DIES and they want to do another film with me afterwards. It's going to be a vampire film, it takes place in Berlin. Berlin is the absolute perfect city for vampires. Way up in the east, there's all these rundown factories and buildings, it's perfect. And I'm trying to finish a book called POSTDAMER PLATZ. It's a crime novel that takes place over here.

Do you ever think you'll say, "Fuck it," and shoot a film about wholesome family living? I don't know. I'm a sick fuck [laughs]. I don't know. I just think the stuff I do is much more interesting than writing stories about wealthy people or the middle class. Maybe I'll mellow with age, but right now, I'm much more drawn to this stuff. This shit is much more interesting to me.

Addenda

On June 26, 2000, I contacted Buddy G for a check on the progress of his latest film. It was in the can, and the name had been changed somewhere along the line from EVERYBODY DIES to THE UNSCARRED...

When I was in Berlin, you had just started pre-production and things seemed a little crazy. There's never enough time to make a film, no matter how much time you have. That's the trick, doing the best you can in the short amount of time you have. I handle this by telling everyone to work faster.

What was it like working in Berlin? It was hard because of the difference in the way they work. They have a set way to work and my way of working was completely different, so there was some period of adjustment on everyone's part, including my own. Jörg [Buttgereit] showed up one day on the set until I had security guards

physically remove him.

I know you were trying to cast James Russo. He was my first choice from the beginning. He's great in the film, I think it's his best work yet.

How long did you have to shoot? The shoot was about six weeks, which is pretty cool for a small film. We used a moviecam camera rig and shot the entire film using a Steadycam, which was a real experience. It's much harder than I thought it would be.

How long did you work on the editing? We cut for about sixteen weeks, maybe more, I can't recall. I worked with a great editor named Katja Dringenberg. She was terrific to work with and extremely talented. She brought a lot to the style and pace of the finished film. And we had a real blast working together too.

Who scored the film? My brother Rick. This is a fantastic score. He composed a heavy metal-techno hybrid that's perfect for the film.

Are you happy with the way it turned out? I'm really happy with the way it turned out, though I think there are problems in the film. It came out the best it could have come out given what we had.

Do you think your films are more popular in Europe than in the USA? Yes. I don't know, it's a mystery to me why Americans don't respond to my work. My first instinct isn't entertainment, maybe that's the problem. People want to be entertained and I want them to be disturbed.

So what's next? POSTDAMER PLATZ is nearly finished. I've started the screenplay adaptation, to be directed by Tony Scott.

Are you still planning on shooting the vampire picture in East Berlin? Absolutely. I'm writing that screenplay now and hoping to be in production by March. There's still a lot of work to do... 🖳

The Herbaceous Headpress Guide to Modern Culture

REVERBSTORM No 7
David Britton & John Coulthart

£3.50 60pp; ISBN 0 86130 102 1; Savoy, 446 Wilmslow Road, Withington, Manchester, M20 3BW

You know the ingredients by now: Oswald Mosely, William Joyce, Jessie Matthews, mutating cyber organisms, cyclopean edifices, black smoking death factories in the qliphothic discorporation zone. Oh, yes, and Humpty Dumpty — best not forget him. Yet, despite its now familiar iconography, Britton and Coulthart's Lord Horror series still soars. And it still shocks to the core, with its debased poetry and its manic juxtaposition of the macabre and the banal. Whilst Britton's 'stories' are becoming increasingly abstract and hallucinatory, Coulthart's brilliant artwork more than matches these flights of dark fantasy, making the fact that *Reverbstorm* is by far the best illustrated comic on the market sound like an understatement.

Comparisons? Strangely enough, though nothing else quite compares in the fields of literature, arts or comics, *Reverbstorm's* apocalypticism resonates strongly with David Tibet's recurring themes in the music of his band Current 93. Despite this, *Reverbstorm* isn't in need of any soundtrack. It's the complete article.
STEPHEN SENNITT

MALEFACT No 7

$7.00 92pp; PO Box 464, Alexandria PA 22313–0464, USA

Shit and piss and some skulls dept. I don't know about you, but when I get up in the morning and go for a dump I tend not to pick it up afterwards, or for that matter scrutinise it or put it in my mouth. For those of you who do get these urges, there's *Malefact* magazine — a fun-filled extravaganza for faecally obsessed regressives who bitterly resent their parents for causing them severe early toilet-training trauma. Now they're 'all growed up', these folks can shove it right back at the straight society that forbids the rights of children everywhere to smear them-
Continued on p.136

"I KNEW I WOULD CARRY THAT SMILE WITH ME TO MY GRAVE"

— Officer Dwight Bleichert, *The Black Dahlia*[1]

by Darren Arnold

THE MURDER OF WAITRESS Elizabeth Short is one of the most intriguing cases to have occurred within the Los Angeles area. Short's demise is often detailed alongside the deaths of Hollywood celebrities (Sharon Tate, Sal Mineo, James Belushi, etc), but in reality she was far from being a star — at least when she was alive. Elizabeth Short (aka Betty Short, Beth Short, 'The Black Dahlia') certainly craved stardom, but made little progress towards that goal during the time she spent in Hollywood. Instead, early 1947 found her in a vacant lot[2] in Leimert Park, her body completely drained of blood and cut in half at the waist.

There are a number of fragments of information that exist regarding the life of Betty Short, and a few books devoted to the subject.[3] There's even, somewhat strangely, a computer game[4] that contains a tenuous Short connection. However, one of the most interesting works to deal with the Short murder is **James Ellroy's** novel **THE BLACK DAHLIA**. Published long before Ellroy became a household name with Curtis Hanson's film of *LA Confidential*, *The Black Dahlia* is an absorbing stand-alone book and, more significantly, a work that raises many interesting points regarding the life (and death) story of its subject.

The 'Black Dahlia' tag is the name that was given to Betty Short, the most common reason for which being that Betty wore dark clothes and dyed her hair black — although the Veronica Lake movie *The Blue Dahlia* was clearly a big influence on the originators of this moniker. The name has strong *film noir* connotations, and most would assume that a woman (real or otherwise) going under such a title would be something of a *femme fatale*. And here's

where it starts to get tricky, as Ellroy's book — which is admittedly a fictional tale based on a real-life event — paints the Dahlia as being no angel, which is in sharp contrast to what is considered to be Betty Short's true story.

Elizabeth Short was born in Hyde Park, Massachusetts, on July 29, 1924. She came from a Baptist family, and her father built mini golf courses. When Elizabeth was five her father — whose business was in serious trouble — appeared to commit suicide, and Betty's mother was left to struggle on with a pile of debts. Eventually, the father resurfaced, but Betty's mother would have no more to do with him. Betty took a keen interest in her father when he moved to California, and she moved in with him for a period — ending with her being told to leave because of her laziness, among other things. Betty tried her luck in Hollywood, and met with little success. An ambition that she held at least equal to film stardom was to get married — ideally to a US serviceman — and this hope also floundered when her pilot fiance was killed in an aeroplane crash.

Unlucky in love and with no career to speak of, Betty Short's life didn't add up to too much. She kept afloat by using her good looks and friendly personality, and this was generally enough to ensure that meals and drinks were always bought for her. Although she may have been aware of the affect she had on men and the material rewards this brought her, Betty Short wasn't exactly the streetwise cynic; if anything, she was a bit of a hick simply trying to muddle her way through life among those alluring bright lights.

James Ellroy's book is an exceptional, bold work that deals with a difficult case. Ellroy has taken the names and lives of real people (Betty

Short, Mack Sennett) and occurrences (such as the truncation of the 'Hollywoodland' sign) and intertwined them with fictional characters and events. It is precisely because so little is known about what actually happened to the Dahlia that Ellroy is given a reasonably free hand to colour in the events surrounding her death — but it nonetheless takes a brave writer to create a novel from splashes of both fact and fiction, especially when the fiction is none too flattering to the deceased.

'The Black Dahlia'

Ellroy's Betty Short plays it fast and loose, chancing her arm until her final undoing. She struggles to pay her rent, invents servicemen boyfriends, and works as a prostitute (clients including members of the LAPD). She appears wise enough to deal with most situations and people, and a measure of the world she inhabits is given when pursuing a porn film lead (or a hint of something stronger) becomes a significant part of the investigation following her death. While Ellroy's take on Betty may be unflattering, it isn't unsympathetic — it's clear that he views the Dahlia as being someone way out of her depth whose ultimate dependence on others proves to be her fatal flaw. And although Ellroy isn't the first person to hint at Betty Short being a bit of a whore, in reality she had a vaginal deformation (revealed

at her autopsy) which meant she could well have died a virgin. With this in mind, endeavours into the world of prostitution seem a little unlikely.

Putting Betty Short's character and behaviour to one side, it is interesting to look at how the facts of the case are represented in Ellroy's book. Short's dates of birth and death[5] are as officially recorded, but there is one notable change when it comes to the exact details of the condition the body was found in.

Ellroy's version of how the Dahlia was found is pretty much in line with all other accounts. As already mentioned, the body was severed at the waist, with the bottom half being found a few feet away from the top portion. The knees were broken, the teeth cracked, and the breasts dotted with cigarette burns and knife wounds. The mouth was slit in an ear-to-ear grin, and, unusually for such a grisly scene, the hair was free of matted blood and appeared to have been washed and set by the killer.

However, one of the stranger details — regarding a small triangle of flesh that had been carved from Short's left thigh — is where Ellroy deviates from the facts. This triangle was actually found during the autopsy, when it was discovered inside Short's body. The triangle contained a rose tattoo. In Ellroy's version the triangle is not found anywhere in or near the body, but is found in the killer's lair, where pursuing policeman Dwight 'Bucky' Bleichert discovers it in a jar. Ellroy's version further differs by way of the tattoo being a heart, not a rose.

It is perhaps not too difficult to see why Ellroy included this difference in his book. The Black Dahlia is a novel where an obsessed police officer follows a tortured path to find Betty Short's killer. Had the triangle been found with the body then it would have precluded a large element of mystery, and the piece eventually being found in a jar is well in keeping with the familiar idea of a killer and their trophy.

Of course, the identity of the killer is an area where Ellroy is free to speculate, as no one was ever convicted of the crime. As with any sensational crime, the chronic confessors came out of the woodwork, and the 'ninety-three phoney confessions'[6]

mentioned in Ellroy's book is somewhat in contrast with the forty-plus figure mentioned in a guidebook to Hollywood murders.[7] (Of course, more than forty could in fact be the same as ninety-three, even though such a description wouldn't be very accurate.)

In The Black Dahlia we are led through numerous twists and turns before Bucky Bleichert finally nails the killer — but even then, as in real life, there is no conviction to speak of. This may take a radically different route to what really happened, but the end situation in the real-life case was somewhat similar; Jack Wilson was a suspect who gave police details of how the Dahlia was killed — as supposedly told to him by an Al Morrison. The police couldn't find any evidence to support the existence of 'Al Morrison', who was by then believed to be an alias for Wilson himself. Before this line of enquiry could be pursued, however, the alcoholic Wilson fell asleep while smoking and burned to death in his bed, taking the last (and strongest) hope of a conviction for the Black Dahlia murder with him. ⌨

NOTES

1 James Ellroy, The Black Dahlia (Mysterious Press, 1987), p87.

2 This area has since been built upon. At the time the location was given as being on the corner of Norton and 39th Street; nowadays the spot is just inside the driveway of 3925 South Norton.

3 Titles looking at the Betty Short case include John Gilmore's Severed: The True Story of the Black Dahlia Murder (see review) and Janice Knowlton's Daddy Was the Black Dahlia Killer (Pocket Books, 1995).

4 The computer game The Black Dahlia was released by

Take 2 Interactive Software in 1998.

5 Short's date of death is recorded as being January 15, 1947. Of course, this is the date when she was found in Leimert Park, and as she was missing for a few days before this date then it would be reasonable to conclude that the actual date of death might have been a day or two earlier than that officially recorded.

6 Ellroy, p155.

7 Ken Schessler, This is Hollywood (Ken Schessler, 1978), p67.

SEVERED
The True Story of the Black Dahlia Murder
John Gilmore

£12.95; 230pp; ISBN 1878923102; Amok Books, 1998

Elizabeth Short, 'The Black Dahlia'. Ever heard of her? The nickname may ring a distant bell, but the chances are you're not sure why. Ever heard of Fatty Arbuckle or Marilyn Monroe? Short's death as much as theirs stands as inspiration for Kenneth Anger coining the phrase 'Hollywood Babylon'. An as-

pirant actress and model, Short was found dead at the age of just twenty-two, her body hacked in half and dumped in an empty LA lot. She had been anally and vaginally violated, and forced to eat human faeces. To ascertain her height, the coroner had to measure the two separate portions of her corpse separately.

Short was the archetypal small-town girl wanting to make it big in movies. With striking features and jet black hair, she stood out in her hometown — but then as now, she was just one of thousands of lookers

in LA. Never able to apply herself, never able to find the right job, the right man (except for one, her fiancée, tragically killed during the last days of WWII), she drifted about sleazy bars, flophouses and shady characters before her untimely demise. It is in this milieu that Gilmore's talents shine: he describes a world now long gone, a world both sleazy and glamorous, cocktail dresses and heroin needles, B-movie actresses and abused prostitutes, lipstick and mascara and blood trickling into gut-

Continued on next page

'Spice Sluts' by Maccad, from *Sick Puppy Comix* No 11.

Continued from p.133

selves in shit, vomit, piss and other bodily excretions. How do they manage this? By drawing pictures of ugly people engaging in this very act! And let me tell you, *Malefact* — a very well-produced magazine, identically formatted to *Esoterra* — is packed to the brim with drawings of ugly people shitting and pissing, and eating shit and piss. Some of these people are so ugly they look like ghouls and monsters. Some of these drawings are cartoonish; some resemble tattoos; some are well-rendered pencil sketches. Some are even by artists you will have heard of! From *Headpress'* Rik Rawling, to the only funny *Malefact* contributor, Mike Diana, to the terminally boring Trevor Brown, it's shit, piss and violent death (via shit and piss suffocation) from cover to cover! And just

in case the *Malefact* editorial slant isn't clear, there's also plenty of gnarled, oozing genitalia on display, most of which are spunking-up onto, yes, you've guessed it, lumps of shit! Sometimes it amazes me how thought-provoking and clever the 'underground' scene can be.
STEPHEN SENNITT

SICK PUPPY COMIX No 11

56pp A5; Aus$5/US$5 postpaid; Rabid Publishing, PO Box 93, Paddington, NSW 2021, Australia; www.sickpuppycomix.com
This treads a similar path to *Malefact* [above], in as much as it features good artwork and questionable subject matter. *Sick Puppy* is also predominantly comic strips as opposed to single-panel sketches — so that's another difference. Some of the work is pretty funny (like 'Tom Cruise is not Gay', wherein the diminutive

Severed continued

ters. Hollywood will never again be as we perceive it to have been in those heady days. And Elizabeth is the perfect metaphor for how we might remember this time few of us actually experienced: happy and gay but with an otherworldly edge; friendly, vivacious, yet never really in the some place as everyone else. *'Elizabeth was of the night. She was the dark...'*
Gilmore (who has had a real Holly-Baby life himself) tells a fascinating story but one which can drag. The first 100 pages, in which various lowlife try to get into Short's pants, feel stretched — Short's character has been established and she doesn't change much, so why all he

detail? What must be appreciated though is the author's devotion: he has spent *twenty years* cocooned within this story, so I suppose the least we can do is listen. And one must respect Gilmore: his obsessive research has added to the sum total of human knowledge. Many facts here have never been brought to light before and he does offer a convincing answer to the mystery of who killed Short. This mystery is the concern of the book's latter half — and fascinating, twisted reading it makes: hardboiled detectives suspicious of one another, innocent men's lives ruined by the same 'tecs desperate to convict somebody, anybody, of the murder, *LA Confiden-*

tial style pondlife hacks digging for dirt... even William Randolph Hearst himself covering up any connection to the slaying of a wealthy heiress who may have fallen prey to the same killer. The inquiry is far more fascinating than the murder itself, just like classic *film noir* rules dictate it should be. Of the murder, the book contains some *very* grisly photos, though I feel it would be inappropriate to direct gorehound thrillseekers towards *Severed* in search of visual titillation. It has far more to after than that.
So who did *kill* her? I have no idea, but I'm prepared to believe Gilmore for now — he has certainly put the graft in. ANTON BLACK

actor has sex with women, picks up female hookers, and beats the shit out of queers to try and dispel the rumours), while most all of it is sex-obsessed: many of the strips conclude with women drenched in sticky ejaculate, courtesy of some big bad mean motherfuckin' man wearing leather and tattoos. Or a horse. The creamed women either love it in a subservient way, or are forced to endure it. Actually I'm lying — only ten out of the thirteen strips end like that (eleven if you include the cover). That's a lie too; you don't think I'd sit here counting cum-covered comic strips, do you? JOE SCOTT WILSON

WEIRD ZINES
Justin Bomba

£1.50 (cash only, incs p&p) 24pp; J. Marriott, 159 Falcondale Road, Bristol, BS9 3JJ (age statement reqd; do not write 'Weird Zines' on envelope)

The man responsible for *Bomba Movies* (and the one-shot *Sadomania*) turns his attentions away from cinema for a moment and toward small press publications that don't encompass music, poetry, politics, riot grrls or fiction. In other words, the kind of zines reviewed in *Factsheet 5* that appealed to Justin Bomba, but were few and far between and took "page upon page to find". Well, you won't get lost with *Weird Zines* — it's only twenty-four pages for a start, and constitutes a diverse collection of cheap'n'cheesy paper oddities, along with their ordering details. Some of this stuff may already be familiar to anyone with their ear to the ground of marginalia, but a lot more won't be. *Sex & Violence* is a zine devoted to obscure B-pictures (some of which might be fictitious) and comics; *Stupor* features interviews with bar-hoppers around Detroit, who drunkenly recount tales of woe and stupidity; *Danzine* is for working girls, with news and advice on things like club conditions, affordable housing in various cities, and bad dates. DAVID KEREKES

CHAOTIC ORDER No 7

£2.00 (3-issue sub £5.00) 40pp: Chaotic Order, 15 Digby Close, Doddington Park, Lincoln, LN6 3 PZ

Chaotic Order is an A5 zine published on a (theoretically) bi-monthly basis which dabbles in much the same sort of dodgy extreme/exploitation culture as *Headpress*, though

admittedly in a less in-depth way. This issue features interviews with Richo Johnson of *Grim Humour* and *Adverse Effect*, industrial band Leech Woman, a sort of FAQ piece on power electronics band Whitehouse (largely culled from the Susan Lawly website), a piece on 'Xenomorphosis' by Cinema of Transgression veteran Nick Zedd, a profile of Nick Zedd's old mucker Kembra Pfahler, articles on Mondo movies and necrophilia, and a pretty terse and opinionated review section. There is also a quite gratuitously revolting and not very good short story called 'Assault' by 'Mr E' — I guess this sort of goes with the territory — and some not very literate poems and other bits and pieces.

Overall, production values are reasonably good, though some more time spent with the spellchecker wouldn't go amiss, and there are a couple of bits of white-on-black text that I couldn't read at all. Like all the best zines though, there is a very personal flavour and distinctive editorial voice to *Chaotic Order*, which you may find either endearing or irritating.

One final point; the editor of *Chaotic Order* is named Bob Smith. I was watching Russ Meyer's *Faster, Pussycat! Kill! Kill!* last night, and 1hr 13mins into the film the name BOB SMITH is clearly visible on Tura Satana's licence plate. Coincidence or something more sinister? I think we should be told. SIMON COLLINS

SHAG STAMP No 8

£1.50/$3 Europe/$4 Elsewhere (incs p&p) 52pp; c/o Mohawk Beaver, Poste Restante, Nørrebro Postkontor, 2200 København N, Denmark

This slim little fanzine is the work of one Jane S, sex worker, performer and wanderer around Europe. She writes about the different places she's visited, the places she's stripped or danced or stayed. There are interesting snippets of conversations and some thoughtful pieces on sexuality, sexism, Annie Sprinkle and the life of a sex worker. Some of the pieces seemed to meander, such as the reminiscence of Glastonbury and Jane's attraction to a bloke called Nick, but on the whole I like the unassuming, unpretentious nature of this. And some of her observations about life, politics and places are spot on. PAN PANTZIARKA

IS IT... UNCUT? No 10

£6.95 56pp; Midnight Media, PO Box 211, Huntingdon, PE29 2WD; tel/fax: 01487 840505; paul@midnight-media.demon. co.uk; www.midnight-media.demon.co.uk

One of my favourite film review zines of recent years, *Is it... Uncut?* runs informed appraisals of obscure DVD and video releases from around the world. The fact that it's published in the censorious UK (its title is something of an in-joke), *Is it... Uncut?* has a healthy tendency to compare and contrast the various prints available of the films it discusses — though thankfully never in the retentive frame-counting manner of *Video Watchdog*. Films covered in issue No 10 include Joaquin Romero Marchent's *Cutthroats 9* (described as 'the ultimate Gore Western'), Irv Berwick's *Hitch Hike To Hell* ('ineptly produced in most departments'), Jack Woods' *Equinox* ('animated beasties chasing slender 60's bimbos'), and H Tjut Djalil's *Misteri Janda Kembang*, an Indonesian horror film that is said to contain 'several gleefully non-PC scenes' (in which men begin to exhibit 'ridiculous "gay" mannerisms') but is 'well-lit throughout'. This edition of *Uncut?* also divulges the disappointing news that Anchor Bay's much heralded recent release of José Larraz' *Vampyres* is far from the uncut print the world was expecting. All this, and an interview with Camille (*I Spit on your Grave*) Keaton, go to make *Is it... Uncut?* an essential purchase for dedicated fans of low-brow movie entertainment. As with most publications from the Midnight Media stable [see also *Ilsa Chronicles*, below], quality is also very high. DAVID KEREKES

ILSA CHRONICLES
Darrin Venticinque &
Tristan Thompson

£10/$15 60pp; Midnight Media (for contact details see *Is It...Uncut?* above)

"Let us consider the uncompromising nature of *She Wolf*," says Tristan Thompson in his introduction to the *Ilsa Chronicles*. "A revolutionary piece of film-making? Certainly not! This is sheer unadulterated EXPLOITATION."

Earning the accolade of being perhaps the most repellent film ever committed to celluloid, *Ilsa She Wolf of the SS* follows the exploits of a sadistic, sex-mad female SS Officer (called Ilsa) who oversees the experiments conducted on human guinea pigs in Medical Camp 9. Made in 1974, its director was Don Edmonds, and its producer, Dave Friedman, only recently owned up to having any involvement. Given that the illustrious Friedman has put his name to all kinds of dodgy crap over the past several decades (including *Love Camp 7*, an earlier Nazi Camp effort), his use of a *nom de plume* on *She Wolf* can be taken as a mark of the film's overt tastelessness and depravity.

She Wolf has little by way of a plot, but revels in scenes depicting the (beautiful and handsome) prisoners of the camp being tortured: having

their toenails removed with pliers; being penetrated with huge, electrically charged dildos (in order to measure female resistance to pain); dipped into scalding hot water; castrated; and infected with new, virulent strains of typhus. The special makeup effects of Joe Blasco are suitably disgusting, and they make for an interesting counterpoint to the film's use of full-frontal nudity and the rampant sexuality of Ilsa, who shows as little mercy to her lovers as she does the victims who pass through her laboratory. And it's because of Ilsa — or rather, Dyanne Thorne, the actress who portrays her — that *She Wolf* has managed to elevate itself to being more than just a cinematic anomaly. Unlike most other Nazi Camp films, part of a cycle that quickly dropped from favour in the seventies, *She Wolf* has gained a sizeable cult following and has spawned several sequels (its box office return is estimated to be in excess of $10M). Even though Ilsa is killed at the end of *She Wolf*, Thorne's popularity ensured that she return the following year as harem keeper to a ruthless oil baron in *Ilsa, Harem Keeper of the Oil Shieks*; as a Colonel in charge of a Siberian prison camp in *Ilsa The Tigress of Siberia* (1977); and as *Greta the Mad Butcher* (1977), an unofficial

entry in the series in which Thorne plays the brutal doctor of a clinic that supposedly treats sexual deviations in women.

Ilsa Chronicles covers all of these films in-depth and features an interview with Dyanne Thorne herself. The overall quality is impeccable, though I'm not sure why Midnight Media adopted a magazine-look. Given the wealth of wonderful illustrations (many in full-colour) and nagging lack of a contents page, *Ilsa Chronicles* would have lent itself nicely to a perfectbound book treatment. DAVID KEREKES

THE BEATLES UNCOVERED
1,000,000 Mop-Top
Murders by the Fans
and the Famous
Dave Henderson

£12.99 143pp; ISBN 1 902799 04 6; The Black Book Co, 2000; distrib by Turnaround

Dave Henderson is the publishing director of *Mojo* and *Kerrang!* With this book he takes a trawl through the weird, wonderful and frequently downright dull world of Beatles wannabes, cover-version artists and their recordings. If that doesn't sound like an awful lot to go on for a book, think of a number and then keep on doubling it — that's how many records are out there that fit into the oeuvre Henderson has devoted himself to pursuing.

Lots of colourful pictures and short, nothing too taxing, manageable bites of text give the book a somewhat inconsequential feel — which isn't necessarily a bad thing when all is considered. After all, we wouldn't want to delve *too* deeply into Liberace's 'Something' or Val Doonican's 'All My Loving', would we? These are some of the more insipid exponents of the Beatles cover version; songs from those folk who are musically competent but about as creative as lint. Far more interesting and entertaining are those people who try and 'interpret' the Beatles, and manage to bring their own particular dynamic to the recording ('Within You, Without You' by Rainer Ptaceck and Howe Gelb, for instance). Alternatively, there are those artists who make such a hash of the job that they hit a plane of relevance that is far, far higher (or removed) to anything they could have earnestly hoed to reach. Take, for instance, Marty Gold's *Moog Plays The Beatles*, an album re-

Like wow, it's *The Beatles Uncovered*.

FEMALES, 18-35, wanted to step on bugs barefoot for short movie

'Death in the Afternoon' — a shot from a Squish Productions video. *Deviant Desires.*

corded in 1970 which was intended to demonstrate the new, exciting and innovative instrument that was the Moog synthesiser — and what better way to do so than via some Fab standards. Unfortunately, Gold had no idea of the Moog's potential and simply banged out shrill twiddly fills and electronic sitar noises over a syrupy backdrop. 'In My Life', reconciles author Henderson, was a track "undoubtedly recorded on the Moon".

There are albums of Beatles covers done in a Latino style (*Tropical Tribute to the Beatles*), in a classical style, in a reggae style, in a soul style, in an indie-pop style, and — it goes almost without saying — plenty of marching bands have felt compelled to cover the Beatles over the years. One of these albums, *The Band of The Royal Military Academy, Sandhurst, Plays Lennon And McCartney*, features on its sleeve Major Fanshawe on his horse, Thor, riding up some rather grand-looking steps. For those who remember *The Exotic Beatles* series of compilation albums in *Headpress 19*, here is the literary equivalent. With plenty of typos.

DAVID KEREKES

BUKOWSKI UNLEASHED! ESSAYS ON A DIRTY OLD MAN
Bukowski Journal Vol 1
Rikki Hollywood, Ed.

£10/$20 (incs p&p); payable: R. Hollywood, Bukowski Journal, PO Box 11271, London, N22 8BF; bukzine@aol.com; http://members.aol.com/bukzine/bukowskizine

Inspired by the new format of *Headpress*, no less, issue No 1 of Rikki Hollywood's *Bukowski Unleashed!* picks up where the former *Bukowski Zine* left off, but in a nice compact book format, and at the upped price of £7.99. A venue for Bukowski-related ideas, suggestions, reviews and artwork, this is pretty much territory for the pre-initiated; neophytes, of course, should start with the real thing. For international aficionados of the dirty old postman, this is probably a very useful resource for reviews, contacts, info, and all things Bukowski-based. The current issue contains pieces on the archetypal Buk kook, Bukowski-themed comic strips, reviews of Bukowski-based films and other, non-Bukowski-related writing. The fact that this is a nicely-produced and well-illustrated journal isn't the only place where

Bukowski Unleashed! has the upper hand over similar publications, however — it also has a ban on "Bukowski-influenced poetry and stories". I'll drink to that.

MIKITA BROTTMAN

DEVIANT DESIRES
Incredibly Strange Sex
Katherine Gates

£16.99/$24.99 252pp; ISBN 1 890451 03 7; Juno Books 2000; distributed in the UK by Turnaround

Taking its cue from such RE/Search volumes as *Incredibly Strange Films* and *Incredibly Strange Music*, Katherine Gates' book takes the reader deep into some *extremely* uncharted territory on the map of human sexuality. *Deviant Desires* makes no attempt to be exhaustive in its coverage of sexual deviation, so there's none of your usual boring flagellation, necrophilia and bestiality — Gates obviously felt she'd be flogging a dead horse! Instead, there's lots of stuff you've never even *thought* of. Areas covered include balloon fetishism, body inflation and giant women fantasies, 'crush' videos, 'slash' fiction by sci-fi fans, extreme fat admiration, robot fetishism, sex with soft toys, mudlarking and fun with messy foodstuffs. If you believe your sex life to be pretty exotic and out there, prepare to think again. There's *no* way you can compete with some of the freaky people in *Deviant Desires*.

Examples are numerous, but here are a few of my personal favourites. Ducky DooLittle has found a niche performing as Knockers the naughty topless clown:

I HATE CAKES... IF THERE'S A CAKE ANYWHERE, I HAVE AN OVERWHELMING DESIRE TO SIT IN IT... I GOT PROTESTED BY BIRTHDAY PARTY CLOWNS IN PORTLAND BECAUSE I SHOW MY BREASTS AND I'M DIRTYING UP THE BUSINESS FOR THEM. THERE'S SOMETHING WRONG WITH THESE PEOPLE.

Ron H produces *Black Giantess* magazine, which is full of his demented collages of black porn models pasted into, and towering over, scenes of urban destruction:

I REMEMBER BEING IN JOBS WHERE I DEALT WITH PEOPLE WHO REALLY REALLY PISSED ME

Continued on p.142

CHAIN SAW CHATTER

An interview with David Gregory, director of *TEXAS CHAIN SAW MASSACRE: THE SHOCKING TRUTH*

by Simon Collins

LEICESTER'S PHOENIX ARTS CENTRE made a small piece of cinema history in June 2000 with a one-day event featuring the first-ever public screening in Britain of Wes Craven's infamous 1972 shocker *The Last House on the Left*. Also playing were *The Texas Chain Saw Massacre* and a new documentary, **TEXAS CHAIN SAW MASSACRE: THE SHOCKING TRUTH**. The day also featured personal appearances by Gunnar Hansen (Leatherface in *Texas Chain Saw*) and David Hess (Krug in *Last House*).

Texas Chain Saw Massacre: The Shocking Truth (available on video and DVD from **Exploited Films**, cert 18) is an exhaustive account of the creation of Tobe Hooper's horror masterpiece. I wanted to know more, so I visited Nottingham and, over a lunch of headcheese and barbecued meat, chewed the fat with its director David Gregory.

HEADPRESS There was an earlier documentary about *The Texas Chain Saw Massacre* which you tried to licence, wasn't there?

DAVID GREGORY Yes. It was called *Texas Chain Saw Massacre: A Family Portrait*. It was made about twelve years ago, and it featured interviews with just the 'family' members — Leatherface, The Cook, Grandpa and The Hitchhiker. We tracked down the rights through Gunnar Hansen, but they were re-cutting for DVD at the time, and they didn't want to enter into any kind of licensing agreement while they were doing that. So we just decided to do our own film.

So your failure to get the rights for that film was the impetus for making your own?

It was one of the things. Another element was the fact that we'd already got an interview with Gunnar Hansen when he was in London last year, and also we *thought* we had an interview with Kim Henkel [co-writer of *The Texas Chain Saw Massacre* and writer/director of *Texas Chain Saw Massacre IV*] which had been shot by some guys at Bangor University. As it turned out, we weren't allowed to use that footage and we had to do our own interview.

Your film came together quite fast, I think?

Very fast. We got in touch with Gunnar again, and he gave us some phone numbers. I had spoken to Jeff Burr [director of *Texas Chain Saw Massacre III*] before. He told me to get in touch with Ted Nicolaou [unit sound recordist for *Texas Chain Saw Massacre*], who's also a director for Charles Band, as Burr is now. Band produces movies like *Subspecies*. So then we thought, why not get some other members of the crew? Obviously the art direction in the film is pretty important, so we got in touch with the art director Bob Burns, who turned out to be one of the most fascinating interviewees of all. And we talked to Wayne Bell, the guy who did the music, which is also a very important element in *Chain Saw*.

Where did you travel to during the filming?

We started in LA, where we did Ted Nicolaou, Jeff Burr, Caroline Williams [Stretch in *Texas Chain Saw Massacre II*] and a couple of other people... we got the soundbites of Jim VanBebber, which are always entertaining. Then over to Austin, Texas, where my sister lived. There were three of us, a DV camera and a Bolex camera. We slept on her floor and just jumped in the car, drove to Houston, drove to Seguin, where Bob Burns lives, a very small, very strange town!

What kind of budget were you

working to?

That was kind of made up as it went along. The three of us who shot it paid our own fares, and Blue Underground, our production company, paid for everything while we were shooting — tape stock, interview fees, that kind of stuff.

The budget got bigger and bigger, though it was still a very low-budget production. As we became more confident that we were producing a more-than-adequate documentary, it was worth spending the money. The film came in for under ten grand [sterling].

So how long did you spend in America doing the interviews?

About three weeks. Ed came back and started editing, and then Tobe Hooper got in touch. We'd had a hell of a job trying to get him to agree to be in the film. We were going ahead as if we weren't going to have Tobe, so we got a lot of soundbites about what Tobe was like, why Tobe wouldn't want to talk about it, etc. Then he called when we were half-way through editing and said, "Yeah, I'll do it." So I went back out for two days. He was the last person we spoke to.

A lot of the people involved in *The Texas Chain Saw Massacre* seem to have very distinctive personalities. Who was the most fun to meet?

Pretty much everyone was fun to meet, but as far as being a character is concerned, Bob Burns is definitely the one. He's great. He's got a big Hawaiian mural on the wall behind his bed and a pair of parakeets. He's into tropical stuff!

He seemed to have these weird effigies of musicians behind him during his interview.

That's Heart Burns and Powder Burns – what he refers to as his sisters. He goes on stage at this old people's talent show which they hold every week in Seguin, which is a *very* small town, and he plays with his arms in their arms, so it looks like they're playing a guitar, but it's actually him playing!

Seguin is known for having the world's biggest pecan nut, and he won some parade competition for making a hat which had this big pecan on it! He's got a hat shaped

like the Empire State Building with King Kong on the top and aeroplanes on wires all around!

Who didn't you talk to in the end?

Ed Neal — who played The Hitchhiker — is the main omission. I spoke to him many times on the phone. Originally he agreed to do it, and started telling me all these stories. I was like, "Great!" but then when I offered him money for the interview, he said, "Oh, it's a professional job. You'll have to talk to my agent." So I spoke to her and then she called me back and said, "No, I've spoken to Ed and he doesn't want to do it."

That's strange, because on the footage of the twentieth anniversary celebration, he seemed to be really into doing The Hitchhiker again and again.

He plays up to his fans. That's why he was going to do it originally, because he thought it was just a fan video. I think he's the one who's most bitter about what happened with *The Texas Chain Saw Massacre* as far as not getting paid [the documentary goes into considerable and depressing detail about where all the money went]. He didn't want more exploitation where somebody else was making money off his being in the film, which in some ways is understandable. We didn't argue about it… There were a couple of other people we'd like to have talked to. There was Terri McMinn, who played Pam, the girl on the hook. Gunnar spoke to her for us, and she just doesn't acknowledge her *Chain Saw* past. Daniel Pearl, the director of photography, *was* willing to talk to us, but he was in Canada shooting a Mariah Carey video. Dottie Pearl, the make-up artist — in retrospect, I wish I'd tried harder to get in touch with her, because for one thing, she was the only woman behind the scenes, and also the make-up's pretty important as well.

There's a lot of stock footage of Nazis whilst you're discussing James Ferman and the BBFC. Do I detect a note of sweet revenge?

I'm sure if he saw it, he'd take his sweet revenge on me in a court of law! That's the part of the documentary that always gets mentioned. Some people are mortally offended by it.

I think you pushed it a bit far, but it was funny.

Exactly! I was only drawing a comparison.

The original music for your film is good. Who did it?

A Nottingham-based guy called Mark Fox. He has a little studio set up in his house, and I knew that he'd done a lot of experimentation with various sounds. I gave him a copy of the film and asked him to come back to me with a bunch of noises that were reminiscent of the ones in the film.

What it sounded like to me was Japanese noise music, like Merzbow and CCCC.

I don't know if it's the sort of thing I'd sit down and listen to, but it was certainly what we needed for the documentary!

Gunnar (Leatherface) Hansen throttles David Gregory.

Your voiceover guy sounds amazingly similar to the one in The Texas Chain Saw Massacre.

I'm glad you said that. That's an old friend of mine called Matthew Bell. He starred in a film I made called *Scathed* in 1995. He's been living in LA and trying to do acting work, but, like most people trying to get acting work in LA, only being moderately successful. I knew he had this excellent deep voice, and he does sound a bit like John Larroquette, who is now, by the way, very famous on American TV.

Presumably it was financially impossible to have footage from The Texas Chain Saw Massacre in your film?

There were two reasons why we didn't have clips. One was that we'd heard from the guy who made *Family Portrait* that you had to pay through the nose to get clips, so that would probably have tripled our budget. And you pay per second, so you have to be really careful and specific about what you want.

The other reason is that by not having clips in it, it was exempt from certification, so we didn't have to give the BBFC their usual piece of the action! The tape is only certificated 18 because of the trailers on it. We bought a copy of the Video Recordings Act and went through it with a solicitor, and made sure we stuck by all the guidelines. Certificating the film would have cost another grand, plus this is a movie that I've made and I *refuse* to give those guys money from my film!

You had a lot of good production stills though.

Yes, mainly from Bob Burns' collection, which has never been published. He had shots of him making the masks, making the armadillo…

A lot of those were from an art exhibit that he did at the University of Texas, where he showed a lot of the props and models before the film was even released.

What is the enduring appeal of The Texas Chain Saw Massacre? Every time I see it, I find new things to admire.

It's got a lot to do with the way that once the horror starts, it doesn't let up. There are quick deaths and prolonged torture deaths. That first killing is so sudden, as is the third, which contrasts nicely with how prolonged the torture of the girl on the hook is. That's a *long* scene, when you think about the fact that she's hanging on a hook. And of course, Sally as well… I think that mixture is really something that hasn't been captured in a horror movie since. ▣

Photo: Simon Collins

Continued from p.139

OFF... IN MY MIND I WOULD IMAGINE THESE SPECIFIC PEOPLE GETTING DESTROYED BY THE GIANT WOMAN... IT'S A KIND OF REVENGE.

Ponygirl Frisky gives a long interview about her personal fantasies of morphing into a pony and being ridden around, as well as discussing the burgeoning human pony scene in general:

APPARENTLY THERE'S A TOWN IN CENTRAL TEXAS THAT'S VERY INTO THIS. THE WHOLE TOWN IS SUPPOSEDLY A *24/7* TRAINING FACILITY.

Quick, somebody tell Louis Theroux! Supersize Betsy is a star model of the 'fat admiring' scene. She's got to the point, though, where she has to watch her weight carefully:

I GET LOTS OF OFFERS FROM MEN WHO JUST WANT TO FATTEN ME UP FOR A NIGHT OR A WEEKEND, BUT I'M *420* POUNDS ALREADY. IF I WERE TO DO THAT, I COULD BECOME IMMOBILE VERY EASILY AND I'D STILL BE SINGLE! THAT WOULD BE DISASTROUS.

Supersize Betsy is one of the more unsettling interviewees in *Deviant Desires*, raising as she does awkward questions about exploitation and self-harm in pursuit of sexual gratification, although she seems very self-determined and forthright about her quest for obese immobility. Most of the people interviewed for the book, though, are doing basically harmless, if extremely weird, stuff.

The glaring and disgusting exception is Jeff 'The Bug' Vilencia, a noted producer of 'crush' videos, which feature barefoot and high-heeled women stomping on a variety of small creatures like bugs and worms, filmed in extreme close-up. Crush videos were last year declared to be obscene under British law in the first prosecution for their importation. Vilencia, incredibly, claims to be a vegan!

As with all RE/Search and Juno books, *Deviant Desires* is beautifully produced, substantial, and copiously illustrated. As with *Modern Primitives*, I should have thought one or two of the photos in here run the risk of attracting unwelcome attention from the authorities, due to the presence of flagrant stiffies. Inevitably, given the marginal nature of the sexual micro-communities Gates is describing, a lot of the fetish material reproduced is amateur or home-made (though often surprisingly sophisticated), which only adds to the obsessive *frisson*. Gates generally approaches her subjects for interview with a warmth and empathy that encourages them to open up and wax lyrical on their bizarre fixations. And how many books can you think of where the author has posed naked with a gun for their author photograph? Respect is due.

One recurring theme in *Deviant Desires* is the way in which most of these people are locked into a very narrow groove, though many of them evince a degree of self-deprecating humour about it. For example, the balloon fetish community — a small enough group, you would have thought — is evidently radically divided between those who revel in the popping of balloons and those who get all anxious and tearful at the very thought of popping balloons! There

Continued on p.145

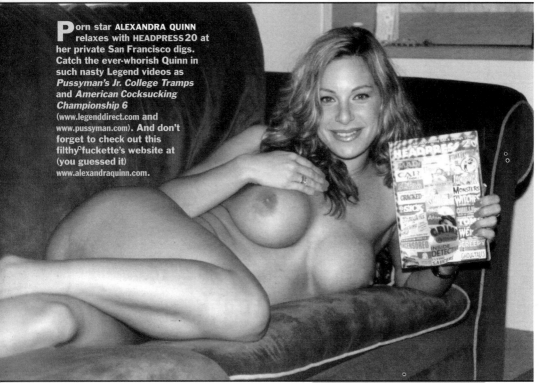

Porn star **ALEXANDRA QUINN** relaxes with **HEADPRESS 20** at her private San Francisco digs. Catch the ever-whorish Quinn in such nasty Legend videos as *Pussyman's Jr. College Tramps* and *American Cocksucking Championship 6* (www.legenddirect.com and www.pussyman.com). And don't forget to check out this filthy fuckette's website at (you guessed it) www.alexandraquinn.com.

Photo: Anthony Petkovich

People Who Read Headpress

HOLLYWOOD BLUE
The Tinseltown Pornographers
Harris Gaffin

£14.99; 208pp; ISBN 0 7134 7906 X;
Batsford Books, 1997

Although Harris Gaffin is an American living in Paris, this book seems ideally constructed for the British market. Imagine a cross between Bill Bryson and Louis Theroux let loose in the San Fernando valley, and you'll have some idea of that this book's about.

The British have this thing about Americans who are willing to make fools of themselves while trying to prove that other Americans are fools (hence the popularity in this country of such minstrel-show Yanks as Theroux, Loyd Grosman, Ruby Wax, Laurie Pike ad nauseum). They also love that kind of bumbling which in the end proves the bumbler is superior to his seemingly more-together subject. The subtext is that some Californian may understand the world of porno, and our reporter may not be able to tie two shoes in one day, but our hero is the 'normal' one.

Many *Headpress* readers will be familiar with Antony Petkovich's *The X Factory*, which for all its up-front sleaziness, is still a more telling look at the porn industry. Compare the titles. Porn is a factory, and the factory is set in the Valley, a perfect place for it. There's nothing 'tinseltown' about it. Which is actually what Gaffin discovers, but he seems as convinced about the image of LA as he is about his own image. Someone ought to tell him to take off the fedora when you're being spanked (as we see Harris being on page 139). Harris never loses his hat, and that's symbolic of his journey through Pornotopia. He's got images created for himself (Hawaiian shirt, fedora), for the blue movie world (glamour and weirdos), and he's never going to get beyond those. On the positive side, Harris' approach allows him to give us a glimpse of what everyday life is like for many of these people who live lives of extreme schizophrenia. As an unthreatening nerd he is able to see beyond the public personae which we know deep down are not real (and which, in Petkovich, are generally accepted as real). If we didn't know that, a look at *SEX: The Annabel Chong Story* [below] would

tell us.

If you're a pornomane already, this book isn't going to tell you much you don't already know. If you're not, you may come away with the idea of the porn business as a cutesy little glamour club, full of people happy to include any grinning Yank in an Indiana Jones surplus topper. Indiana Harris and the Search for the Magic Video anyone?

SEX
The Annabel Chong Story
dir: Gough Lewis

USA, 1999; 86mins; Cert. 18

Sex may well be Annabel Chong's story, but it isn't the story that this fine and disturbing documentary tells. The film is the story of Grace Quek, a Singapore-born student in California, who also happens to be a porn star and, briefly, holder of the world record for 'gang-banging' 251 men in one filmed session, and it's not a pretty one.

Annabel may be convincing as the star of *The World's Biggest Gang Bang*, and in her Chong persona she may be able to sell herself as a sort of liberated, post-modern sexual liberating heroine, but the further we scratch beyond that persona and into the psyche of Grace Quek the more disturbing the picture becomes. This contrast is never more evident than in the actual footage of the gang bang. Chong tells us that she wants to prove women are more than passive sex objects. And she is more than just passive, particularly in contrast to Jasmine St Claire, as analysed in particularly penetrating depth by Petkovich in *The X Factory*. But for all the talk, it's hard to see anyone on the rammee end of Ron Jeremy as being in control of anything, and for all her liberated lingo, Quek got ripped off by the film's producers, going unpaid, while St Claire, with far less effort at being in control, grabbed both the new 'world record' and the cheques.

Out of Annabel mode, Quek, who looks like a turtle from a children's cartoon, is an unlikely candidate for sex goddess. The industry seems to agree. We get Michael J Coxx telling us the gang bangs give the porn industry a bad name, and Ona Zee telling us about the porno 'film noirs' she makes, but for the most part, *SEX*'s look at the industry is not a flattering one. "Guys like us are mad for turtle meat," sang Leonard Cohen, and he could've been talking about these kings of the Valley. And though she may have a certain ability to separate herself from her orifices, Grace herself doesn't seem to hold up very well, especially when she returns to Singapore and finds herself compelled to tell her old teachers and, more importantly, her mother, just exactly what she has been doing to put herself through school.

Grace says she came to California because: "if armageddon comes it's going to start in LA." Is she as self-destructive as she seems? As she perhaps wants to seem? We see her practicing self-multilation, and I get the feeling that Grace and her best-buddy are due for a long speed rush that leads to a quickly accelerated downhill ride. As we sence her deterioration, *SEX* begins to get very confused about its own purpose. It tracks the filming of her gang bang wih such enthusiasm you get the feeling they're trying to excite the punters, only to bring them down. The problem is, to bring them down, you have to hope they have enough humanity to feel Grace's plight behind the Chong façade.

You might think that would be inescapable, but then you watch a clip of Annabel on Britain's own *The Girlie Show*, and you realise that the bimbos reading their *Blind Date*-style questions off cue cards don't get it, can't get it, won't get it — and if Annabel's own contemporaries are that clueless what hope is there for the great unwashed with one hand on the pause button and the other on their schlongs. Annabel debates at the Cambidge Union, and the great washed who will soon be running Britain don't come off (or get off) much better.

There is no resolution in this film, not for Annabel with her mother, or with the porn industry, or with herself. And that ambiguity, in the end, is what makes it so compelling.

GANGBANGING

with
Michael Carlson

LOST HIGHWAYS
An Illustrated History of Road Movies
Jack Sargeant & Stephanie Watson, Eds.

£14.95/$19.95; 288pp; ISBN 1 871592 68 2; Creation, 2000

There are things about Monte Hellman's *Two-Lane Blacktop* that make repeated viewings eminently gratifying. It's a film that is outwardly sparse, containing very little dialogue, and sequences which take a long time to get to nowhere in particular (the end of the film arrives only because the film stock itself has ignited under the heat of the projector lamp). The viewer must approach *Two-Lane Blacktop* like a painter might approach a blank canvas; repeated viewings are the application of more layers and depth. Of course, it was a disastrous flop on its release in 1971, particularly given that Dennis Wilson (of the Beach Boys) and James Taylor were its stars and in them Universal believed they had a sure-fire *won't-the-kids-just-dig-it* hit on their hands.

The story — such as it is — has Wilson and Taylor riding around the US, making their money by pitting their souped-up '55 Chevy against other vehicles in illegal street races. When they encounter another wanderer, Warren Oates in his flash-looking GTO, a cross-country race ensues in which the winner is the first to reach Washington DC, and the loser forfeits their vehicle. The paths of the racers constantly cross, and a young hitchhiker (Laurie Bird) who has drifted into the lives of the three men provides an unexpected distraction, before she suddenly drifts out again.

Other than Warren Oates (and a couple of cameos), none of the people in *Two-Lane Blacktop* are 'real' actors. But this fact isn't detrimental to the picture. Non-actor Wilson (known only as The Mechanic; none of the characters have real names) doesn't even appear to realise he's in a movie at times: he watches the other characters and listens to their dialogue as if he is genuinely hearing what they say for the first time. He is completely wrapped up in the events unfolding around him. On more than one occasion he starts to laugh in the middle of a sentence, or when he's 'delivering' a line — these are moments of truthfulness that no amount of method acting could hope to emulate. Something suddenly strikes him as funny; that happens to people sometimes.

Quite rightly, *Two-Lane Blacktop* gets a chapter to itself in *Lost Highways*. In a way it's the defining road movie; a road movie in its purest form. It's a film in which the viewer spends more time inside cars than he does outside of them; where The Driver (Taylor) turns the radio off while he's driving because "it gets in the way", and where he and The Mechanic only speak when there is something to say about the car. The only time The Driver appears comfortable speaking to anyone else is when he's ordering parts for the car from a guy in an accessories store (the use of technical terminology makes most of the dialogue in the film sound like it's an alien language). When The Driver tries to make small talk with The Girl (Bird) she says "You bore me". Later, when the two men have a near-accident, the first thing The Mechanic does is check the car; when he checks the engine prior to a race, the car *really is* running at its peak and

Dennis Wilson as The Mechanic in Two-Lane Blacktop, *the defining road movie.*

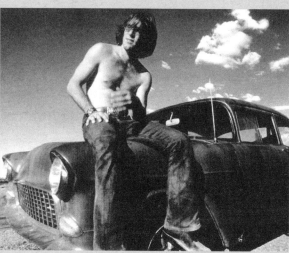

really has the power to beat the other vehicles. It's not that these two men don't want communicate, it's that they *can't* — they are bonded by their car and something that eludes them both. They have a common goal, which is that neither knows what it is they're after. "It's best to keep the hunger on," The Driver says to his buddy at one point.

There are other chapters in *Lost Highways*, some with interesting takes on the road movie — such as the Vampire Road Movie, and The Road as River (incorporating *Aquirre, Wrath of God* and *Apocalypse Now*). But I'm particularly fond of the film *Two-Lane Blacktop*, and I like the fact that Adam Webb, author of the *Two-Lane Blacktop* chapter, says the film 'was simply too dark for success'.

DAVID KEREKES

Continued from p.143

are rival websites and chatrooms where the two groups diss one another.

Another point evident throughout *Deviant Desires* is the extent to which the internet has revolutionised the lives of these people, creating thriving little subcultures, relationships and scenes where initially there could only have been isolation and frustration. And of course, a lot of the weirder fantasies described here — such as Roald Dahl-style body-inflation or giant women — are only realisable through computer-generated imagery and/or movie special effects. Much of the material covered is available online. Gratifyingly, *Deviant Desires* is peppered with website addresses for you to do some erotic window-shopping of your own.

On the back cover, veteran sexual adventuress Annie Sprinkle challenges you to read *Deviant Desires* and not get turned on. Whether you actually find any of this stuff exciting, however, seems to me beside the point. I feel enriched just by knowing that such possibilities exist. Though I must admit I'm pretty attracted to the idea of 'plushies' or 'furverts', people who have a sexual thing for funny cartoon animals like Bugs Bunny and who dress up in furry costumes (with strategically-placed holes) to act out their fantasies. Th-th-that's all folks!
SIMON COLLINS

STRAIGHT FROM THE FRIDGE, DAD
A Dictionary of Hipster Slang
Max Decharne

£9.99; No Exit Press

Dig this, daddy-o. It's a lot of fun simply leafing through the pages of this compendium of jive talk, and Decharne should be swelled up like a poisoned pup about it. But call me cubistic, because I'm not really gone on this volume, and let me blow the works about it, straight from the cookhouse. First, Decharne's hipster slang is really a combination of two things. The major one is beat talk from the fifties, which is largely derived from musical influences, primarily the blues and jazz records where, by and large, the beatniks found it. The other source is hard-boiled detective fiction, primarily from the thirties. What they have in

common is that they *sound* cool to us today, but these two elements were not necessarily part of any one slang, not as anyone would define it or use it. Maynard G Krebs would be no more likely to tell someone to lamp a frail's gams than Sam Spade would be to talk about a no-goodnik from creepsville.

Second, many of the citations here aren't really part of slang at all, but rather a single writer's invention. When Philip Marlowe says he "found a good bottle and went into executive session with it", does that mean 'executive session' was something people actually said when they meant drinking, or is it just Raymond Chandler coming up with another brilliant turn of phrase by using a business term as a metaphor? Donald Hamilton (the Matt Helm creator) is cited for "Let's brush it hard and see where the dandruff falls". Far from being slang, this is a takeoff on fifties ad-man speak: "Let's run it up the flagpole and see who salutes" of which there are as many different versions as there are issues of *Mad* magazine. And is "flat as a matzoh" really slang, or is flat (meaning broke) the slang, and 'as a matzoh' just a simile, replaceable by any nearly-two-dimensional noun?

There are older, standard terms here, like 'four-flusher', which surely goes back to the nineteenth-century, and others, like 'bobby-soxer', which are specific to an era and were part of general slang in America. Hipster or no, everyone knew what a four-flusher was. It would be nice if Decharne had investigated some derivations. Four-flusher, for example, refers to poker, and trying to pass off four good cards as a flush. Decharne defines 'straight, no chaser' as meaning the undiluted truth and attributes it to a jazz record by Art Taylor. Well, it's also a tune by Thelonius Monk, covered famously by Cannonball Adderly, and of course it refers to drinking whiskey neat, without a beer or water to chase it. This doesn't change the meaning, but it might be nice to know. Like 'dead presidents' being slang for cash money? Of course that's because presidents are on American bills. But they are dead presidents because American law prohibits anyone living from being represented on currency (or stamps). And of course, no one really knows

where 'eighty-six' — meaning to get rid of — comes from. It can be traced to restaurant use, but its origins are still debatable (rhyming slang for 'nix', perhaps?).

Decharne doesn't show much curiosity along those lines. You get the sense that he has simply done a lot of good reading and heard a lot of good music, and noted down the interesting phrases as he went. There's nothing wrong with that, and it makes for an entertaining book, but as a reference of any kind, it won't get your knowledge box hitting on all cylinders. MIKE CARLSON

NOWHERE MAN
The Final Days of John Lennon
Robert Rosen

£14.99/$22.50 221pp; ISBN 1 887 128 46 8; Soft Skull Press, 2000; distributed in the UK by Turnaround

There are many books on the market which claim to offer some refreshing new slant on the man and legend that is John Lennon. I haven't read most of them so cannot say how this compares. However, I'm sure *Nowhere Man* has something which those other books do not — principally, the diaries of John Lennon. Rather, author Bob Rosen had the diaries but they were stolen. Fred Seaman, Lennon's personal assistant and a close friend of Rosen, had been collaborating with Rosen on a book about Lennon for some months prior to the ex-Beatle's assassination. The idea to write a book came from Lennon himself apparently, who was sick of living a lie and wanted the world to know that his time at the Dakota was far removed from the official picture of happy house-husbandry, doting father and bread-baker, glad to let his wife Yoko Ono take care of business. In reality, Lennon was miserable and insecure, locked like a prisoner in his bedroom as servants tended to his every need. After Lennon's murder, Seaman was promoted to Yoko's executive assistant, and he took this opportunity to feed Rosen with the exclusive material now at his fingertips. Amongst the many photographs, slides, unreleased audio- and videocassettes, random scribblings and notes, were Lennon's own journals. Rosen started transcribing these at the end of October 1981, spending long, amphetamine induced hours each day decipher-

ing the scrawl. For six months, Rosen claims to have "lived like a monk, confronting on a daily basis The Gospel According to John". But then Rosen claims he was burgled and the whole lot was taken. Certain that Seaman himself was behind the deed, he went to see Yoko, who promptly had Seaman arrested.

Lennon's last days in *Nowhere Man* come courtesy of Rosen's memory of the journals and his interviews with the late-musician's friends, family and lovers. The concept of stolen diaries (now back in Yoko's possession) is an intriguing one (and reminiscent of *Paperback Writer*, a spoof alternate history of The Beatles). *Nowhere Man* engagingly depicts a life spiralling slowly into madness, with Lennon locked onto dietary fads, astrological charts and meaningless minutiae. Not many days are happy days here. DAVID KEREKES

NECROTOURIST
Bella Basura
DOC. GORDON TRIPP LECTURES AGAIN
Bella Basura

28pp/12pp; contact: Bella Basura, PO Box 5454, Leicester, LE2 0WP; bella@pixie-inc.demon.co.uk

The internet may well be a car-boot sale for any Joey's opinion, but getting something printed on paper still displays a desire to *make an effort*. Bella Basura's simple A5 booklets are prime examples of this ethos. *Doc. Gordon Tripp Lectures Again* is dry pastiche filtered through mock-scientific record: Dream Machine stuff. Much more interesting is *Necrotourist*, a collection of brief travelogues to places most year-out students will hopefully remain ignorant of. Like all the best adventures, the set plan of each journey inevitably becomes mislaid: exiting the Paris Catacombs, Basura finds herself lost in the city, perhaps miles from her bike; in Mexico, the Frieda Kahlo museum is undergoing repairs, which unwittingly sends Basura to the house where Leon Trotsky was assassinated; a motorcycle trip to Derek Jarman's bleak seaside cot-

tage in Kent is cut short by a notice in the window from the present occupier dissuading visitors and photography:

WE SLOUCHED AWAY, FEELING SLIGHTLY DISAPPOINTED, SLIGHTLY EMBARRASSED TO FIND OURSELVES NOSING AROUND IN A COMPLETE STRANGER'S GARDEN.

Over all too quickly, there are five compelling journeys in *Necrotourist*. It's well worth a visit. MARTIN JONES

NINETEEN SEVENTY SEVEN
David Peace

£8.99/$14; 341pp; Serpent's Tail, 2000

The second in Peace's Yorkshire Noir trilogy (*Nineteen Seventy Four* was the first) follows alcoholic true crime journo Jack Whitehead and not-completely-corrupt cop Bob Fraser as they search through the whore houses, red light districts, porno scum, police corruption, lies, racism and human degradation for the Yorkshire ripper. Like James Ellroy, Peace uses actual historical events as a springboard for his own explorations of the outer fringes of the human psyche, in this case the Ripper murders. Indeed if there is any comparison here it is with Ellroy's LA Quartet, and especially with *The Black Dahlia*, which also uses the extreme violence enacted on supposedly fallen women as a way into the neither regions of the soul. Stylistically, Peace writes in a stripped down barren language that uses few words and relies on moments of punctuating repetition, in such a way as to make the whole page reflect the scream of his protagonists.

'Course, nothing Peace has done reaches the staccato brutality of Ellroy's *White Jazz*, but it took Ellroy ten-plus volumes to get there, and Peace already has an understanding of the genre that shows he's well on the way to becoming a master. English noir is an understated genre — its true master remains Derek Raymond — but Peace has written a page-turner, and I'm already looking forward to the next volume of Yorkshire Noir. JACK SARGEANT

I WAS FOR SALE
Confessions of a Bondage Model
Lisa B Falour

£9.95/$14.95; 192pp; ISBN 1 84068 053 9; Velvet, 2000

In endeavouring to bring something of the profundity which underlies the unremittingly squalid life of your typical bondage model, author Ms Falour has seen fit to quote from William Peter Blatty's *Exorcist* sequel, the almost incoherent and interminably rambling *Legion*. This should come as no surprise as, at the outset, Falour admits: "my spirit is broken, I am alcoholic and my bouts of depression are lasting years at a time." Prepared for the worst, we certainly get it — in spades — as the author reveals her hopeless confusion and misery via a series of anecdotal 'true confessions' which outline her seedy life in late-seventies New York. Nothing remarkable here, except the almost bovine tolerance for self-inflicted deprivation, which the author secretly revels in — despite her protestations to the contrary. Pathetic — in the truest sense of the word. STEPHEN SENNITT

THREE NEW TITLES FROM CRITICAL VISION

SEE NO EVIL
Banned Films and Video Controversy
David Kerekes & David Slater

£15.95/$25.95; 416pp; ISBN 1 900486 10 5; Critical Vision, 2000; for ordering details see p.176

Of the various books that have been published in the last ten years about the campaign against 'video nasties' (including Martin Barker's *The Video Nasties* and Nigel Wingrove and Marc Morris' *The Art of the Nasty*), *See No Evil* is by far the most interesting and comprehensive. Kerekes and Slater's 416-page book is a reference work of sorts — though far more compelling than most similar works — which includes plot synopses and analyses of all the original 'nasties'. There's also a close analysis of the roles of key figures like David Alton, Mary Whitehouse and James Ferman, as well as a study of

the press coverage given to so-called 'copycat' crimes like the Dunblane Massacre and the murder of James Bulger.

One thing I particularly liked about this book was its authors' eye for rare gems and video diamonds in the rough, especially genuinely naff British obscurities, which are treated to a real appreciation of their more endearing qualities. Kerekes and Slater seem to have an almost gleeful affection for the cheap cinematic absurdities and pathetic attempts to shock that were basically a crap attempt to cash in on the whole 'nasty' debate. Consider, for example, this description of Julio Perez Tabernero's 1981 abortion, *Cannibal Terror*:

THE JUNGLE SOUNDTRACK COMPRISES AN UNENDING LOOP OF A SINGLE BIRDCALL. THE SUPPOSED HEART OF THE JUNGLE IS A CLUSTER OF PALM TREES SOME ONE HUNDRED YARDS FROM A BUSY ROAD WITH VEHICLES VISIBLE IN THE DISTANCE. MOST OF THE JUNGLE NATIVES ARE ACTUALLY CAUCASIAN, WEARING BODY PAINT AND CARRYING STICKS MOUNTED WITH CHEAP PLASTIC SKULLS. SOME TRIBESMEN SPORT ELVIS PRESLEY SIDEBURNS, OR MOUSTACHES, AND SEVERAL LOOK EVERY INCH LIKE OUT-OF-CONDITION BUSINESSMEN WITHOUT THEIR CLOTHES ON. FEW OF THEM CAN REFRAIN FROM LAUGHING WHEN THEY ARE SUPPOSED TO BE ENGAGED IN A TRIBAL DANCE (OF WHICH THERE ARE MANY), OR CANNIBALISING THEIR VICTIMS AND TUGGING ON RAW OFFAL.

Most interesting, however, are the chapters dealing with press hysteria and the many raids that took place on the homes of 'illegal dealers'. In retrospect, the whole bizarre affair seems like the symptom of a kind of ten-year national psychosis, a kind of mass delusion. We laugh at 'primitive' people who believe the soul is captured by the camera, but here was an entire nation of supposedly 'rational' and 'civilised' people gripped by a superstitious terror of reels of magnetic videotape. It's hard to believe how widespread is the belief — even today — that videotapes can contain 'evil', and have the power to transform kids into perverted killers and to release crazed demons upon an unsuspecting populace. And, as the authors remind us, this wasn't just a theoretical issue. People had their houses raided and ransacked and were actually given prison sentences simply because they possessed these 'evil' spools of tape.

Another thing I really enjoyed about this book is the way in which Kerekes and Slater — without being in any way dogmatic or polemical — gradually bring up more and more ridiculous examples of spurious 'links' between 'video nasties' and real-life acts of crime. The result suggests utter madness on a huge scale, a kind of 'folie de nation'. One final example. During a police raid on his home, one gent had the movie *Death Scenes* confiscated, while the book of stills from the film was seen

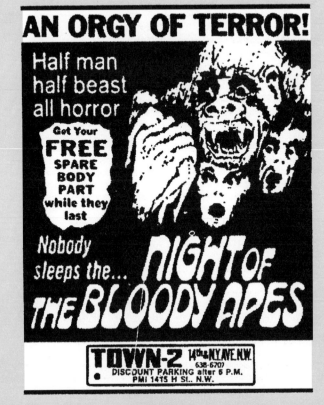

AN ORGY OF TERROR!

Half man
half beast
all horror

Get Your
FREE
SPARE
BODY
PART
while they
last

Nobody
sleeps the...

NIGHT OF
THE BLOODY APES

TOWN-2 14th & N.Y. AVE. N.W.
638-5707
DISCOUNT PARKING after 6 P.M.
PMI 1415 H St.. N.W.

as relatively harmless. This, I think, has some very serious implications about our beliefs in the power of the moving image. If the moving image *doesn't* contain magical powers of persuasion, then the whole debate is irrelevant. If it *does*, then surely the sacrilege is nothing to do with 'video nasties', but that such a powerful and spiritual medium is used to make films like *Patch Adams*. MIKITA BROTTMAN

SEE NO EVIL
David Kerekes & David Slater
Details above.

Imagine; a small island stuck in the middle of the Atlantic Ocean, inhabited, for the main part, by a bunch of small minded, racist chumps, hateful of anything not immediately fathomable and willing to believe any scare-mongering stories fed to them by tabloid newspapers. An island with no written constitution, and thus no right to free expression. Sound familiar? Welcome to the UK circa 1980 with the video explosion underway and the Christian rightwing, under Thatcher *et al*, running the whole show…

The following story should, of course be familiar to every British reader of *Headpress*, and forms the basis of the two-Davids long awaited *See No Evil*, a well-illustrated investigation into the 'video nasty' culture of the eighties and nineties. *See No Evil* opens with a brief but astute exploration of the video boom in the UK. It then explores the growth of interest in horror videos, and the sudden moral panic that saw a handful of predominantly cheesy horror movies labelled by the press as video nasties and subsequently condemned to a cultural Siberia, under the cold auspices of the Video Recordings Act. This Act — which became law in 1985 — made people who distributed uncertified videos criminals who could, in theory, be fined upwards of £20,000.

An exploration of the video nasties — and others which were often accused of being nasties but managed to beat-the-ban (*The Evil Dead* for instance, which fought legal cases almost continually in order to stay-on-the-shelves) — forms around half of this book, with each video examined and critiqued by the authors, who remain analytical enough to achieve a critical distance, but fanboy enough to clearly care about

some of these movies when lesser mortals may give up (I'm sorry, but nothing would make me watch *Funhouse* again, and even the authors admit that *Evilspeak* is 'terrible').

Most interesting, and certainly most worrying, though, are the book's later chapters which begin with tales of video busts, set-ups, and illicit video-dealing. These include such terrifying accounts as one luckless individual losing his job for the mere crime of letting slip the fact he possessed two video recorders, circumstances which must therefore dictate — at least to the perverse logic of his employer — that he was an avid consumer/disseminator of 'snuff films'. Of course, this may seem like an almost comically absurd scene of doublethink and fascism, but the luckless victim of these events is still unemployed and unable to find work. These personal accounts — frequently of a similarly hellish nature — are followed by an absorbing exploration of the media's ability to link actual crimes to films (and often non-existing-scenes in films). Through spree-killers, serial killers, rapists and murderers, the last twenty years have seen dozens of films blamed for crimes that — as the authors suggest — are always more likely to have been caused by other factors that are conveniently ignored by the likes of *The Sun*, *Daily Mail*, *Daily Express*, *Daily Mirror*, *et al*. The point is, people in the UK believe their tabloids and believe (or *want to* believe) in easy solutions, and few solutions come as simple as the cause-and-effect logic of video violence — poverty, familial abuse and so on, are questions that are rarely raised until long after the media outcry and knee-jerk MPs have had their say, but then it is easier to blame a crappy horror movie than, say, a family life in which children grow up ill-educated and poor, and, when faced with bullying are only able to express themselves through the same violence they experience at home.

The two-Davids deconstruct the media lies and hypocrisy with a consummate ease that would be funny if it wasn't so perturbing in the first place. Indeed, the authors let-the-gleeful-deconstruction-slip when they notice — with only partial irony — that the *Daily Mail* had on one occasion neglected to scapegoat vid-

eos because 'the newspaper had another crusade at the time — generating hatred towards the impending influx of Kosovan refugees…' That vast numbers of people appear to uncritically believe media generated scapegoating is possibly one of the most perturbing aspects to emerge from this study: the gaff, comic books, hippies, *Oz* magazine, *Gay News*, video nasties, refugees, all are equally to blame for moral decline and rising crime according to the tabloids and numerous Christian watchdogs. And, on the whole, people believed it (and, it should be noted, they still do).

The conclusions the writers draw are hardly surprising to the knowing reader, although, in their eagerness to illustrate the absurdity of banning these films they do come a little unstuck, suggesting that 'the news media does incite imitative crime' (p.362). Such a blank generalisation is too convenient (although the premise is an interesting one). The two-Davids also note that in the media frenzy to blame movies, other factors such as a criminal's consumption of alcohol and drugs have, in the past, been overlooked. Of course, drugs and booze are regularly scapegoated by the same newspapers, but films are an easier target for a lazy journalist out to make a name for himself. But this is a very minor quibble.

At the most superficially entertaining level this book is an amusing guide to almost forgotten period of video-insanity (several of these films have subsequently been lauded as classics — most obviously *The Driller Killer*, as well as the academically fashionable movies such as *Blood Feast*, *The Beyond*, *Death Trap*, *I Spit On Your Grave*, and *Tenebrae*), and if that was all this book consisted of then it would still be more than worthwhile. However, beyond that, *See No Evil* is a disturbing discourse that shows exactly how gullible and easily led people are, how cynical the media is, and how moral panics may effect us all. As such it offers a fascinating insight into the varied (and sometimes strange) allegiances between journalists, government, and the masses, whose own desire for increased-censorship often defies belief. *See No Evil*, then, is book that is necessary not just to solve those late night arguments about who actually starred in *SS Experi-*

ment Camp, but also in order that people better understand the very real — and very dangerous — power the media has over public opinion in this country. JACK SARGEANT

FLESHPOT
Cinema's Sexual Myth Makers & Taboo Breakers
Jack Stevenson, Ed.

£14.95/$19.95; 256pp; Critical Vision, 2000; ISBN 1 900486 12 1; for ordering details see p.176

I was living in San Francisco for a few months in 1998, and on one occasion went for a dinner at the home of filmmaker Sarah Jacobson. The guests were a veritable who's who of underground filmmaking: George Kuchar sat there with his camera, filming and chatting whilst he ate. Dennis Niback, the archivist of various neglected movies, was there, as was fetish-photographer Charles Gatewood. And Jack Stevenson. He was in town to curate a series of movies from his archives, and the meal was, if memory serves, in his honour.

Over the next week I sat in a fancy museum and watched a hefty chunk of the movies that Jack had brought to town. A wild collection of visual treats that he had pulled from the stinking trash and sewage filled basements (metaphorically and, I'm sure, literally) of bankrupt (morally — certainly, fiscally — thanks to video, yes) inner city porn stores. All manner of movies spun across the screen. I remember some religious sci-fi movie, porn cartoons, the trailer for porno movie *Get That Sailor*, the first reel of *Animal Lover* (not the sex sections, just the scary 'intellectual' describing bestiality) and numerous other neglected sleazy and bizarre classics. Jack would introduce the screenings and — on one occasion — ran tag-team interference throughout, ad-libbing verbal footnotes with Dennis during the projection of several sixties scopotones. One thing was for sure this was a truly obsessed man sharing his passion for cinematic sleaze and movie weirdness.

You could be forgiven for thinking, if you read *Fleshpot*, or see his film shows, that Stevenson is a rabid porn fiend, somebody who cares about Bodil movies. He has an incredible ability to unearth films and information that is *always* fascinating, and nearly-always strange-as-hell to

most people's way of thinking. Moreover, he can write about this stuff with the zealous enthusiasm of a fan-boy, but with the distance of a 'critic' (which, thank fuck, he isn't... he's not pushing his tastes on any reader as some absolute benchmark of truth). The tone is informative, witty, lucid, occasionally revealing, and, most important, accessible.

In *Fleshpot*, Stevenson (and his equally obsessive cohorts in the project) delve into such areas as sex-educationals, German underground sex flicks, early stag movies, underground gay porn films, British pornloop director John Lindsay, willing/unwilling cocksmoker Linda Lovelace, as well as many other pieces. And — yup — Bodil (who is something of an obsession with anybody who has delved into the murky waters of porno. Understandable when you consider that her story has it all: sex, dogs, sex, pigs, sex,

horses, sex, men, sex, poverty, fame, prostitution, and — hanging over it all like a big greasy meaty bovine erection — the fucking question: why would anybody actually choose to do *that* and then admit to it publicly? Some of these pieces have seen the light of day before — but unless you subscribe to Northern European film journals the chances are you've never read them. Those that you may have seen before are reworked and

updated, so you need to read them again. Add to that contributions from George Kuchar and Kenneth Anger and you know that this volume is a must have.

One complaint: Jack why can't you produce a book like this every six months or so? JACK SARGEANT

NASTY TALES
Sex, Drugs, Rock'n'Roll and Violence in the British Underground
David Huxley

£13.95/$19.95; 191pp; ISBN 1 900486 13 X; Critical Vision, 2001; for ordering details see p.176

Summer 1978: I was fifteen-years-old and my heart was palpitating in anticipation of my first visit to London! My sister, Susan, had recently married and moved there, and together we were going to visit Dark They Were And Golden Eyed, a true-to-life comic shop just like they had

The Fabulous Furry Freak Brothers make a stand for decency in *Nasty Tales*.

Art: Gilbert Shelton

in America — I couldn't believe it! Just a few weeks earlier I had an inkling of the type of stuff they might sell when I bought a book called *Masters of Comicbook Art*, which had features on the likes of Richard Corben, Moebius, R Crumb and Victor Moscoso. These lurid and sexy images immediately riveted me, opening up for me a whole new world of insight into the possibilities of the comicbook genre.

CHRISTOPHER WALKEN: MOVIE TOP TEN
Jack Hunter, Ed.

£12.95/$17.95; 134pp; ISBN 1 871592 84 4; Creation, 2000

It's been hard to approach Creation's 'Movie Top Ten' series with anything but mild contempt, especially since reading a sneeringly wonderful comment on the series in an edition of the *Midian Mailer*: "Will appeal to readers of *Neon*". In fact, it's a job to think of who would want to return to these titles again and again. The essays in *Christopher Walken: Movie Top Ten* range from nosebleed-inducing film theory to straightforward facts-and-all articles, but, generally, the same conclusions are inevitably reached about the Alien Actor. Walken is, after all, one of that select breed who can light up any old shit by simply doing nothing. The best writings jettison theory-for-theorists: James Marriott's short essay on *The Dead Zone* works as a reintroduction point for both David Cronenberg's and Stephen King's work; David Prothero and Jonathan Wright's essays — on *The Comfort of Strangers* and *Suicide Kings* respectively — balance insight with film history; whilst Richard Goodwin's

piece on *Communion* offers a touch of humour in a relatively humourless book. Nice to see underrated straight-to-video flick *The Prophecy* get some recognition as well.

Of course, the problem with any 'best of' is that it creates instant dispute between writer and reader: why is there only a mention of Walken's career-starting turn in *Annie Hall* (a memorable role that acts as the set-up and pay-off to one of the film's best jokes)? And nothing on *Wild Side*, Donald Cammell's final work? Nag, nag, nag, and the doubt remains as to who's going to buy this book. There's a filmography and a good selection of b&w illustrations, but thirteen quid is a lot to ask for that plus ten essays of wildly varying quality.

Perhaps now is the time to kick this series into the exploitation swamp, where an army of cult actors and pin-ups await *their* turn? **MARTIN JONES**

ESOTERRORIST
Selected Essays 1980–1988
Genesis P-Orridge

68pp £11.99, 1994, MediaKaos/Alecto, available from: AK Distribution, PO Box 12766, Edinburgh, EH8 9YE

Genesis P-Orridge (or 'P'Orridge', as he is unaccountably referred to on the cover), the man behind COUM Transmissions, Throbbing Gristle, Thee Temple Ov Psychick Youth and Psychic TV, veteran provocateur, media terrorist and 'cultural engineer', has been going through something of a cultural rehabilitation process in the UK of late. Last summer's triumphal 'Time's Up' gig at the Royal Festival Hall (his first appearance in Britain for seven years, following his self-imposed exile in the USA) was merely part of a string of events including the publication of Simon Ford's *Wreckers of Civilisation*, the definitive history of COUM and TG, a spate of articles in the quality press, and an interview on Channel 4's *DisinfoNation* that seemed to signal Gen's readiness to come in from the cold (though by all accounts he's now very happy in the States), and/or the British establishment's willingness to have him back. The past year has also seen the release of the first two volumes of Psychic TV's *Origin of the Species* box sets, a retrospective look at the influential acid/hyperdelic phase of the band. What better time, then, to take a fresh look at some of his writ-

Nasty Tales continued

The shop certainly didn't disappoint me. Though funds were severely limited, I came away with a copy of *Heavy Metal* (the first I'd ever seen), a Frazetta poster, and several recent editions of *Creepy*. However, the whole time I was in the place, my rather nervous sidelong glance kept returning to the cheap-looking underground comix which were ruled out-of-bounds (Susan deciding that *Heavy Metal* was "quite adult enough" for me at that time). The titles — *Skull*, *Zap!*, *Slow Death* — glowed intensely in my brain, but also some titles that struck me as *odd* in some way: *Nasty Tales, Cozmic Comics, Brainstorm*... What was it about them that bothered me? Suddenly, thunderstruck, I realised what it was: they were *British* undergrounds, and I never thought there were such things!

A few weeks later came the discovery of *Near Myths* No 1. I subscribed immediately and was extremely irritated when copies were rolled up

and posted in a cardboard tube! Another discovery was a battered copy of *Graphixus* No 5 on a Doncaster market stall — an issue featuring Brian Bolland's adaptation of Harry Harrison's 'The Streets of Askelon', which I'd read originally in *The Seventh Pan Book of Horror Stories*. Now the ball was rolling good and proper. I sent off for the Forever People underground list. I scoured everywhere I could think of to get these disreputable items (more difficult for me than you'd imagine: although I was sixteen by now, people took me for a precocious twelve-year-old because I was so small and innocent-looking!). I even wrote to Mal Burns for back issues of *Graphixus*, enclosing several weeks' worth of pocket money, but I never received anything in return.

What's the point of all this reminiscing, you might ask? Simply that it all flooded back to me with the same sense of excitement and, somehow, *involvement*, when I picked up David Huxley's marvellous *Nasty Tales* — the first book to classify and put these

now obscure and wonderfully unsavoury British publications into some sort of perspective. In this sense, Huxley has done a great job. *Nasty Tales* is methodical, strategically and logically-planned, and excellently researched. What it suffers from in a little dryness is more than made up for in its evocation of a chaotically exciting period in British publishing history, every bit as distinctive and challenging as the more familiar story of American undergrounds. Huxley's approach is unsensational and objective, and he divides his subject matter into sections which allow for the optimum use of analysis of these comix' major themes — Sex, Censorship, Drugs, Violence — with more specific subsections. Huxley's book is a long-awaited tribute to a bygone era, which over the years seems to increase in vitality when one compares it to ninety-nine per cent of today's apathetic products. *Nasty Tales* looks set to be the standard text on the British undergrounds for years to come. **STEPHEN SENNITT**

ten output?

Esoterrorist was originally issued in America by OV-PRESS in 1989, and this reprint is unrevised. What's gathered here are various short pieces that first saw the light of day as TOPY and PTV mailings, publications in anthologies and the like, nicely interspersed with photos and hermetic collages by Gen. Highlights include 'His Name Was Master', a moving eulogy to the late Brion Gysin, pieces on Muzak and 'German Order', and five linked essays on 'Behavioural Cut-Ups and Magick'. All the familiar P-Orridge preoccupations are present — Control and authority in all its manifestations, the quest for alternatives to linearity and rational thought, a plea for reintegration of the human organism.

So, a top quality read, then? Well, *no*, actually — for twelve quid I was expecting something rather more substantial than this. The pieces in the book are interesting enough, but there are nowhere near enough of them for the money. Granted that Gen's writing is dense and aphoristic, it's still a *lot* of money for only sixty-eight pages, and the production, binding etc aren't marvellous either. A couple of the pages in my copy have smeared print on them.

It's a shame that no more up-to-date or exhaustive collection of Gen's work is available — a thinker and artist of his significance deserves better representation than this. In the meantime, you'd do better to trawl the internet. Start at the official site www.genesisp-orridge.com, which contains just as much interesting material as this book, free for the taking.

I ordered *Esoterrorist* sight unseen from a bookshop, and was sorely disappointed in what I got. Now you know more than I did, don't let the same happen to you! Avoid.
SIMON COLLINS

APOCALYPSE CULTURE II
Adam Parfrey, Ed.
£11.99/$18.95; 458pp; ISBN 0 922915 57 1; Feral House, 2000; www.feralhouse.com; distributed in the UK by Turnaround

I know a few people who own a copy of *Apocalypse Culture*, and many of them don't know why. They rarely pick it off the shelf but when they do they usually find something in there that either strikes a resonant chord or makes them want to throw the

THE COVERT WAR AGAINST ROCK
Alex Constantine
£9.99/$14.95; 179pp; ISBN 0 922915 61 X; Feral House, 2000; Distributed in the UK through Turnaround

In the wake of Alex Constantine's previous Feral House hardcore conspiracy-theory classics (*Psychic Dictatorship in the USA* and *Virtual Government*), this present volume may at first glance seem comparatively lightweight. After all, we've all heard the 'folk legend'-style rumours surrounding the mysterious deaths of Jim Morrison and Brian Jones, and read about the sinister ramifications behind the shooting of John Lennon. However, as we've come to expect from Constantine, *The Covert War Against Rock* sets these previously unsubstantiated rumours on more solid ground, the author supplying his usual meticulous and painstaking research in order to reveal a picture every bit as disturbing as any of his previous forays into the shadowy world of covert politics.

Constantine's basic premise — based on the research of the late Mae Brussell — is that various politically motivated Rock stars (such as Jimi Hendrix, Bob Marley, Tupac Shakur, Michael Hutchence, and others) have suffered a strategic and concentrated campaign of intimidation and eventual assassination at the hands of a covert CIA-Mafia alliance code-named Operation Chaos, which is intent on eradicating those who speak-out on political issues in opposition to its own commercial and political ambitions. While this may seem rather far-fetched, Constantine backs up his thesis with a welter of chilling detail and voluminous references, all of which seem authentic, and... oh, wait a minute, what's this? Hold the presses! On page thirty-six I've spotted a reference to a 1970 'Process church bulletin' quoted verbatim by the author, and presented as genuine. The only problem with this is that it's a fake which was circulated in 1988 at the same time as *NOX No 6: The Process* special issue. Both items have the same electronic typewriter type-face. How do I know this? I was the editor of *NOX* magazine! How can I be sure the '1970 bulletin' is a fake? I should know, of all people: I wrote it! Just goes to show — no matter how good certain conspiracy books are, and Alex Constantine's *are* good, they should always be approached with extreme scepticism. Remember folks, this is the only field where the author is more gullible than the reader. STEPHEN SENNITT

Ed: For anyone who doesn't believe that we're all pawns in some big, premeditated plan, here's a cautionary tale to accompany the above: I selected Stephen as a reviewer for Constantine's book at random — I hadn't read the book and I knew nothing about the 'bulletin' it mentions...

loathsome tome into the trash. The unrelenting focus on the symptoms of despair and madness allows for no passive stance — the reader either senses its purpose or flinches in horror.

At the time of it's publication the editor Adam Parfrey declared that there was no possibility of a sequel, which may be a reflection on just how far down the slide into madness the world has gone because now, thirteen years after the first edi-

tion, comes just such a volume.

In that intervening period there has been the rise of an entire 'underground' or 'Alternative' culture (which is really just a small and grubby part of the ever-consuming mainstream behemoth) and a number of publications that have served to seemingly steal the thunder of this new book. Regular readers of *ANSWER Me!*, *Panik*, *Funeral Party*, *Headpress* and others may
Continued on p.154

PUSSEY
Daniel Clowes

ISBN 1 56097 183 5; Fantagraphics Books Inc, 7563 Lake City Way NE, Seattle, WA 98115, USA; www.fantagraphics.com

COMICS — TOO OFTEN THEY'RE DISMISSED AS SIMPLE-MINDED IRRELEVANT PABULUM FOR MENTAL DEFECTIVES...
—from the introduction

Anyone who's ever written or drawn comics and harboured dreams of 'making it' in the industry, anyone who reads SFX and would begin hyperventilating if they missed an episode of *Buffy the Vampire Slayer*, shit — anyone who grew up reading comics and liking sci-fi, only to find themselves ostracised by the 'normal, sporty' kids will find this book a painful reading experience. Every disappointment, every unrequited dream, every embarrassment is here, rendered with the stark and unflattering line of Daniel Clowes. It is simply a truth too close to the cockshrivelling reality of it all.

The individual stories originally appeared in the early issues of *Eightball* and were far easier to ingest in small doses. Read as one volume they are simply mind-blowing as Clowes absolutely rips into the comics world, propelling his goofy-toothed, double-chinned nerd-hero through a succession of adventures that pull the whole history of the comics medium under the relentless laser beam of his sensibilities.

As a young boy Pussey (pronounced 'Poo-Say') runs from the disaffection of his family dynamic into the welcoming fantasy-arms of 'Volcano Boy' and his myriad pals.

As a teenager, he stumbles into the world of arcane rituals and sweat-freezing patheticness that is comics fandom. Once he's got his foot on the first rung of the ladder as a professional penciller he becomes a pawn in the game — manipulated by horrific caricatures of established comics 'luminaries' who represent the opposing ends of the comics spectrum — superhero crap or avant-garde bollocks. Eventually he 'makes it', right at the height of the nineties comics 'boom' when distinctly average talents raked in millions and set their jaded eyes on the big movie deal.

Every single aspect of the comics world — from Marvel's well-documented rip-off of its writers and artists over the years to *Raw*'s absurd 'We're so fucking out there' art pranks, from modern art's 'appropriation' of images by Brian Bolland and John Buscema to the current grim and relentless decline of the medium as an artform — is assaulted with absolutely no prisoners taken. Clowes wades in with the facial caricatures, relentless character assassinations (the comic mart dealer in the 'Who Farted?' T-shirt being especially accurate) and truly scathing observations. Not that Clowes actually says anything new about the idiotic machinations that go on in the medium (and the entertainment world at large) but he does manage to distil what have been endless tedious debates in places like *The Comics Journal* down to two or three panels. The reader is never allowed to feel comfortable, as every possible stance is revealed to be as ridiculous and as pathetic as the rest. You never really empathise with Pussey and yet the other characters are so repellent that you are left with little choice. Besides, Pussey is that part in all of us who just wants to be left alone to dream while the world around goes fucking crazy. He embodies our most cherished childhood dreams and our most shameful teenage memories. Lost in a world of cynical manipulators and total bastards he is, at the very least, human. This book is relentlessly, laugh-out-loud funny throughout, but by the end you come out shell-shocked and sober. It says more about ambition, dreams and the fucked-up world in which we live than any shedful of Booker prize nominees. And it's only a comic!... Who's going to read crap like that anyway?

CARICATURE
Daniel Clowes

£20.99; ISBN 1 56097 329 3; Fantagraphics Books (details as above)

Hailed by many as the only man who can save comix from itself, Clowes is a difficult man not to admire, if only for his work ethic which is focused on consistent (as opposed to prolific) output and a belief in the viability of comix as a storytelling medium on a par with cinema and the novel. So far, so good, but my problem with Clowes, and his admirers, is that for all his deserved praise, awards and kudos, he does come out with some real shite sometimes.

His ongoing title *Eightball* has evolved over the years from a *Mad*-inspired anthology of decidedly patchy quality to what is now a marketing banner for his latest, longer and more involving stories like 'David Boring'. The major shift in focus and content came with 'Ghost World', his poignant and understated study of two American teenage girls on the cusp of adulthood. This work was a breakthrough for Clowes, allowing him to leave behind annoying and silly shit (like 'Zubrick') so he could pour all his attention into the type of work for which he feels comix should be celebrated.

Caricature collects nine stories originally published alongside 'Ghost World', and compared to previous Clowes collections (*Lout Rampage* and *Orgy Bound*), it almost reads like the work of a different artist. His drawing style has matured considerably and he no longer veers between styles and techniques so much.

Clowes has developed a way of depicting America today as a mirror of itself and recent decades past — perspectives which blur into one another. His twilight cityscapes, windblown streets and empty yards are haunted with potential that, unfortunately, is only occasionally fulfilled. Of the nine stories collected here only four are really any good, which is not a good score for a book costing over twenty quid. The title story, 'Caricature,' is recognised by some as a modern classic and is certainly one that resonates here the longest. Mal Rosen is an artist working the County Fair circuit, drawing caricatures for $10 a time. Told in the first person, we are privy to Mal's diary entries as he is forced to doubt his place and purpose in the world. He meets Theda, a strange young fe-

TWO BY CLOWES
Rik Rawling

male who acts as the catalyst for Mal's doubts that his work has any real validity. Clowes manipulates the reader's emotions skilfully so that we feel equal amounts of pity, loathing and despair for the ultimately sad figure of Mal. "I think art is like shitting," says Theda at one point and this becomes the overriding metaphor, particularly during the curious and vacant finale where Mal seems to conquer his doubts, only to see his reflection in the toilet bowl, a caricature of the person he thought he knew. This strip also gives an ideal opportunity for Clowes to flex his strongest muscle — drawing the faces of ordinary Americans in all their tragic, unadulterated glory.

The strips 'Blue Italian Shit' and 'Like A Weed, Joe' both feature Rodger Young, yet another mask for Clowes to hide behind, as he reels out what must be episodes from his own life, blurred by the screen of fiction. How much of these stories is pure fiction is irrelevant — the tone of these strips is obviously more heartfelt as he recounts younger years living with his grandparents or alone in New York with a succession of surreal and horrific flatmates. It's telling that both strips are rendered in a decidedly more 'cartoonish' style than that employed on 'Caricature'. Rodger Young himself appears as little more than an assembly of dots and slash lines, as if anything approaching a realistic depiction would give the game away completely.

There is no real story here and it doesn't really matter. The reader is encouraged to remember similar episodes from their own life and thus the all-important connection with the artist and 'great insight' is made. However, it is good to see Clowes stoking the embers of his misanthropy as he lays into the freaks from his past, a trait he may not be too proud of but which certainly helps empower his best work and should be utilised more as far as I'm concerned. Do what you do best, not what it's best to do.

'MCMLXVI' (1966, for the rest of us) is an attempt at laying into the 'scenesters' who've decided America's cultural apotheosis was garage rock, Batman with Adam West, Sinatra's 'Rat Pack', trash/sleaze paperbacks, Tiki lounges and 'authentic diners'. We're encouraged to sneer at anyone who's desperately appropriated these totems as part of

their 'lifestyle' but it's obvious that Clowes, and no doubt many of his readers, are nuts for this stuff. The references are too accurate, the tone a little strained in it's detachment — it's like someone overcompensating their story in an obvious lie. Again, it's a sign that Clowes' best work comes not just from his observations and obvious artistic abilities but also when he injects a little bit of heart and soul. Which is where the other strips in this collection fall down badly…

'Green Eyeliner' is a six-pager originally published in Esquire (not that that means shit). Clowes has since claimed that six pages is nowhere near enough space to really do a

story justice, but I suppose it's not worth pointing out that this wasn't a problem for him with the early issues of Eightball where one- and two-page strips are commonplace. It doesn't excuse a poor strip, focusing on a vain young woman descending into a kind of madness.

'Immortal, Invisible' is about a boy who's a little too old to go out trick-or-treating, a tale that wants to recall the tone of 'Ghost World' but ends up fumbling with metaphors and goes nowhere.

'Black Nylon' is a guy in a home-made superhero costume who drifts through a fatuous and unfocussed narrative that seems to have been made up as it went along. If a complete unknown had come up with this strip, The Comics Journal would have rained down molten hot turds of contempt upon it. But because it's Clowes it rules, obviously.

These strips that make up the latter half of the book are devoid of something vital — a sense of purpose or even a sense that they have anything to say. Clowes has, throughout his career, made a bad habit of doing strips that many other comic artists would leave as forgotten notes and doodles in their notebooks. This has

helped to flesh out a few issues of Eightball and add to his image of prolificity but it doesn't really make for an impressive body of work.

Some of Clowes' strips are pure genius, some are total crap. The drunken slew between these two sides of the artistic highway is fascinating and frustrating to follow, but I'd like to hope that one day he will finally crash the car into the ditch marked 'Ghost World, Caricature and Pussey' and not the other — the other really is a dead end.

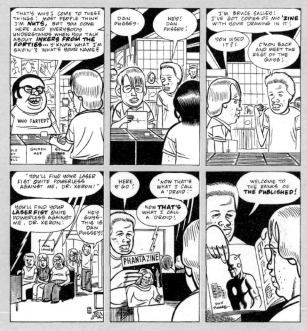

Art/Story: Daniel Clowes

Panels from 'The Origin of Dan Pussey!' in *Pussey*.

Continued from p.151

find some of the potential 'shock' factor of its contents reduced by regular exposures to weird shit. However, Parfrey has used his considerable resources to find the real signposts that point to the region described here as The Forbidden Zone. There are a couple of familiar names from the original *Apocalypse Culture* — Boyd Rice, James Shelby Downard and the now completely over-exposed Peter Sotos — but the majority of material comes from new writers with new perspectives. The subjects covered are everything from serial killer confessionals, paedophilic art, religious icons and 'conspiracy theories'. The astute assembly of the book and the often contradictory and jarring juxtaposition of the contents serves to add to the inevitable sensation of psychic overload that you get when reading the book in long sittings:

• Colin Wilson displays his consummate skill and experience in the telling of the case of Issei Sagawa, a 'sexual cannibal' who killed and partially ate a Dutch student, went on to be found Not Guilty and is now a widely published author. This is followed by a list of recipes for meals like Stillborn Stew and Sudden Infant Death Stew.

• The enigmatic series of incidents and co-incidences that surrounds the capture of Ted Kaczynski, The Unabomber, are covered by James Shelby Downard understudy, Michael A Hoffman II.

• Parfrey himself checks out the 'Slash' convention where women — 'chronic suburban masturbators' — meet to share their obsession with gay porn fantasies featuring TV heroes like Starsky & Hutch and Kirk & Spock.

• Peter Sotos' increasingly shrill voice is applied to the JonBenet Ramsay case, where he seems to imply that the media coverage of the murder, and others like it, were a mass collective 'rape' of the dead girl's corpse. Quotes from Geraldo Riviera's show are interspersed with self-indulgent fantasies clearly written by Sotos while wanking himself silly. Yes, Trevor Brown's in there too, and the cover art is by Joe Coleman but it never devolves into a roll-call of 'the usual suspects' (unlike the recent *Suture*) thanks to excellent articles by Dan Kelly (Hi-Tech Market Research), Parfrey himself (on Rich-

ard Green, lone member of the radical group 'Jews for Hitler') and, most surprisingly, Crispin Glover who lays into our modern homogenised culture and dares to ask the following:

IS IT POSSIBLE THAT THE COLUMBINE SHOOTINGS WOULD NOT HAVE OCCURRED IF STEVEN SPIELBERG HAD NEVER WAFTED HIS PUTRID STENCH UPON OUR CULTURE, A CULTURE HE HELPED HOMOGENIZE AND PROPAGANDIZE.

Genesis P-Orridge describes this book as the New Testament. What it stands as a testament to is more than just the fact that the world is mad; the world has to be mad otherwise it wouldn't work. Meanwhile we can't seem to help ourselves, staring into the abyss, scribbling notes and making sketches. Are we trying to understand our condition? Are we making records for future generations? Are we mapping the outer edges of man's society?

If it wasn't such an excellent collection of fantastically weird shit then it would still be a valid document, even if only to stand as a significant lump of *Yang* to the *Yin* of Ally McBeal, Harry Potter and DreamWorks. Buy this book and save your soul.
RIK RAWLING

ANAMORPHOSIS
STEWART HOME, SEARCHLIGHT AND THE PLOT TO DESTROY CIVILISATION

"LARRY O'HARA" & FRIENDS

ANAMORPHOSIS
Searchlight and the Plot to Destroy Civilisation
Stewart Home

£3.75; 48pp; ISBN 0951441795; Sabotage Editions, BM Senior, London, WC1N 3XX

There really isn't much to recommend in Stewart Home's latest little tract, unless you're a 'fan'. *Anamorphosis* continues the ideological feud

between Home and Larry O'Hara, Michel Prigent and others. It's no longer even entertaining, and to be honest Home doesn't come out of this particularly well. Come on, surely he's got something better to do with his time than this? The stories aren't especially funny, the pretend letters boring. The best of the collection is 'Death In June Not Mysterious', which has already been published on the internet, but it does show that Home has interesting things to say when he can be bothered. **PAN PANTZIARKA**

ANOTHER BOOK TO BURN
The State of Scotland
JN Reilly, Ed.

£9.99; Bootleg Editions, 1998; 44 Knightsbridge Street, Glasgow, G13 2YN

Touted as 'The Book that Sounds the Death Knell of New Labour in Scotland', this is a selection of poetry, short fiction and journalism on the subject of the horrors of New Labour and all the terrible things Tony Blair has done to Scotland. Amateur writing by teachers, peace activists, trade unionists, retired crofters and other lounge-room literati. If these are 'Scotland's finest poets, essayists, authors and artists', then no wonder the place is going to the dogs. I suggest taking the book's title at its word. **MIKITA BROTTMAN**

THE DEAD WALK
Andy Black

£11.99; 160pp; ISBN 0 9536564 2 X; Noir Publishing, 2000; PO Box 28, Hereford, HR1 1YT; noir@appleonline.net

Back in the mid-1990s Andy Black edited *Necronomicon*, a Devon-based horror film magazine. Much has changed since then, with the mag going to book format (through a dalliance with Creation Books) and ending up on Black's own newly-formed Noir Publishing. *The Dead Walk* is the third title to be released by them, an updated, revised version of an earlier book by Black concentrating on movie zombies. More of a general overview than a detailed examination, it contains chapters on the likes of George Romero and Lucio Fulci, as well as going off down roads less travelled (the sci-fi undead of *Invasion of the Body Snatchers*; the 'social' zombies of *A Clockwork Orange*). Black even manages to shoehorn in references to drug-soaked singer Roky Erickson. Straight after reading the Romero

chapter I sat down and rewatched *Day of the Dead*, which must count for something.

Perhaps more importantly, *The Dead Walk* marks a huge leap in design and typesetting standards for Noir Publishing, and also sports a great cover featuring proto-industrial babe Mindy Clarke from *Return of the Living Dead 3*. **MARTIN JONES**

PULP FICTION
Dana Polan
95pp; ISBN 0851708080
THELMA & LOUISE
Marita Sturken
94pp; ISBN 0851708099
DEAD MAN
Jonathan Rosenbaum
96pp; ISBN 0851708064; £8.99 each; BFI Modern Classics, 2000

More curious entries in the BFI's Modern Classics series (others include *Independence Day*, *Titanic* and *Seven*). I'm not sure whether the BFI are deliberately courting critical controversy by focusing almost exclusively on mainstream films in this series, or whether they are seeking to appeal to a broader audience than that normally found by critical works. Whatever the aim, I'm afraid that these three titles can't really be considered a success by most criteria. I have no problem with the packaging: they're all beautifully designed, and boast a large number of well-chosen stills printed on glossy, thick paper. The content, however, as with most of the subject matter, falls far short of the presentation. Why the BFI haven't taken this opportunity to focus on less well-known films is a mystery — most of the audience for *Titanic* or *Independence Day* simply won't buy books of film criticism, no matter how glossy. These books probably won't even appeal to your average *Empire* bore, and are simply too uninspiring for anyone used to intelligent film writing. The problem isn't solely with the choice of films for the series — mainstream cinema is in many ways a far richer source of critical interpretation than anything more leftfield. But none of these authors have anything approaching an angle; the razor-sharp arguments you might expect from a series of such apparent prestige are missing. Instead there is waffle, dull, second-rate Media Studies theorising, stilted political correctness and a lack of verve.

Of the three, *Dead Man* is the most entertaining read, but only because the author heavily quotes Jarmusch himself, who is as eloquent as ever. Infuriatingly, most of the more interesting avenues pointed to in the book are never explored — Rosenbaum posits the idea of the 'acid Western' but, beyond listing films for inclusion in such a sub-genre, fails to explore the idea at all. Similarly, in *Pulp Fiction*, there is a look at the fan culture surrounding Tarantino, but as soon as this gets interesting the focus shifts to Samuel L Jackson's hair. For sure, the format of the books probably encourages such a dilettante approach — a desire to skim over all of the ideas and, in so doing, cover none satisfactorily — but authors from the sister 'BFI Classics' series seem to cope better. Special vitriol is reserved for *Thelma & Louise*, a terminally woolly study in which the author's critical faculties appear to have been irreversibly skewed by her painstaking efforts to cause no offence to her 'sisters'. Don't get me wrong — this is not an attack on the feminist angle inevitably taken here, but rather on the author's inability to commit throughout, or to follow any idea past a surface, glib expression. I had to read some Jim Goad rants afterwards to get the endlessly dithering tone out of my head. I hope that these are at the lower end of the quality spectrum for this series — Iain Sinclair's *Crash* study is superb — but these haven't really inspired me to check out any of the others. **JAMES MARRIOTT**

UNRULY PLEASURES
The cult film and its critics
Xavier Mendik &
Graeme Harper, Eds.
£14.99/$19.95; 253pp; ISBN 1 903254 00 0; FAB Press, 2000; PO Box 178, Guildford, Surrey, GU3 2YU; info@fabpress.com; www.fabpress.com

As with David Kerekes' Critical Vision imprint, Harvey Fenton's FAB Press publishing house grows in stature with each new publication. Mr Fenton's vision and strength lies in getting people to do the bizzo who're resident experts in their chosen field. Hence his choice of editors for this, his latest offering — Xavier Mendik, a lecturer in media and popular culture at University College Northampton, and Graeme Harper, director of Creative and Performing Arts at the University of Wales in Bangor. The joint editors gather to their bosom an awe-inspiring collection of academics, writers and respected journalists, each contributing an essayistic chapter of their own choice on the subject of the so-called 'Cult Film'; the discussions and arguments, the relevance and appeal, of just what constitutes a movie, TV-series or even film-maker hitting cult stature.

Now let's get one thing straight, this here book ain't no pick'n'flick easy read. A 260-page large format paperback, quality production, it requires a good deal of attention and concentration. This series of innovative and highly interesting articles covers many aspects of the medium, delving into the cult film's definitions, genres, film styles and even gender depictions.

No doubt some will accuse *Unruly Pleasures* of delivering too much psycho-babble. Well, that's their opinion. Mine is that this book's a pleasure to read, worthwhile and rewarding. You only gets out what youse put in! Genre highlights presented for your edification include: *The Rocky Horror Show* (of course!), *Starship Troopers*, *Rollerball*, *Thunderbirds*, Lucio Fulci, Roger Corman, David Cronenberg, and *The Exorcist*. Plus a healthy clutch of down-and-dirty articles covering *Showgirls* [*Ed: This particular down-and-dirty article and its author were singled out for some feminist criticism at a recent cult movie conference in Nottingham*], Russ Meyer and an excellent focus on the so-named 'snuff movie' as a cult phenomenon. Respected writers include Michael Grant, Mikita Brottman, IQ Hunter, Bill Osgerby and Leon Hunt, to name but a few. Each and every article shining with obvious care and attention.

Unruly Pleasures deserves a place on the bookshelves of every genre film cineaste and serious filmophile. **JOHN CARTER**

ANTICRISTO
The Bible of Nasty Nun Sinema & Culture
Steve Fentone
£29.99/$50.00; 318pp; ISBN 1 903254 02 7; FAB Press (contact details as *Unruly Pleasures* above)

Am I dreaming? I could have sworn a big fat book devoted to sexy nuns-on-film arrived on my doorstep...
Continued on p.158

ON THE BUS IN THE SUMMER OF SAM

by Darren Arnold

AS FAR AS TOPICS ESSAYED ON screen and in print go, serial killing ain't too fresh. This decade has seen the serial killer break into mainstream cinema through works such as *The Silence of the Lambs*, *Kiss the Girls* and *Se7en*. Ed Gein has enjoyed wide distribution with representations (of sorts) in both Gus Van Sant's *Psycho* remake and the twenty-fifth anniversary re-release of *The Texas Chain Saw Massacre*, which hit cinema screens within a few months of each other. Even John McNaughton's groundbreaking *Henry: Portrait of a Serial Killer* has been subjected to a ludicrous sequel, which provides incontrovertible proof (if any were needed) that the whole concept is now producing results that are positively threadbare. With this in mind, **Spike Lee's SUMMER OF SAM (1999)** stands up as one of the most interesting pictures of recent years for the way in which it gives a much-needed facelift to the cinema's treatment of the serial killer.

Taking its cue from the glut of slayings carried out by New York resident David Berkowitz way back in the summer of 77, *Summer of Sam* — a title which puns rather clumsily on Berkowitz' 'Son of Sam' moniker — makes a direct hit from the off by making it clear that this story is about real events, people and places. No 'based on a true story…' flannel; no pseudonymous representation of the killer. But rather, cold hard facts. Lee springs this on the audience by way of a rather rambling introductory monologue from Jimmy Breslin. Breslin, as many will know, is the New York tabloid journalist who received a number of bizarre letters from Berkowitz, and Lee, by having Breslin appear as himself at the beginning of the movie, makes a declaration regarding his intentions for the oncoming picture. Breslin effectively tops and tails the movie, also appearing at the end to reiterate his

opening points and provide some information on Berkowitz' prison sentence. While this device is rather clumsy, it leaves no doubt in the audience's mind, and therefore expels any potential distancing between viewer and subject.

David Berkowitz — who was known in the opening act of his spree as 'the .44 calibre killer' on account of his chosen weapon — killed six people, and wounded another seven. This not inconsiderable tally might well present enough material for a movie on its own, yet *Summer of Sam* is not entirely concerned with David Berkowitz and his crimes. Instead, Lee has chosen to use the killings as a backdrop to that period in American history, which perhaps isn't too surprising when we think of how the director has chronicled other impor-

tant modern-day American events through works such as *Get On The Bus*, *Malcolm X* and the documentary *Four Little Girls*.

Sam uses three central characters to tell its story. Vinny (John Leguizamo) is a womanising hairdresser, oblivious to the real needs of his hardworking wife Dionna (Mira Sorvino). Vinny has to be seen to be keeping in with his friends, despite his obvious affection for one of their number who has been virtually ostracised. That member, and the third point in Lee's narrative triangle, is Ritchie (Adrien Brody) a onetime 'regular' guy in Vinny's circle who has recently begun to follow the punk movement that has been imported into Manhattan from Britain. Ritchie's behaviour arouses suspicion among his none-too-tolerant friends, who start to think that Ritchie might be the killer. Matters aren't helped when they discover that Ritchie earns his cash through working at strip shows and in porno movies.

Much of *Summer of Sam* takes place in the Bronx neighbourhood that was Berkowitz' hunting ground. The vast majority of the characters are Italian-American, and Lee has used the oft-portrayed closeness of the Ital-

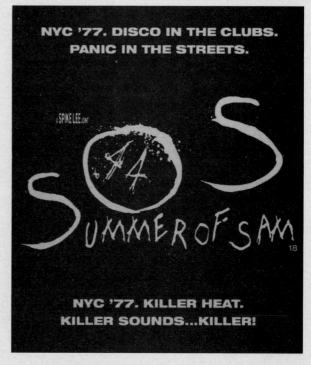

NYC '77. DISCO IN THE CLUBS. PANIC IN THE STREETS.

A SPIKE LEE JOINT

SOS
.44
SUMMER OF SAM

18

NYC '77. KILLER HEAT. KILLER SOUNDS…KILLER!

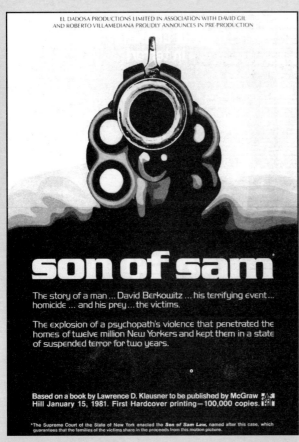

EL DADOSA PRODUCTIONS LIMITED IN ASSOCIATION WITH DAVID GIL
AND ROBERTO VILLAMEDIANA PROUDLY ANNOUNCES IN PRE-PRODUCTION

son of sam*

The story of a man... David Berkowitz ... his terrifying event...
homicide ... and his prey... the victims.

The explosion of a psychopath's violence that penetrated the
homes of twelve million New Yorkers and kept them in a state
of suspended terror for two years.

Based on a book by Lawrence D. Klausner to be published by McGraw
Hill January 15, 1981. First Hardcover printing—100,000 copies.

*The Supreme Court of the State of New York enacted the **Son of Sam Law**, named after this case, which
guarantees that the families of the victims share in the proceeds from this motion picture.

**A different, earlier
Son of Sam picture.**

ian family as a means of showing the frightening way in which vigilante groups are formed. In most of Lee's films, it is the black voice who proves to be the victim of prejudice, but here he puts a different spin on things by showing how mindless prejudice is directed at anything outside the norm — in this case, Ritchie, who at best is sneeringly likened to a "British fag", and at worst is thought to be the Son of Sam. All because of the way he dresses, the clubs he frequents, and the music that he listens to.

The role of David Berkowitz (played by Michael Badalucco), as already mentioned, does not take up too much screen time. The Son of Sam is largely presented in one of two modes — in his filthy apartment, where he covers his ears and screams in an effort to block out the barking of his neighbour's dog, or through a car windscreen as he lets rip with his .44. The way in which Lee has filmed the killings is of real interest, especially keeping in mind the way that serial killings tend to be portrayed in the cinema. In *Summer of Sam*, the deaths are filmed in a brutal, matter-of-fact, yet strangely unaffecting way. Here, audiences don't get to squirm as Buffalo Bill makes some attire from human skin, or gag as John Doe's 'gluttony' victim is found. And although some may argue that bold representation is nothing new (think of the horrors present in the aforementioned *Henry*), *Summer of Sam* manages to present an icy, detached spree of killing that gets the point across without being — or intending to be — the least bit shocking.

At times, the scenes in Berkowitz' apartment smacks of cliché. Filmed in a washed-out style that is out of step with the rest of the film, we see Berkowitz in his underpants, screaming, and writing stories on his wall about the things that live inside. Flies buzz around, landing on rotten scraps in the hovel, newspaper cuttings are plastered on the walls, and we've definitely seen this sort of thing done many times before. But, rather oddly, these textbook serial-killer-at-home scenes seem to work. The talking dog that tells Berkowitz to kill is strangely effective, and although it'll get more than its fair share of laughs, few can deny that the idea of Berkowitz and the talking dog is little short of being inordinately creepy.

Some critics have suggested that Lee is ill at ease with his predominantly white cast in this film, but this seems a little unfair. Lee has coaxed excellent performances from his entire cast, with the three stars ably supported by the likes of Bebe Neuwirth, John Savage and Jennifer Esposito At two-and-a-half hours and with more than 100 speaking roles, *Sam* is a massive film that has been expertly handled by one of America's most controversial filmmakers. The African-American viewpoint is in there, too, and Lee skilfully interweaves the story of the 1977 blackout and subsequent looting with the story of Berkowitz.

For the serial killer sub-genre, *Summer of Sam* represents a massively important step. The killer is pushed to the background, and Jimmy Breslin's sign-off speech refers to David Berkowitz as a "sick fuck", which is in line with Spike Lee's painting of Berkowitz as being neither very funny nor a particularly good solitary subject for a movie. Many serial killers are not half as interesting as the hysteria that their crimes generate, and it's taken until *Summer of Sam* for that point to be made on a cinema screen.

Continued from p.155

Nothing bad can be said about *AntiCristo*. It's a well-researched, heavily illustrated, great-looking volume aimed — and here's the important bit — squarely at an incredibly select market, with a mere 666 print run in hardback. Talk about specialist, niche and marginalia — I'm having to pinch myself as I write! The impetus for *AntiCristo* appears to have been Ken Russell's *The Devils*, a film which author Steve Fentone (who also produces the zine dedicated to Mexican wrestling movies, *Panicos!!*) regards as the epitome "of all that is Nasty Nun Sinema". From here an obsession was born.

The main body of *AntiCristo* is comprised of an alphabetic listing of movies whose main focus is nuns. Everything from 'serious' productions (such as Norman Jewison's *Agnes of God*), through to obscure horror (like Juan Lopez Moctezuma's *Alucarda, Hija de las Tinieblas*), and the many soft-focus fantasies to have emerged from Europe are covered. Each entry comes with production

hardcore nun oeuvre (once again, with plenty of pictures). Strangely, nuns even find a place in Japanese porno with occidental Sisters lapsing into erotic fevre dreams in *Seijo No Hard-Lez* (1992), and *Seijū Gakuen* (1974), whose scandalous imagery incorporates a novice urinating over an effigy of the crucified Christ. How's about that, Borowczyk! A supplementary section deals with movies in which nuns might only play a peripheral role, such as *Airplane!*, *Cannonball Run II* and *The Magic Christian*. Other sections of the book cover the depiction of nuns on stage, TV (including *The Benny Hill Show* and *Are You Being Served?*), comics (Noe and Barreiro's fabulously blasphemous *The Convent of Hell*), pop music (songs about nuns, by nuns, and bands with nuns in their name), multimedia (nunsploitation in the digital age), and ultimately advertising and merchandising (the Fighting Nun glove puppet and a *Flying Nun* lunchbox).

Several printers turned this job down flat. Whatever next? **DAVID KEREKES**

important events such as the war in Bosnia, the subject of *Safe Area Gorazde*.

What Joe Sacco has done using his unique way of reporting — graphic journalism — is present the facts in a way that is both easily digestible and highly absorbing.

It was in the towns and villages of Eastern Bosnia that Bosnian Serb forces butchered and massacred the Muslims. When the UN finally intervened, it designated 'Safe Areas' which ironically became the most dangerous places in Bosnia. One of these Safe Areas, Gorazde, was the only place that survived the War. Following his time spent in Gorazde, Sacco shows us the lives of the people trapped there and presents their harrowing tales.

As someone with a patchy knowledge of the Bosnian war, this book with its superb comic strip drawings and engrossing story helped bridge the gap in my limited understanding. With a subject as confusing and complex as this, I cannot imagine a better medium with which to get to

Art/Story: Noe & Barreiro

details, alternate titles, a synopsis and Fentone's comments. Photographs for many of the entries are also included, along with promotional artwork and the occasional photo-strip comic adaptation so popular on the continent. You'll be glad to know that the cloistered life — rather, our wishful interpretation of it — lends itself nicely to porno as well, and Fentone has done a masterful job of weeding out what surely must stand as the bulk of the

SAFE AREA GORAZDE
The War in Eastern Bosnia 1992–1995
Joe Sacco

£19.99; 229pp; ISBN 1 56097 392 7; Fantagraphics, 2000; distributed in the uk by Turnaround

I hate to say it, but too many of us don't take enough interest in the troubles around the world unless they are on our doorstep or concern us directly. I myself feel particularly ignorant of details regarding certain

grips with the basic facts.

My initial reaction to the book was one of surprise as I hadn't seen comic journalism before (I've not read that many graphic novels) and wondered how successful it would be. Upon picking it up however, I realised that I had been wrong to doubt, and saw instantly what a perfect medium it is for explaining the basic facts.

Of course, news and documentary are necessary in their own right, but

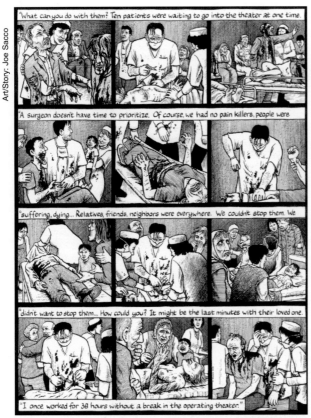

Art/Story: Joe Sacco

"What can you do with them? Ten patients were waiting to go into the theater at one time."

"A surgeon doesn't have time to prioritize. Of course, we had no pain killers, people were"

"suffering, dying... Relatives, friends, neighbors were everywhere. We couldn't stop them. We"

"didn't want to stop them... How could you? It might be the last minutes with their loved one."

"I once worked for 38 hours without a break in the operating theater."

PREVIOUS PAGE: All Hell breaks loose in 'The Convent of Hell', as featured in *AntiCristo*.

ABOVE: All Hell breaks loose in *Safe Area Gorazde*.

strips, means he would probably glass the media twats and then go neck some more rocket fuel cider. The guy brings a much needed energy and sense of humour to the 'radical politics' underground. Some of that humour is either as subtle as a sledgehammer or nothing better than a Hale & Pace sketch with piercings — 'Arnie the Anarchist' features a lot, as does 'Sub Vert Man' ("he's been on the cider and he's fuckin' angry!") and the political sophistication they convey is almost non-existent, but it's that total lack of subtlety that engages in more ways than any tedious anarchist pamphlet ever could. Patriotic yobs get beat up, coppers (THE enemy) get grenades stuck down their throats, insensitive punk boys get routinely leathered by their feisty Tank Girl friends. It's all very much an unfocussed howl of rage at the fucked-up state of England in the nineties and seems the best kind of response to the Paxman-endorsed level of debate that we've become used to. While a lot of it may be pissing in the wind it comes infused with genuine human emotion, missing from most levels of art these days. It's worth a measly £6 for the reminder. RIK RAWLING

TOO GOOD TO BE TRUE
The Colossal Book of Urban Legends
Jan Harold Brunvand
£22/$29.95; 480pp; ISBN 0 393 04734 2; WW Norton, 1999

THE BIG BOOK OF URBAN LEGENDS
Various artists
£9.99/$14.95; 223pp; ISBN 1 56389 165 4; Paradox Press, 1994; distributed in the UK by Turnaround

When I was nine-years-old I told the world that an alsation dog had been discovered in the freezer compartment of a local Chinese takeaway with its legs cut off. How did I come to know this? My best friend had told me. He got the news off some other kid whose parents apparently knew someone who knew a health inspector. Or something. At nine-years-old it didn't really matter where the news came from — it was a gross story with something dead in it. But then, into my teenage years and beyond, I heard others recount the same tale anew and pertaining to some other suitably ambiguous eating establishment in the locality — occasionally

for understanding the basics, this book is brilliant. Trying to make sense of world news day after day in its serious, straightforward way is often confusing and difficult for many of us and events can slip by with us knowing little about them. With text, drawings and maps, the unintimidating comic strip here proves itself as an ideal means through which to convey historic events. BEN BLACKSHAW

PUNK STRIPS
Simon Gane
£6/$12; 128pp; ISBN 1-899866353; Slab-O-Concrete Publs, PO Box 148, Hove, BN3 3DQ; mail@slab-o-concrete.demon.co.uk; www.slab-o-concrete.demon.co.uk

"Anarcho Terrorist from the REAL punk underground" — here we fucking go. It would be easy to imagine this work summed up as 'Jamie Hewlett on speed' but 'Jamie Hewlett on White Lightning' might

be more appropriate seeing as each page comes reeking of dosser juice. Not that any of this bollocks does Simon Gane's work justice. While many other fly-by-nights have dipped their toes in the UK zine underground, only to fuck off back to their day jobs as soon as it got cold or graduated to doing shit illos for 'lad's mags', Simon Gane continues to do his thing and do it well. His truly idiosyncratic style — really chunky marker pen line-work, stark spotted blacks and a *Roobarb & Custard* approach to pacing — is just the type of thing advertising twats love to grab hold of and suck dry. Six months of doing ads for mobile phones, club compilation CD covers and *Guardian* feature illos and the guy would suddenly be deemed redundant by our ever more avaricious culture — which isn't going to happen as Simon Gane's political stance, made crystal clear in these

'foreign' but more and more of the fast-food restaurant variety. Sometimes, a patron of the restaurant had to be rushed into hospital after a chicken bone had become lodged in their throat — only, upon examination, it wasn't the bone of a chicken but that of a rat.

I found a vague familiarity in other stories I was hearing, too. Stories concerning disfigured escaped lunatics prowling lovers' lanes, and lick-and-stick tattoos for kids that had been impregnated with LSD (a café I once visited had a notice warning parents to be vigilant of innocent-looking Disney transfers that actually contained mind-altering chemicals). But it wasn't until I read Jan Harold Brunvand's *The Choking Doberman* did I realise how widespread these tales were, how so many of them had little or no factual basis, and how they keep on coming back. They are instead part of a social phenomenon known as the Apocryphal Tale, or the Urban Legend.

After twenty-odd years of collecting these stories and studying their origins, Brunvand is something of an authority on the subject, and his new book, *Too Good To Be True*, is a kind of Brunvand-greatest-hits package. Sweeping from the Kentucky Fried Rat and other old favourites through to kidney heists and "gerbilling", the tales are categorised and come complete with an analysis, often supplemented by comments sent to Brunvand by readers of his earlier books. There's a sense of perverse satisfaction in discovering that supposed 'news-breaking' stories you may have heard only a few weeks ago are in fact false and have been kicking around for fifty or more years — carried by word of mouth, or resurrected through the media (radio phone-ins are a prime source for the resurrection of an urban legend). Of course, tales of poisoned dresses, indecent exposure at the hair salon, secret cake recipes and such like, are related by people in all good faith — that's the nature of the beast. Probe beneath the surface of these stories, however, and everything is always suitably ambiguous: the tale has an indeterminate setting in which the participants are all someone somebody else knows, or friends of a friend. It's interesting to note how many of these legends turn up in motion pictures and advertising, of-

ten as plot devices or elaborate gags (dog in a high-rise chasing a ball out of the window, for example). Mondo films also utilise urban legends — alligators in the sewers of New York, for instance, is one myth which *This Violent World* plays out as a statement of fact. Brunvand's approach is rarely haughty or overbearing, but constantly engaging and entertaining. *Too Good To Be True* is a fascinating, funny and fairly definitive collection.

A very good companion to the above is *The Big Book of Urban Legends*, part of the Factoid series of books, in which a chosen topic is adapted by various artists in comic form. (Other volumes have been devoted to Hoaxes, Conspiracies, Martyrs, Losers, Vice, Death and Scandal.) The stories — of which there are approximately 200 — are generally related to a page apiece, with penmanship by many familiar artists being consistently high. The introduction is by Brunvand so it's no surprise that the stories and their categorisation are a lot like *Too Good To Be True*. There is no extraneous comment or analysis here, however. But then there really is no need — the comic strip form works well and most adaptations convey the humour and creepiness inherent in the tales without further embellishment. And let's face it, if you want insight you're not going to be on the look-out for a series entitled *The Big Book of*— anyway. DAVID KEREKES

BARROOM TRANSCRIPTS
featuring Tony Straub
Compiled by Rich Stewart

$11.95; 229pp; Craphouse Press 1999; Craphouse Press, PO Box 2691, Lancaster, PA 17608, USA; craphousepress@aol.com

Who is Tony Straub? I had no idea until I picked this book up, and it was only well into the text itself that I began to have an inkling. The introduction gives little away, other than to call Straub "notorious". *Barroom Transcripts* comprises a bunch of true stories and snippets of conversations recorded in or around Lancaster, Pennsylvania, during 1999. Drinking and bar-hopping naturally predominate the tales, as does Straub. Other folk who have tales to tell include Old Joe Blow Crackhead, Jack Groovy, Buggy and JS. Raymond Carver made a career of writing stories in which nothing happens. Nothing much happens in Tony's stories

either, but I doubt that he or his drinking buddies will pluck a career out of them — more the pity, for *Barroom Transcripts* is highly entertaining. In 'The Handgun', Tony relates how he once disarmed a man who pulled a revolver on him: he spat in his eyes.

HE WILL BLINK... THE HANDGUN'S YOURS. IT ONLY TAKES A SECOND, 'CAUSE IT SHATTERS YOUR EYES FOR A SECOND OR TWO.

In 'Takin' Care of Business', Tony speaks of his fondness for Karaoke and how he came to fall out with Dancin' Dan. It all started in the bar, like this:

LIKE DANCIN' DAN THAT ONE NIGHT. HE WAS TERRORIZIN' ME. HE SAYS, "OH, ARE YOU GONNA TRY TO SING KARAOKE TONIGHT?"
WELL THAT DISTURBED ME, RIGHT? HE DID IT ABOUT FOUR TIMES. "ARE YOU GONNA TRY TO SING TONIGHT?"
I SAID, "WHY DON'T YOU GET UP THERE AND SING, GUY? LET'S SEE HOW GOOD YOU ARE."

The tensions escalate when Tony next bumps into Dan. This time Dan chides Tony for wearing his "Indian stuff... a necklace made with a feather on it."

SO I SAID, "DON'T YOU WORRY ABOUT WHAT I'M WEARIN' GUY. IT'S NONE OF YOUR BUSINESS. DON'T MAKE ANY COMMENTS ON ME AND BY THE WAY, THE NEXT TIME I SEE YA, I'M GONNA FUCK YA UP! IS THAT ALL RIGHT WITH YOU?" SO THE BARMAN SAID, "TONY, YOU GOT TO LEAVE."
I SAID TO HIM, "YOU GOT ME THROWN OUT OF THIS PLACE AND I DIDN'T EVEN GET A BEER YET."

In another story, 'Tony Beats the Bartender', a fight ensues when Tony pops George the bartender for not serving him a beer. Four or five guys drag Tony outside and start to beat him up. The tale concludes with Tony being arrested: "...and I forgot what came out of it. Nothin' pro'bly." Elsewhere conversations arise concerning the tape recorder that Rich Stewart uses, compiler of the book. Soon the conversation transmutes from the recorder into the subject of Don X, a man who wasn't quite normal and decided one day he wanted

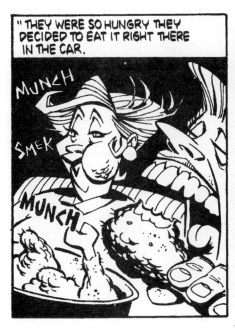

"THEY WERE SO HUNGRY THEY DECIDED TO EAT IT RIGHT THERE IN THE CAR.

MUNCH
SMEK
MUNCH

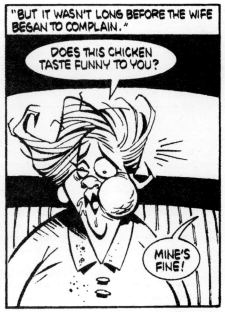

"BUT IT WASN'T LONG BEFORE THE WIFE BEGAN TO COMPLAIN."

DOES THIS CHICKEN TASTE FUNNY TO YOU?

MINE'S FINE!

Art: Glenn Barr

Too good to be true? The story of 'The Kentucky Fried Rat' in *The Big Book of Urban Legends*.

to make something out of tree stumps. BC recounts a tale of Don in the early seventies:

I TALKED TO HIM AND HE WAS NORMAL. BUT HE WAS A LITTLE OUT IN LEFT FIELD. AND WE WOULD HAVE GOOD CONVERSATIONS. BUT THEN I HAD A BUSINESS UP IN MARION COURT CALLED 'LIVING WOODS'. IT WAS A SHOP. AND ONE DAY HE WALKED INTO THE SHOP AND HE SAID TO ME THAT HE WAS INTERESTED IN TREE STUMPS. HE WANTED TO PROVIDE ME WITH TREE STUMPS BECAUSE HE WANTED TO TAKE SOMETHING THAT WAS SOCIALLY NEGATIVE AND TURN IT INTO SOMETHING THAT WAS SOCIALLY POSITIVE. AND HE SAID, "WHAT I WOULD LIKE TO DO IS, I WOULD LIKE TO HAVE THESE STUMPS THAT PEOPLE COULD PUT IN THEIR LIVING ROOMS AND GROW WATERMELONS OUT OF THEM." OK? "AND CANTALOUPES." NOW I'M LISTENING TO HIM AND I'M ON THE VERGE OF BREAKING INTO HYSTERICAL LAUGHTER. THEN I SAID TO HIM, "DON, A STUMP TO ME IS SOMETHING THAT'S THIS HIGH OFF THE GROUND, TWO OR THREE OFF

THE GROUND OR IT COULD BE SOMETHING LEVEL WITH THE GROUND." THEN I SAID, "WHICH ARE YOU INTERESTED IN?" HE LOOKED AT ME AND HE SAID, COMPLETELY SERIOUS, "LET ME ASSURE YOU I DO NOT WANT ANYTHING THAT HAS BEEN DEFECATED UPON." SO THAT RULED OUT THOSE GODDAMN LOW STUMPS.

"Everybody's got their own sense of nonsense," deduces JS at the end of the tale.

But *Barroom Transcripts* isn't all fun and games. Later in the book Tony is taking Librium for the shakes and assorted pills to help him eat. He recalls how, having checked himself into a Substance Abuse Centre following a week-and-a-half drinking binge, he was asked to leave early. The reason being he was "running his own program". Do yourself a favour — buy this book and get pissed.
DAVID KEREKES

DISSECTING MARILYN MANSON
Gavin Baddeley

£9.99; 176pp; ISBN 0 85965 283 1; Plexus, 2000

Here are a few of the influences cited in *Dissecting Marilyn Manson*:

Frederick Nietzsche, Kiss, *The Bible*, fascism, Queen, Sigmund Freud, absinthe, Alice Cooper, Aleister Crowley, *The Rocky Horror Show*, Charles Darwin, Kenneth Anger, the Church of Satan and... Dr Hook? Anomalies aside, it reads like a rolecall of the misanthropic male, and the male in question is Marilyn Manson, the USA's alternative rock ghoul of choice; a man whose success has allowed for experimentation with every available excess, and, on a sweeter note, allows him to shack up with that actress from *Scream* who got her tits caught in the garage door (semi-naked picture of her in here, flesh fans!).

Gavin Baddeley's book sets out to do just what the title suggests (although I'm sure quite a few people would enjoy a literal interpretation) and break down the influences from childhood onwards that have made this 'Antichrist Superstar' the person he is today. The trouble is that in attempting analysis, Baddeley also shows us how devastatingly unoriginal Marilyn Manson is. Admitting that the actual music is the least of his concerns, Baddeley creates — sometimes very tenuous — links between subject and influences and comes an embarrassing cropper more than once. Briefly touching on

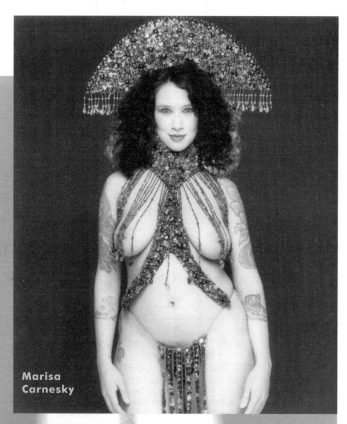

Marisa
Carnesky

JEWESS TATTOOESS
The Greenroom, Manchester, February 25, 2000

*Ye shall not make any cuttings in your flesh for the dead,
nor tattoo any marks (Lev 19.27–28)*

Marisa Carnesky is both Jewish and tattooed — an open contravention of Jewish law as proscribed in the Torah (above). It was also the starting point for the recent solo show by the London-based performance artist and founder of the Dragon Ladies [in which she performed as Marisa Carr; see *Headpress17*]. JEWESS TATTOOESS combined elements of Yiddish and Victorian melodrama, as well as horror films, in particular *The Cabinet of Dr Caligari* and *The Exorcist*. It was an intense and at times awkwardly personal exploration of a young woman's coming-of-age, and her relationship with her mythological and historical past. Carnesky veered from the role of lost little girl to mother-figure to self-created freak (unfortunately, further bodily desecration courtesy of the proposed live tattoo of a Star of David didn't materialise), in an atmospheric and edgy performance that reached its undoubted peak with Carnesky's incarnation of Lilith. The 'mythological demon said to cause nocturnal emissions amongst sleeping men' raised itself onto its toes and remained in a position of threat and horror for an inordinately long time, its tongue lolling out of its mouth in a puke-green colour. Unforgettable. DAVID KEREKES

the subject of Manson's father's role in the Vietnam war (as a helicopter pilot responsible for dropping Agent Orange), he rightly states how the hedonistic Paris of the 1890s was a result of the Franco-Prussian war, and that the same was true for WWI and 1920s Berlin, before cocking it all up with:

COULD THERE BE A LINK BETWEEN AMERICAN DECADENCE — AS PERSONIFIED BY MARILYN MANSON — AND THE HUMILIAT-ING DEFEAT EXPERIENCED BY THE US IN VIETNAM?

For fuck's sake! We are, after all, talking about a 'decadent' culture where Nietzsche can be para-phrased by the narrators of 'danger-ous sports' videos; where Henry Rollins is thought of as a renaissance man; where a band like Slipknot are considered threatening because they wear masks… Throughout the book, Baddeley also attempts to draw par-allels between events of the past and acts of the present, as undertaken by Marilyn Manson. It's a pretty wide chasm to leap across, and, unless you're a rabidly devoted fan (there's probably no other kind), you'll fin-ish this book thinking all little Marilyn represents is a composite of Iggy Pop's self-hate, Throbbing Gristle's shock tactics, David Bowie's stage personas, and Alice Cooper's the-atrics (strangely, the book's cover photo shows Manson to be the spit-ting image of Cooper). The last chapter even hints at a slide into messianic self-immolation, a route taken by so many others in rock his-tory.

The best level on which *Dissecting Marilyn Manson* works is as a primer for less-obvious gothic culture. There are some dank alleys to go down, not just the usual ones populated by bats and shit. Here are a few: nine-teenth-century decadent artists, Roald Dahl, *Lie*, Dr Seuss, JG Ballard, the Marquis de Sade, the 'White Album', classic gothic litera-ture, David Lynch, Phillip K Dick, and Alejandro Jodorowsky. If this book does nothing else, I hope it leads Marilyn Manson fans on to some-where else. Somewhere different. MARTIN JONES

RADICAL DESIRE
Housk Randall & Mark Ramsden

£16.99; 105pp; ISBN 1 85242 653 5; Serpent's Tail, 2000

This is a book where, for once, the graphics and the text are perfectly matched. Housk Randall's pictures have always reflected some of the realities of the fetish scene. His models are not just models, they're real people, with bodies that don't always match the silicone perfection and svelte proportions of a lot of fetish glamour work. There's a witty feel about them too, a reminder that people do these things because they enjoy them. That said some of the piercing photos had me squirming in my seat. There ain't no way anybody's ever going to do that to me. To go with the graphics Mark Ramsden's text is also witty, interesting and sometimes defiantly sensible. The description of 'An Evening at the Torture Garden' is priceless, and does much to deflate some of the pompous prats who plague the fetish scene.

There are lots of fetish anthologies on the market, and this is definitely one of the better ones.
PAN PANTZIARKA

UFO
Richard Brunswick
Photo Collection

317pp; Goliath, 1999; ISBN 3 9805876 3 0; distributed in the UK by Turnaround

Richard Brunswick, we are told, has spent much of his life devoted to collecting photographs of UFOs as well as documents, films and newspaper cuttings. Here he presents us with 300 snaps of UFOs (and a distinct lack of text) sighted over various holiday spots around the globe. Although quite pleasing to the eye, the photographs look pretty much like every other UFO picture (which is perhaps the point) and there are one or two that are suspiciously a little too scratched and filthy.

For the most part, the 'craft' are of the saucer-shaped variety but towards the end of the book we come to the highly amusing 'eye witness' reports and 'corresponding photographs'. Amongst these we see a Chinese man with an antenna coming out of his head (for alien contact), bruised buttocks (the result of buggery by aliens), and perhaps most alarming of all a group of naked children wearing nought but

sunglasses (preparing for a rocket trip to space)!

For someone who — we glean in the briefest of introductions — has not only studied air and space travel technology, but also devoted forty years of his life to collecting related photos and films, one would have expected to see a little more written information on the enigmatic Mr Brunswick. Further to his technical qualifications, he is said to be an abductee who supposedly remains in contact with aliens!

If nothing more, the book does provide a few laughs. And if you're not sure of where Brunswick is coming from, you should have a fair idea by the time you get to the final photograph of a rock formation that resembles an alien head.

This book might make you ask some big questions — but not about UFOs particularly. BEN BLACKSHAW

BURGER DUDE
Jonathon Stone

$9.95 (payable Jon Stone, incs p&p) 47pp; ISBN 0 7414 0435 4; Buy Books on the web.com, 2000; Jon Stone, PO Box 5121, Kinchelow, MI 49788, USA; info@buybooksontheweb.com

Somewhere in North America, 1971. Hippie Ray wants cash fast to buy some wheels so he and his pal Richie can cruise off down the highway: "It'll be like Easy Rider — except with a car." Ray gets his hair chopped and takes a temporary job at McBurger's flipping cow chunks. Fourteen years later, he's still there. Richie, however, has become a corporate cock-rack. Two decades-plus of the same job, same apartment, lousy cars, lousy sex, lousy money all take their toll, and, after hallucinatory visits from giant talking burgers, Ray turns up at work one day with a loaded rifle, ready to deal it out to employers and former friends…

Burger Dude isn't particularly well-written, reading more like a screenplay that hasn't been cut into scenes yet. It's also fairly monotonous and predictable, but maybe that's the author's intention, as Ray's life is just the same tedious shit all day every day. Burger Dude works best as a depressing realisation of non-skilled working life: where you're always going to get another job next week, where the plank between 'paying the bills' and 'eviction' is supported only by a pittance wage, where employers' demands become increasingly

tiresome, where all you find yourself doing after each shift is getting drunk in front of the TV… Millions of kids being trained to say 'enjoy your meal' and easy access to firearms? Why hasn't the apocalypse arrived yet? MARTIN JONES

Close encounters of a scratchy kind in UFO.

HARRIET STAUNTON
A Victorian murder ballad
MJ Weller

£5 (direct from publisher, payable Visual Associations, incs p&p); ISBN 0 9528135 9 9; Visual Associations, 1999; c/o 3 Queen Adelaide Court, Queen Adelaide Road, Penge, London, SE20 7DZ; mikejweller@hotmail.com

On Friday 13, 1877, the body of thirty-six-year-old Harriet Staunton was found at a house at Penge, in South East London, apparently a victim of "cerebral disease and apoplexy". A few days earlier, her baby son Tommy had also died. At a widely publicised trial, Harriet's husband and young in-laws were accused of murdering her by starvation. Author MJ Weller takes what has the potential to be a really fascinating story, and instead of analysing details of the case, re-enacts the story in the style of a 'Victorian murder ballad' — though thankfully not in verse — which leads to a lot of tedious and ham-fisted attempts to reproduce Victorian diction and

courtroom style. Section titles include 'Go Back, Missus Harriet', and 'Is She Keeping the Food Down, Clara?'. Yet another reason to steer clear of small press fiction. **MIKITA BROTTMAN**

SEEK!
Rudy Rucker
£13.50; ISBN 1 56858 138 6; Four Walls Eight Windows

This anthology of magazine, diary, and occasional pieces from the past decade-and-a-half suffers badly from the difficulty of collected writing on cutting-edge subjects. While they may have been hot several years ago, they have become either side-tracked or redundant as science and information technology makes near-weekly quantum leaps. Rucker is a professor of computer science and an award-winning writer of science fiction novels, among them *Infinity and the Mind*, and the *Ware* series. He writes in a chatty, laid-back style, usually very smooth and readable, sometimes boring and self-absorbed. Mostly, though, quite good fun if, that is, your interest is piqued by things cybernetic and SF-related. The pieces are organised into three sections: Science, Life, and Art, and range from interesting musings on nanotechnology (remember that?), to past-their-sell-by-date musings on fractals and artificial life, to pointless musings on a dog called Arf. Rucker is writing all the time and about everything. Unfortunately, only sporadically does he have interesting observations to make, electing on publishing pieces that should have either remained as journal notes or stripped of their chaff. Articles written just a few years ago on what was then cutting-edge stuff often feel very dated, occasionally irrelevant. I'd question the point of reprinting such writing, which takes me back to my computer science lessons: hour after hour learning stupefyingly outdated facts about card-hole reading machines and ferrous-core memory drives. Rucker's pieces were written for magazines, consequently they don't have the fact-density that would make for absorbing reading. You find yourself snacking on odd paragraphs, wearied or amused on being reminded about datagloves and the struggles he had to create a virtual cube on old CAD software. The historical value is marginal, and a few min-

utes on the web shows me what's happening now. This book is a repository; don't go here to seek out where things are going. This is future past.

The anecdotal pieces work better. 'Drugs and Live Sex' is a beatnicky evening with strung-out New Yorkers. Funny. And the 'Jerry's Neighbours' chapter is very good on the paranoia that crept over Rucker after he'd pissed-off a right-winger. The interview chapters and reported conversations also engage. Rucker meets Ivan Stang (the man behind the Church of the SubGenius), nanotechnology proselytiser Eric Drexler, and Stephen Wolfram, the creator of Mathematica. Also enjoyable are the pieces on silicon chip-fabrication plants, trip to Japan and Hawaii, and the experience of making a movie on Portugal with Robert Anton Wilson (who is an ordinary mortal with ordinary mortal gripes and emotions as it turns out.) What I do not like is paying to read about Rucker's dog (so many times I've tried and failed to read this chapter), his shopworn *Star Trek*-SF concepts, and his hopes of being remembered as an SF writer as great as Philip K Dick, a writer for whom Rucker sees purely in terms of ideas, grasping non of the late writer's anger and political awareness. I can't help feeling that things are just a little too comfortable in Rucker's tenured world for his ideas to be more than merely mildly interesting. Pages spent plugging concepts of robots and artificial life and how they are worked-up in his fiction had me flicking to other sections. This is and always will be one of the perils of writing about science fiction. While robots may well be where it's at out Rucker's way, to me they're about as interesting as those plastic tropical fish that bob around on magnets (how *do* they work?). A century of work into and speculation about robots, and where are we? Car assembly plants and substitute-pet automata. Follow-up pieces to these chapters wouldn't have been a bad idea.

For a writer with two Philip K Dick awards to his name, I find *Seek!* dejecting. **EUGENE CARFAX**

BUTCHERSHOP IN THE SKY
Premature Ejaculations 1989–1999

James Havoc
£11.95/$19.95; 208pp; ISBN 1 871592 66 6; Creation, 1999

IF HIS LUDICROUS 'ANTI-NOVEL' *RAISM* HAD NOT EXISTED, THERE WOULD HAVE BEEN NO REASON, NO INSPIRATION TO FORM *CREATION* PRESS, WHICH I DID (WITH THE INVALUABLE COLLABORATION WITH ALAN MCGEE) SOLELY IN ORDER TO INFLICT THIS ATROCITY UPON AN UNSUSPECTING WORLD.

Thus writes James Williamson in his forward to this remarkable collection of writings.

James Havoc has evidently been around since the late eighties, creating literary havoc and knocking about as a Primal Scream groupie, persuading Bobby Gillespie to frock up as the Gilles de Rais for a Super-8 film, and recording his own LP, *Church of Raism*. His writings — or rather, outpourings — are a pungent mixture of extreme sex and violence, set in an unspecified 'time of legends'; places packed to the skies with viscera and monsters. But for the super-concentrated nature of pieces such as *Satanskin*, *Third Eye Butterfly* and *White Skull*, this book could be classed as erotica, yet Havoc's incredible facility for imagery and language, and his relative lack of narrative interest puts these works in quite another league — too elaborate to be nightmares, too overwrought to be invested with more than mere curiousness.

And here lies Havoc's strengths and his weaknesses. In contrast to regular erotic writing, there is no variation of tone, no boring bits of 'proper' story between the good juicy bits. No characters to engage with, no story to speak of, just atmosphere and a barrage of violent sexual events. Everything is pitched at the same level of screaming intensity. This is not a criticism as these are not your usual one-handed erotic writings. Havoc shoots for short and intense, the language equivalent of sequences from a Jerry Bruckheimer movie, or a series of MTV-market commercials extolling the sights of Hell. His feel for language is extraordinary, if untamed; plenty of gems cumulating in over-decoration, simple stories festooned to a point where they read like cut-ups. Take this example:

THEY CONSTRUCT A SPIRALLING GARRISON FROM CARNAGE, A FOLLY OF PUBIC PELTS AND SAWN SCALPS, THE JUICE OF EXPLODED SEXES, SUCCULENT STOOLS SPECKLED WITH TAPEWORMS, SPINE RIPPLED BY THE HAND OF RABIES, CRAB-LIKE IN PATTERNS, NIPPLES PUNCTUATED BY GREEDY FLOWERS, ALL RIGGED TIGHT WITH GELATINOUS HAWSERS OF HEAD INTEGUMENT AND PACKED IN ICE.'

I cannot in my heart of hearts get excited about this stuff because the hyper-baroque stylings make for a tiring and obscure read. Leaving out the 'children's' Gingerworld fragment and a couple of other pieces which should have gone in the bin, Havoc's often haphazard, sometimes unreadable gifts are a rare and strong meat, like being trapped in an oubliette with a crazed adolescent who badly needs a Valentine's card. Taboo after taboo is thrust into one's eyes, every repulsive and necrotic act that de Sade didn't get round to describing. It would all be a bit of harmless fun, but Williamson's forward over-selfconsciously builds Havoc up as some kind of legendary literary 'character'. And Jack Sargeant's next introduction, hailing Havoc's 'importance' as a libertarian crusader (and bizarrely citing his colloquial use of language), alternates between the insightful and the pretentious, even more gratuitous than Havoc's pieces.

With so much polite, good taste, crap on the shelves, this book deserves to be out there if only to give people with unfossilised reading habits the chance to expose themselves to something decidedly unmainstream. How widely it is distributed is another question. Many bookshops will still behave in a scandalised fashion if you enquire whether they carry Crowley's *White Stains*. If words had the power to replace drugs, *Butchershop in the Sky* would be whipped-up by the tabloids into a national moral panic. That isn't going to happen, of course, but the analogy goes some way to expressing my feelings towards both the strengths and the absurdities of this work. Fine for it to have been published. But then, if it wasn't, if it stayed in Havoc's bottom drawer, it wouldn't matter that much.

The two illustrative strips by Mike Philbin are imaginative, let down by school-magazine draughtsmanship and for being uncoloured. I keep returning to look at them: comedy and evil pouring from every scratch of his nib, strong hints of Goya's influence.

Havoc is supposed to have 'disappeared' after an eleven-day binge in Tokyo on Millennium Eve. The scrupulous logging of the details of this binge by James Williamson (even down to the label of beer Havoc was on), and the seemingly intimate knowledge of Havoc's life in the years before that makes me wonder if Williamson is none other than the real-life incarnation of the shadowy Havoc. It would be Havoc's best story yet, if true. **EUGENE CARFAX**

TV POEMS
Chris Mikul

No, not a collection of rhymes by or about transvestites, *TV Poems* is actually a collection of pieces by Chris Mikul of *Bizzarism* fame. This tiny selection of poems revolves around the TV-centred world of suburban Australia when young Chris was growing up. This really isn't my kind of thing, I'm afraid to say, and I admit that I found the two pages of notes on the TV programs and films mentioned in the poems more interesting than the poems. **PAN PANTZIARKA** [Ed: *TV Poems* has since been expanded into a full-blown title, courtesy of Pluto Press Australia.]

Yep! That's *Lemora* director **RICHARD BLACKBURN** at his **West Hollywood** home. If you're interested in obtaining a crisp **VHS** copy of Blackburn's *Lemora: The Lady Dracula*, the director has copies! US orders go for **$43.50** (priority mail), while all foreign orders are **$49.00** (global priority). Cheques or money orders should be made payable to Richard Blackburn and sent to him c/o The Golden Apple, 7711 Melrose Ave, Los Angeles, California 90069, USA. For credit card orders, plug into www.goldenapplecomics.com. [*Lemora* can be obtained in the UK through Exploited, PO Box 5022, Nottingham, NG3 5FU; www.prima.net/exploited.] Unfortunately, since the recent death of Blackburn's good friend Paul Bartel, the sequel to their 1982 sleaze classic *Eating Raoul* is temporarily on hold.

THE END OF ARBITRARITY - Joachim Luetke's POSTHUMAN

by Thomas Ballhausen

HEADPRESS The choice of publishing house for your book *Posthuman* seems really unusual, because Weitbrecht is mostly known for literature, especially children's books.

JOACHIM LUETKE My publisher told me recently that he tries to balance commercialism and patronage. And — in this case — he really is something of a patron. It all started a few years ago, when I illustrated a book for Thienemann, another part of the Weitbrecht publishing house. The book was *The Filthy Prince* by Martin Auer, a very good Austrian author. I really like his style, and I was free to choose which text to illustrate, and so we did this book together. And as a deal in return Weitbrecht printed and published *Posthuman*.

Could you give us a short overview on the structure of *Posthuman*?
The book starts with works inspired by mythical stuff and HP Lovecraft. Then there is what I'd like to call the 'psychic abysses' section. This important part of the book is something of a discussion with myself. The last chapter is about my work on Marilyn Manson. It shows how great the connection between music and the pictorial arts can be; how these disciplines interact and create something completely new.

How did you start working with Marilyn Manson?
Two years ago he saw one of my videos and really liked it. A few days later his management called me: "Yeah, there are some sculptures he's fond of, and he wants them for his new video-clip, and we need the sculptures yesterday" and so on, stuff like that. But finally it worked pretty well. We organised the transport and the sculptures were used in the 'Long Hard Road Out Of Hell' clip. I put the clip on the web, and synergies were made. It worked so well that I started comparing Manson's 'world' and my 'world', creating connections between the two. It was fascinating to find so many analogies between them; between us. The pictures are a part of this process. It was great, and that's how the Manson-Files, the final chapter in my book, were created.
You're not supposed to manipulate or treat Manson stuff, in spite of his enthusiasm for my sculptures. The first step was the management, the second — naturally — the star-photographers. They really hate to give any of their stuff to other artists. It took about three months for us to get all the permissions.

How do you integrate the Manson-stuff in your other work, especially on the internet? Do you think that Manson could be some kind of semantic depleted Grand Guignol harlequin?
The Manson-Files are a special part of www.luetke.com. There you can see all the combinations between mine and his works, and my special

view on the figure/character Marilyn Manson.
Manson is definitely no harlequin, but he is often mistaken for one. But all the media-stuff on this topic is really crap: he's not the type of person to be a harlequin; it's not that simple. He's the first musician since Alice Cooper in the early seventies who's been able to polarise society to such a great extent: hate and rejection on one hand, and almost religious devotion and worship on the other. Quality polarises, it always does.

How about the reactions to your work?
Reaction is mostly positive. Most of it comes from the States, from Australia, seldom from Europe. Sometimes my pictures and sculptures provoke kinky and strange stuff, but that's something I have to deal with.

How much of an influence do the perceptions of 'high culture' and 'popular culture' have on these reactions? How do these differences in culture influence you?
Popular culture is extremely important to me — comics for example: Moebius, Bilal, some Japanese guys and stuff like *Preacher*. But I want to point out that comics are also part of high culture. All the citations in my pictures are carefully placed, like the mixture of Moebius and the 'The Last Supper'. And there are also the connections with 'accepted' culture: literature, classical stuff and so on. I do like that too. We mentioned Lovecraft... there is also stuff from Trakl in my book... I really like Meyrink. But I like Clive Barker too. From the sector of the visual arts, I like Giger best, because he made huge steps with his ideas; his new

point of view. He showed us that there is much more than flowers, fairies, elves and all the rapes of mythological structures and topics. And Giger didn't give a fuck for 'political correctness' — we really have to be terribly grateful for that, for him being the way he is.

That's the point. There is no arbitrariry in this cultural continuum, there is no place for arbitrariry in the visual arts at all. And I always try to present a very personal surrogate. In this situation it's stupid: you can't use the term 'high-culture'; the term should be obliterated. ▣

POSTHUMAN
Joachim Luetke

$38; 128pp, ISBN 3 522 71935 2; Weitbrecht Verlag, K Thienemanns Verlag, Stuttgart, Germany; online orders via Online Artshop at www.luetke.com

Posthuman is a book from German artist Joachim Luetke, displaying his futuristic view of humanity. Looking through its pages it is impossible to avoid the strong influence of Giger, perhaps the last surrealist. Giger uses different techniques — illustration, 3-D construction, photography, collage/montage — in the tradition of the surrealists. Luetke's illustrations depict some mechanical human shapes, obsolete structures and also a daring interpretation of *The Last Supper*.

Posthuman comprises a series of photographs of Gothic Luetke's crafty work. Using bits and bobs he has produced some dusty humanoid. Rags, bones (precious remnants from many meals), dolls of his childhood, a foetus he has found, baby pacifiers — these are some of the ingredients of Luetke's fantasy and fetishism.

German people are concerned about environment. I saw in Luetke's work a mark of this Teutonic identity. In the book Luetke says, "Rag and trash: I want to retrieve their right by using them." Thus by his recycling habit he intends to reveal a lost humanity.

Luetke's work is crammed with symbolism, so much so that it is difficult to know where to begin. The work has a general industrial and Third Reich feel about it. The statements are in your face. The line of handmade humans, stamped with Nazi lookalike symbols, has no depth beyond being a morbid army. His babies with chicken feet instead of hands are senseless and don't contain any aesthetic. Jesus is part of the parade too; he wears a yellow cross... why not!

We are dealing with Luetke's genocide complex. Mythology, religion, politics, sex and death are also on his agenda and the references to childhood are numerous. The clichés express his metaphysical concerns,

THIS PAGE AND PREVIOUS: Images from Joachim Luetke's *Posthuman*, including the eerie child with hoop and goat (above).

but there is little room for imagination.

I couldn't finish this observation without mentioning the hero of *Posthuman*: Marilyn Manson. The artist has devoted a good part of his photographic work to the red-eye rock star — an easy way to tackle matters of gender and show off some PhotoShop skills, too. *Posthuman* is a curiosity which provoked in me a condescending smile. Ironically, the book's big square shape looks uncannily like a compilation of records covers... By the way, I've forgotten to mention that record covers is what Luetke does for a living. Maybe he should stick to doing that and avoid this artistic masturbation which doesn't give me any pleasure? **MARIE-LUCE GIORDANI**

RED WINE MOAN
Jeri Cain Rossi

£7.99/$11.95; 138pp; ISBN 0 916397 62 9; Manic D Press, 2000; distributed in the UK by Turnaround

Jeri Cain Rossi is an author (*Angel With a Criminal Kiss*), a musician (she's opened for Sonic Youth, The Birthday Party, and Nick Cave and the Bad Seeds) and a filmmaker (*Black Hearts Bleed Red*). Perhaps she's spreading herself a bit thin, because this collection doesn't really hang together. The theme of the book seems to be boho life in the sultry and exotic underworld of New Orleans, but the overriding vision is inconsistent. The first seven short stories are brief nihilistic vignettes of drunken bums and elderly strippers who inhabit a world like that of Hubert Selby Jr's *Last Exit to Brooklyn*, but less poignantly detailed. This is a promising start, but what follows is a hundred-page story of a rather monotonous unrequited love affair — all flaming hearts and wine-fuelled passion — recounted in a naïvely humourless and romantic tone quite at odds with the bleak realism of the opening stories. Iris falls in love with Jack. Jack is kind and then cruel, leaves then returns, is devoted then heartless. Iris finds solace in red wine. A very uneven collection. **MIKITA BROTTMAN**

DIRTY MONEY
and Other Stories
Ayn Imperato

£7.99/$11.95; 142pp; ISBN 0 916397 61 0; Manic D Press, 1999; distributed in the UK by Turnaround

As with Jeri Cain Rossi's *Red Wine*

Moan [above], these 'strange tales of bizarre employment and punk rock hijinx' form another terribly inconsistent collection from another 'writer and musician' who maybe needs to make up her mind which art she's going to focus on. As with *Red Wine Moan*, the unevenness of this collection suggests that Imperato doesn't have enough material for a full-length novel, and is seldom willing to stray too far from the realms of personal experience. What struck me most about this collection of scenes from the writer's early life as a dropout Goth is how ordinary it all is. Reading *Dirty Money* is more like reading somebody's personal journal than reading a sustained collection of stories — which might be interesting if the writer was leading a particularly fascinating life, or had an especially profound capacity for self-reflection — neither of which are the case here. Moreover, *entire pages* are taken up with banal and disconnected scenes, like this one:

WALKING TO THE PHILLY TRAIN, SNOW COMING DOWN. BIG FLAKES LIKE TINY GHOSTS, ALMOST SCARING ME. THE TRACKS LAID OUT. A YOUNG GIRL RUNS TO CATCH IT AS IT RUNS AWAY. THE TRAIN MOVES ON THROUGH THE HAUNTING.

This kind of thing really confirms all the clichés about small press fiction. **MIKITA BROTTMAN**

SUBCULTURE
Sarah Veitch

£9.95 (payable Palmprint Publications, incs p&p) 252pp; ISBN 0953795306; Palmprint Publications, PO Box 1775, Salisbury, SP1 2XF; www.palmprint.fsbusiness.co.uk

My first impression of this book was that the Nexus Classics imprint had had a make-over, and that they'd commissioned the extremely talented Lynn Paula Russell to do a cover. In point of fact this isn't a Nexus book at all, though the livery is close enough to fool the casual observer. However the name Sarah Veitch should be known to most Nexus readers, especially given the recent batch of Classics which have been re-issued. To the uninitiated Ms Veitch specialises in Corporal Punishment (CP) fiction, with females on the receiving end of all manner of stern punishments. In addition to the Nexus novels and short story collec-

tion, she is also a regular in magazines like *Kane*, *Forum* and *Desire*. *Subculture* is both Sarah Veitch's latest novel and also the launch title for a new CP press called Palmprint. The story involves a private Health Clinic in Malta, run by the enigmatic Dr Landers and his team of young, female staff. Arriving to work with Dr Landers is Lisa, the archetypal innocent abroad. What she discovers is that Dr Landers, a self-confessed disciplinarian, has no compunction in putting her across his lap. Here's an extract:

'GLAD TO HEAR IT,' MICHAEL SAID, 'THE REST OF THE STAFF ARE JUST BEGINNING TO ENJOY YOUR SQUIRMING.' HE WATCHED THE COLOUR SPREAD OVER THE BACK OF HER NECK AND KNEW THAT HER FACE WAS A SIMILAR SHAME-FILLED SHADE. 'TIME I PUT THAT NICE PLUMP CUSHION UNDER YOUR BELLY,' HE ADDED SOFTLY, 'SO THAT YOUR BUM STICKS EVEN MORE FULLY OUT.' HE PICKED UP THE SATIN-CLAD SQUARE, 'AFTER ALL, AN ARSE THAT'S BEING PUNISHED SHOULD BE A FULLY RAISED TARGET. AND WE WANT THE OWNER OF THAT BOTTOM TO KNOW THAT SHE CAN'T ESCAPE.'

Of course the story sounds familiar, much CP writing involves variations on a theme. Whether you go for it or not depends largely on whether spanking and CP are your thing. Palmprint are unashamedly targeting the CP aficionado, and with Sarah Veitch kicking things off they can hardly go wrong. **PAN PANTZIARKA**

TICK
Peter Sotos

£9.95/$16.95; 224pp; ISBN 1 84068 048 2; Creation, 1999

Peter Sotos, perhaps best known as frontman of the extreme noise band Whitehouse, describes himself as a 'pornographer', but *Tick* isn't easily recognisable as the pornography most of us are familiar with, and those compelled by this particular vision of lust, sadism and child-murder have probably already discovered Sotos' work long ago. For the rest, his work remains difficult, perhaps frightening; as a result, his writing tends to be either coarsely mocked or nervously shunned. Those who do review Sotos' books generally find his fascination with child abuse an easy target for ridicule and scorn. But Sotos is a talented writer with a loyal following, and his work deserves to be taken very seriously. *Tick* has no central narrative in the traditional sense, but is composed of a series of subtly interlinked and darkly contrasting vignettes. Questions posed to child-murderers in real criminal trials are juxtaposed with apparent first-person reminiscences, scenes from pornographic films, and incidents from actual sex murder cases reported in the press, or in crime literature (Polly Klaas, Nicole Brown Simpson, Matthew Shepherd, JonBenet Ramsey). This fusion of the factual and biographical is especially powerful, lifting the veil on the bleak truths of human sexuality and sexual relationships, and revealing some of the ways in which mediated depictions of and reactions to sex murder are one of the primary factors in the incitement to child abuse. Description takes the place of commentary, and the sordid violence of this psychosexual landscape is left to speak for itself. Sotos is most articulate when he allows his own pathology to speak through his art. When he does so, his own criminality becomes an adversarial gesture, as in the writing of Genet, which gives the finger to bourgeois society in a very similar way. Also like Genet, Sotos never seems to care very much about his market, or what others may think of him. Consequently, regardless of commercial concerns, he allows himself to pursue his deviant compulsion until it exposes the void beneath all 'legitimate' sexual acts. In brief, this is a very cruel book, but one that tells the truth about human nature, and the sordid extremes to which it leads us. MIKITA BROTTMAN

THE EXPLOITS OF ENGELBRECHT
Maurice Richardson

£20; 194pp; ISBN 0 86130 107 2; Savoy, 2000; 446 Wilmslow Road, Withington, Manchester, M20 3BW; tel: 0161 445 5771; fax: 0161 446 2894; office@savoy.abel.co.uk; www.savoy.abel.co.uk

This is the first in a proposed series of fantasy classics from Savoy — others to follow include the possibly even more obscure *Zenith the Albino* by Anthony Skene, *The House on the Borderland* by William Hope Hodgson and *The Killer* by Colin Wilson. As the good people of Savoy are keen to point out, these are no ordinary reprints. Unlike Millennium's current Fantasy Masterworks series, these are not set from old galleys, but are exquisitely produced, limited edition hardbacks with a good deal of supplementary material — in this case artwork from John Coulthart, Kris Guidio and James Cawthorn, a further Richardson story, an introduction by Cawthorn and an epilogue by Michael Moorcock. This last casts Richardson as a boozy chancer, as quick with his fists as his wit and ever keen to trade a story for a drink — a writer who'd fit seamlessly into any Iain Sinclair book — but for me the defining reference point is a photo of him in late middle age, looking like a cross between JG Ballard and Terry-Thomas. The style of prose here isn't far off such a cross, either: English Surrealism with the psycho-sexual seriousness replaced by a sense of theatrical fun.

Unlike most other Savoy products, and to the inevitable disappointment of the Greater Manchester authorities, *Engelbrecht* is a book which contains no graphic bloodletting, no sexual deviancy (unless you count the pugilist dwarf's date with a Giant Sundew) and nothing to make it inaccessible or dull to, say, a nine-year-old who liked Harry Potter books. And mescaline. What it does contain is a series of extracts from the Surrealist Sportsman's Club Chronicles, in which the titular boxer, a gentleman of short stature and simian aspect, is pitted against an assortment of foes and obstacles, from villainous octopi to Butlin's Redcoats. That the dwarf should prevail each time is the only thing to be expected — otherwise there's a gleeful sense of play at work here, unlikely juxtapositions carried by a lean, pacy prose style and offset by perfect comic timing. You can imagine Richardson honing the stories on bleary-eyed cronies in favoured drinking dens — they're made to be listened to — and a *Sir Henry at Rawlinson's End* musical treatment would work perfectly. It's criminal that *Engelbrecht* hasn't enjoyed the same degree of exposure as *Sir Henry* — both are true classics of English Surrealism — and hopefully this Savoy edition will go some way towards restoring the balance. JAMES MARRIOTT

[Ed: David Britton's **Baptised in the Blood of Millions**, Savoy's new 'Lord Horror' novel, is now available. It will be reviewed in **Headpress 22**.]

666 WAYS TO GET INTO HEAVEN
Jamie Hill

$9.99; 184pp; ISBN 0 9702673 0 4; Stuck Pig Productions, 2000; www.stuckpigproductions.com

Not really sure what the point of this is — perhaps the literary equivalent of a novelty record — but apparently intended mainly as a vehicle by which the author can refer to and name-drop his many friends and drinking companions. Perhaps he could give it to some of them for Christmas; I'm really not sure who else is going to be buying it. The book consists of — yes — 666 ways to get into heaven, each listed in spacious paper-wasting capital letters on the page, with occasional addenda. Reasons include #404 BUY BEER, #368 PUT GAS IN GOD'S CAR, and #888 GET A NOTE FROM YOUR MOTHER ("an idea of Jacqueline's", apparently). Illustrated with two pictures of the author and some of his drinking buddies in a bar, this is a vanity publication by some pathetic soul who's been hanging around with people foolish enough to make him believe he's some kind of a wit. So sad and pathetic I could hardly bear to read it. MIKITA BROTTMAN

BLOOD AND BLACK LACE
dir: Mario Bava

Italy 1964; VHS; 85 mins; Nouveaux Pictures; Cert. 18

In an exclusive community a beautiful model is murdered, and, whilst speculation runs wild as to who her

murderer might be, the girl's secret diary is found, crammed with incriminating evidence... The first twenty minutes of Mario Bava's 1964 film *Blood And Black Lace* sound like the blueprint for David Lynch's *Twin Peaks*. Probably coincidence, but Bava's film *is* responsible for a host of cinematic innovations. Generally agreed by horror critics to be the original *giallo* movie, it contains a check-list of items later used by Dario Argento (especially in *Suspiria* and *Inferno*) and others: primary colours washing over every scene, eerie set design (one of the most stunning items is a red mannequin with black hair), a masked, gloved, raincoated killer, attractive girls dying in horrible ways, a soundtrack that lurches from jazz club to dungeon effortlessly, a plot that makes no sense at all unless you've watched the film way into double figures and read every slice of literature on it.

Models at bewitching Eva Bartok's fashion house all have reason to fear an imminent demise, being as everyone's past seems to be a mess of sex, drugs and duplicity. The faceless killer is destroying beauty in ugly ways. *Very* ugly ways. One girl has her face burnt off, one is the victim of a death mask (imitating Bava's earlier *Black Sunday*), and, most memorably of all, one is drowned in a bath, her lifeless body eventually hovering below the surface of clear water. I can't vouch for any cuts made in Nouveaux' version, but in a recent *Empire* horror special Kim Newman notes that you can see more of the bath murder in Pedro Almodovar's *Matador* than on any official UK or US release. Cut or uncut, *Blood And Black Lace* is a film so classy you half expect Audrey Hepburn to wander through it. With a knife in her eye socket.
MARTIN JONES

QUILLS
dir: Philip Kaufman
USA/Germany, 2000; On release theatrically in the UK, Cert. 18

Quills stars Geoffrey Rush as the Marquis de Sade and a buxom Kate Winslet as his sexy laundress-muse, Madelaine. The film, based on a stageplay by Doug Wright, uses a certain amount of poetic license to show us how the infamous Marquis still managed to publish filthy and scandalous masterpieces like *Justine*, *Juliette* and *The 120 Days of Sodom* while imprisoned in the asylum at Charenton. Rush plays a leering, arrogant, lascivious de Sade; Michael Caine plays Royer-Collard, the equally sadistic doctor sent to sort him out, and Joaquin Phoenix is Abbe Coulmier, the re-

TASCHEN ROUND-UP

MAN RAY
Manfred Heiting, Ed.
£24.99/$39.99; 251pp; ISBN 3 8228 7185 0; Taschen, 2000; www.taschen.com

Man Ray (along with André Breton) was responsible for bringing the Dadaist movement to New York — the photographer who throughout his life was adamant that photography was not art. Man Ray, the photographer who took thousands of photos throughout the twenties without even using a camera!

Man Ray was more a thinker than a photographer, a philosopher more than an artist, but when he did turn his hand to the creative, the results are impressive. It's hard, I have to admit, to sum up a person like Man Ray in one book, but hats off to Taschen and the editors — they certainly have a go. It comes complete with an illuminating text written by Emmanuelle de l'Ecotais, who studied Man Ray for her Doctorate. It's also wonderfully designed. Glossy black-and-white photos mix with quotes from the man himself, displaying his approach and attitude to his artist endeavours:

THERE HAVE ALWAYS BEEN, AND THERE STILL ARE, TWO MAIN THEMES IN EVERYTHING I DO: FREEDOM AND PLEASURE.

DREAMS HAVE NO TITLES.

I MAINTAIN THAT PHOTOGRAPHY IS NOT ARTISTIC.

Man Ray was able to continue as a photographer because he subsidised himself by freelancing for popular magazines of the day, like *Vanity Fair* and *American Vogue*, where he stylised his subjects with the use of classic portrait and fashion shoots. Outside of work he was experimenting with camera-free photographs which he called Rayographs — a process utilised by placing items directly on to photographic paper, now standard part of most O-level photography courses (but renamed photograms).

He was also responsible for photographing some of the day's top names from the world of art, poetry and literature. Subjects caught on film include Picasso, Miró, Cocteau, Marcel Duchamp, André Breton, James Joyce and Max Ernst. All framed forever in Man Ray's distinctive style that gives each subject a humanistic look (as opposed to the demi-god idol worship so much in evidence today).

This is a great book because it encapsulates some of those important moments of Dada history; it pays good homage to a man of many mediums and means. **WILL YOUDS**

EROTICA UNIVERSALIS II
Gilles Neret
£16.99/$29.99; 765pp; ISBN 8 8228 6418 8; Taschen, 2000

This second volume of 'Erotica Universalis' from Taschen, has the same brick-like weight and dimensions as its predecessor. The format hasn't changed either: the text comes in three languages, of which even the English has a definite Euro feel about it. Not that there's much in the way of interesting text — the emphasis is on the graphics, of which there are hundreds, most in colour.

The artists featured range from Rembrandt to Picasso, Carlo to Stanton, Robert Crumb to Guido Crepax. What you get out of a book like this very much depends on personal tastes, obviously. While I enjoyed the sections on Carlo, Stanton and Crepax, I'll show myself up as a philistine and admit that Rembrandt, Picasso and some of the other more worthy artists bored me to tears. Still, what do you expect from an old pervert?

I also have to say that the format of the book doesn't help. While Taschen have stuffed the book to the gills, the sheer size and weight of it make it unwieldy and not very practical.
PAN PANTZIARKA

MODEL RELEASE
Richard Kern
192pp; ISBN 3 8228 7428 0; Taschen

Frighteningly fresh-faced girls abound in this latest Taschen erotic-photography volume. Given that Richard Kern (former NY Underground filmmaker) is at the helm, many of the teen girls are captured in typically transgressive poses,

Model Release © Taschen

One of the models in Richard Kern's *Model Release*.

snarling playfully with their KAOS tattoos, for instance. Others are caught in less than typical situations, doing not-so glamorous things like squeezing blackheads in the mirror, picking their nose or lying naked with a used condom hanging halfway out of their vagina. There are portraits that look every inch like snapshots from a high school yearbook — skinny wretches with freckles and braces on their teeth — and it comes as little surprise that Kern's work in *Model Release* has previously appeared in mags like *Candy Girls*, *Live Young Girls*, *Tight*, *Barely Legal*, *Hawk*, *Taboo* and *Finally Legal* — not that I've been keeping a record; Kern says so. DAVID KEREKES

FORBIDDEN EROTICA
The Rotenberg Collection
512pp; ISBN 3 8228 6413 7; Taschen

Dating as far back as 1870, the b&w photography of *Forbidden Erotica* is a little startling. First of all, it knocks

on the head the argument that pornography is a recent phenomenon, (not that anyone but pro-censorship lobbies ever claim it is), and secondly the material here ain't quaint in a period-piece way by any stretch of the imagination. Indeed, there is something inherently confrontational in this material. It looks… well… kind of *sinister*. As in much antiquated porn, some of the men in *Forbidden Erotica* turn their face away from the camera, or wear a mask or hat to conceal their identity. Others smile broadly under a huge moustache as they direct their erect member into some lass' open mouth or outstretched rump. These men have the glare of the criminal class, and most of the women look like aged whores or ill-at-ease innocents. Some of the pornographers utilise primitive photographic tricks (etched-on piss, for example). But I suppose the real trick in these old images was managing to keep perfectly still and maintain

an erection whilst waiting the small lifetime for the photographic plate to capture the fleeting moment. Oh yeah, *Forbidden Erotica* is 100 per cent hardcore. Stick that in your great grandad's pipe and smoke it. DAVID KEREKES

ROY STUART VOL III
250pp (approx); ISBN 3 8228 6054 9; Taschen

Another massive compendium of mostly restrained, tasteful soft-porn from a photographer at the top of his form. These sometimes whimsical photo sessions and situations derive for the most part from *Leg Show* magazine — a strangely anachronistic vehicle in today's hardcore world. Nothing so *direct* here in the work of Roy Stuart, who shows only the merest glimpse of the sacred *yoni* in favour of scrutinising the panty gusset and the garter belt, and, rather unfortunately to my taste, the gussets of frequently laddered tights. The models are quite attractive, for the most part 'real', as opposed to girlie-mag totty or porn bimbos. This also is not directly to my taste as, despite understanding the desire to avoid overt stereotypes, I prefer girlie-mag glamour to gritty reality any day. But a lot of you weirdoes disagree, it seems, and the optimum word in describing Roy Stuart's work seems to be 'sexy' — at least according to the females I've shown this book to. STEPHEN SENNITT

pressed asylum priest tortured by sexual fantasies of Kate Winslet's heaving breasts. Blimey.

Just as it sounds, it's all a bit ridiculous, especially the climatic scenes where the Marquis' sordid tales of lusty gents, ripe young wenches and oysters waiting to be plucked get the other madmen so worked up that they end up burning down the asylum. Meanwhile, Michael Caine's virginal young wife Simone (Amelia Warner), brought straight home from the nunnery, turns out to be a closet Marquis de Sade buff, and ends up shagging the decorator while her old man's out at work. Sound familiar? If so, it's because *Quills* is basically a porn movie without any sex — except for the extracts read from de Sade's literary works.

Granted, the film doesn't make any claims to be the 'true' story of the Marquis de Sade and his time at Charenton. But even then, this is strictly de Sade-lite. Gone are the real horrors of the Marquis' life and marriage, his abuse of his wife and the violent crimes that got him locked up in Charenton in the first place. This is de Sade meets Merchant Ivory, where the Marquis is made to seem no more harmful than a lusty old uncle who likes a few dirty jokes now and then; Winslet and her mother (Billie Whitelaw) gasp and titter away, but they love every minute of it. You might enjoy this film if you're happy to pay the price of admission for a glimpse of Kate Winslet's tits (and I bet many of you are, you sad bastards). But if you're a fan of the Marquis de Sade, give it a miss; this oyster's not worth the popping.

MIKITA BROTTMAN

GROOVE FOUNDATION
Leaving Home

CD; 1st Stone Records, 626 Santa Monica Blvd., Suite 235, Santa Monica, CA 90401 –2538, USA; www.groovefoundation.com, www.1ststonerecords.com

What is it with Americans and guitar-driven indie rock? Given the wretched state of the British singles charts, I couldn't make out a credible case that we're much hipper and cooler, but it's undoubtedly the case that the reverberations of the grunge revolution are still being felt in the States in a way that they aren't in Britain, with Queens of the Stone Age currently being touted as the natural successors to Nirvana. Groove Foundation are a West Coast sorta

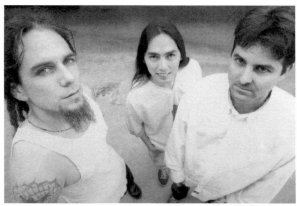

Too mellow by far.
Groove Foundation.

melodic/hardcore/grunge/indie kind of thing. I was reminded of Everclear, Cracker, Fishbone, fIREHOSE and the milder moments of the Meat Puppets. I dunno — maybe if you live in California, this kind of music makes sense, but for my taste this is too mellow by far.

SIMON COLLINS

DAYGLO ABORTIONS
Death Race 2000

CD; God Records, PO Box 44132-3170, Till I cum Rd. (?), Victoria, BC, Canada, V9A 7H7; godrecords.com

THE LOUDMOUTHS/
HOT ROD HONEYS

7" EP; Wrench Records, BCM Box 4049, London, WC1N 3XX; http://home.earthlink.net/~bbloudmouth/

"I shit and eat and sleep death!" Take a line like that and combine it with the band's name and you know that Dayglow Abortions are about as subtle as hanging around a playground with your trousers down. With titles like 'Drink Beer Smoke Pot' and 'Stupid Drunkin Fuckin Cunt', we're in shout-and-grind country here, where a bunch of unrepentant males muse over their redneck lifestyles with pride. Hit the bong, down some beers, drive home blotto and bang your old lady — that's pretty much the content of *Death Race 2000*. Not such a cultural divide as you'd like to think: Dayglo Abortions are the Canadian equivalent of The Macc Lads. For similar subjects tackled with more intelligence, check out Wisconsin snailcore gurus Killdozer instead.

For some reason, San Francisco's The Loudmouths cover a Dayglo

Abortions song ('Argh Fuck Kill') on their side of a vinyl EP shared with Hot Rod Honeys. It's sung by their roadie. Both bands offer up short blasts of middle-finger punk rock. All-male Belgium three-piece Hot Rod Honeys lose out in the looks department by appearing on the cover naked. Their music veers towards rockabilly (punkabilly?), although the singer sounds like he's had one bottle of white cider too many. Or perhaps not enough. Far more appealing are The Loudmouths, two girls and a guy kicking the shit out of four-track recording methods. On the cover, bassist Beth sports a *Texas Chain Saw Massacre* T-shirt. This is good enough for me. Even better is singer/guitarist Dulcinea. Looking like Tura Satana's younger, more evil sister, she'd probably get thrown out of the Lunachicks for being 'disruptive'... Hey, image *does* count! More, please.

MARTIN JONES

SALLY
Sally

CD; Rise Above Records

I told some young dude that I wrote for *Headpress*. "Oh yeah? What kind of stuff do you write?" they asked. "This-and-that," I replied. "Some music-based articles, that kind of thing." "Why don't you write something on all this Kiss fuckin' revival shit?" they blurted back with considerable venom. The idea was a horrible one, alright, and it filled me with real dread. Even with all the paraphernalia that has come with the Kiss revival — little Ace Frehly dolls and crap (I'm guessing it's Ace. Is that

what he looks like? Is that how you spell his name? I haven't a clue) — the idea of an article on Kiss made me want to run home and play Sally again. I like Sally. They're no-nonsense Brummies who sound like Black Sabbath. They also appear to be on the periphery of the Stoner Rock explosion and I can't quite figure why they aren't closer to the epicentre. Not that I think Kiss are Stoner Rock. Kiss have got a fuckin' revival going, for crissakes — with dolls. JOE SCOTT WILSON

VARIOUS
The Orange Spot Sessions Vol 2
CD; Orange Peal, PO Box 15207, Fremont, CA 94539, USA; www.orangepeal.com
DYNAMO HUM
Fallopian
CD; PO Box 9253, Calabasa, CA 91372-9253, USA; www.dynamohum.com
Under the veil of something called the 'Worldwide New Rock Showcase', The Orange Spot Sessions packs in twenty-one indie bands from around the globe. Well, that's what the tedious between-song announcer keeps telling you. Closer inspection shows that only one of the combos hails from beyond North America. I'm sure all the bands here are hard-working and serious about their music, but that doesn't necessarily make them any good. It's like watching twenty-one competent jugglers. There's not one second of music or vocals that offers a interesting glitch in this CD, and even its most untypical song ('Fade' by Fourforty) does nothing more than follow the NIN blueprint. By the time I'd realised that one track sounded horribly similar to Eagle Eye Cherry, I was forced to leave the room. California's Dynamo Hum, who are featured on The Orange Spot Sessions, are one of those bands cursed

with the 'sounds like' tag. The sleeve of their CD, Fallopian, even has a 'looks like' quality to it, as in: looks like Vaughan Oliver's work for 4AD records. The music within is reminiscent of Throwing Muses' early, uncomfortable albums, and vocalist Jen sounds uncannily like PJ Harvey before she caught the storyteller bug. Sometimes I was even reminded of The Breeders, but not for any positive reasons. In the end Dynamo Hum are akin to their engineering namesake: reliable, but they wear you down. One point for rhyming 'fallopian' with 'scorpion', though. MARTIN JONES

BORLEY RECTORY
Borley Rectory
CD; Borleyrectory@hotmail.com (step into the Rectory at Mp3.com)

STEP INSIDE THROUGH THE GATES INTO THE RECTORY / DEMONS WILL TAKE YOUR COAT, GHOSTS WILL MAKE YOU A SANDWICH...

Well, that's right neighbourly of them! Here we have four tracks of Sabbath-alike dirge metal with very silly lyrics. The singer (who rejoices in the name of Blade D Crabhole) sounds a bit like Peter Steele from Type O Negative. The music's OK, for that kind of thing, but it all gives the impression of having been much more fun to record than to listen to. No doubt it's some hilarious in-joke, but I'm not sure why anybody who's not mates with the band would be interested. SIMON COLLINS

INHALER
Metal Inferno
CD EP; Seriously Groovy Music; seriously.groovy@virgin.net; www.seriously groovy.com
This is heavily processed industrial dance metal in a Ministry/NIN/Pitchshifter/Godflesh/Prodigy stylee, and is actually pretty good. Barrages of massively distorted guitar fade in and out of waves of feedback and samples while the infernal techno beat goes on like roadworks outside your bedroom window at 7:30 in the morning. Standout tracks include 'Nothing Ahead' and 'Under (remix)'. 'On and On' is a lo-fi Blues Explosion-type rock-out. 'A Recipe For Disaster' reminded me of Leftfield. A well-developed sense of irony is evident in the intergalactic ghetto-blaster and Flying V cover

artwork, and in lyrics like this (from 'Metal Inferno'):

I AM THE KING OF ROCK, DARK LORD SUPREME / TURN UP THE LEVEL, HEAR THE SPEAKERS SCREAM...

Evidently all the tracks on 'Metal Inferno' are remixes and outtakes from the recording sessions for an earlier release entitled 'Chang'. There's nothing else I can tell you about Inhaler, but I liked what I heard. SIMON COLLINS

THEME
On Parallel Shores Removed
CD; Fourth Dimension, PO Box 63, Herne Bay, Kent, CT6 6YU
DETONATOR
7" single; Suggestion Records, PO Box 1403, 58285 Gevelsberg, Germany
The first track of On Parallel Shores Removed suggests that Theme are luring you in for an album of midnight worry music, but then they pull the rug from under your feet. Unfortunately. 'Parallel Meaning Now (pts 1 & 2)' stretches to almost fourteen minutes: quiet guitar loops take their time and then eventually merge into something resembling a synthesiser boffin's moment of contemplation. Except for one subsequent song, the same atmosphere is never quite regained. Dub/drum and bass remains the theme of Theme, the kind of stuff lost souls at music festivals stumble upon when they're looking for something else entirely. 'Parallel Meaning Now' is matched only by 'Peninsula Rising', which comes on like the unearthly soundtrack of Aguirre, Wrath of God given some musical grounding in reality. It's the kind of song that makes you wonder what these musicians are really capable of. Buy On Parallel Shores Removed for tracks one and five, and programme them to play through until the breaking daylight.
Four-piece Detonator paste sweet female French vocals over grumbling percussive backing: one song each side squeezed between slices of blackboard-scraping noise. The bass-heavy rumble of 'Dans Ton Coeur' is sinister only if you wish to live your life like a cheap crime paperback, whilst 'Simply Wonderful' is all accordion applied to the same rules as above. Probably best appreciated by Gallon Drunk lookalikes in some Camden hole or other. MARTIN JONES

THE FILTH AND THE FURY

dir: Julian Temple

UK/USA, 1999; Cert. 15

Birmingham New Street Odeon on a Wednesday afternoon. Minutes before the film. Voices behind me: a man and two girls. The male is an ex-punk, a member of that strange faction who are 'more into dance music nowadays'. The girls are at university, and act suitably impressed by his tales of Bands of Yore. Before the lights dim, the conversation is capped by one of the girls admitting that 'all the music around today is boring,' and how 'there's nothing good around anymore…'

The good old days. As I write this a scratchy single-LP copy of *The Great Rock'n'Roll Swindle* plays on the stereo. I'd like them to be otherwise, but my first proper memories of the Sex Pistols start with that album. Cartoon punks, fitting for a kid not even into double-figure age yet. The post-Rotten Pistols belonged to us. Me and my mates preferred 'Friggin' In The Riggin" to 'God Save The Queen' any day. Of course, the Pistols terrorised Britain for three singles and an album, and *The Filth and the Fury* kicks *Swindle* back into the right context (it was all Malcolm McLaren's fault), even erasing memories of that recent, horrible reunion tour, a mega-bucks package that conveniently forgot about John Lydon's work with Public Image Ltd.

Julian Temple's film has a stench of the past attached to it that is intoxicating. *The Filth and the Fury* lets the surviving band members tell their own stories for once. Each has his face hidden in the shadows, as if they are still stuck in some peculiar witness protection programme for crimes against Punk Rock. Malcolm McLaren is barred from this authorised version. Any words he speaks are accompanied by a screen-filling image of a pulsating, inflatable bondage mask. We've already heard his gospel enough times to be bored shitless by it: he invented Punk, he wanted the Pistols to be the

next Bay City Rollers, he let Sid Vicious slide down the infected needle of heroin abuse. No matter, McLaren's fate is assured. On Channel 4's recent 'Punk Top Ten' programme, he appeared to be transforming into Vivienne Westwood. A more hideous punishment could not be imagined.

There are no scene-of-the-crime details from roadies here. What you get is John Lydon (the would-be world-changer), Glen Matlock (the muso), Paul Cook and Steve Jones (the lager lout brothers) laying down the details over tons of footage, much of it previously unseen. Temple also craftily splices in comedians of the day (Tommy Cooper, Benny Hill), Laurence Olivier's *Richard III* (a big influence on Lydon, apparently), and all-too-real events such as the dustmans strike and the crepe-paper hell that was the Silver-fucking-Jubilee. Every moment of this film is priceless: the tingle that still greets you when the opening chords of 'Anarchy' escape; Lydon's hidden tears over Vicious' death; Jones admitting that talking politics with fans bored him, and that all he was looking for was a decent blow-job (US birds did it better, apparently); rock journo Nick Kent digging his own grave with a slurred 'punk good — music press bad' rant…

And then there's the familiar stuff: a pissed-up Bill Grundy leching over Siouxsie Sioux whilst Steve Jones ridicules him; Lydon sitting on the drum raiser staring out across the audience towards The End as the band trudge through 'No Fun' in San Francisco (their last gig); and gruesome footage of rock's most wholesome couple, Sid Vicious and Nancy Spungen. Sid always was punk's Boy of Little Brain. We've all had one, the mate who's equal parts fun and embarrassing, who just carries on and on until death gets in the way. Sat in a park deckchair, Sid comes across as confident and amusing; nodding off to an interviewer's questions whilst Nancy whines beside him, he's a lost cause. But he was never going to be jogging around the lakes of Switzerland with Bowie, was he? Spungen herself is even more horrible and annoying than Chloe Webb's impression of her in *Sid and Nancy*, a swollen-nosed New York Dolls groupie with glossy, lipstick-smeared lips you'd only allow around your cock under forced

gunpoint. From there, go thou to Courtney Love, and shudder.

But it's not all despair. *The Filth and the Fury* is a cut-and-paste ride of emotions, the most poignant being the footage of The Pistols' Christmas Day 1977 benefit for striking firemen: a children's party followed by a concert. All the band agree that it was one of the best experiences, and we see them handing out presents; Vicious — a natural kids entertainer — clowning around, an ecstatic Lydon being pelted with cake as he

The Dead Boys abduct a groupie for a special Punk edition of *Super Rock* — admittedly nothing to do with *The Filth and the Fury*.

sings (all this soundtracked by 'Bodies'!). It's a strange shot of a band together for no other reason than to enjoy themselves and entertain others, before differences and deaths and self-parody and reunions destroyed it all…

As I left the cinema, I remembered another thing one of the girls sitting behind me had said, about how — nowadays — you're either 'alternative' or 'trendy'. Odd, to be able to make such clear-cut distinctions. It's like sodding *West Side Story*, or something. Punks and Teds, Mods and Rockers. There's always conflict in culture. *The Filth and the Fury* shows that the Sex Pistols didn't always get on. But Lydon, Cook and Jones all seem to agree on one perfectly clear point: Glen Matlock was a right boring cunt. **MARTIN JONES**

ALSO RECEIVED...

The part of the show where we can't fit any more in.

Unless stated otherwise, all comments are by David Kerekes

ADDICTED: The Myth and Menace of Drugs in Film / Jack Stevenson, Ed.
Book / £14.95/$19.95; 272pp; ISBN 1 84068 023 7; Creation, 2000 / Keep this one next to Critical Vision's own *Fleshpot* (see p.149) — what Stevenson did for sex cinema in that volume, here he does for drug cinema. Drugs in underground film, commercial and non-commercial film, films around the world...Once again, a highly entertaining and enlightening read from the film historian and cohorts.

ADVERSE EFFECT Vol II No 4
Zine / £2/$4; Richo Johnson, PO Box 63, Herne Bay, Kent, CT6 6YU / Formerly *Grim Humour*, generally regarded as one of the best in the field of 'alternative' music zines... Reviews, interviews (e.g. German minimalist Thomas Brinkmann — an 'artist' it seems) and Richo's always readable ramblings... the only bad points are the magazine's seeming brevity. [Anton Black]

BEDLAM No 2
Zine / £3 (incs p&p); 40pp; Chimera Arts; 13 Foliage Crescent, Brinnington, Stockport, Cheshire, SK5 8AP / Taking as its inspiration the fine Skywald line of horror comics, *Bedlam* is a labour of love that is showcasing some real comic talent.

BODY WEAPON / dir: Aman Chang
DVD; 85mins; Hong Kong Legends; Cert. 18 / There's nothing here to lift *Body Weapon* above countless other high-kicking Hong Kong action films, apart from the psychological twist that motivates the bad guy.

THE DIRTY SQUAD: The Inside Story of the Obscene Publications Branch by its Former Head / Michael Himes
Book / £16.99; 303pp; ISBN 0 316 85321 6; Little Brown, 2000 / A woman who liked to film herself *in flagrante* with dogs, Boy George, Operation Spanner, and those men who prey on children are just a few of the subjects tackled by Himes (not without some wit and, at times, sympathy). Recounting his days spent at Scotland Yard, Himes is only too aware of the shortcomings of the law. With regard to the hullabaloo over sex education videos a decade or so ago, he says: "The Obscene Publications Act at that time was — and to a huge extent still is — really rather silly."

THE EVIL DEAD COMPANION / Bill Warren
Book / £12.99; ISBN 1 84023 1874; Titan, 2000 / Everything you could possibly want to know about Sam Raimi's *Evil Dead* trilogy, from the dependable Bill Warren...but nowhere does he say that parts II and III sucked.

FLASHPOINT No 3
Zine / $3; 44pp; Shannon Colebank, Flashpoint, PO Box 5591, Portland, OR 97228, USA / Alternative healthcare and medical scams and conspiracies. This issue features AIDS facts and fallacies. Slogan: "Desperate times call for desperate zines"! [Stephen Sennitt]

HOUSE OF PAIN / Pan Pantziarka
Book / £8.95/$13.95; 191pp; ISBN 1 84068 052 0; Creation / Welcome reprint of this tough novel of sexual rage and off-beat desires.

JOHNNY CASH: The Man His World His Music
DVD; 196?; USA; 90mins; Cherry Red; Cert. Exempt / This vintage documentary is a remarkably cheap affair, shot entirely, it seems, with just the one camera. The filmmaker doggedly follows Cash as he embarks on a tour across the US, playing prison gigs, going to a recording session with Bob Dylan (from which neither artist emerges untarnished), writing a song for the Native Indians massacred by Custer at Wounded Knee ('Big Foot'), spending time with a young hopeful musician, receiving an award for his *Folsom Prison* album, and other stuff. For PC-minded country fans, the film even opens with Cash on a hunting trip, shooting a bird, and then singing to it a song.

KING OF THE WORLD /dir: John Sacret Young
VHS; 89mins; Endemol Entertainment; Cert. 18 / This dull bio-pic of Muhammad Ali is very obviously a TV-movie. But it's timeline is so fragmented and confusing that one has to suspect the original version ran on for much longer — several hour-long parts perhaps. If it didn't, then director Young has no excuse at all.

MATCHLESS / On the Surface and in the Deep
CD EP; Matchless, 1122 E. Pike St, Suite 685, Seattle, WA 98122-3934, USA / Wonky pop with some solid backbeats and female vocals make one wish there were more than just five tracks to this CD from Matchless.

NEKROMANTIK / dir: Jörg Buttgereit
DVD; Germany 1987; Blood Pictures; www.nekromantik.de
DVD; Germany 1987; Barrel Entertainment; www.barrel-entertainment.com
Two very different digital releases of Buttgereit's cult classic, which are destined for collector status themselves. The Barrel release boasts a cleaner, sharper-looking print, while Blood has a more 'earthy' quality about it. Both come with their own unique commentary tracks and special features, which include early shorts from Buttgereit's pre-*Hot Love* days.

NICO: An Underground Experience + Heroine
DVD; Visionary; 100mins; Cert. Exempt / Two live films of Nico on one disc: *Heroine* is a solo performance recorded at Manchester's Library Theatre, while *An Underground Experience* has a wired Nico fronting her punk band in a basement club someplace. No fancy camera angles or footwork, just full-on historic recordings.

PEEPSHOW / Mr C
Zine / £0.50 plus SAE in the UK/$2ppd elsewhere (cash only); 30pp; A5 format; c/o Vegas Recordings, PO Box 45, Mirfield, W. Yorks, WF14 9YQ; vegadiscs@yahoo.com "Don't be fooled," the missive that accompanied this booklet read, "ninety per cent of *Peepshow* is based on fact."

PERIOD / Dennis Cooper
Book / £8.99; 224pp; ISBN 1 85242 671 3; Serpent's Tail / Brings Cooper's 'LA cycle to a close' apparently.

SONG DEMO FOR A HELLEN KELLER

WORLD / dir: Larry Wessel
VHS; USA 1999, 2hrs; $25/$30 (outside the US, post-paid), payable Larry Wessel, PO Box 1611, Manhattan Beach, CA 90267-1611, USA / John Trubee is the guy responsible for 'A Blind Man's Penis', the deliberately obtuse set-your-poem-to-music record that became a cult sensation. This video captures Trubee with his band The Ugly Janitors of America writing, rehearsing and recording several new material. Whether or not you dig this depends on how much you like Trubee's scathing 'vision', but it's also an interesting insight into the creative process.

WES CRAVEN'S LAST HOUSE ON THE LEFT: The Making of a Cult Classic / David A Szulkin
Book / £14.99/$19.95; ISBN 1 903254 01 9; FAB Press, 2000 / "Recommended wholeheartedly" determined the review for the original edition of this book in *Headpress 16*. Well, the book just got better and is completely revised, updated and revamped.

WHAT HAPPENED ON THE MOON? An Investigation into Apollo
VHS; £15.95; 222mins; Aulis; VHS; Cert. Exempt; 25 Belsize Park, London, NW3 4DU This two-tape set is a companion piece to Aulis' book *Dark Moon* [see *Headpress 19*], and further challenges the authenticity of NASA's moon-landing programme with plenty of damning photographs and interviews. Like the book, the sheer volume of evidence suggesting foul-play is hard to dismiss and most open-minded viewers will come away with a seedling of doubt, if not totally rejecting the notion that NASA ever put a man on the Moon at all. Yes, *Whatever Happened on the Moon?* is that convincing. (And, at £15.95 for two-tapes, bloody good value too!)